Real-time 3D Character
Animation with Visual C++

This book is dedicated to David Lever (1927–2001).

My Dad, who is greatly missed.

Real-time 3D Character Animation with Visual C++

Nik Lever

Focal Press

OXFORD AUCKLAND BOSTON JOHANNESBURG MELBOURNE NEW DELHI

Focal Press
An imprint of Butterworth-Heinemann
Linacre House, Jordan Hill, Oxford OX2 8DP
225 Wildwood Avenue, Woburn, MA 01801-2041
A division of Reed Educational and Professional Publishing Ltd

Ⓡ A member of the Reed Elsevier plc group

First published 2002

British Library Cataloguing in Publication Data
A catalogue record for this book is available from the British Library

Library of Congress Cataloguing in Publication Data
A catalogue record for this book is available from the Library of Congress

ISBN 0 240 51664 8

For information on all Focal Press publications visit our website at:
www.focalpress.com

Composition by Genesis Typesetting, Laser Quay, Rochester, Kent
Printed and bound in Great Britain

PLANT A TREE

BTCV
British Trust for
Conservation Volunteers

FOR EVERY TITLE THAT WE PUBLISH, BUTTERWORTH-HEINEMANN
WILL PAY FOR BTCV TO PLANT AND CARE FOR A TREE.

Contents at a glance

Real-time 3D Character Animation with Visual C++

The Toon3D Creator application.

Contents in summary

Real-time 3D Character Animation with Visual C++

Real-time 3D Character Animation with Visual C++

Animating with Toon3D.

The Toon3D logo.

Real-time 3D Character Animation with Visual C++

About the author

The author has been programming for about 20 years. Professionally, he started out as a drawn animator. These days he spends most of his time programming, but occasionally gets his pencil out. He is married with two children, one of whom spends far too long glued to his PS1!! He lives high in the Pennines in England and tries to get out sailing when it's not raining, which means he spends most of his time playing with computers, because it rains a lot in England.

Using the Toon3D application.

Introduction

Who should read this book?

To get the best from this book, you need some experience with C and a reasonable knowledge of C++. It does not attempt to teach the basics of C/C++ programming. If you are new to programming then I recommend getting a good introduction to C++ programming, particularly Visual C++.

If you have ever looked at a PC or Playstation game with characters running and leaping through an exciting landscape and wondered how it was done, then you should read this book. You may be a hobby programmer, a student or a professional.

Hobby programmer

The book takes you on an exciting adventure. From the basics of 3D manipulation to morph objects and subdivision. On the way, you get Visual C++ project files to load and software that runs on the Windows desktop. You get a full-featured development environment for 3D character animation, so even if you find the maths and the code hard to follow, you can still create games to impress the kids. The game engine even has an ActiveX control that allows you to distribute your work on the Internet.

Student

The computer games industry has become an important employer, always looking for new talent. After reading this book you will be ready to create the sample programs that will get you that first job. You will be guided through the maths and the principal ideas involved in displaying

complex moving characters. You will get an insight into the artist's problems in keeping the characters interesting while not exhausting the game engine.

Professional

You need to display characters in architectural walkthroughs or you may want to add this level of sophistication to multimedia kiosks that you produce. Maybe you use Director and want to add 3D support via an ActiveX control. If you are a web developer then you will find the chapter on streaming and compression particularly useful.

Using the CD

Most of the chapters have example programs to help illustrate the concepts described. These example programs provide you with source code to get you started with your own programs. The CD has two folders, Examples and Toon3D.

Inside the Examples folder you will find folders labelled Chapterxx, where xx is the chapter number. To find the examples for the chapter you are reading simply look in the appropriate Chapter folder. Many of the examples use Microsoft Foundation Classes (MFC). When programming with Visual C++, MFC is a common approach. You will find a brief introduction to MFC in Appendix B; if you have never used MFC then I recommend reading this and perhaps getting one of the many introductory MFC books.

The Toon3D folder contains all the source code for a Web3D application. Toon3D allows you to develop in Lightwave 3D or Max and import the geometry, surface data and animation into Toon3D. In the application you can add interactive behaviour and then publish the material suitable for the Internet. Toon3D is mentioned throughout the book because it is used to illustrate some concepts; the application is also in the Toon3D folder along with some content to play about with. Toon3D is explained in detail in Appendix A.

There is no installation program on the CD. If you want to use an example then copy it to your hard drive and remember to change the file attributes from Read-only. In Explorer you can do this by selecting the files and right clicking; in the pop-up menu select Properties and uncheck the Read-only check box.

Altering file attributes using Windows Explorer.

Typographic conventions

All code examples are set out using Courier New:

```
BOOL CMyClass::CodeExample(CString str){
    CString tmp;

    if (str.Find("code example")!=-1) return FALSE;
    tmp.Format("The string you passed was %s", str);
    AfxMessageBox(tmp);

    Return TRUE;
}
```

All C++ classes are prefixed with the letter C. When variables or function names are used in the text they are italicized; for example,

CodeExample uses the parameter *str*. I prefer not to use the *m_* to indicate a member variable in a class. Additionally, I do not use Hungarian notation to indicate the variable type. Source code style is a matter of heated debate but I prefer *name* rather than *m_szName*. Variables are all lower case and function names use capital letters to indicate the beginning of a word, for example *CodeExample*.

How much maths do I need?

3D computer graphics uses a lot of maths, there is no denying it. In this book I have kept the maths to a minimum. You will need basic school maths up to trigonometric functions, inverse trigonometric functions and algebra. When concepts are introduced they are explained fully and if you find some of the later chapters confusing in their use of the trig functions then I recommend reading Chapter 1 again, where the concepts are explained more fully. You will not find any proofs in this book. If you want to find why a particular technique for using a curve works rather than taking it on trust, then I suggest you look at Appendix C. Appendix C provides a list of alternative sources of information if you want to delve deeper into a particular topic.

All vertex transformations are done with the processor in the sample code. This helps illustrate what is going on, but it does mean that the accelerated graphics card that includes transformations is not being used to its best effect. Once you are familiar with the techniques you may choose to let the hardware look after transformations, leaving the processor to look after the logic.

Credits

The development of 3D graphics has been a combined effort by many people. In the text I explain most techniques with no clear indication of who should be given the credit for developing the technique in the first place. Appendix C on further information makes some attempt to give the credit to the individuals who devised the techniques and also to those who have provided much needed assistance to fledgling developers in the 3D industry.

Contacting the author

I hope you enjoy the book and find it useful. If you do then send me an email at nik@toon3d.com, if you don't then send me an email at nik@anywhere-else.com; just kidding, I would like to hear your views good and bad.

1 3D basics

In this chapter we are going to introduce the 3D basics. We will look at how to store the information required for a computer to display a 3D object. In addition, we will consider the maths required to manipulate this object in 3D space and then convert this to a 2D display. We need a sufficiently general scheme that will allow us to store and manipulate the data that can be displayed as a box, a teapot or an action hero. The method generally used is to store a list of points and a list of polygons. Throughout this book, all the source code is designed to handle polygons with three or four sides.

In later chapters we will leave most low-level operations to a graphics library, which will manage most of the mathematical manipulation. In this book we use the graphics library, OpenGL. But to ease the creation of seamless mesh characters, we will need to do some of our own manipulation of point data; to understand how this code operates you will need to follow the methods outlined in this chapter.

OpenGL is the most widely adopted graphics standard

From the OpenGL website www.opengl.org

'OpenGL is the premier environment for developing portable, interactive 2D and 3D graphics applications. Since its introduction in 1992, OpenGL has become the industry's most widely used and supported 2D and 3D graphics application programming interface (API), bringing thousands of applications to a wide variety of computer platforms. OpenGL fosters innovation and speeds application development by incorporating a broad set of rendering, texture mapping, special effects and other powerful visualization functions. Developers can leverage the power of OpenGL across all popular desktop and workstation platforms, ensuring wide application deployment.'

Describing 3D space

First let's imagine a small box lying on the floor of a simple room (Figure 1.1).

Figure 1.1 A simplified room showing a small box.

Figure 1.2 A simplified room with overlaid axes.

How can we create a dataset that describes the position of the box? One method is to use a tape measure to find out the distance of the box from each wall. But which wall? We need to have a frame of reference to work from.

Figure 1.2 shows the same room, only this time there are three perpendicular axes overlaid on the picture. The point where the three axes meet is called the origin. The use of these three axes allows you as a programmer to specify any position in the room using three numerical values.

In Figure 1.2, the two marked lines perpendicular to the axes give an indication of the scale we intend to use. Each slash on these lines represents 10 cm. Counting the slashes gives the box as 6 along the x-axis and 8 along the z-axis. The box is lying on the floor, so the value along the y-axis is 0. To define the position of the box with respect to the frame of reference we use a *vector*,

[6, 0, 8]

In this book, all vectors are of the form [*x*, *y*, *z*].

The direction of the axes is the scheme used throughout this book. The y-axis points up, the x-axis points to the right and the z-axis points out of the screen. We use this scheme because it is the same as that used by the OpenGL graphics library.

Transforming the box

To move the box around the room we can create a vector that gives the distance in the x, y and z directions that you intend to move the box. That

is, if we want to move the box 60 cm to the right, 30 cm up and 20 cm towards the back wall, then we can use the vector [6, 3, 2] (recall that the scale for each dash is 10 cm) to move the box. The sum of two vectors is the sum of the components.

$$[x, y, z] = [x1, y1, z1] + [x2, y2, z2]$$

where $x = x1 + x2$, $y = y1 + y2$ and $z = z1 + z2$

For example, $[12, 3, 10] = [6, 0, 8] + [6, 3, 2]$

Describing an object

The simplest shape that has some volume has just four points or *vertices*. A tetrahedron is a pyramid with a triangular base. We can extend the idea of a point in 3D space to define the four vertices needed to describe a tetrahedron. Before we can draw an object we also need to define how to join the vertices. This leads to two lists: a list of vertices and a list of faces or *polygons*.

The vertices used are:

```
A: [ 0.0,  1.7,   0.0]
B: [-1.0,  0.0,   0.6]
C: [ 0.0,  0.0,  -1.1]
D: [ 1.0,  0.0,   0.6]
```

To describe the faces we give a list of the vertices that the face shares:

```
1: A,B,D
2: A,D,C
3: A,C,B
4: B,C,D
```

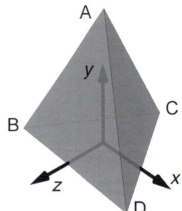

Figure 1.3 A tetrahedron.

Although the triangles ABD and ADB appear to be the same, the order of the vertices is clearly different. This ordering is used by many computer graphics applications to determine whether a face is pointing towards the viewer or away from the viewer. Some schemes use points described in a clockwise direction to indicate that this face is pointing towards the viewer. Other schemes choose counter-clockwise to indicate forward-facing polygons. In this book we used counter-clockwise. There are no advantages or disadvantages to either scheme, it is simply necessary to

be consistent. Think about the triangle ABD as the tetrahedron rotates about the *y*-axis. If this rotation is clockwise when viewed from above then the vertex B moves right and the vertex D moves left. At a certain stage the line BD is vertical. If the rotation continues then B is to the right of D. At this stage in the rotation the face ABD is pointing away from the viewer. Since we know that the order of the vertices read in a counter-clockwise direction should be ABD, when the order changes to ADB, the triangle has turned away from the viewer. This is very useful because in most situations it is possible to effectively disregard this polygon. (If an object is transparent then it will be necessary to continue to render back-facing polygons.) We will look at other techniques to determine back-facing polygons, but vertex order is always the most efficient to compute.

Figure 1.4 A polygon normal.

Polygon normals

A normal is simply a vector that points directly out from a polygon. It is used in computer graphics for determining lighting levels, amongst other things. For the software accompanying this book we store the normal for every polygon in a scene. We have already seen how to deal with the sum of two vectors. The method is easily extended to allow us to subtract two vectors:

$$[x, y, z] = [x1, y1, z1] - [x2, y2, z2]$$
$$= [x1 - x2, y1 - y2, z1 - z2]$$

For example, $[6, 0, 8] - [6, 3, 2] = [6 - 6, 0 - 3, 8 - 2]$
$$= [0, -3, 6]$$

But what happens when we choose to multiply two vectors. In fact, there are two methods of 'multiplying' vectors. One is referred to as the *dot product*. This is defined as

$$\mathbf{a \cdot b} = |\mathbf{a}||\mathbf{b}| \cos(\theta) \text{ where } 0 \leq \theta \leq 180°$$

The symbol |a| refers to the magnitude of the vector **a**, which is defined as:

$$|\mathbf{a}| = \sqrt{(x*x + y*y + z*z)}$$

This is a method of measuring the length of the vector. It is a 3D version of the famous theorem of Pythagoras that gives the length of the hypotenuse of a right-angled triangle from the two other sides.

For example, if \mathbf{a} = [6, 3, 2], then:

$$|a| = \sqrt{(6*6 + 3*3 + 2*2)}$$

$$= \sqrt{(36 + 9 + 4)}$$

$$= \sqrt{49} = 7$$

The dot product is a scalar; this simply means it is a number with a single component not a vector. Given two vectors \mathbf{a} = [a_x, a_y, a_z] and \mathbf{b} = [b_x, b_y, b_z], the dot product is given by

$$\mathbf{a} \cdot \mathbf{b} = a_x \times b_x + a_y \times b_y + a_z \times b_z$$

The dot product is very useful for finding angles between vectors. Since we know that

$$\mathbf{a} \cdot \mathbf{b} = |\mathbf{a}||\mathbf{b}| \cos \theta$$

This implies that

$$\frac{\mathbf{a} \cdot \mathbf{b}}{|\mathbf{a}||\mathbf{b}|} = \cos \theta$$

Now we can calculate *cos* θ directly. We can then use the inverse function of *cos*, *acos*, to calculate the value of θ. Here is a code snippet that will pump out the angle between two vectors.

```
double angleBetweenVectors(VECTOR &v1, VECTOR &v2){
    double s,dot,mag1,mag2;
    //Calculate the magnitude of the two supplied vectors
    mag1=sqrt(v1.x*v1.x + v1.y*v1.y + v1.z*v1.z);
    mag2=sqrt(v2.x*v2.x + v2.y*v2.y + v2.z*v2.z);
    //Calculate the sum of the two magnitudes
    s=mag1 * mag2;
    //Avoid a division by zero
    if (s==0.0) s=0.00001;
    dot=v1.x*v2.x + v1.y*v2.y + v1.z*v2.z;
    //Cos theta is dot/s. Therefore theta=acos(dot/s)
    return acos(dot/s);
}
```

The alternative technique for 'multiplying' vectors is the *cross product*. This method creates a further vector that is at right angles or *orthogonal* to the two vectors used in the cross product. Unlike the dot product the operation is not commutative. This simply means that

$A \times B$ does not necessarily equal $B \times A$. Whereas $A \bullet B = B \bullet A$

The cross product of two 3D vectors is given by

$$A \times B = [Ay{*}Bz - Az{*}By, \; Az{*}Bx - Ax{*}Bz, \; Ax{*}By - Ay{*}Bx]$$

This is easier to remember if we look at the pattern for calculating determinants. Determinants are important scalar values associated with square matrices. The determinant of a 1×1 matrix $[a]$ is simply a. If A is a 2×2 matrix then the determinant is given by

$$A = \begin{bmatrix} a & b \\ c & d \end{bmatrix}, \qquad \det A = \begin{bmatrix} a & b \\ c & d \end{bmatrix} = ad - bc$$

That is the diagonal top left, bottom right minus top right, bottom left. When extended to 3×3 matrices we have:

$$A = \begin{bmatrix} a & b & c \\ d & e & f \\ g & h & i \end{bmatrix}, \qquad \det A = a\begin{bmatrix} e & f \\ h & i \end{bmatrix} - b\begin{bmatrix} d & f \\ g & i \end{bmatrix} + c\begin{bmatrix} d & e \\ g & h \end{bmatrix}$$

$$= a(ei - fh) - b(di - fg) + c(dh - eg)$$

Here we take the top row one at a time and multiply it by the determinant of the remaining two rows, excluding the column used in the top row. The only thing to bear in mind is that the middle term has a minus sign. If we apply this to the vectors A and B we get

$$A = \begin{bmatrix} x & y & z \\ Ax & Ay & Az \\ Bx & By & Bz \end{bmatrix} \qquad \det A = x\begin{bmatrix} Ay & Az \\ By & Bz \end{bmatrix} - y\begin{bmatrix} Ax & Az \\ Bx & Bz \end{bmatrix} + z\begin{bmatrix} Ax & Ay \\ Bx & By \end{bmatrix}$$

$$= x(AyBz - AzBy) - y(AxBz - AzBx) + z(AxBy - AyBx)$$

$$= x(AyBz - AzBy) + y(AzBx - AxBz) + z(AxBy - AyBx)$$

The x, y and z terms are then found from the determinants of the matrix A.

The purpose of all this vector manipulation is that, given three vertices that are distinct and define a polygon, we can find a vector that extends at right angles from this polygon. Given vertices A, B and C we can create two vectors. **N** is the vector from B to A and **M** is the vector from B to C. Simply subtracting B from A and B from C respectively creates these vectors. Now the cross product of the vectors **N** and **M** is the normal of the polygon. It is usual to scale this normal to unit length. Dividing each of the terms by the magnitude of the vector achieves this.

Rotating the box

There are many options available when rotating a 3D representation of an object; we will consider the three principal ones. The first option we will look at uses Euler angles.

Euler angles

When considering this representation it is useful to imagine an aeroplane flying through the sky. Its direction is given by its heading. The slope of the flight path is described using an angle we shall call pitch and the orientation of each wing can be described using another angle which we shall call bank. The orientation can be com-pletely given using these three angles. Heading gives the rotation about the *y*-axis, pitch gives rotation about the *x*-axis and bank gives rotation about the *z*-axis.

Figure 1.5 *Euler angle rotation.*

To describe the orientation of an object we store an angle for the heading, the pitch and the bank. Assuming that the rotation occurs about the point [0, 0, 0] as the box is modelled then heading is given from the 3 × 3 matrix:

$$H = \begin{bmatrix} \cos(h) & 0 & \sin(h) \\ 0 & 1 & 0 \\ -\sin(h) & 0 & \cos(h) \end{bmatrix}$$

Rotation in the pitch is given by:

$$P = \begin{bmatrix} 1 & 0 & 0 \\ 0 & \cos(p) & -\sin(p) \\ 0 & \sin(p) & \cos(p) \end{bmatrix}$$

and bank rotation is given by:

$$B = \begin{bmatrix} \cos(b) & \sin(b) & 0 \\ -\sin(b) & \cos(b) & 0 \\ 0 & 0 & 1 \end{bmatrix}$$

Combining columns with rows as follows is another form of matrix multiplication:

$$\begin{bmatrix} a & b & c \\ d & e & f \\ g & h & i \end{bmatrix} \begin{bmatrix} A & B & C \\ D & E & F \\ G & H & I \end{bmatrix} = \begin{bmatrix} Aa + Db + Gc & Ba + Eb + Hc & Ca + Fb + Ic \\ Ad + De + Gf & Bd + Ee + Hf & Cd + Fe + If \\ Ag + Dh + Gi & Bg + Eh + Hi & Cg + Fh + Ii \end{bmatrix}$$

Using this method we can combine the **H**, **P** and **B** rotation matrices:

$$\mathbf{HPB} = \begin{bmatrix} \cos(h)\cos(b) - \sin(h)\sin(p)\sin(b) & \cos(h)\sin(b) + \sin(h)\sin(p)\cos(b) & \sin(h)\cos(p) \\ -\cos(p)\sin(p) & \cos(p)\cos(b) & -\sin(p) \\ -\sin(h)\cos(b) - \cos(h)\sin(p)\sin(b) & -\sin(h)\sin(b) + \cos(h)\sin(p)\cos(b) & \cos(h)\cos(p) \end{bmatrix}$$

Matrix multiplication is non-commutative, so **HPB, HBP, PHB, PBH, BHP** and **BPH** all give different results.

Now, to translate the object vertices to world space we multiply all the vertices as vectors by the rotation matrix above. Vector and matrix multiplication is done in this way:

$$R = \begin{bmatrix} a & b & c \\ d & e & f \\ g & h & i \end{bmatrix} \quad v = \begin{bmatrix} x \\ y \\ z \end{bmatrix} \quad Rv = \begin{bmatrix} ax + by + cz \\ dx + ey + fz \\ gx + hy + iz \end{bmatrix}$$

So the vertex (*x*, *y*, *z*) maps to the vertex (*ax* + *by* + *cz*, *dx* + *ey* + *fz*, *gx* + *hy* + *iz*). If the object also moves in the 3D world by **T** = (*tx*, *ty*, *tz*), then the new position of the vertex should include this mapping. That is, the vertex maps to **Rv** + **T**, giving the world location

$$(x, y, z) \rightarrow (ax + by + cz + tx, \; dx + ey + fz + ty, \; gx + hy + iz + tz)$$

Euler angle rotation suffers from a problem that is commonly called gimbal lock. This problem arises when one axis is mapped to another by a rotation. Suppose that the heading rotates through 90°, then the x- and z-axes become aligned to each other. Now pitch and bank are occurring along the same axis. Whenever one rotation results in a mapping of one axis to another, one degree of freedom is lost. To avoid this problem, let's consider another way of describing rotations which uses four values.

Angle and axis rotation

The values used are an angle θ and a vector A = $[x, y, z]^{\mathsf{T}}$ that represents the axis of rotation. When the orientation of the box is described in this way the rotation matrix is given by:

Figure 1.6 Angle and axis rotation.

$$R = \begin{bmatrix} 1 + (-z^2 - y^2)(1 - \cos(\theta)) & -z\sin(\theta) + yx(1 - \cos(\theta)) & y\sin(\theta) + zx(1 - \cos(\theta)) \\ z\sin(\theta) + yx(1 - \cos(\theta)) & 1 + (-z^2 - x^2)(1 - \cos(\theta)) & -x\sin(\theta) + zy(1 - \cos(\theta)) \\ -y\sin(\theta) + zx(1 - \cos(\theta)) & x\sin(\theta) + zy(1 - \cos(\theta)) & 1 + (-y^2 - z^2)(1 - \cos(\theta)) \end{bmatrix}$$

We can use this rotation matrix in the same way as described for Euler angles to map vertices in the object to a 3D world space location.

Quaternion rotation

Yet another way to consider an object's orientation uses quaternions. Devised by W. R. Hamilton in the eighteenth century, quarternions are used extensively in games because they provide a quick way to interpolate between orientations. A quaternion uses four values. One value is a scalar quantity w, and the remaining three values are combined into a vector $v = (x, y, z)$. When using quaternions for rotations they must be unit quaternions.

If we have a quaternion $q = w + x + y + z = [w, v]$, then:

The norm of a quaternion is $N(q) = w^2 + x^2 + y^2 + z^2 = 1$
A unit quaternion has $N(q) = 1$

The conjugate of a quaternion is $q* = [w, -v]$

The inverse is $q^{-1} = q*/N(q)$. Therefore, for unit quaternions the inverse is the same as the conjugate.

Addition and subtraction involves $q_0 \pm q_1 = [w_0 + w_1, v_0 + v_1]$

Multiplication is given by $q_0 q_1 = [w_0 w_1 - v_0 v_1, v_0 \times v_1 + w_0 v_1 + w_1 v_0]$; this operation is non-commutative, i.e. $q_0 q_1$ is not the same as $q_1 q_0$. The identity for quaternions depends on the operation; it is $[1, \mathbf{0}]$ (where $\mathbf{0}$ is a zero vector $(0, 0, 0)$) for multiplication and $[0, \mathbf{0}]$ for addition and subtraction.

Rotation involves $v' = qvq*$, where $v = [0, v]$.

Turning a unit quaternion into a rotation matrix results in

$$R = \begin{bmatrix} 1 - 2y^2 - 2x^2 & 2xy + 2wz & 2xz - 2wy \\ 2xy - 2wz & 1 - 2x^2 - 2z^2 & 2yz - 2wx \\ 2xz + 2wy & 2yz - 2wx & 1 - 2x^2 - 2y^2 \end{bmatrix}$$

We will consider the uses of quaternions for smooth interpolation of camera orientation and techniques for converting quickly between the different representations of rotation in Chapter 8.

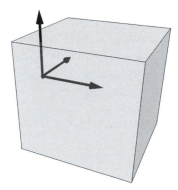

Figure 1.7 Rotation about a pivot point.

Rotation about a point other than the origin

To rotate about an arbitrary point, which in many CGI applications is called the *pivot point*, involves first translating a vertex to the origin, doing the rotation then translating it back. If the vertex $[1, 1, 1]^T$ were rotated about the point $(2, 0, 0)$, then we want to consider the point $(2, 0, 0)$ to be the origin. By subtracting $(2, 0, 0)$ from $[1, 1, 1]^T$ we can now rotate as though this is the origin then add $(2, 0, 0)$ back to the rotated vertex.

Scaling the object

The size of the object has so far been unaffected by the operations considered. If we want to scale the object up or down we can use another

matrix. The scaling in the *x*-axis is *Sx*, scaling in the *y*-axis is *Sy* and scaling in the *z*-axis is *Sz*. This results in the matrix

$$\mathbf{S} = \begin{bmatrix} Sx & 0 & 0 \\ 0 & Sy & 0 \\ 0 & 0 & Sz \end{bmatrix}$$

Scaling should be applied before any other operations. We can concatenate our rotation matrix to ensure that scaling occurs first. If *R* is our rotation matrix from either Euler angles or from the angle/axis method, then the matrix becomes:

$$\mathbf{R} = \begin{bmatrix} a & b & c \\ d & e & f \\ g & h & i \end{bmatrix} \quad \mathbf{S} = \begin{bmatrix} Sx & 0 & 0 \\ 0 & Sy & 0 \\ 0 & 0 & Sz \end{bmatrix} \quad \mathbf{RS} = \begin{bmatrix} aSx & bSy & cSz \\ dSx & eSy & fSz \\ gSx & nSy & iSz \end{bmatrix}$$

The full operation to translate a vertex in the object to a location in world space including pivot point consideration becomes

RS(v − p) + t + p, where **R** is the rotation matrix, **S** the scaling matrix, **v** is the vertex, **p** is the pivot point and **t** is the translation vector.

For every vertex in a solid object, **t + p** and **RS** will be the same. Pre-calculating these will therefore speed up the transformation operations. It is highly likely that the pivot point of an object will remain constant throughout an animation, so the object could be stored already transformed to its pivot point. If this is the case then the equation becomes

RSv + t

So now we can move and rotate our box. We are now ready to transfer this to the screen.

Perspective transforms

Converting 3D world space geometry to a 2D screen is surprisingly easy. Essentially we divide the *x* and *y* terms by *z* to get screen locations (*sx*, *sy*). The technique uses similar triangles to derive the new value for (*sx*, *sy*) from the world coordinates. Referring to Figure 1.8, here we indicate the position of the camera, the screen and the object. Following the vertex *P* to the image of this on the screen at *P'*, we get two similar triangles, *CPP•z* and *CP'd*, where *d* is the distance from the camera to the screen. We want to know the position of *P'*:

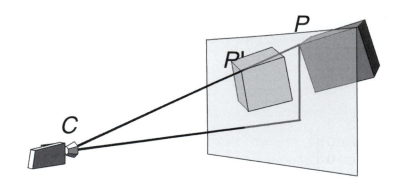

Figure 1.8 Perspective transform.

$$(Px - Cx)/(Pz - Cz) = (P'x - Cx)/d$$

$$(Py - Cy)/(Pz - Cz) = (P'y - Cy)/d$$

which can be rearranged to become

$$P'x = ((Px - Cx)*d)/(Pz - Cz) + Cx$$

$$P'y = ((Py - Cy)*d)/(Pz - Cz) + Cy$$

The value for *d*, the distance from the camera to the screen, should be of the order of twice the pixel width of the 3D display window to avoid serious distortion.

The above equations assume that the centre of the display window is (0, 0) and that *y* values increase going up the screen. If (0, 0) for the display window is actually in the top left corner, then the *y* values should be subtracted from the height of the display window and half the width and height if the display is added to the result.

$$sx = ((Px - Cx)*d)/(Pz - Cz) + Cx + \text{screen width}/2$$
$$sy = \text{screen height}/2 - (((Py - Cy)*d)/(Pz - Cz) + Cy)$$

Using 4 × 4 matrix representations

Although rotation and scaling of an object can be achieved using 3 × 3 matrices, translation cannot be included. To get around this problem it is usual to add a row and column to the matrix. We move from

$$\begin{bmatrix} a & b & c \\ d & e & f \\ g & h & i \end{bmatrix}$$

to

$$\begin{bmatrix} a & b & c & 0 \\ d & e & f & 0 \\ g & h & i & 0 \\ tx & ty & tz & 1 \end{bmatrix}$$

where (tx, ty, tz) is the translation in the x-, y- and z-axes respectively.

This technique requires us to add a component to the vector representation of a vertex. Now a vertex is defined as $[x, y, z, 1]^T$. Such coordinates are often referred to as homogeneous coordinates. The matrix can now include the perspective transform that converts world coordinates into the 2D screen coordinates that the viewer ultimately sees. By concatenating the above matrix with a matrix that achieves this perspective transform, all the calculations necessary to take a vertex from model space through world space to camera space and finally to screen space can be achieved by a single matrix.

Summary

The basic operations presented here will act as building blocks as we develop the character animation engine. To get the most out of this book, you need to be confident of the use of vectors, matrix multiplication and the simple algebra manipulation we used in this chapter. I have tried to present the material in a form that is suitable for those who are unfamiliar with mathematical set texts. If the reader wishes to explore the mathematics presented in this chapter in more depth, then please check Appendix C, where further references are mentioned.

2 Drawing points and polygons the hard way

Some people like to climb mountains, others prefer to fly over them sipping a chilled wine. If you are a climber then this chapter is for you. Most of this book uses the OpenGL library, which originated on the SGI platform and is now available for Windows, Mac and Unix boxes. The advantage of using such a library is that it shields much of the complexity of displaying the 3D characters we create. Another very definite benefit is that the library takes advantage of any hardware the user may have installed. The disadvantage to the climbers is that we have no understanding of how the display is actually generated at the individual pixel level. This chapter takes you through this process; if you are a climber then read on, if you are a flyer then feel free to skip this chapter, no one will ever know!

Creating memory for a background display

In this chapter we are trying to avoid using Windows-specific code wherever possible. For this reason we use a class library that deals with a memory-based *bitmap*. This class library, which is supplied as part of the sample code for this chapter on the CD, is called CCanvas. CCanvas has a constructor that can be supplied with a width and a height in pixels, together with the bit depth.

A colour can be specified in many ways. Generally you will need a red value, a green value and a blue value. Many applications allow for 256 levels of red, 256 levels of green and 256 levels of blue. Zero to 255 is the range of values available in 1 byte. One byte contains 8 bits of information. Hence with 8 bits for red, 8 bits for green and 8 bits for blue, we have a 24-bit colour value, 8 + 8 + 8.

When colour is specified using 3 bytes in this book, it is called an RGB value. If we define the colour value for an array of pixels then we can display this as a bitmap. If the value for each pixel were the same, then

the display would simply show a flat coloured rectangle. If we carefully choose the value for each pixel then we can display a photograph. If the range of colours in the displayed bitmap is limited then we could choose to store the bitmap as a combination of all the different colours used, followed by a list of where to use these colours. This type of display is called a palletized display and we are not supporting palletized displays in this book. Usually, palletized displays are limited to 256 colours. Creating an optimized palette for each frame of animation is time consuming. The alternative is to use a master palette, which has definite restrictions on the way that the display can handle lighting. Imagine the simplest of scenes with three bouncing balls all lit from above. Ball A is red, B is blue and C is green. If the master palette has about 80 levels of red, green and blue, then 240 slots in the palette have been used. Now in comes a purple, yellow and orange cube. Somehow, this has to be displayed using the remaining 16 colours; the results, while acceptable on desktop computer platforms 10 years ago, simply do not cut it by today's standards.

Another type of display uses 16 bits for the colour value of each pixel. This gives just 32 levels of red, 32 levels of green and 32 levels of blue. This standard is often used in computer games, resulting in faster frame rates with most hardware than 24-bit displays. A 32-bit display can use the additional 8 bits for alpha or stencil use or it can be used by the display driver to ensure all colour calculations use 32-bit integers. This results in fewer instructions for the processor to handle and consequently faster image transfers.

The code for the creation of the buffer is:

```
// Create a new empty Canvas with specified bitdepth
BOOL CCanvas::Create(int width, int height, int bitdepth)
{
    // Delete any existing stuff.
    if (m_bits)) delete m_bits;
    // Allocate memory for the bits (DWORD aligned).
    if (bitdepth==16) m_swidth =width*2;
    if (bitdepth==24) m_swidth =width*3;
    if (bitdepth==32) m_swidth =width*4;
    m_swidth = ( m_swidth + 3) & ~3;
    m_size= m_swidth *height;

    m_bits = new BYTE[m_size];
    if (!m_bits) {
        TRACE("Out of memory for bits");
        return FALSE;
```

```
        }
        // Set all the bits to a known state (black).
        memset(m_bits, 0, m_size);
        m_width=width; m_height=height; m_bitdepth=bitdepth;
        CreateBMI();
        return TRUE;
    }
```

Two things to notice here. First, the code to ensure that our line widths are exact multiples of 4.

```
    m_swidth = ( m_swidth + 3) & ~3;
```

We do this by adding 3 to the storage width and then bitwise And-ing this with the bitwise complement of 3. A bitwise complement has every bit in the number inverted. If we take an example, suppose that the width of the bitmap is 34 pixels and it is stored as a 24-bit image. A 24-bit image uses 3 bytes of information for each pixel, so if the storage width was simply the width times 3 then it would be 102. However, 102 is not a multiple of 4. We need to find the next multiple of 4 greater than 102. Three as a byte wide binary value is 00000011. The bitwise complement is 11111100. The algorithm adds 3 to the storage width, making it 105. Now 105 as a binary value is 01101001; note here that one of the lowest 2 bits is set, which means it cannot be a multiple of 4. 01101001 And 11111100 = 01101000, which is 104. This is divisible by 4 as required. The effect of the operation is to clear the last 2 bits of the number. This kind of alignment is used regularly in such buffers because it allows a pixel location in memory to be found with fewer instructions. The memory variable, m_swidth, holds the storage width of a single line and m_size keeps a check on the buffer size, so that we can easily check for out of bounds memory errors.

The other curiosity is the call to CreateBMI. Our canvas uses a Windows structure called BITMAPINFO, so that ultimately we can display the canvas on the user's screen using a simple Windows API call. A BITMAPINFO contains a BITMAPINFOHEADER and a single RGBQUAD. We are only interested in the BITMAPINFOHEADER, so we cast our member variable to a header to fill in the appropriate details. By keeping it in a function call, this minimizes the changes necessary to port this code to another platform.

```
    BOOL CCanvas::CreateBMI(){
        // Clear any existing header.
        If (m_pBMI) delete m_pBMI;
```

```
    // Allocate memory for the new header.
    m_pBMI = new BITMAPINFO;
    if (!m_pBMI) {
        TRACE("Out of memory for header");
        return FALSE;
    }
    // Fill in the header info.
    BITMAPINFOHEADER *bmi=(BITMAPINFOHEADER*)m_pBMI;
    bmi->biSize = sizeof(BITMAPINFOHEADER);
    bmi->biWidth = m_width;
    bmi->biHeight = -m_height;
    bmi->biPlanes = 1;
    bmi->biBitCount = m_bitdepth;
    bmi->biCompression = BI_RGB;
    bmi->biSizeImage = 0;
    bmi->biXPelsPerMeter = 0;
    bmi->biYPelsPerMeter = 0;
    bmi->biClrUsed = 0;
    bmi->biClrImportant = 0;
    Return TRUE;
}
```

Blitting the display to the screen

My rule about not using Windows code falls down again here, since at some stage we need to display the result of our labours. Windows uses device contexts in such operations. This book does not go into any detail in this regard. There are many other books that explain graphics operation for Windows; the Appendix lists some of the author's favourites. We use a simple blit to get our memory-based bitmap onto the screen. Now you will realize why the BITMAPINFO structure was needed.

```
// Draw the DIB to a given DC.
void CCanvas::Draw(CDC *pdc)
{
    ::StretchDIBits(pdc->GetSafeHdc(),
                    0,              // Destination x
                    0,              // Destination y
                    m_width,        // Destination width
                    m_height,       // Destination height
                    0,              // Source x
```

Figure 2.1 PolyDraw Sample drawing lines.

```
0,                      // Source y
m_width,                // Source width
m_height,               // Source height
m_bits,                 // Pointer to bits
m_bmi,                  // BITMAPINFO
DIB_RGB_COLORS,         // Options
SRCCOPY);               // Raster operation code (ROP)
}
```

So that is it for the Windows stuff. Now we can get down to the actual code.

Drawing a line with Bresenham's algorithm

We now have in memory a BYTE buffer. We can draw on this by setting the RGB values at a particular memory location. For convenience, the class includes a private function GetPixelAddress(x, *y*), which returns a

pointer to the pixel or NULL if it is out of range. The function includes a simple clip test. If either *x* is greater than the bitmap's width or *y* is greater than the bitmap's height, then it is out of range. Similarily, if *x* or *y* are less than 0 then they are out of range. To indicate this fact, the function returns a null pointer. The bitmap is stored in memory one line following another. We know how many bytes are required for a single line; this is the information that we ensured was divisible by 4, the storage width. To access the appropriate line, we simply need to multiply the storage width by the value for *y*. The distance along the line is dependent on whether we are using a 24-bit pixel or a 32-bit pixel. If we are using a 24-bit pixel then we need to multiply the *x* value by the number of bytes in a 24-bit pixel, that is 3. A 32-bit pixel needs 4 bytes for each pixel, hence the *x* value needs to be multiplied by 4. Having calculated the offset from the start of the bitmap in memory, all that remains is to add this to the start of the bitmap 'bits' memory to return the memory location of the pixel (*x*, *y*).

```
BYTE* CCanvas::GetPixelAddress(int x, int y)
{
    // Make sure it's in range and if it isn't return zero.
    if ((x >= m_width) || (y >= m_height()) || (x<0) || (y<0)) return
      NULL;
    // Calculate the scan line storage width.
    if (m_bitDepth()==24) x*=3;
    if (m_bitDepth()==32) x*=4;
    return m_pBits + y * m_swidth + x;
}
```

We want to create a function that will draw an arbitrary line that is defined by the starting and ending points. Before we go any further with such a function, we need to ensure that the start and end of the line are actually within the boundaries of the off-screen buffer we are using as a canvas. For this we will create a ClipLine function. The aim of the ClipLine function is to adjust the (*x*, *y*) values of each end of the line so that they are within the canvas area. That is $0 \le x <$ width, where width is the CCanvas width, and $0 \le y <$ height, where height is the CCanvas height.

The ClipLine function creates a code value for the start point, *cs*, and the end point, *ce*. This code value determines whether the point is within the canvas area, off to the left, right, above or below, or a combination of these. This is done using the code:

```
cs=((xs<0)<<3)|((xs>=m_width)<<2)|((ys<0)<<1)|(ys>=m_height);
```

Here, *xs* and *ys* are the *x*, *y* values of the starting point for the line. If *xs* is less than 0, then *cs* is given the value 1 shifted three places to the left, which is 8. If *xs* is greater than or equal to the width of the canvas, then 4 is added to the code value. If the *y* value is less than 0, then 2 is added to the code value, and finally if *ys* is greater or equal to the height of the canvas, then 1 is added to the code value. This places the point in one of the number sections of Figure 2.2, the number being the code value for a point in that section. For example, if we have the point (−3, 16) on a canvas that is 200 pixels square, then

```
cs = ((-3<0)<<3)|(-3>=200)<<2)|((16<0)<<1)|(16>=200)
cs = (1<<3)|(0<<2)|(0<<1)|0
cs = 8|0|0|0
cs = 8
```

From the code value, we know that the point (−3, 16) with respect to our canvas is to the left in the section labelled 8 in the diagram.

The next step is to determine the slope of the line. This is done using the *y* distance divided by the *x* distance. The *x* distance is the end *x* value minus the start *x* value. The *y* distance is the end *y* value minus the start *y* value. The slope of this line is a floating point value; since the values for *x* and *y* are all integer values, we must remember to cast the integer values as doubles to get a meaningful result for the slope. Now we have a point location and a slope. By doing a bitwise And-ing of the start and end locations, we determine whether the line remains off-screen throughout its length.

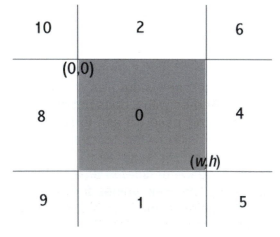

Figure 2.2 Determining point location.

Real-time 3D Character Animation with Visual C++

Table 2.1

Codes	0	1	2	4	5	6	8	9	10
0	0	0	0	0	0	0	0	0	0
1	0	1	0	0	1	0	0	1	0
2	0	0	2	0	0	2	0	0	2
4	0	0	0	4	4	4	0	0	0
5	0	1	0	4	5	4	0	1	0
6	0	0	2	4	4	6	0	0	2
8	0	0	0	0	0	0	8	8	8
9	0	1	0	0	1	0	8	9	8
10	0	0	2	0	0	2	8	8	10

A table of values for a bitwise And-ing of the start and end point codes will help in the understanding of the result of this operation (Table 2.1).

Looking at Table 2.1, we can see that if the start point is in section 1 and the end point is in section 5, then the result of a bitwise And-ing is 1; since this is not zero the function returns FALSE, indicating that there is nothing to draw. If the bitwise test results in a zero value then the aim of the remainder of the function is to determine where the line crosses the canvas area and return both a TRUE to indicate that drawing is required and revised values for xs, ys, xe and ye that are within the canvas area.

To adjust the start and end points we use the slope or gradient of the line that we have calculated and stored as the variable m. If the code value for the point when And-ed with 8 does not equal zero, then the point must be off to the left; in this case we aim to set x to 0, but what value should we store for y? Here we use the fact that we have added $-x$ to the y value, so we must subtract x times the slope of the line to y. Similar principles are adopted for each off-screen area. Having adjusted the line the function loops, setting the code values for the start and end points. This continues until the point is totally within the canvas area at which point the function exits returning a TRUE value. This clever clipping routine is known as Cohen–Sutherland after its creators.

```
BOOL CCanvas::Clip(int &xs, int &ys, int &xe, int &ye){
    int cs, ce;
    double m;
    //Calculate the slope of the line (xs,ys)-(xe,ye)
    m = (double)(ye-ys)/(double)(xe-xs);
    while (cs|ce){
        cs=((xs<0)<<3)|((xs>=m_width)<<2)|((ys<0)<<1)|↵
          (ys>=m_height);
        ce=((xe<0)<<3)|((xe>=m_width)<<2)|((ye<0)<<1)|↵
          (ye>=m_height);
        if (cs & ce) return FALSE;
        if (cs){
            if (cs & 8) ys-=(int)((double)xs*m), xs=0; else
            if (cs & 4) ys+=(int)((double)(m_width-xs)*m),↵
              xs=m_width-1; else
            if (cs & 2) xs-=(int)((double)ys/m), ys=0; else
            if (cs & 1) xs+=(int)((double)(m_height-ys)/m),↵
              ys=m_height-1;
        }
        if (ce){
            if (ce & 8) ye+=(int)((double)(0-xe)*m), xe=0; else
            if (ce & 4) ye+=(int)((double)(m_width-xe)*m),↵
              xe=m_width-1; else
            if (ce & 2) xe+=(int)((double)(0-ye)/m), ye=0; else
            if (ce & 1) xe+=(int)((double)(m_height-ye)/m),↵
              ye=m_height-1;
        }
    }
    return TRUE;
}
```

Running this function with the values (−10, 100)–(150, 300) for a 200 pixel square canvas gives the following results:

```
Slope is 1.25
Loop 1 cs = 8 ce = 1 Starting point ( -10, 100) End point (150,300)
Loop 2 cs = 0 ce = 0 Starting point ( 0, 112) End point (70,199)
```

We now know both the starting and ending points are on-screen. If neither were on-screen then there is nothing to do, so we exit. Assuming we actually have something to draw, we adjust the drawing width to the canvas storage width. Remember a 24-bit file will have a storage width

Real-time 3D Character Animation with Visual C++

that is at least three times the pixel width, plus the extra up to 3 bytes to ensure divisibility by 4. We set two variables *x* and *y* to the starting value. Then we create two distance variables for the *x* distance, *dx*, and the *y* distance, *dy*.

We set *xinc* and *yinc* to 1. The value for *xinc* indicates whether *xe* is greater than *xs*. If so, then we will reach *xe* by 1 to *xs*, a *dx* number of times. If, however, *xs* > *xe*, then we must subtract 1 from *xs*, *dx* number of times. We check *dx* to indicate which direction we are working in. If *dx* is less than 0, then the *xinc* is made to be –1 and the value for *dx* is negated. A similar technique is used for the *y* values.

The COLORREF parameter passed to the function is simply a 32-bit integer. The values for red, green and blue are embedded in this value, and we retrieve them with the code:

```
red= col&0xFF;
green=(col&0xFF00)>>8;
blue=(col&0xFF0000)>>16;
```

Now we use a switch statement to select based on bit depth. In our code we only support 24 bits, but it gives us flexibility for the future to support alternative bit depths.

```
void CCanvas::DrawLine(int xs,int ys,int xe,int ye,COLORREF col){
    int x, y, d, dx, dy, c, m, xinc, yinc, width;
    BYTE red,blue,green;

    if (!ClipLine(xs,ys,xe,ye)) return;
    //If ClipLine returns false then start and end are out off the
    //canvas so there is nothing to draw
    //m_swidth is the DWORD aligned storage width
    width=m_swidth;
    //x and y are set to the starting point
    x=xs; y=ys;
    //dx and dy are the distances in the x and y directions
    //respectively
    dx=xe-xs; dy=ye-ys;
    //ptr is the memory location of x,y
    BYTE* ptr=GetPixelAddress(x,y);

    xinc=1; yinc=1;
    if (dx<0){xinc=-1; dx=-dx;}
    if (dy<0){yinc=-1; dy=-dy; width=-width;}
```

```
red =(BYTE)col&0xFF;
green=(BYTE)(col&0xFF00)>>8;
blue =(BYTE)(col&0xFF0000)>>16;

d=0;
switch (m_bitdepth){
case 24:
    if (dy<dx){
        c=2*dx; m=2*dy;
        while (x!= xe){
            *ptr++=blue; *ptr++=green; *ptr++=red; //Set↵
              the pixel
            x+=xinc; d+=m;
            if (xinc<0) ptr-=6;
            if (d>dx){y+=yinc; d-=c; ptr-=width;}
        }
    }else{
        c=2*dy; m=2*dx;
        while (y!=ye){
        *ptr++=blue; *ptr++=green; *ptr=red; //Set the↵
          pixel
        y+=yinc; d+=m; ptr-=width; ptr-=2;
        if (d>dy){ x+=xinc;↵
          d-=c;ptr+=xinc;ptr+=xinc;ptr+=xinc;}
        }
    }
    break;
}
}
```

When drawing the line we need to decide whether our principle increment axis is going to be x or y. The test involves simply testing which is greater, the y distance or the x. If x is greater, then we use the x-axis. For every column in the x-axis, we need to colour a pixel. If the line were horizontal, then simply incrementing along the x-axis would be sufficient. But we also need to find the y position. For each column the y value can increment by 1 or decrement by 1. The maximum slope of a line where x is the principle axis is a 45° slope. For this slope, y is incremented for each x increment. So the question we need to ask as we move to the next x column is: Do we need to alter our y value?

To answer this question we use three variables. Double the x distance, c, double the y distance, m, and an incremental value d. For each x value,

we add *m* to the incremental value *d*. If it tips over the value for *dx* then we need to increase *y*. When we increase *y* we decrease the incremental value *d* by *c* and adjust our memory pointer to point to another line. The operation for the *y*-axis works in the same way. So now we can draw arbitrary lines on our memory bitmap using integer arithmetic alone.

A simple class to implement a polygon

Now we have an off-screen buffer in the form of *CCanvas* and the ability to draw an arbitrary line on this buffer defined by two points. The next step is to implement a class to store and display a polygon. This class is defined as:

```
class CPolygon
{
public:
  //Member variables
  POINT3D pts[4];//Stores the vertex data
  CVector normal;//The unit length normal
  int numverts;//Number of vertices in polygon
  double h,p,b;//Euler angle rotation
  COLOUR col;//RGB values for the unshaded colour of the polygon
  BYTE red,green,blue;//Used for all drawing operations
  CTexture *tex;//Bitmap texture pointer
  CPolygon *next;//Used if the polygon is one of a list
  //Functions
  CPolygon();//Constructor
  CPolygon(int total, CVector *pts);//Constructor
  ~CPolygon();//Standard destructor
  BOOL Facing();//True if screen coordinates of vertices
               //are in counter clockwise order
  void SetColour(int red,int green, int blue);
  void AveragePointNormal(CVector &norm);//Define normal from an
                                    //average of the vertex
                                    //normals
  void SetNormal();//Calculates normal from vertex positions
  void HorzLine(CCanvas &canvas, int x1, int x2,
        int y, double light=1.0, double ambient=0.0);
  BOOL SetPoints(int total, CVector *pts);//Set the vertex values
  void SetColour(COLOUR col);//Set the colour value
  void SetTexture(CString &filename);//Set texture from bitmap
                              //filename
```

```
    void DrawOutline(CCanvas &buffer);//Draw outline version of
                                    //polygon
    void DrawFlat(CCanvas &buffer);//Draw flat coloured version
    void DrawShaded(CCanvas &buffer, BOOL drawNormal=FALSE);↵
        //Draw shaded
    void DrawTextured(CCanvas &buffer);//Draw textured polygon
protected:
};
```

The POINT3D class is a structure defined as:

```
typedef struct stPOINT3D{
    double x,y,z;//Untransfromed position
    double nx,ny,nz;//Untransformed normal
    double wx,wy,wz;//Transformed position
    double wnx,wny,wnz;//Transformed normal
    int sx,sy;//Screen location
    int snx,sny;//Normal screen location
}POINT3D;
```

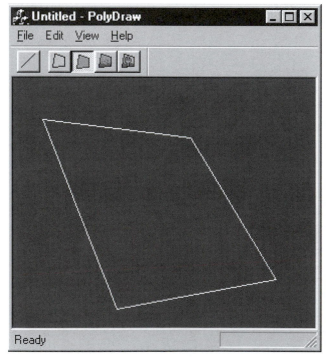

Figure 2.3 An outline polygon.

Drawing an outline polygon

We can use this new class to draw an outline polygon simply by connecting all the points in the polygon. Once the polygon has been transformed to screen coordinates using the techniques from the previous chapter, this involves just this simple code. Note that, once a polygon has been transformed, the screen coordinates are stored in the *sx* and *sy* members of the POINT3D structure points.

```
void CPolygon::DrawOutline(CCanvas &buf){
    if (numverts<3) return;
    for (int i=0;i<numverts-1;i++){
        buf.DrawLine(pts[i].sx, pts[i].sy, pts[i+1].sx, ↵
          pts[i+1].sy,col);
    }
    //Finally join the last point to the first
    buf.DrawLine(pts[numverts-1].sx, pts[numverts-1].sy, ↵
      pts[0].sx, pts[0].sy,col);
}
```

Figure 2.4 A flat coloured polygon.

Drawing a flat coloured polygon

In order to paint a filled polygon we need to raster scan the polygon. That is, we need to break up the polygon into horizontal lines and draw each of these in turn. To keep things simple we will work only with triangles. If the polygon has four sides then we draw one half first and then the next. A triangle can sometimes be orientated so that one of its sides is horizontal, but an arbitrary triangle can be split into two triangles, each with one horizontal side.

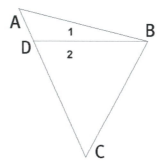

Figure 2.5 Dividing a triangle into two, each with a horizontal line.

To determine the starting point of each horizontal line in the traingle we need the slope of all three lines. In our code we first order the points by height; to create variables y[max], y[mid] and y[min]. The slope of each side is the y distance divided by the x distance. Using this information, we can determine the start and end points of each horizontal line and draw the line for each y value. The starting point for each horizontal line is given by the starting point for this slope, the slope of the line and the current y value.

If we look at an example then it will be clearer. The vertices of the triangle in Figure 2.5 are

A(28, 16) B(268, 76) C(150, 291)

Taking the line AC, we can calculate point D using the following technique. First determine the slope of line AC.

The slope of the line is the y distance divided by the x distance:

$(291 - 16)/(150 - 28) = 275/122 = 2.254$

Real-time 3D Character Animation with Visual C++

Now we want the x value when the y value on this line is 76, i.e. the y value for vertex B. A line is defined as

$$y = mx + c$$

where m is the slope and c is a constant.

Since we know that the vertex (28, 16) is on the line, we can calculate c as

$$c = y - mx = 16 - 2.254 \times 28 = -47.112$$

We also know that the vertex (150, 291) is on this line, so a quick check gives

$$y = mx + c = 2.254 \times 150 - 47.112 = 290.98$$

which rounded up is the 291 y value of this vertex.

Having calculated this constant, we can rearrange the equation for a line to derive the x value:

$$x = (y - c)/m$$

For our line we know that y is 76 and the slope is 2.254, so the x value on the line AC when y is 76 is

$$(76 - (-47.112))/2.254 = 54.62$$

So the point D is (54.62, 76).

When we draw the triangle, we use the same technique that we have used to determine the point D to determine the horizontal values for the start and end of each horizontal line. To calculate the end points of each horizontal line in the triangle ABD we will also need to know the slope and constant value for the line AB. Using this information, we know the start and end x values for each integer y value in the triangle ABD. Having drawn the upper triangle ABD, we go on to draw the lower triangle DBC. For this triangle we need to know the slope and constant value for the line BC. We can then go on to draw each horizontal line in the triangle DBC.

One end of the line will be the slope from y[min] to y[max] and the other end will change when the y value reaches the mid value. The code works through each section in turn.

```
void CPolygon::DrawFlat(CCanvas &buf){
    //This function will draw a triangle to the off screen buffer
    //class CCanvas
    //Only 24 bit supported a the moment
    if (buf.GetBitDepth()!=24) return;
    //The polygon is facing away from camera
    if (!Facing()) return;
    int count,min,max,mid,i;
    int x[c],y[c];
    double m1, d1, m2, d2, q, u, v;
    count=1;
    //Set the values for red, green and blue directly. No shading
    red=col.red; green=col.green; blue=col.blue;

    while(count<(numverts-1)){
        x[0]=pts[0].sx; x[1]=pts[count].sx; x[2]=pts[count+1].sx;
        y[0]=pts[0].sy; y[1]=pts[count].sy; y[2]=pts[count+1].sy;
        //Sort points by height
        max=(y[0]<y[1])?1:0;
        max=(y[max]<y[2])?2:max;
        min=(y[0]<y[1])?0:1;
        min=(y[min]<y[2])?min:2;
        mid=3-(max+min);
        //x distance
        q=(double)(x[max]-x[min]);
        //Avoid division by zero
        q=(q)?q:EPSILON;
        m2=(double)(y[max]-y[min])/q;
        d2=y[max]-m2*x[max];
        //Now we know the highest. middle and lowest y positions
        //Draw horizontal lines from highest to middle position
        if (y[max]!=y[min]){
            q=(double)(x[mid]-x[max]);
            q=(q)?q:EPSILON;
            m1=(double)(y[mid]-y[max])/q;
            d1=(double)y[mid]-m1*x[mid];
            for (i=y[max];i>y[mid];i-){
                u=((double)i-d1)/m1; v=((double)i-d2)/m2;
                HorzLine(buf, (int)u, (int)v, i);
            }
        }
        //Reached the mid point
```

```
if (y[mid]!=y[min]){
    q=(double)(x[mid]-x[min]);
    q=(q)?q:EPSILON;
    m1=(double)(y[mid]-y[min])/q;
    d1=(double)y[mid]-m1*x[mid];
    for (i=y[mid];i>y[min];i-){
        u=((double)i-d1)/m1; v=((double)i-d2)/m2;
        HorzLine(buf, (int)u, (int)v, i);
    }
}
count++;
    }
}
```

The function to draw a horizontal line is quite simple. We do some simple clipping to ensure we stay within memory, get a memory pointer and paint the pixels one after the other. Notice the class *CPolygon* has colour values red, green and blue defined by member variables.

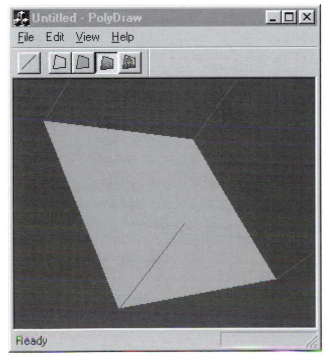

Figure 2.6 Drawing a shaded polygon.

```
void CPolygon::HorzLine(CCanvas &canvas, int x1, int x2, int y){
    //Put x1 and x2 in the right order
    int i;
    if (x1>x2){ i=x1; x1=x2; x2=i; }
    if (x1<0) x1=0;
    i=canvas.GetWidth()-1;
    if (x2>i) x2=i;
    BYTE* ptr=canvas.GetPixelAddress(x1,y);
    if (!ptr) return;//Off screen point
    //24 bit only at the moment
    for (i=x1;i<x2;i++) *ptr++=blue; *ptr++= green; *ptr++= red;
}
```

Painting a shaded polygon

So far, the choice of colour is determined simply by a predetermined value. More realistic computer graphics uses lighting. As the model moves through the light, its on-screen colour changes. The simplest example of this involves painting a single polygon. The most basic lighting model varies the strength of a polygon's colour, based on its angle towards the light. This is called *Lambertian* reflection. A light can be defined simply by direction. This is a difficult concept for any photographers out there, since intuitively they will think a light needs a position as well as a strength value. Position is not necessary to create a convincing render. But this still leaves the problem of angle. If we define a light by direction only, then we need to track this direction. The angle of a polygon is described using its normal, as we know from Chapter 1. We need to work out a value from the light vector and each polygon normal that gives us a value for the current angle. Following on from Chapter 1, we can determine the angle between two vectors using the dot product of the two vectors.

$$\cos(\theta) = \frac{\mathbf{L} \cdot \mathbf{N}}{|\mathbf{L}||\mathbf{N}|}$$

If each vector has magnitude 1, then this simplifies to

$$\cos(\theta) = \mathbf{L} \cdot \mathbf{N}$$

Using the inverse function *acos*, we can calculate the angle:

$$\theta = \text{acos}(\mathbf{L} \cdot \mathbf{N})$$

Often, we need a lighting level even when no light is present. In computer graphics models this is the ambient level. In our very simple model we define ambient to be 0.12. The result of the angle calculation will be a value between 0 and π radians. We require a value between 0 and 1 so the result of the calculation is divided by π.

```cpp
void CPolygon::DrawShaded(CCanvas &buf, BOOL drawNormal){
    //Only 24 bit supported a the moment
    if (buf.GetBitDepth()!=24) return;
    //The polygon is facing away from camera
    if (!Facing()) return;
    int count,min,max,mid,i;
    int x[3],y[3],tri=0;
    double m1, c1, m2, c2, q, xs, xe, light;
    //Create a unit length lighting vector
    CVector lvec(0.707,-0.707,0.0);
    //We are using an ambient of 0.12 so we scale the light level
    //to 1.0-ambient level=0.88 then add the ambient level
    light=acos(lvec*normal)/PI*0.88+0.12;
    //Set shaded colour value these values are used by HorzLine
    //col stores the unshaded value of the polygon
    red=(BYTE)((double)col.red*light);
    green=(BYTE)((double)col.green*light);
    blue=(BYTE)((double)col.blue*light);

    count=1;
    //Repeat for each triangle using vertices
    //(0,1,2) (0,2,3) . . . (0,n-2,n-1) where n is the number
    //vertices in the triangle
    //This technique is fast but will paint concave polygons
    //incorrectly
    while(count<(numverts-1)){
        x[0]=pts[0].sx; x[1]=pts[count].sx; x[2]=pts[count+1].sx;
        y[0]=pts[0].sy; y[1]=pts[count].sy; y[2]=pts[count+1].sy;
        //Sort points by screen height
        max=(y[0]<y[1])?1:0;
        max=(y[max]<y[2])?2:max;
        min=(y[0]<y[1])?0:1;
        min=(y[min]<y[2])?min:2;
        mid=3-(max+min);
        q=(double)(x[max]-x[min]);
        //Use EPSILON, a very small value, to avoid division by zero
        //errors
```

```
        q=(q)?q:EPSILON;
        //m2 is slope of one line, c2 is constant value for y=mx+c
        //line equation
        m2=(double)(y[max]-y[min])/q;
        c2=y[max]-m2*x[max];
        //Now we know the highest. middle and lowest y positions
        //Draw horizontal lines from highest to middle position
        //Only draw the first section if they values differ
        if (y[max]!=y[mid]){
            q=(double)(x[mid]-x[max]);
            q=(q)?q:EPSILON;
            //m1 is slope of other line, c1 is constant value for line
            //equation
            m1=(double)(y[mid]-y[max])/q;
            c1=(double)y[mid]-m1*x[mid];
            for (i=y[max];i>y[mid];i-){
                xs=((double)i-c1)/m1; xe=((double)i-c2)/m2;
                HorzLine(buf, (int)xs, (int)xe, i);
            }
        }
        //Reached the mid point, only draw if y values differ
        if (y[mid]!=y[min]){
            q=(double)(x[mid]-x[min]);
            q=(q)?q:EPSILON;
            m1=(double)(y[mid]-y[min])/q;
            c1=(double)y[mid]-m1*x[mid];
            for (i=y[mid];i>y[min];i-){
                xs=((double)i-c1)/m1; xe=((double)i-c2)/m2;
                HorzLine(buf, (int)xs, (int)xe, i);
            }
        }
        //If a four point polygon then repeat for the second triangle
        count++;
    }
    //If required paint the normals in red
    if (drawNormal){
        COLOUR normcol;
        normcol.red=255;normcol.green=0;normcol.blue=0;
        for (i=0;i<numverts;i++){
            buf.DrawLine(pts[i].sx, pts[i].sy, pts[i].snx, ↵
              pts[i].sny, normcol);
        }
    }
}
```

This is the simplest of lighting models. We have used a single normal vector to calculate a lighting level for the entire polygon. An alternative approach uses each vertex normal to get a lighting level for that vertex, then interpolation between vertices when drawing the on-screen pixels. This method is called *Gouraud* shading and gives a low polygon model the illusion of a much denser mesh, where the polygons appear to be much smoother than they really are. In our simplistic shading model we have not considered the highlights resulting from a high level of *specularity*. To achieve accurate highlights it is necessary to interpolate between vertex normal vectors to calculate the vector for each on-screen pixel. This model gives accurate highlights at the expense of additional calculations and is called *Phong* shading.

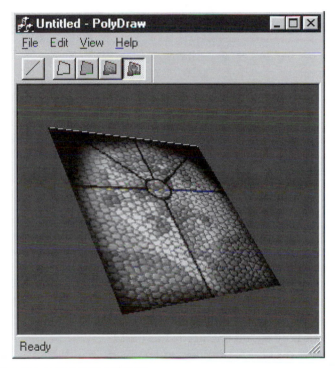

Figure 2.7 Drawing a textured polygon.

Painting a textured polygon

When creating low polygon displays, textures play an important role. Instead of very dense meshes, the illusion of complexity can be achieved by replacing the diffuse colour value with the colour value of a pixel from

a bitmap. The simplest mapping between a polygon and a bitmap is to use a four-vertex polygon where the corners of the bitmap map directly to the vertices of the polygon. The challenge then becomes one of determining, for each on-screen pixel from the polygon, which texture pixel (*u, v*) to choose for the display.

There are many approaches to this and there are several references to further information for the interested reader in the bibliography. In essence, we need a function that goes from screen space to texture space, via world space. In other words, an inverse function of the mapping we use to transform a vertex in world space to screen space.

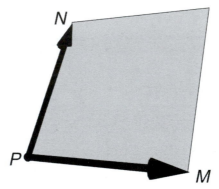

Figure 2.8 Overview of position P and vectors M and N.

First we define vectors **P**, **M** and **N**. **P** is simply a vertex one. For simplicity, **P** does not need to be on the polygon. It is, however, a point in world space. Vectors **M** and **N** define the orientation of the texture in world space. For simplicity here, we define them as vertices 0 and 2 of our polygon. So vertex 0 is **P** + **N**, vertex 2 is **P** + **M** and vertex 3 is **P** + **M** + **N**. This will stretch the texture over the whole polygon. Using different values for **P**, **M** and **N** could stretch the texture over several polygons.

If we consider a point **a** on the plane defined by **P**, **M** and **N**, it can be defined as

$$\mathbf{a} = \mathbf{P} + u\mathbf{M} + v\mathbf{N}$$

where *u* and *v* are values between 0 and 1.

We need functions that define *u* and *v* from screen coordinates. When going from world space to screen space (*sx, sy*), we perform a mapping; at its simplest this perspective transform is

Real-time 3D Character Animation with Visual C++

$$sx = ax/az$$

$$sy = ay/az$$

We actually need to make the origin the centre of screen space rather than the top left corner, but to make for easy equations we will ignore that for now. If you look through the code for this chapter you will see the actual factors we need to consider. To go from screen space to world space we manipulate the function to give

$$ax = sx*az$$

$$ay = sy*az$$

Expanding the equation for **a** we get:

$$ax = Px + u*Mx + v*Nx$$

$$ay = Py + u*My + v*Ny$$

$$az = Pz + u*Mz + v*Nz$$

Now if we substitute these values into

$$ax = sx*az$$

$$ay = sy*az$$

we get

$$Px + u*Mx + v*Nx = sx*[Pz + u*Mz + v*Nz]$$

$$Py + u*My + v*Ny = sy*[Pz + u*Mz + v*Nz]$$

With some careful algebra, we can transform these equations into

$$u = \frac{sx*(Nz*Py - Ny*Pz) + sy*(Nx*Pz - Nz*Px) + (Ny*Px - Nx*Py)}{sx*(Ny*Mz - Nz*My) + sy*(Nz*Mx - Nx*Mz) + (Nx*My - Ny*Mx)}$$

$$v = \frac{sx*(My*Pz - Mz*Py) + sy*(Mz*Px - Mx*Pz) + (Mx*Py - My*Px)}{sx*(Ny*Mz - Nz*My) + sy*(Nz*Mx - Nx*Mz) + (Nx*My - Ny*Mx)}$$

If we define three vectors **A**, **B** and **C** as the cross products of **P** × **N**, **M** × **P** and **N** × **M** respectively, then the equations simplify further:

$$u = \frac{sx*Ax + sy*Ay + Az}{sx*Cx + sy*Cy + Cz}$$

$$v = \frac{sx*Bx + sy*By + Bz}{sx*Cx + sy*Cy + Cz}$$

To achieve the textured polygon we need to raster scan the polygon in the same way that we have done for flat and shaded polygons. For each screen pixel we calculate the texture coordinates (u, v), scale them by the width and height of the texture, and paint to the screen the colour of the texture for the coordinates calculated. You will see from the example that this is a slow operation. To speed up the results, we can use interpolation techniques, calculating texture coordinates for the start and end of a scan line then interpolating between these. There are many other ways to speed up the results.

Summary

We learnt a great deal in this chapter, but although this is fascinating stuff, unless you want to rewrite the OpenGL graphics library you will not have to deal with graphics operations at such a low level. But it is useful to know how things are happening in the background if only to leave you with a sense of awe that computers are able to deal with so many instructions to display a real-time animation display.

3 Drawing points and polygons the easy way with OpenGL

OpenGL is a graphics library that essentially takes lists of vertices in world space, turns these into polygons and paints them to a 2D buffer that can be displayed. The library includes the ability to shade and texture (apply a section of a bitmap to) these polygons. OpenGL can be used to display transparent polygons and can use fogging to facilitate distance culling. If distance culling is used without some kind of fogging, then it can result in an annoying popping on and off for distant objects. The most important feature of OpenGL is that it uses hardware wherever possible to speed up processor-intensive operations. Before you can use OpenGL on a Windows machine you need to set up the main display window so that it is suitable for OpenGL and direct OpenGL to use this window for its display. In this chapter we will concentrate on these set-up procedures and then use this newly created window to display some very basic geometry. This is probably the best time to check out the examples for this chapter, which you will find on the CD in the folder 'Examples\Chapter 03'.

Introducing the OpenGL library

First, let's consider what OpenGL cannot do. The standard library contains no methods for creating complex geometry or importing models from leading CGI packages such as 3Dstudio Max or Lightwave 3D. That is not to say that you cannot use OpenGL to display such content, you can, but preparing the content in a way that is suitable for OpenGL will be your job as a developer. OpenGL is designed to take a vertex list, turn this into shaded and textured polygons, and rasterize (convert to a 2D screen buffer) the result suitable for display on the computer screen. The basic OpenGL library contains no hardware-specific window commands. It deals exclusively with a hidden off-screen buffer. The display of this buffer is where operating system-specific code is used. In this book we are only

considering the Windows platform, but most of the code will transfer readily to other platforms. Only the short code stubs that deal with the final display of a window will need revising for a different platform.

OpenGL is a state machine. You set a flag in the system to say how the rendering engine should respond to subsequent commands. For example,

```
glEnable(GL_LIGHTING);
```

Using this line in your code would ensure that the render engine would use any active lights to determine the shading of a pixel:

```
glDisable(GL_LIGHTING);
```

This would deactivate any lighting calculations so that just the basic colour or the direct pixels in a texture map would be painted without any further calculations resulting from lights.

Using the different states of the render engine it is possible to display the same geometry as:

- A wireframe model with no hidden lines.
- Flat shaded polygonal model with no textures and no lighting.
- Flat shaded polygonal model with no textures but lighting enabled.
- Smooth shaded polygonal model with no textures with lighting enabled.
- Smooth shaded polygonal model with textures and lighting.
- Smooth shaded, depth-cued (fog) with textures and lighting.
- Smooth shaded, depth-cued, transparency enabled with textures and lighting.
- Smooth shaded, depth-cued, transparency enabled with textures and lighting using anti-aliasing.

The realism of the scene will increase as you work through the list, but this occurs with an inevitable performance hit. As a developer you need to decide between frame rate and visual realism.

All OpenGL commands begin with 'gl', then the name of the command and finally an indication of the parameters being passed. As an example, when indicating the colour to use the syntax can be one of the following:

```
glColor3f( 1.0, 0.0, 0.0);
Glfloat col[]={ 1.0, 0.0, 0.0};
glColor3fv( col);
```

Here '3f' indicates that three floating-point values are being passed to the function. '3fv' indicates that a floating-point array with three components is being passed. Check the documentation with your compiler for the full list of parameters that can be passed. If you are used to specifying colours using byte wide arguments for red, green and blue, then you may find it strange to specify a colour using floating-point values. Colour levels vary between 0 and 1.0; a colour value of 1.0 compares with the byte wide equivalent of 255.

On a Windows-based machine, all the OpenGL functions are provided via a dynamic link library that is stored in the 'System' folder. This library is called 'OpenGL32.dll' and it must exist on your computer in order to use OpenGL. It is installed by default during Windows set-up. Along with this file, another file is installed called 'glu32.dll'; this is the OpenGL utility library. The file contains some useful shortcuts for using OpenGL, it simplifies view orientation set-ups and contains NURBS routines. All OpenGL commands that begin with 'gl' use the main library and all OpenGL commands beginning with 'glu' use the utility library. You can achieve everything you want from OpenGL without using the utility library, but your life will be that much more difficult.

Using the OpenGL Utility Toolkit

In addition to the main OpenGL files 'OpenGL32.dll' and 'Glu32.dll', there is a useful library written by Mark Kilgard, called the GLUT, which stands for the OpenGL Utility Toolkit. This library is particularly useful for quick code examples and we will use it now to create a first window. You will find the GLUT library and include file on the CD. If you intend to compile any of the GLUT examples then you will need to tell your compiler where to find the include file and the library. Other GLUT-related downloads are available at http://reality.sgi.com/mjk/glut3/glut3.html

The example 'GLUTExample' is a simple application that displays a coloured cube, which can be rotated with the movement of the mouse. Here is the 'main' code for this application.

```
void main (void)
{
    glutInitDisplayMode(GLUT_RGB | GLUT_DOUBLE | GLUT_DEPTH);
    glutInitWindowSize(width, height);
    glutCreateWindow(appName);
    glutDisplayFunc(display);
    glutReshapeFunc(resize);
```

Real-time 3D Character Animation with Visual C++

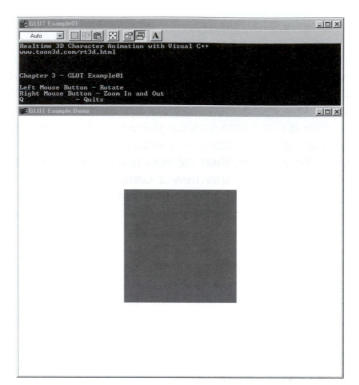

Figure 3.1 GLUT Example program.

```
glutKeyboardFunc(keyboard);
glutMouseFunc(mouse);
glutMotionFunc(motion);
init();
glutMainLoop();
}
```

The declarations for each of these functions, along with a description of the use of the function, are outlined below:

- void **glutInitDisplayMode**(unsigned int *mode*)
 This specifies a display mode such as RGB or RGBA. The argument 'mode' is a bitwise Or-ed combination of the display colour depth, whether single or double buffering and the additional buffers required.

 When animation is used it is best if the display is created off-screen and then flipped to the foreground when all drawing is complete. This technique is referred to as double buffering and eliminates the

annoying flickering that can occur when a single buffer is used with animated sequences.

OpenGL can use several buffers in addition to the actual display buffer. In this example we use the depth buffer. The purpose of the depth buffer is to ensure that foreground polygons appear to be in front of more distant polygons. As each polygon is rasterized, the *z* distance from the viewer is compared with the value stored in the depth buffer for this pixel. If the *z* distance stored in the buffer is greater than that for the pixel under consideration, then the new pixel is painted using the data for the new polygon and this new *z* distance is stored in the depth buffer. If the value in the buffer is less than the value under consideration, then the current pixel is ignored because the polygon being rasterized must be behind a polygon that has already been painted.

- void **glutInitWindowSize**(int *width,* int *height*)
Requests windows created by the next function to have an initial size in pixels indicated by the width and height arguments. The initial window size is only a hint to the system and may be overridden.

- void **glutCreateWindow**(char **name*)
Creates a window with the caption indicated by name appearing in the title bar. The window is not actually displayed until the call to **glutMainLoop**().

GLUT functionality comes from the use of callback functions. These functions are called in response to a system event.

- void **glutDisplayFunc**(void (**func*)(void))
This function is called whenever the contents of the window need to be redrawn. This can happen because the window was hidden and is now revealed or in response to a call to **glutPostRedisplay**().

- void **glutReshapeFunc**(void (**func*)(int *width*, int *height*))
The reshape function is called whenever the window is resized. The callback is usually used to adjust the projection matrix to accommodate for the new aspect ratio. More on this later.

- void **glutKeyboardFunc**(void (**func*)(unsigned int *key*, int *x*, int *y*))
When a key is pressed, the ASCII value for this key is passed to the argument key and the mouse coordinates in window-relative pixel coordinates are passed to *x* and *y*.

- void **glutMouseFunc**(void (**func*)(int *button*, int *state*, int *x*, int *y*))
The mouse function is called in response to a press or release of a mouse button. The button argument can be GLUT_LEFT_BUTTON, GLUT_MIDDLE_BUTTON or GLUT_RIGHT_BUTTON. The state argument can be either GLUT_UP or GLUT_DOWN. The values for *x* and *y* are window-relative pixel coordinates.

- void **glutMotionFunc**(void (*func)(int x, int y))
 This function is called as the mouse moves. The values for x and y are the window-relative pixel coordinates of the mouse.
- void **glutMainLoop**(void)
 Enters the GLUT processing loop, never to return. Now all registered callbacks will be used as system events instigate them.

All the calls in the main function use GLUT functions except for one, the call to 'init'. This function is in the source file on the CD for the example. We use 'init' to store set-up code that only needs to be called once. The function is as follows:

```
void init (void)
{
    glClearColor(0.0f, 0.2f, 0.3f, 0.0f);
    glEnable(GL_DEPTH_TEST);

    printf("Realtime 3D Character Animation with Visual C++\n");
    printf("www.toon3d.com/rt3d.html\n\n\n\n");
    printf("Chapter 3 - GLUT Example01\n\n");
    printf("Left Mouse Button - Rotate\n");
    printf("Right Mouse Button - Zoom In and Out\n");
    printf("Q              - Quits\n");
}
```

Using the OpenGL command 'glClearColor' we set the default background colour, which includes a value for the alpha. Usually, a redraw will begin by completely clearing the existing buffer for the colour display and the depth buffer. The value of the clear colour will be entered for every pixel in the cleared buffer. To ensure that z-buffering is being considered we use the OpenGL call 'glEnable' passing the constant 'GL_DEPTH_TEST'.

Setting up a projection

The 'resize' callback function is responsible for setting up how OpenGL will convert from world space vertices to screen space. This involves a projection from world to the flat plane of the screen. OpenGL uses matrices to perform all mappings; once a matrix is created then subsequent transformation commands modify it. OpenGL uses three different matrices, the *modelview*, *projection* and the *texture* matrix. You

direct OpenGL to use a particular matrix by specifying which matrix mode is being used with a call to 'glMatrixMode'. In the 'resize' function we use the projection matrix. The first step in setting up a projection is to clear the existing matrix, which we do by using the call to 'glLoadIdentity'. If you are confident with matrices then you will realize this sets the leading diagonal of the matrix to all ones, while all other entries are zero. The effect of multiplying a matrix by an identity matrix is to leave the original matrix unchanged. Mathematical identities always have this form. They leave the original unchanged under some operation.

The most complicated call in the function is the use of 'gluPerspective'. Since the function call begins with 'glu' this must come from the utility library 'glu32.dll'. The declaration of this function is:

- void **gluPerspective**(GLdouble *fovy*, GLdouble *aspect*, GLdouble *zNear*, GLdouble *zFar*)

Here fovy specifies the field of view in degrees in the y direction. If this is set to more than around 100°, then the display will have a highly distorted 'fish-eye' look. In order to make sure that squares remain looking square, the renderer needs to know the aspect ratio of the current viewport. Simply dividing the window width by the window height specifies this. Just as the edge of the screen is determined by the size of the window, OpenGL sets a near and far distance clip, so that things extremely close to camera or distant disappear from view. For simple demos, setting this to a large range suffices. However, in order to make the maximum use from the z-buffer it is important to set realistic values for the near and far clipping planes. If you always use some default value of, for example, 0.1 for near and 1 000 000 for far, yet all the geometry you draw is in the range 10–12, then the accuracy of the z-buffer will plummet. Setting the near and far clipping planes to 5 and 20 will ensure that the z-buffer calculations are considerably more accurate and if you use fog then it will blend much more subtly if the range for the near and far clipping planes is relevant to your scene.

```
void resize(int w, int h)
{
    if (!h) return;

    width = w;
    height = h;

    glViewport(0, 0, width, height);
```

```
        glMatrixMode(GL_PROJECTION);
        glLoadIdentity();

        gluPerspective(60, (double) width / height, 1, 1000);

        glutPostRedisplay();
    }
```

Using transformations

Drawing the display begins by clearing anything that is already there. Since we are using a depth buffer it is quicker to tell OpenGL to clear both the colour buffer and the depth buffer in a single command. This is done by bitwise Or-ing the two constants 'GL_COLOR_BUFFER_BIT' and 'GL_DEPTH_BUFFER_BIT'. This is followed by switching the matrix mode to the modelview matrix and clearing this using the 'glLoadIdentity' function call. Now we come to the interesting bit; here we use 'glTranslatef' and 'glRotatef' to alter the contents of the modelview matrix. 'glTranslate' has the effect of moving the viewer in relation to any geometry that is later going to be drawn. The parameters are the movement along the x-, y- and z-axes respectively. In this example we use the variable, zvalue; this is set with the mouse move callback function 'motion'. Using this method we can adjust the z position of the object.

After translating the object we rotate it. 'glRotatef' has four parameters; the first is an angle, the remaining three give the axis around which this rotation operates. In this example we rotate the object using Euler angles around the standard axes. When objects are transformed using the modelview matrix, the effect is as though the first operation performed is the last one specified. In this example all the rotations would be performed before the translation.

In matrix notation, if **T** is the translation and **P** is the first rotation specified, **H** the second and **B** the last, the overall result would be

TPHBv

if **v** is the vertex being operated on.

Having set up the matrix, we can now draw some geometry. In the example we use a function that is part of the source code, to draw a simple cube, 'DrawCube'. Having drawn the cube, the off-screen buffer is flipped to the front with the GLUT function 'glutSwapBuffers'.

```
void display(void)
{
    glClear(GL_COLOR_BUFFER_BIT | GL_DEPTH_BUFFER_BIT);

    glMatrixMode(GL_MODELVIEW);
    glLoadIdentity();

    glTranslatef(0.0f, 0.0f, -zvalue);
    glRotatef(rot[0], 1.0f, 0.0f, 0.0f);
    glRotatef(rot[1], 0.0f, 1.0f, 0.0f);
    glRotatef(rot[2], 0.0f, 0.0f, 1.0f);

    DrawCube();

    glutSwapBuffers();
}
```

Drawing some geometry

All OpenGL drawing is sandwiched between a 'glBegin' and a 'glEnd'. 'glBegin' has a single constant parameter that tells the renderer how to work with the data passed. In this example we are using four vertex polygons or *quads*. OpenGL interprets each set of four vertices as a polygon. We first give a new colour so that each face has a different colour, then a list of four vertices using the OpenGL function 'glVertex3f'. Having drawn the six faces that make up the cube, we finish with a 'glEnd' call.

```
void DrawCube(void)
{
  glBegin(GL_QUADS);
      // front
      glColor3f(1.0f, 0.0f, 0.0f);
      glVertex3f(-10.0f, -10.0f, 10.0f);
      glVertex3f(10.0f, -10.0f, 10.0f);
      glVertex3f(10.0f, 10.0f, 10.0f);
      glVertex3f(-10.0f, 10.0f, 10.0f);
      // back
      glColor3f(0.0f, 1.0f, 0.0f);
      glVertex3f(10.0f, -10.0f, -10.0f);
      glVertex3f(-10.0f, -10.0f, -10.0f);
```

```
        glVertex3f(-10.0f, 10.0f, -10.0f);
        glVertex3f(10.0f, 10.0f, -10.0f);
        // left
        glColor3f(0.0f, 0.0f, 1.0f);
        glVertex3f(-10.0f, -10.0f, -10.0f);
        glVertex3f(-10.0f, -10.0f, 10.0f);
        glVertex3f(-10.0f, 10.0f, 10.0f);
        glVertex3f(-10.0f, 10.0f, -10.0f);
        // right
        glColor3f(1.0f, 1.0f, 0.0f);
        glVertex3f(10.0f, -10.0f, 10.0f);
        glVertex3f(10.0f, -10.0f, -10.0f);
        glVertex3f(10.0f, 10.0f, -10.0f);
        glVertex3f(10.0f, 10.0f, 10.0f);
        // top
        glColor3f(1.0f, 0.0f, 1.0f);
        glVertex3f(-10.0f, 10.0f, 10.0f);
        glVertex3f(10.0f, 10.0f, 10.0f);
        glVertex3f(10.0f, 10.0f, -10.0f);
        glVertex3f(-10.0f, 10.0f, -10.0f);
        // bottom
        glColor3f(0.0f, 1.0f, 1.0f);
        glVertex3f(-10.0f, -10.0f, -10.0f);
        glVertex3f(10.0f, -10.0f, -10.0f);
        glVertex3f(10.0f, -10.0f, 10.0f);
        glVertex3f(-10.0f, -10.0f, 10.0f);
    glEnd();
}
```

GLUT is a great way to experiment with OpenGL commands, but sometimes you need a little more control over the runtime of your application. For this reason you need to learn how to set up the windows without using GLUT. On the Windows platform, most of the OpenGL-related windows code is prefixed with 'wgl'. Let's look at how to set up a window using these methods.

Creating a double buffered window using PIXELFORMATDESCRIPTOR

Now we will look at another method for setting up an OpenGL application, this time using Microsoft Foundation Classes (MFC). This book does not

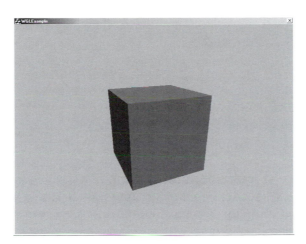

Figure 3.2 MFC Example program.

aim to teach MFC, you will need to get hold of an MFC book for further information if you are not familiar with this Windows programming style. Appendix B gives a very brief introduction to MFC. You will find the example 'MFCExample' on the CD, the basis for the code snippet in this section. Many of the ideas from the GLUT example are repeated. There is a resize event, a mouse move event and a paint event which is the equivalent of 'display'. These echo similar callbacks in the GLUT example.

Working through the code example, we created a Dialog-based OpenGL application. 'OpenGL32.lib' and 'Glu32.lib' were added to the linker in the dialog box for 'Program Settings' and 'gl.h' and 'glu.h' are added as include files. You could add these to 'stdafx.h' if you choose or to all files that include OpenGL code. Where the code for this example departs radically from the first is in window creation. Unlike the GLUT example, you have to do considerably more work when creating a window suitable for OpenGL. You will need to use class wizard to create a 'PreCreateWindow' method and an 'OnCreate' function.

OpenGL needs the window to have the styles WS_CLIPCHILDREN and WS_CLIPSIBLINGS set. So we set these in the PreCreateWindow function by bitwise Or-ing the CREATESTRUCT member 'style' with these constants.

```
BOOL CWGLExampleDlg::PreCreateWindow(CREATESTRUCT& cs)
{
    cs.style |= (WS_CLIPSIBLINGS | WS_CLIPCHILDREN);
    return CDialog::PreCreateWindow(cs);
}
```

We must now add two member variables to the Dialog class for our application CWGLExampleDlg:

HDC m_hDC;
HGLRC m_hRC.

If you have done much Windows programming then you will realize that m_hDC is a handle to a device context. These are used extensively in Windows programming to shield the programmer from the actual hardware on which their software runs. m_hRC, however, may well be new to you. This is a special rendering context used by OpenGL to allow a single thread to use the OpenGL engine for several different views. In this simple example we only have one view that contains an OpenGL display; consequently, we have a single rendering context which we store in the member variable, m_hRC. Before we can create a rendering context we need to tinker with the way that our main device context deals with pixels. For this there is a structure called a PIXELFORMATDESCRIPTOR and that is exactly what it does, it describes the pixel format. The full declaration of a PIXELFORMAT-DESCRIPTOR is given below.

```
typedef struct tagPIXELFORMATDESCRIPTOR { // pfd
    WORD    nSize;
    WORD    nVersion;
    DWORD   dwFlags;
    BYTE    iPixelType;
    BYTE    cColorBits;
    BYTE    cRedBits;
    BYTE    cRedShift;
    BYTE    cGreenBits;
    BYTE    cGreenShift;
    BYTE    cBlueBits;
    BYTE    cBlueShift;
    BYTE    cAlphaBits;
    BYTE    cAlphaShift;
    BYTE    cAccumBits;
    BYTE    cAccumRedBits;
    BYTE    cAccumGreenBits;
    BYTE    cAccumBlueBits;
    BYTE    cAccumAlphaBits;
    BYTE    cDepthBits;
```

```
    BYTE    cStencilBits;
    BYTE    cAuxBuffers;
    BYTE    iLayerType;
    BYTE    bReserved;
    DWORD   dwLayerMask;
    DWORD   dwVisibleMask;
    DWORD   dwDamageMask;
}  PIXELFORMATDESCRIPTOR;
```

We use a small fraction of the possible members in our example. First, we set the size of the structure and the version number. In the example we declare that our pixel format is suitable for OpenGL and that it is double buffered using the bitwise Or-ed constants PFD_DRAW_TO_ WINDOW, PFD_SUPPORT_OPENGL and PFD_DOUBLEBUFFER. Unfortunately, the use of double buffering means we cannot use any GDI (Graphics Device Interface) methods to draw on this display in the current Windows implementation of OpenGL. This means that we have to use OpenGL to write text to the screen; the GDI function DrawText will not work. You will see in a later chapter how the 'glu' functions can be used to enable the use of multiple fonts in an OpenGL window. The pixel format type is RGBA and the display window is 24 bit. The only other member of the structure that we set is the depth buffer. For our simple example we could actually get by without a depth buffer, since just the use of backface culling ensures that the window paints correctly. If you imagine a die, as you rotate it no more than three faces are visible, all hidden faces are effectively back facing just using the order of the points in the faces. See Chapter 1 for a more detailed description of culling by the clockwise or counter-clockwise nature of the vertices of a polygon.

Having set up the PIXELFORMATDESCRIPTOR structure, we then choose this for our device context. The function 'ChoosePixelFormat' tries to get the best match for the format you want on the device you are using. Then you can set this pixel format for the device using 'SetPixelFormat'. If this fails then you cannot have an OpenGL window on this device. If everything goes well then you can create a rendering context using one of the 'wgl' functions, 'wglCreateContext'. Before you can use this new rendering context for any drawing, you need to make it the current rendering context using another 'wgl' function, 'wglMake-Current'. Finally, we tell OpenGL to use a *z*-buffer by enabling the depth test and that counter-clockwise-oriented polygons are the ones that are front facing. The 'OnCreate' function is given in full below:

```
int CWGLExampleDlg::OnCreate(LPCREATESTRUCT lpCreateStruct)
{
    if (CDialog::OnCreate(lpCreateStruct) == -1)
    return -1;

    int nPixelFormat;
    m_hDC = ::GetDC(m_hWnd);

    static PIXELFORMATDESCRIPTOR pfd = {
        sizeof(PIXELFORMATDESCRIPTOR),
        1,
        PFD_DRAW_TO_WINDOW |
        PFD_SUPPORT_OPENGL |
        PFD_DOUBLEBUFFER,
        PFD_TYPE_RGBA,
        24,  //Colour bits
        0,0,0,0,0,0,0,0,0,0,0,0,0,
        16,  //Depth Buffer bits
        0,0,0,0,0,0,0};
    nPixelFormat = ChoosePixelFormat(m_hDC, &pfd);
    VERIFY(SetPixelFormat(m_hDC, nPixelFormat, &pfd));
    m_hRC = wglCreateContext(m_hDC);
    VERIFY(wglMakeCurrent(m_hDC,m_hRC));
    // Hidden surface removal
    glEnable(GL_DEPTH_TEST);
    // counter-clock-wise polygons face out
    glFrontFace(GL_CCW);
    // Do not calculate backfacing polygons
    glEnable(GL_CULL_FACE);
    // Turquoise background
    glClearColor(0.0f, 0.2f, 0.3f, 0.0f );
    return 0;
}
```

We must remember to tidy up when the window is destroyed, so we override the OnDestroy event:

```
void CSomeGLView::OnDestroy()
{
    if(wglGetCurrentContext()!=NULL){
            // make the rendering context not current
            wglMakeCurrent(NULL, NULL) ;
```

```
      }
      if (m_hRC!=NULL){
              wglDeleteContext(m_hGLContext);
              m_hRC = NULL;
      }
      if (m_hDC){
          ::ReleaseDC(m_hWnd,m_hDC);
        m_hDC = NULL;
      }

      // Now the associated DC can be released.
      CDialog::OnDestroy();
  }
```

So now we can create a window with either GLUT or an MFC application. A Win32 application would need to ensure that the window style conformed to the WS_CLIPCHILDREN and WS_CLIPSIBLINGS styles when the window is first being created and respond to WM_CREATE, WS_DESTROY messages. Check out Win32Example on the CD for more details. Most of the examples in this book use MFC as the basis because the author finds it convenient to create menus and respond to events

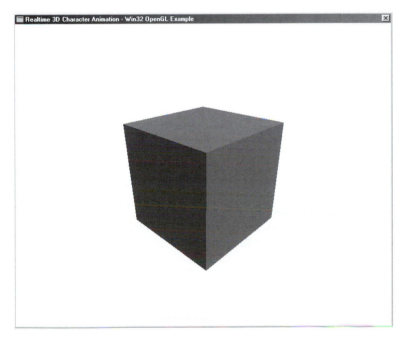

Figure 3.3 Win32 Example program.

using MFC, rather than case statements the Win32 way. Now that we have our window and can draw a cube, we will experiment with some alternative ways of viewing the cube.

Highlighting the vertices

In all the examples so far we have drawn the cube using unshaded polygons; OpenGL has the facility to draw in several different modes. It is often useful to highlight aspects of an object so that it can be distinguished from other objects in a scene. This technique is used extensively in development engines. If we want to highlight the vertices that make up the cube then we can append the 'DrawCube' function with the following code:

```
if (m_drawVertices){
    glPointSize(3.0f);
    glColor3f(0.5f, 1.0f, 1.0f);
    glBegin(GL_POINTS);
        glVertex3f(-10.0f, -10.0f, 10.0f);
        glVertex3f(10.0f, -10.0f, 10.0f);
        glVertex3f(10.0f, 10.0f, 10.0f);
        glVertex3f(-10.0f, 10.0f, 10.0f);
```

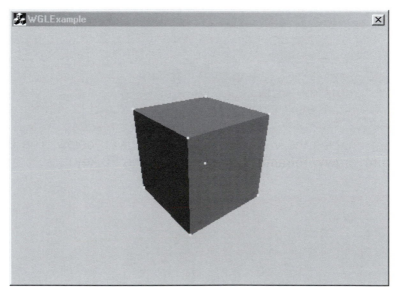

Figure 3.4 Cube with vertices highlighted.

```
            glVertex3f(10.0f, -10.0f, -10.0f);
            glVertex3f(-10.0f, -10.0f, -10.0f);
            glVertex3f(-10.0f, 10.0f, -10.0f);
            glVertex3f(10.0f, 10.0f, -10.0f);
        glEnd();
    }
```

In the example, pressing F2 toggles drawing the vertices by toggling the Boolean value m_drawVertices. Notice how the glBegin call uses GL_POINTS instead of GL_QUADS. When GL_POINTS is used each vertex is drawn individually. The size of the vertex is a single pixel by default. In this example, 'glPointSize' is used to set the vertex size to three pixels.

If the depth buffer is temporarily disabled before the vertices are drawn, then the hidden vertex will be drawn. In the example F5 toggles the use of the depth buffer.

Highlighting the object by drawing edge outlines

Another technique to highlight the object is to redraw the object edges. Here we can use several different methods. OpenGL can use either lines, in which case each pair of vertices is connected by a line in the current colour, or line strips where the first two vertices indicate the first line. After that, each subsequent vertex is connected by a line to the previous. The final option is to use line loops which behave like line strips with the addition that the first vertex is connected to the last. In the example I have used line loops to draw the front and back faces, then used simple lines to connect these faces. If you experiment with the code, changing the method of drawing from line loops to line strips, you will see that the front and back polygons have only three edges highlighted. Activating or deactivating the depth buffer using F5 will give a clear idea of the effect of depth testing when displaying even such a simple scene. The section of code that enables the wireframe drawing is given below. The Boolean variable m_drawWireframe is toggled using the F3 key.

```
if (m_drawWireframe){
        glColor3f(1.0f, 1.0f, 0.5f);
        glBegin(GL_LINE_LOOP);
            glVertex3f(-10.0f, -10.0f, 10.0f);
            glVertex3f(10.0f, -10.0f, 10.0f);
            glVertex3f(10.0f, 10.0f, 10.0f);
            glVertex3f(-10.0f, 10.0f, 10.0f);
```

Real-time 3D Character Animation with Visual C++

```
glEnd();
glBegin(GL_LINE_LOOP);
        glVertex3f(10.0f, -10.0f, -10.0f);
        glVertex3f(-10.0f, -10.0f, -10.0f);
        glVertex3f(-10.0f, 10.0f, -10.0f);
        glVertex3f(10.0f, 10.0f, -10.0f);
glEnd();
glBegin(GL_LINES);
        glColor3f(0.0f, 0.0f, 1.0f);
        glVertex3f(-10.0f, -10.0f, -10.0f);
        glVertex3f(-10.0f, -10.0f, 10.0f);
        glVertex3f(-10.0f, 10.0f, 10.0f);
        glVertex3f(-10.0f, 10.0f, -10.0f);
        glVertex3f( 10.0f, -10.0f, -10.0f);
        glVertex3f( 10.0f, -10.0f, 10.0f);
        glVertex3f( 10.0f, 10.0f, 10.0f);
        glVertex3f( 10.0f, 10.0f, -10.0f);
glEnd();
}
```

Summary

At the time of writing there are two competing APIs for getting access to 3D graphics hardware: OpenGL and DirectX. OpenGL is much easier to

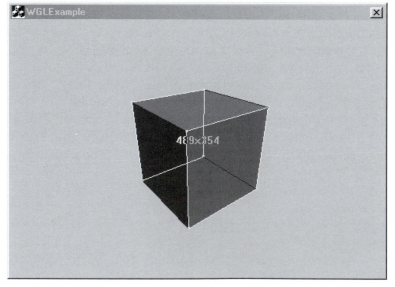

Figure 3.5 Cube with edges highlighted and no depth buffer.

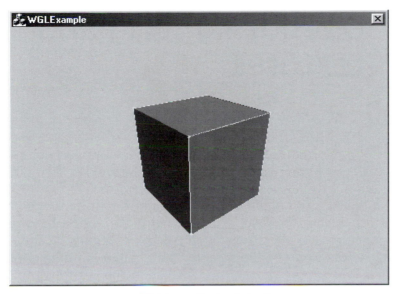

Figure 3.6 Cube with edges highlighted with depth buffer.

use and allows access to everything that is currently available in hardware. It has remained consistent since it was developed in 1992. DirectX changes radically with each new release. In this chapter you began what we hope will be an exciting journey of discovery into the capabilities of the OpenGL engine and how you can leverage it to develop your own application. In the next chapter we will take these first steps a stage further before we begin to look at how we can put these techniques to use in the real-time display of character animation.

4 OpenGL lighting and textures

So far we have looked at the mathematics behind the basic geometry of computer graphics, the way this geometry can be displayed on a computer screen and using the standard graphics library, OpenGL, to put some simple geometry on the screen. This chapter is where things start to look so much more convincing. Animation that uses some kind of lighting model has a realism that unshaded models can never match. While realism may not be your goal in terms of the geometry that you are displaying, your characters may be extreme caricatures, or have a cute cartoon feel; the overall display will still benefit from the use of a lighting model. OpenGL allows the developer a huge amount of flexibility in the way that your characters and scenes are displayed. Much of this flexibility stems from the intelligent use of the OpenGL lighting model, lights and materials. In this chapter we will look first at how to set up a simple lighting model and then how to set the surfaces of your geometry so that it uses all the features that OpenGL offers. Finally, we will look at the way that textures can be added to the surface of the geometry that you are displaying. Along the way, we will introduce some new OpenGL drawing techniques that help optimize the drawing routines.

Using lights in OpenGL

In order to use lights in OpenGL lighting calculations must be enabled. This is done in the usual way by using

```
glEnable(GL_LIGHTING)
```

In each implementation of OpenGL there are at least eight lights available. If you are at all familiar with a CGI program then you will find these lights easy to understand. If you have ever done any studio photography then you will find the lights highly desirable. OpenGL lights

do not have to be placed on stands, they are perfectly even in the distribution of light and can be turned on and off at will. You can turn on some lights while you are drawing some of the geometry in a scene and other lights to draw different parts of the scene, or even change the properties of the light halfway through doing a render of the current frame. In addition to enabling lighting calculations, each light is enabled or disabled using the following syntax:

```
glEnable(GL_LIGHTx) 0 ≤ x < 8
```

will turn the light on and

```
glDisable(GL_LIGHTx)
```

will turn the light off.

The lights come in three basic flavours, directional, positional and spotlights.

Directional, positional and spotlights

A directional light shines on all polygons from the same direction. It does not matter where the light is placed, it can even be behind the object. All that matters is that if it points directly down then all polygons will be lit by a light that appears to shine directly down; similiarily, if it shines to the right, left or any other direction, all polygons are lit as though their surface is hit by a light striking the surface at the same angle.

A positional light does not have a direction. It shines out in every direction, but it does have a location. If the light is placed behind an object it will look as though it is lit from the rear.

Spotlights have both a location and direction. Because of this they require an angle that defines how wide the beam that shines from the light appears; this is called the GL_SPOT_CUTOFF. If this is set to 180° then effectively the spotlight is a positional light because the beam of light is cast in a half circle in both directions. If the angle is set to 30° then the beam of light is 60°. Figure 4.1 shows how this works. Spotlights behave in a way that is much closer to the way that a real light would interact with a studio lit scene. Moving a spotlight has an effect and rotating the light also has an effect. We will look at how to set up positional lights and spotlights later; for now we will concentrate on directional lights. In some software, directional lights are called distant lights.

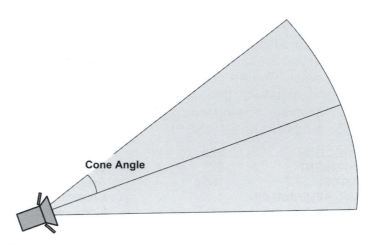

Figure 4.1 Cone angle for spotlights.

Ambient, diffuse and specular are parameters that all OpenGL lights share. Each of these parameters has four components, one each for the red, green, blue and alpha. The ambient parameter sets the level of illumination that the light throws out that is not connected with position or direction. This lights all surfaces in the scene regardless of their orientation to the light. If you want full blacks in your scene then this must be set to zero. If the scene wants to have a general blue tinge, or orange tinge, then the ambient level is the best place to start for illumination. The level that is set for each component is a value between 0 and 1 in the same way that colours are indicated. The diffuse level is the colour of the light; if you have a blue light then the diffuse level may well be set to (0.0, 0.0, 0.7, 0.0), which will be a very blue light. The specular component defines the colour of the beam that lights the highlighted part of a surface that is shiny. If the material for a polygon is matt, then this parameter will have no effect. If, however, the material is shiny then it will define the colour of the specular highlights.

Before we go any further you are highly recommended to play with the demonstration software for this chapter. Take a look on the CD and find the GLLighting example in the Chapter04 folder. The software lets you experiment by adjusting the ambient, diffuse and specular levels of the light. You are also encouraged to adjust the material properties for the surface of the sphere that is presented in the OpenGL display. The only material properties that you can adjust in this demonstration software are the emission level and the diffuse colour. In order to limit the number of sliders in the control box, one slider controls all four values for the ambient, diffuse and specular levels of the light. This is simply a restriction

Table 4.1 OpenGL light parameters

Parameter name	Default value	Meaning
GL_AMBIENT	(0.0, 0.0, 0.0, 1.0)	Ambient RGBA levels
GL_DIFFUSE	(1.0, 1.0, 1.0, 1.0)	Diffuse RGBA levels
GL_SPECULAR	(1.0, 1.0, 1.0, 1.0)	Specular RGBA levels
GL_POSITION	(0.0, 0.0, 1.0, 0.0)	(x, y, z, w) position of light
GL_SPOT_DIRECTION	(0.0, 0.0, −1.0)	(x, y, z) direction of spotlight
GL_SPOT_EXPONENT	0.0	Spotlight exponent
GL_SPOT_CUTOFF	180.0	Spotlight cut-off angle
GL_CONSTANT_ATTENUATION	1.0	Constant attenuation factor
GL_LINEAR_ATTENUATION	0.0	Linear attenuation factor
GL_QUADRATIC_ATTENUATION	0.0	Quadratic attenuation factor

of this software for demonstration purposes; please remember that as a developer you have full control over all four components of the ambient, diffuse and specular levels. If you take a moment to play with the demonstration program then you will realize that it is the combination of light properties and materials properties that controls the way that polygons are rendered. Notice that by ramping up the emission level of a material it acts as though it has its own internal lighting. Try turning the diffuse level of the light right down but turning the emission level of the

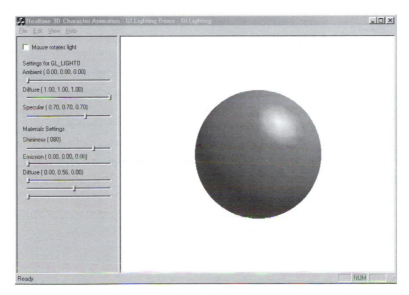

Figure 4.2 GLLighting demo.

material up. At the extreme you will simply have a white disc. Before we look in detail at how this demonstration program works we will have a short introduction to material properties.

Using materials in OpenGL

Each material has parameters for ambient, diffuse, specular, shininess and emission. By carefully setting these levels the material can be made to ignore any ambient light or have a specular colour that combines with a light's specular colour in an interesting way. The emission parameter sets whether the material is self-illuminating or luminous. Shininess has just the effect you would expect; it can take a value between 0 and 128. Table 4.2 lists the parameters together with their default values.

Table 4.2 OpenGL material parameters

Parameter name	Default value	Meaning
GL_AMBIENT	(0.2, 0.2, 0.2, 1.0)	Ambient colour of material
GL_DIFFUSE	(0.8, 0.8, 0.8, 1.0)	Diffuse colour of material
GL_SPECULAR	(0.0, 0.0, 0.0, 1.0)	Specular colour of material
GL_SHININESS	0.0	Specular exponent
GL_EMISSION	(0.0, 0.0, 0.0, 1.0)	Emissive colour of material

It is worth noting that, despite having an alpha setting for most values, only the alpha value of diffuse is used in the calculations for the alpha component.

How lights and materials are used in the rendering of a frame update

Firstly, we use the following enables. In the sample program these are never altered so are placed in the window creation function.

```
glEnable(GL_COLOR_MATERIAL);
glEnable(GL_LIGHTING);
glEnable(GL_LIGHT0);
```

If we need other lights, then these too must be enabled. If the lights need to behave as spotlights then we would need to consider the cut-off angle for the spotlight. If you have looked at any of the Toon3D demonstration projects then you may be interested to know that I use the following for spotlights:

```
glLightf(GL_LIGHTx, GL_SPOT_CUTOFF, coneAngle));
glLightf(GL_LIGHTx, GL_SPOT_EXPONENT, 2.0);
```

If a light that has been used as a spotlight is later used as a directional or position light, then you must reset these values to the default, using this code snippet:

```
glLightf(GL_LIGHTx, GL_SPOT_CUTOFF, 180.0f);
glLightf(GL_LIGHTx, GL_SPOT_EXPONENT, 1.0);
```

The code to draw the display is placed in the OnDraw event. MFC uses this as standard when creating an application template. The window where OpenGL drawing takes place is derived from an MFC CView class. The first thing we do is clear the colour and depth buffers and reset the modelview matrix. Next we set the ambient and diffuse levels for the light. In this sample we have a single member variable of the document class for each of these. This is used for all three components of the ambient and diffuse RGB, with the alpha being set to 1.0. If this MFC style is unfamiliar then take a quick look at Appendix B, where you can read a brief introduction to MFC's Document/View architecture.

Having set up the properties for the light, we move on to set up the material properties. In this example we set the emission, specularity, shininess and diffuse colour. Only the diffuse colour acts as a true RGB value. Finally, before we set the position for the light, we translate and move the scene, ensuring that the light moves with the object. If the light position is set after the matrix is cleared and before the translation and rotation, then the modelview matrix does not affect the values for the light, since the identity matrix leaves data unchanged. The last manipulation is to set a position for the light. Here we use a vector with four values, (x, y, z, w). If w is 0.0 then lighting calculations regard the light as directional. If w is any other value then lighting calculations assume the light to be positional. If we were using a spotlight then now would be the time to set the spotlight's direction using the following code snippet:

```
Glfloat spot_rot[] = { -1.0, -1.0, 1.0};
glLightfv(GL_LIGHTx, GL_SPOT_DIRECTION, spot_rot);
```

So if we put this together we get the following code:

```
void CGLView::OnDraw(CDC* pDC)
{
    GLfloat flt,v[4];

    glClear(GL_COLOR_BUFFER_BIT | GL_DEPTH_BUFFER_BIT);

    glMatrixMode(GL_MODELVIEW);
    glLoadIdentity();

    //Set the light properties
    flt=GetDocument()->m_ambient;
    v[0]=flt; v[1]=flt; v[2]=flt; v[3]=1.0f;
    glLightfv(GL_LIGHT0, GL_AMBIENT, v);

    flt=GetDocument()->m_diffuse;
    v[0]=flt; v[1]=flt; v[2]=flt; v[3]=1.0f;
    glLightfv(GL_LIGHT0, GL_DIFFUSE, v);

    //Set the material properties
    flt=GetDocument()->m_emission;
    v[0]=flt; v[1]=flt; v[2]=flt; v[3]=1.0f;
    glMaterialfv(GL_FRONT, GL_EMISSION, v);

    flt=GetDocument()->m_specular;
    v[0]=flt; v[1]=flt; v[2]=flt; v[3]=1.0f;
    glMaterialfv(GL_FRONT, GL_SPECULAR, v);

    flt=GetDocument()->m_shininess;
    glMaterialf(GL_FRONT, GL_SHININESS, flt);

    GetDocument()->GetColour(v);
    glMaterialfv(GL_FRONT, GL_DIFFUSE, v);

    glTranslatef(0.0f, 0.0f, -zvalue);
    glRotatef(rot[0], 1.0f, 0.0f, 0.0f);
    glRotatef(rot[1], 0.0f, 1.0f, 0.0f);
    glRotatef(rot[2], 0.0f, 0.0f, 1.0f);

    GetDocument()->GetPosition(v);
    glLightfv(GL_LIGHT0, GL_POSITION, v);

    DrawSphere(48,32,15.0);

    SwapBuffers(m_hDC);
}
```

v1

v0

v2

v3

v4

GL_TRIANGLE_FAN

v0 v1
v2 v3
v4 v5
v6 v7
v8 v9

GL_QUAD_STRIP

Figure 4.3 Vertex numbering for triangle fans and quad strips.

The call to DrawSphere is a little routine that is included with the code for this example as a further example of using OpenGL drawing primitives. The first parameter in the function call defines the number of segments that will be used in drawing the sphere, the second the number of slices and the last the radius of the sphere. Take a look at the code to see how to use two other types of painting, GL_TRIANGLE_FAN and GL_QUAD_STRIP.

A triangle fan uses the first vertex as a vertex in all subsequent triangles. The next two vertices define the first triangle; after that, each subsequent vertex defines a triangle which takes the first vertex and the previously defined vertex as its three vertices. It is a little more efficient because it uses fewer vertices in the definition. With quad strips, the first four vertices define the first quad then each subsequent quad is defined from the previously defined two vertices and two new vertices. In the function, triangle fan is used to cap the top and bottom of a sphere and quad strips form rings of latitude around the sphere. This is only one way to draw a sphere, a simpler way is to use the GLUT library function:

glutSolidSphere*(Gldouble radius*, Glint *slices*, Glint *stacks*).

But this doesn't help you create your own drawing functions. Yet another way is to use all triangles. Hopefully, this short function will show you how a little bit of trigonometry can go a long way. Any point on a circle centred at the origin and of radius r is defined as ($r \cos \theta$, $r \sin \theta$), where θ is an

angle defined in radians between 0 and 2π (recall that there are 2π radians in a revolution just as there are 360°). In this function we start by calculating the radius of the base of the first slice. To do this, imagine that we are looking at the sphere down the z-axis. Next think of a line pointing vertically up; we want to rotate this line around by half a revolution divided by the number of slices. Using this angle we can calculate the distance from the y-axis to the circle using the sine of the angle together with the radius of the circle. The sine gives the length of the side opposite the angle and the cosine gives the length of the side adjacent to the angle.

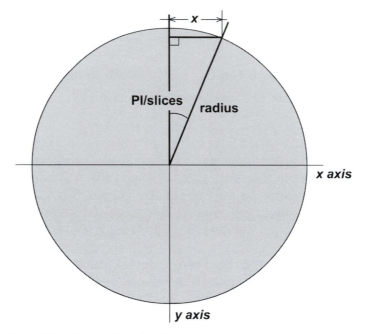

Figure 4.4 Calculating the radius of a slice.

Having calculated the radius of the top slice, we can use a similar technique to calculate the position of each vertex. We know the y position of each vertex in the triangle fan, vertex 0 will have a y value of radius and all subsequent vertices will have a y value of radius * cos(π/slices). When considering the x and z values we can think in two dimensions. We simply need the positions on a circle. This is just the same problem as calculating the radius of the first slice; each position will be (radius * cos(angle), radius * sin(angle)) for some value of angle. The angle parameter starts at 0 and increments by 2π/segments for each subsequent vertex. When drawing the remaining slices we need two radii and two y values, one for

the top of the quad strip and one for the bottom. The bottom slice uses the triangle fan method and is effectively the same as the top, only this time flipped around the *x*-axis so that the *y* values are negative.

```cpp
void CGLView::DrawSphere(int segments, int slices, double radius)
{
    //Draw a sphere centred at the origin with radius=radius
    //Segments are the number of polygons around the main axis
    //Slices are the number of polygons up and down
    int i,j;
    double theta,sliceradius, sliceradiusb;
    CVector vertex, vertexb, norm;
    GLfloat col[3];

    GetDocument()->GetColour(col);
    //Draw the top

    glColor3d(col[0],col[1],col[2]);
    glBegin(GL_TRIANGLE_FAN);
        //First set vertex 0
        vertex.Set(0.0, radius, 0.0);
        norm.Set( 0.0, 1.0, 0.0);
        glNormal3d(norm.x, norm.y, norm.z);
        glVertex3d(vertex.x, vertex.y, vertex.z);
        //All subsequent vertices use the samey value
        vertex.y = radius*cos(PI/(double)slices);
        sliceradius = sqrt(radius*radius-vertex.y*vertex.y);
        for(i=0;i<=segments;i++){
            theta = PI2*((double)i/(double)segments);
            vertex.x = sliceradius*cos(theta);
            vertex.z = sliceradius*sin(theta);
            norm = vertex;
            norm.Normalize();
            glNormal3d(norm.x, norm.y, norm.z);
            glVertex3d(vertex.x, vertex.y, vertex.z);
        }
    glEnd();

    //Draw the middle
    glBegin(GL_QUAD_STRIP);
        for(j=1;j<(slices-1);j++){
            vertex.y = radius*cos(((double)j/(double)slices)*PI);
            sliceradius = sqrt(radius*radius-vertex.y*vertex.y);
```

```
            vertexb.y = radius*cos(((double)(j+1)/(double)↵
              slices)*PI);
            sliceradiusb = sqrt(radius*radius-vertexb.↵
              y*vertexb.y);
            for (i=0;i<=segments;i++){
                theta = PI2*((double)i/(double)segments);
                vertex.x = sliceradius*cos(theta);
                vertex.z = sliceradius*sin(theta);
                norm = vertex;
                norm.Normalize();
                glNormal3d(norm.x, norm.y, norm.z);
                glVertex3d(vertex.x, vertex.y, vertex.z);
                vertexb.x = sliceradiusb*cos(theta);
                vertexb.z = sliceradiusb*sin(theta);
                norm = vertexb;
                norm.Normalize();
                glNormal3d(norm.x, norm.y, norm.z);
                glVertex3d(vertexb.x, vertexb.y, vertexb.z);
            }
        }
    glEnd();

    //Draw the bottom
    glBegin(GL_TRIANGLE_FAN);
        //First set vertex 0
        vertex.Set(0.0, -radius, 0.0);
        norm.Set( 0.0, -1.0, 0.0);
        glNormal3d(norm.x, norm.y, norm.z);
        glVertex3d(vertex.x, vertex.y, vertex.z);
        //All subsequent vertices use the same y value
        vertex.y = radius*cos(((double)(slices-1)/(double)↵
          slices)*PI);
        sliceradius = sqrt(radius*radius-vertex.y*vertex.y);;
        for(i=segments;i>=0;i-){
            theta = PI2*((double)i/(double)segments);
            vertex.x = sliceradius*cos(theta);
            vertex.z = sliceradius*sin(theta);
            norm = vertex;
            norm.Normalize();
            glNormal3d(norm.x, norm.y, norm.z);
            glVertex3d(vertex.x, vertex.y, vertex.z);
        }
    glEnd();
}
```

Using textures with OpenGL

The last major part in the armoury of our 3D engine must be texture mapping. When low polygon scenes use bitmaps on the surface of the polygons they are transformed from ridiculously simplistic to at least vaguely plausible, and as the polygon count goes up they can become ever more realistic. Texture mapping is no black art and OpenGL makes it quite easy to achieve. The main stages to placing textures on your polygons are:

1 Loading the bitmaps into memory.
2 Informing OpenGL how the bitmaps are stored in memory.
3 Creating a texture ID number.
4 Binding the texture ID and setting up wrapping and filtering parameters.
5 Generating the texture object.
6 Calculating texture coordinates for each vertex of each polygon that uses a texture.
7 Choosing a texture rendering mode.
8 Enabling textures.

Let's look at each of these in turn.

Loading the bitmaps into memory

In Chapter 6 we will explore the techniques necessary to load windows bitmap files (bmp), Truevision Targa files (tga) and JPEG compliant files (jpg). In all the loaders the result is converted to an uncompressed 24-bit windows bitmap. Windows bitmaps are aligned in such a way that each raster line is exactly divisible by 4 (DWORD aligned). But another aspect of the loader is to ensure that the image stored in memory has sides that are an exact power of 2. If the image was saved as (150 × 62), then it will be loaded then resized to 128 × 32. Here the next power of 2 down is used. The resizing method is simply to duplicate or delete pixels and does not contain any intelligent filtering technique. If you do use the loading source code provided, then I recommend resizing your bitmaps using a good bitmap editor, such as Paint Shop Pro or Photoshop; the result will be far better since good filtering algorithms are used in the resize. Space prohibits going into great detail regarding bitmap loaders and file formats. If you intend to write your own loader then get hold of a good book on bitmap file formats. For most purposes the loaders that come with this

book will be sufficient. Having got the bitmap into memory it will be stored so that the first pixel in memory is actually the first pixel of the last rasterline; all the data of this last rasterline follow before it moves on to the next to last rasterline and so on until the top line is read. The upside-down nature is common to the Windows Bitmap format.

Informing OpenGL how the bitmaps are stored in memory

OpenGL is able to work with many different storage methods. Four-byte alignment is just one method; 1-, 2- and 8-byte alignments are also available. Because we are resizing the bitmap to a power of 2 for the width and height, it is already aligned, so we can set the alignment to 1; now no additional bytes are expected at the end of a rasterline regardless of the size of the bitmap. Another setting that you may sometimes use is byte ordering. This varies between processors. Some processors, notably Intel, have the lower value byte before the higher value byte. In others, the opposite is true. Setting up the way that pixels are stored can mean setting the byte order. The native byte ordering for the computer on which OpenGL is running is the default setting.

If you wish to extract a section of a bitmap then you will need to set values for the row length, and the number of pixels and rows to skip. The values for these three parameters define a small rectangle within the full

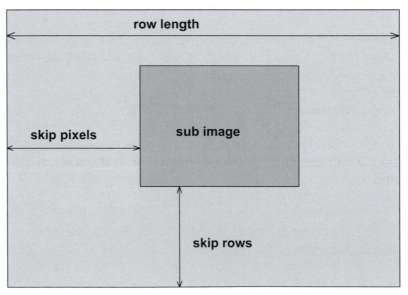

Figure 4.5 Parameters necessary for extracting a sub image.

Table 4.3 glPixelStore() parameters

Parameter name	Default value	Range
GL_UNPACK_SWAP_BYTES	FALSE	TRUE/FALSE
GL_UNPACK_LSB_FIRST	FALSE	TRUE/FALSE
GL_UNPACK_ROW_LENGTH	0	Any non-negative integer
GL_UNPACK_SKIP_ROWS	0	Any non-negative integer
GL_UNPACK_SKIP_PIXELS	0	Any non-negative integer
GL_UNPACK_ALIGNMENT	4	1, 2, 4, 8

bitmap. Figure 4.5 shows how these values define the rectangle within the bitmap.

Table 4.3 lists a full set of possible values that can be used when setting up the pixel storage parameters for unpacking a bitmap image into OpenGL texture memory.

Creating a texture ID number

To use textures efficiently in OpenGL you need to use texture objects. Some older cards may not be able to work with texture objects, but any recent card handles them very efficiently, storing the pixel data on the card rather than in main memory. Before OpenGL can handle these data it needs to know which texture object you are dealing with. You need to get a number for this object, then to use this texture object in future you inform OpenGL that the texture with this ID is the texture object to be used in subsequent texture operations. You use

> void **glGenTextures**(*Glsizei n*, Gluint *texIDs*)

to generate 'n' ID numbers. You must store these values because you will need them when deleting the texture objects with the IDs you have just generated.

Binding the texture ID and setting up wrapping and filtering parameters

In order to use the texture objects they need to be bound using glBindTexture(). The first call to glBindTexture() creates the texture object

with the ID passed to the routine. You can have one- or two-dimensional texture objects. We make no use of one-dimensional texture objects in this book; however, you need to pass two parameters to the glBind-Textures() function, the first declaring whether the texture object is one- or two-dimensional.

glBindTexture operates in one of three ways. The first call using a texture ID generated by glGenTextures() is to create the object; subsequent calls make the texture the active texture. The final alternative is to call glBindTexture with a value of 0. This clears the previously active texture.

A texture object has many parameters other than simply the image data. The most important of these is the method used to enlarge and to shrink pixels in an image. The quickest way to enlarge a pixel is to copy it to more than one pixel on the target screen. The quickest way to shrink an image into a pixel is to delete unnecessary pixels and just choose the pixel nearest to the target position. The smoothest way to do this is to consider surrounding pixels in the calculation and derive a weighted average of pixels around the target position for shrinking the pixel and interpolation of surrounding pixels when enlarging. Since we are concerned with performance we choose the quickest not the smoothest solution in the examples in this book.

The other important parameter is how it handles painting the texture if the calculation tries to look for a pixel outside the width and height of the bitmap. The choice is to repeat the texture so that it tiles or to clamp the value of the pixels around the edge of the bitmap. The full list of parameters stored within a texture object are image data, width, height, border width and height, internal format, resolution of the components, minification and magnification filter wrapping modes, border colour and texture priority. Their values are listed in Table 4.4.

Table 4.4 glTexParameter*() parameters

Parameter name	Values
GL_TEXTURE_WRAP_S	GL_CLAMP, GL_REPEAT
GL_TEXTURE_WRAP_T	GL_CLAMP, GL_REPEAT
GL_TEXTURE_MAG_FILTER	GL_NEAREST, GL_LINEAR
GL_TEXTURE_MIN_FILTER	GL_NEAREST, GL_LINEAR
GL_TEXTURE_BORDER_COLOR	RGBA component values
GL_TEXTURE_PRIORITY	[0.0 to 1.0] for current texture object

Generating the texture object

Now we have set up all the necessary parameters, it is time to get the pixel data from the memory store. This is done with the function glTexImage2D. The details of this function call are

void **glTexImage2D**(Glenum *target*, Glint *level*, Glint *internalFormat*, Glsizei *width*, Glsizei *height*, Glint *border*, Glenum *format*, Glenum *type*, const Glvoid **pixels*);

Nine parameters, aargh! But fear not, it is fairly easy to use. Target is whether we are dealing with real data or a proxy. A proxy is used to enable the developer to try to create a texture object and then check whether this would work. Texture memory is a limited resource and the developer could decide to size the texture down so that it will fit into memory or clear out other textures that they may feel have a lower priority. A texture object is not really created using a proxy and the value for the pixel data passed to it should be NULL. The level parameter allows a single texture object to use more than one bitmap; the base level is 0, subsequent levels scale the bitmap down. OpenGL can then use a smaller version of the bitmap when the texture object is more distant. More on using multiple levels of detail later. The internalFormat can be one of 38 different constants that define how the pixel data are stored when the texture object is created. In the example we use GL_RGB to store the pixels as RGB values. Width and height are self-explanatory. A texture can have a coloured border, turned on or off using the border parameter, 0 for no border and 1 for a border. The format dictates the way that pixel data are stored before unpacking; in the sample we use GL_BGR_EXT, which is the way that standard windows bitmaps are unpacked. The data type in our example is GL_UNSIGNED_BYTE. Finally, the last parameter is the actual pixel data.

The final code snippet to create a texture object is:

```
glGenTextures(1,&m_texID);
glBindTexture (GL_TEXTURE_2D, m_texID);
glPixelStorei GL_UNPACK_ALIGNMENT, 1);
glTexParameteri (GL_TEXTURE_2D, GL_TEXTURE_WRAP_S, GL_CLAMP);
glTexParameteri (GL_TEXTURE_2D, GL_TEXTURE_WRAP_T, GL_CLAMP);
glTexParameteri (GL_TEXTURE_2D, GL_TEXTURE_MAG_FILTER,
   GL_NEAREST);
glTexParameteri (GL_TEXTURE_2D, GL_TEXTURE_MIN_FILTER,
   GL_NEAREST);
glTexImage2D(GL_TEXTURE_2D,0,GL_RGB,tex.GetWidth(),tex.
   GetHeight(),0,GL_BGR_EXT,GL_UNSIGNED_BYTE,tex.
   GetPixelAddress(0,0));
```

Calculating texture coordinates for each vertex of each polygon that uses a texture

When we draw with textures we need to inform OpenGL which part of the 2D texture to use on a polygon. We do this at the vertex level; for each vertex that we draw we need to give a value for the texture coordinates. These coordinates are values between 0.0 and 1.0 for both the width and the height. To pass the value of the lower right coordinate of a bitmap to OpenGL you use (1.0, 1.0) rather than (bitmap_width, bitmap_height). Using this method a single bitmap can be wrapped around a highly complex object. Generating the values for these coordinates can involve quite a complex interface and we will look at various techniques in Chapter 6.

Choosing a texture rendering mode

There are many ways that you can tell OpenGL to use your texture objects. The different methods are set using glTexEnv*(). In the software in this book we always modulate the texture with a white polygon surface, this is set up using:

```
glTexEnvf (GL_TEXTURE_ENV, GL_TEXTURE_ENV_MODE, GL_MODULATE);
```

You are advised to look through the documentation available with Visual C++, do a search for glTexEnf in the MSDN help engine, or via the OpenGL website (www.opengl.org) to see how using different environment modes may work more effectively with your application.

Enabling textures

The last thing we need to do is enable textures using:

```
glEnable(GL_TEXTURE_2D);
```

The function that draws the cube combines textured and untextured surfaces. It is in the folder 'Chapter04' on the CD and is called GLTextures.

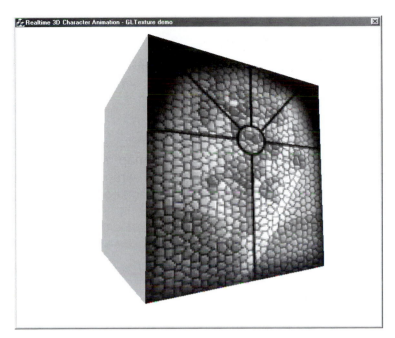

Figure 4.6 Using OpenGL textures.

```
void CWGLExampleDlg::DrawCube()
{
    //Draw textrued faces
    glEnable(GL_TEXTURE_2D);
    glBegin(GL_QUADS);
        // front
        glColor3f(1.0f, 1.0f, 1.0f);
        glTexCoord2f(1.0f,0.0f);
        glVertex3f(-10.0f, -10.0f, 10.0f);
        glTexCoord2f(0.0f,0.0f);
        glVertex3f(10.0f, -10.0f, 10.0f);
        glTexCoord2f(0.0f,1.0f);
        glVertex3f(10.0f, 10.0f, 10.0f);
        glTexCoord2f(1.0f,1.0f);
        glVertex3f(-10.0f, 10.0f, 10.0f);
        // back
        glTexCoord2f(0.0f,1.0f);
        glVertex3f(10.0f, -10.0f, -10.0f);
        glTexCoord2f(1.0f,1.0f);
        glVertex3f(-10.0f, -10.0f, -10.0f);
```

```
        glTexCoord2f(1.0f,0.0f);
        glVertex3f(-10.0f, 10.0f, -10.0f);
        glTexCoord2f(0.0f,0.0f);
        glVertex3f(10.0f, 10.0f, -10.0f);
    glEnd();
    glDisable(GL_TEXTURE_2D);

    //Now just draw coloured faces
    glBegin(GL_QUADS);
        // left
        glColor3f(0.0f, 0.0f, 1.0f);
        glVertex3f(-10.0f, -10.0f, -10.0f);
        glVertex3f(-10.0f, -10.0f, 10.0f);
        glVertex3f(-10.0f, 10.0f, 10.0f);
        glVertex3f(-10.0f, 10.0f, -10.0f);
        // right
        glColor3f(1.0f, 1.0f, 0.0f);
        glVertex3f(10.0f, -10.0f, 10.0f);
        glVertex3f(10.0f, -10.0f, -10.0f);
        glVertex3f(10.0f, 10.0f, -10.0f);
        glVertex3f(10.0f, 10.0f, 10.0f);
        // top
        glColor3f(1.0f, 0.0f, 1.0f);
        glVertex3f(-10.0f, 10.0f, 10.0f);
        glVertex3f(10.0f, 10.0f, 10.0f);
        glVertex3f(10.0f, 10.0f, -10.0f);
        glVertex3f(-10.0f, 10.0f, -10.0f);
        // bottom
        glColor3f(0.0f, 1.0f, 1.0f);
        glVertex3f(-10.0f, -10.0f, -10.0f);
        glVertex3f(10.0f, -10.0f, -10.0f);
        glVertex3f(10.0f, -10.0f, 10.0f);
        glVertex3f(-10.0f, -10.0f, 10.0f);
    glEnd();
}
```

Using multiple levels of detail

When sizing down a bitmap using the GL_NEAREST option, the results can be a great distortion of the original bitmap. Since we have chosen to skip pixels when a 64 × 64 texture is drawn at 8 × 8, it is using only an

eighth of the pixels across and an eighth of the pixels down. If it is important that the image still looks like the original, then as a developer you have a choice, you can sacrifice performance and use filtering to create the shrunken image, or you can pre-filter a set of bitmaps and use the most appropriately sized image from the pre-filtered set. This is what mipmaps are about. They are created once using filtering techniques then OpenGL uses the best size image from the set when it is drawing the display. The GLU library has a function call that makes creating mipmaps as easy as creating a single texture. Use

> int **gluBuild2DMipmaps**(Glenum *target*, Glint *internalFormat*, Glsizei *width*, Glsizei *height*, Glint *border*, Glenum *format*, Glenum *type*, const Glvoid **pixels*);

instead of glTexImage2D when creating the texture object and all the levels of detail will be automatically created. OpenGL will know which bitmap level to use and as a developer you use the texture object in the same way as one with a single level. If you want more control then you can create your own mipmaps using multiple calls to glTexImage2D with different levels set.

Summary

So there we are, lights and textures, our armoury is complete. In the last two chapters we have breezed through an introduction to OpenGL. If you intend to develop your own engine then this should provide the foundation. With space at a premium I have only included those parts of OpenGL that we are going to use extensively in later chapters. Take a look at the bibliography to see where to go for further information on using OpenGL in different ways. The next thing we need is some geometry so that we can start to create interesting real-time animations.

5 Creating low polygon characters

This chapter is something of a departure from the rest in that it deals with the subject of real-time character animation from the artist's perspective. The reasoning behind this is entirely personal. I started life as a cartoon animator and, as an artist that writes code, I think that sometimes it is clear that code is written that pays scant regard to the user's needs. Most readers of this book will be interested in the code examples, but if you are keen to excel at real-time character animation then you definitely need to know the artist's problems and concerns. If you decide to skip this chapter then, at least as a result of the examples on the CD, you have two low poly models to play with.

Modelling software

At the time of writing, January 2001, the leading CGI packages are Softimage, Maya, Rhino, 3DS Max and Lightwave 3D. I choose to illustrate the modelling process using my preferred software, Lightwave 3D. Lightwave 3D is a polygon modeller, unlike Softimage, which in the latest version has no polygon tools at all. In fact, it ships with the old version in order to provide polygon modelling tools. The other reason for choosing Lightwave 3D is the excellent developer support that is available free via the mailing list. See the back of the book for useful sources of support. The final reason for choosing Lightwave 3D is the fact that the file formats for models and animation are public domain and the available documentation is both comprehensive and accurate. Some CGI software developers have, in recent years, kept their file formats under wraps unless you become part of a very expensive developer network.

Choosing a modelling package

Following the examples in this chapter we are going to create two characters. One is the typically low polygon super woman, where an

alarming amount of polygons are devoted to the upper body! The other a very cartoony character. As an animator of some 20 years' experience, I think it is at least disappointing that so much computer animation attempts to create a realistic interpretation of the real world, some more successfully than others. Animation allows the creators to develop fantasy lands that no one will ever experience any other way. As a developer I encourage you to develop content that provides a personal view of the world rather than a faithful recreation of reality. But, with a view to sales, I have chosen to take the well-trodden route of the sexy girl.

Modelling the head

When creating our model we are aiming at around 1000 polygons for the central character. The supplied software gets 30 frames per second from 5000 poly scenes on a 800 MHz machine with a Nvidia GeForce 2 graphics card. In no time at all that spec will seem ludicrously low, but you will learn in later chapters how to scale your models for higher end platforms using subdivision surfaces. Lightwave 3D has an option to use subdivision surfaces, but the algorithm used is different from the interpolating one discussed later in this book. If you do work through the tutorial in the Lightwave package, then by all means use the Tab key to get a smoother subdivided mesh, but bear in mind that this smoother mesh is inside the cage rather than sitting on the cage. This has the effect of making the limbs of the character particularly appear slimmer than they will appear if you choose to display either the actual geometry modelled or a subdivided mesh based on this geometry, but using an interpolating algorithm.

The principal tools we will use to create the mesh are:

- Point Creation Tool
 Using the point creation tool and the three standard views, Top, Front and Side, you can create a single vertex in 3D space.
- Polygon Creation Tool
 By selecting points and then choosing this tool a polygon is created with the selected vertices.
- Weld
 Any vertex can be welded to any other vertex. An extension of this for Lightwave 3D modeller is Multiweld, which is provided on the CD. Multiweld is an LScript plug-in for Lightwave that welds points based on their selection order. The first point selected is welded to the second point selected, the third to the fourth, and in general point $2n - 1$ is welded to the point $2n$. The result is, for $2n$ points, n welded points. This

Real-time 3D Character Animation with Visual C++

technique is useful for joining heads to bodies, legs to hips and arms to shoulders.

- Drag
 This tool allows you to move a single point or a line of points.
- Move
 This tool moves the current point or polygon selection.
- Rotate
 This tool rotates the current point or polygon selection.
- Smooth Shift
 This tool creates new geometry by taking a selected polygon(s) and extruding it along the vertex normals by an amount specified.
- Bevel
 This tool insets a polygon(s) by a specified amount.
- Knife
 This slices through the geometry, creating new edges and dividing polygons where they have been sliced.
- Magnet
 By defining an area the user can move a set of points with fall-off.

We will look in more detail at each tool as we use it for the first time.

Figure 5.1 Front, Side and Back view sketches of 'Charlie'.

The importance of drawing

A sketch is very useful when creating low polygon models. By using the sketch as a reference throughout the modelling process, the relative scale of the polygons you use to define your character is constantly available. The more accurate your drawing the easier you will find the modelling process. I used the sketches shown in Figure 5.1 as a backdrop for the Front and Side views when modelling 'Charlie'.

In the sketch the pencil suggests the stretching of the fabric of the costume. In low polygon modelling you make no attempt to recreate these creases with your geometry; this detail will be left for texture mapping, which is covered in detail in the next chapter. The aim of your modelling is to define the main volume of the character. You might find it useful while modelling to add some relevant surface colours to your polygons to help when judging the results.

Triangles or quads

Ultimately, your character is going to be a mesh that deforms as the character goes through her paces. As she deforms her vertices, any polygons that have more than three vertices will become non-planar. Figure 5.2 (see page 82) shows the problems associated with non-planar polygons. The polygon at the top left appears to be planar. As it rotates, however, it is clear that it is far from planar. This situation causes the render engine great difficulty in determining whether a polygon is front or back facing. As you will recall, this is done using the order in which the vertices appear when rendered on in screen coordinates. The same diagram illustrates the polygon split into two triangles. Now it is clear how the geometry should be rendered.

The problem of non-planar polygons is that the rendering software will be considering triangles. If you have a four-sided polygon, then the renderer will effectively split this into two triangles. If one of these triangles is angled in such a way as to appear to be back facing, then your model will develop holes. For this reason your mesh must be triangular. But modelling with a triangular mesh is hard. It is always easier to model with a combination of quads and triangles. So what to do about those quads. All CGI packages have the ability to change a mesh into a triangular mesh, but this is done without regard to the overall geometry. With low polygon models the direction in which a quad is split into two triangles makes a great difference to how the deforming mesh will appear when animating. There are intelligent triple engines available that attempt to put the edge where you would choose. No intelligent triple will do as good a

Figure 5.2 The problems of non-planar polygons.

job as an experienced artist, but when time is precious there is often no alternative. The areas of particular concern with respect to the way a quad mesh is tripled are where the mesh will be bent the most. These areas of maximum deformation can often be treated independently. If a mesh contains 1000 triangles, then it is probably important to make sure that around 100 of these are tripled correctly. Around the armpit, elbow and knee are the key areas. Polygon modelling software will have the ability to make a new polygon from a point selection, then remove the old polygons that have the wrong orientation. Figure 5.3 shows what can happen around a knee joint if the polygon tripling chooses the wrong diagonal for the division. Good tripling can make an enormous difference to the way the silhouette of a mesh appears when deforming.

Making a start with the head

All modellers find their own methods. Some like to start with a ball or a box and deform it into the shape they are aiming at. Others like to start with a blank sheet. I chose one method for the head and another for the body. When creating a head I prefer to build the polygons from scratch, but when creating a body I like to start with a basic mesh. At this point all generality falls over and we look at how to build this geometry with Lightwave 3D. At the time of writing, the latest Lightwave version is 6.5.

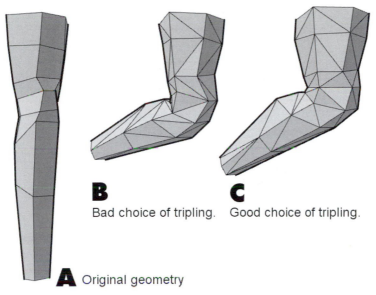

B Bad choice of tripling. **C** Good choice of tripling.

A Original geometry

Figure 5.3 *How the tripling of quads can affect the rendering of a deformable mesh.*

Figure 5.4 *The modeller interface with Lightwave 6.5.*

Real-time 3D Character Animation with Visual C++

For basic low polygon mesh creation, all versions of Lightwave are just as useful. Lightwave's user interface is shown in Figure 5.4.

This is typical of a modeller, splitting the screen into four user views. Three of the views are orthographic, showing no perspective foreshortening. The interface is very configurable but by default the top left view shows a view looking down the y-axis from above. Left and right in this view is the x-axis, and up and down represents the z-axis. Bottom left is the front view looking straight down the z-axis. In this view left and right are again the x-axis, but up and down is the y-axis. Bottom right shows the side view with left and right representing the z-axis and up and down again representing the y-axis. The final view in the top left is a perspective view shown using OpenGL rendering. Clicking on the rotate icon for this view can rotate this view and the position can be moved using the transform icon. At any time, pressing the 'g' key in an orthographic view centres the view over the position of the mouse. The less than and greater than keys ('<' and '>') zoom in and out. Pressing the 'a' key scales the views so that the model is fully visible in all the views. When making a model you will use both point selection and polygon selection modes, which are activated by pressing the appropriate button at the bottom left of the screen. In point selection mode, clicking on any point in the views will select that point; if you keep the left button down then you can select several points. Having released the left mouse button, clicking on any selected point deselects it. To add to the selection press the shift key while clicking on a point. To clear a selection click in the grey area to the bottom left of the screen. Polygon selection is done in much the same way, but instead of clicking on a point you click on an edge and any polygons that share this edge are selected. By releasing the left mouse key and then clicking on selected polygons in one of the three views, you can easily select just the polygons that you want to work on. If you have a selection then you can zoom in to this by pressing the 'a' key while pressing shift.

We will start by loading a backdrop image. If you are working along with this tutorial then you will find a side and back view for 'Charlie' in the 'Chapter05\Charlie\Images' folder on the CD. The images are called 'FrontSketch.tga' and 'SideSketch.tga'. To load a backdrop image, press 'd' to open the display options dialog box. Select the 'Backdrop' tab. The front view is number 4, so select 4 and from the image dropdown choose 'Load image'. Navigate to the appropriate file and click open. Repeat for view 4, only this time choose the side view. If you selected correctly then you should have a view like that in Figure 5.5. To view close in on the face use a combinaton of the 'g' key to centre the view over the mouse cursor and the '>' key to zoom in.

Figure 5.5 *Using a backdrop image in Lightwave 3D.*

This rather simple sketch will help when creating the geometry for the face. The first step is to create some polygons for the mouth. To do this, select the point tool. This tool is available under the 'Create' tab at the top of the screen. Having selected 'Create', the buttons on the left will include 'Point' near the bottom left. Select this tool. Using the point tool you can create points by clicking with the right mouse key. Click around the outside of the lips and again around the inside. Because we are aiming at a symmetrical face, we can just build one side of the face and, having accomplished this, we can mirror and weld the points where both sides join to create the final result. Figure 5.6 shows the first few polygons in the construction of the face.

To arrive at this result I first created the points that form the polygons around the lips. I then selected four points in a clockwise direction. Then, using the 'Make polygon tool', which can be found under the 'Create' tab and is named 'Make Pol', we turn this selection of points into a single polygon. Repeat this for all the points in the lips. Then choose 'Polygon Selection', you should find that all your polygons are selected, having just been created. If not, then select them by drawing a ring around them, while pressing the right mouse button. Now press the 'q' key; this brings up a basic surface dialog. Here you can give this set of polygons a surface name. Type in 'Lips' and set the surface colour to red, set specularity to 60 per cent and click the smooth button. This will ensure that the lips appear smoothed rather than faceted. At this stage the geometry for the lips will be correct in the Front view only. In the Side view it will be totally flat. Continue to build polygons until you arrive at the model in Figure 5.6 in the Front view. Now it is time to add depth to this geometry. To do this select points using the 'Point Selection Tool' and then press the 't' key, which activates the 'Move Tool'. This tool allows you to move the selection, whether the selection is a point set or a polygon set. It is easy

Figure 5.6 Early work on Charlie's face.

to get confused about which point in the Front view represents a point in the Side view. If in doubt waggle the point about and check to see what is moving in the Side view. Remember that to deselect a set of points choose the 'Point Selection Tool' and then click in the grey area to the bottom left of the screen. Hopefully you have been able to create this geometry and colour the polygons using the 'Surface' dialog box. But, if you feel like cheating, load 'Chapter05\Charlie\Objects\Face01.lwo', which is the model that you can see in the screen grab. It is now time to mirror this geometry and weld the points around the axis. The 'Mirror Tool' is activated using Shift-V or by choosing the 'Multiply' tab and selecting the 'Mirror' button. Click to define the axis and drag the mouse. A mirrored copy of the geometry is created. Deselect the tool and choose 'Point Selection'; click on a point around the join. If this point is indicated as a single point then the 'Mirror Tool' has successfully welded the points together. If you have any points that are not welded then weld them together now using the 'Weld Tool', which can be found under the 'Detail' tab. An alternative to welding a pair of points at a time is to use the

Figure 5.7 Stage 2 in creating Charlie's face.

'Multiweld.ls', Lscript plug-in which is available on the CD under 'Utilities'. To use this, use the 'Point Selection Tool' to select a point on one side of the join and a point on the other. Having selected several pairs of points in this way, select the 'Construct' tab. Near the bottom left of the screen choose the Lscript dropdown button and select LW_Lscript; from the file open dialog box choose 'Multiweld.ls'. This simple plug-in joins pairs of points and welds them into a single point. At this stage you should have the face shown in Figure 5.7.

Creating Charlie's body

Now it is time to start on Charlie's body. The Lightwave interface uses a layer style, in much the same way as a Photoshop or Paint Shop Pro bitmap file can use several layers in the creation of the final image. Having created the face in layer one, we will now move to layer two to start work on the body. The layer palette is in the top right corner of the screen. Here you will see 10 rectangles cut through by a diagonal. If you click in the lower part then you set this as the active background. A background in Lightwave shows through as a black line image in all the views. It is useful for aligning your geometry to existing models. This is precisely what we wish to do now. So click on the upper part of layer two and the lower part

of layer one. You should be able to see the face as a black line in all the views. If you have been working through the tutorial then you will have the backdrop images as a useful guide. Use the 'g' and '<' keys to zoom out and recentre the views so that all of the guide backdrops are visible. Step one is to create the waist. We will use the disc tool. This is accessed from the 'Create' tab. Click on the 'Disc' button then drag an ellipse in the 'Top' view. The ellipse will define the size of Charlie's waist. Before leaving this tool, press the 'n' key. This brings up a numeric dialog box. This allows you to set various parameters for the disc tool. Many of Lightwave's tools have numeric options that are all accessed via the 'n' key. In the option for the number of sides, select 16. Drag again in the 'Front' view and you will see an elliptical cylinder appear. This mesh has two polygons with 16 vertices. These two polygons are likely to cause havoc with any real-time engines. So it is best to remove them. The problem polygons are the top and bottom faces of the cylinder. Draw a ring around one of them using the right mouse button in 'Polygon Selection' mode and when the polygon goes yellow you can delete it by pressing the 'delete' key. An alternative way to select polygons with more than four sides is to select the 'Polygon Statistics' dialog box by pressing the 'w' key. Using this dialog box you can quickly find geometry that may cause problems with the real-time engine. The dialog box contains buttons to select '+' or deselect '−' polygons with one, two, three, four or more than four sides. If you are working through this tutorial then this dialog box should indicate one polygon with more than four sides. Press the '+' button next to this and the offending polygon should be highlighted in yellow. Again, to delete the polygon press the 'delete' key. You should now have a cylinder with no top or bottom.

To add geometry we will knife through the upper part of the cylinder in the 'Front' view. Select the 'Knife Tool' under the 'Construct' tab. Draw a line in the front view by clicking on the 'Front' view and then dragging the handles of the line. Press the 'Space' bar to confirm the knife action. You should now have an additional row of points in the elliptical cylinder. Because Charlie's body is symmetrical we are going to delete the left half so that we can concentrate on the right half for the construction. Once we have got near to completing the right half, we will mirror it in just the same way as we did with the face, welding the points along the mirroring axis. To delete the left half, simply draw a ring around the polygons on the left in 'Polygon Selection' mode and press the delete key. The highlighted polygons will be deleted. Now select the upper row of points by switching to 'Point Selection' mode and drawing a ring around these points using the right mouse button. Press the 't' key to activate the 'Move' tool and drag these up until they are at shoulder height. Now knife through the geometry just below the bust line. Highlight this latest row of points and

use the 'Stretch' tool, which is accessed using the 'Modify' tab or by pressing the 'h' key. The stretch tool allows you to move a group of points or polygons. The first click defines the centre of the stretch. Dragging the mouse then enlarges or shrinks the selection in the axis of the drag. You want to stretch this row of points until the size of this section is comparable to the sketch. It is now that you will realize the usefulness of this simple sketch. Otherwise, adding geometry requires a very good eye and lots of experience. Repeat the knifing and stretching until you have four new rows of points. Take a look at the object called 'Body01.lwo' in the Objects folder for Charlie to see where you need to have arrived at.

It is now time to cap the neck area. To do this, highlight the upper row of polygons and press the '=' key. This hides any geometry that is not selected. This does not mean it is deleted; it is simply hidden from view. Pressing the '\' key at any time will restore the full geometry. To cap the neck area we will make some polygons out of sets of four vertices in the top row of points. The outer polygon will have just three vertices. By selecting the newly created polygons and choosing the 'Smooth Shift' tool we can extrude this set of polygons and create a new row. Smooth shift is accessed from the 'Multiply'. The selection of polygons will be shifted along the vertex normals as you drag left and right. The neck is just 12 vertices in a row so we must weld some points together to achieve this. Take a look at 'Body02.lwo' to see the stage we have arrived at.

To continue we need to 'Smooth Shift' polygons near the armpits to create the geometry that will form the arms. This will be knifed to create an indent for the elbow. Knife through the lower section and form the hips in the same way that we have created the upper body. The lowest row of points will be used to form an area in which to create the legs. Draw a ring around this lowest row of points and press '=' to show just this selection. In the 'Top' view select just the front and back points for the points nearest the middle and weld these together. Repeat this for the next points. Then, using the 'Drag' tool reshape the remaining points so that they form a hexagon. Select these points and choose 'Make Pol' to create a polygon from these points. Press the '\' key to show again the full geometry and select just the newly created polygons. 'Smooth Shift' allows you to create the beginnings of a leg. The 'Knife' and 'Stretch' tools will allow you to shape this leg close to the geometry of the backdrop images. To get closer to the final geometry you will need to use a combination of the 'Drag' tool and the 'Move' tool with point selections to drag and move the points into their final locations. This part of the process is all about judging which points are which in the user views. Lightwave 6 allows you to select points in the perspective view, which certainly makes a difficult to locate point much easier to find. 'Body03.lwo' is the stage we have now reached.

Real-time 3D Character Animation with Visual C++

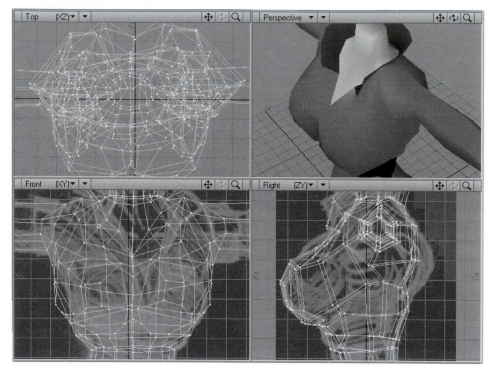

Figure 5.8 Creating Charlie's upper body.

To add Charlie's collar use the 'Point Selection' tool to select the points where the base of the collar will be formed. Copy this point selection by pressing the 'c' key. You can then paste this to another layer. Move these new points to where the top of the collar will be. Then press 'c' again to copy the new points. Move back to the original layer and paste the points. Now use the 'Point Selection' tool to select the base points and the new points. Press the '=' key so that only the selection is visible and select sets of four points and use 'Make Pol' to turn the point selection into a polygon. If everything went correctly then 'Charlie' should be the proud owner of a new collar.

Creating Charlie's hands and feet

To form Charlie's hand, we start with the last two polygons of her left arm and select these. Using 'Smooth Shift', extend these polygons out to form the area where Charlie's palm will be. We need three polygons to create the thumb, index finger and remaining fingers. To get three polygons

repeat the 'Smooth Shift'. Use one side polygon and the two end polygons to form the digits. Because 'Smooth Shift' moves a set of polygons together we will use the 'Bevel' tool. This tool deals with each polygon in isolation. In addition to being able to drag the mouse left and right to move the new geometry along the vertex normals, 'Bevel' allows you to enlarge or shrink the end polygon. Use this feature to shape the fingers. You should by now have a roughly shaped hand. We are dealing with a low polygon character so we cannot put very much detail into a hand, but it is important that the shape is at least a rough representation of a hand. In much the same way we arrived at the final geometry for the body, use 'Drag' and 'Move' with point selections to shape the hand. Having created the left hand use the 'Polygon Selection' tool to highlight the left hand and then use the 'Mirror' tool to duplicate a mirrored image of this polygon selection. Now delete the end polygons from Charlie's right arm and weld the free-floating right hand to the end of her arm.

For the feet, we first 'Smooth Shift' the end polygons of the left leg to form the left ankle. In the same manner as the hands we will create a single foot. Having shaped the foot to our satisfaction, we highlight this

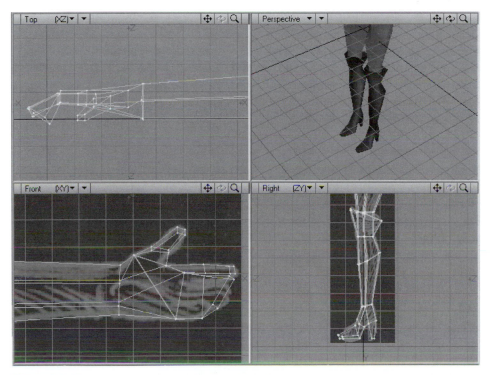

Figure 5.9 Creating low polygon feet and hands.

group of polygons and mirror them to create the right foot, welding the right foot onto the polygons at the end of the right leg. Then change the selection to the front face of these new polygons. Using 'Smooth Shift' again, this time the polygons will be created pointing forward rather than down. Select the back lowest polygon and 'Smooth Shift' this to form the heel. Knife through the forward-facing polygons twice. You now have all the polygons necessary to shape a foot. The final shaping is done using a combination of dragging and moving of point selections. The last task in creating Charlie's body is to add the top of her boots. This is done in the same way we created her collar. Since we need to create two sets of these polygons, one for the left boot and one for the right, it is best to create a single set, mirror it and weld the new one in place.

Finishing Charlie

The final stage of creating Charlie is to weld her head onto her body and shape her hair. Copy Charlie's head to the body layer and weld the points in her face to the neck. To form Charlie's hair, highlight the points in the left edge of Charlie's face and copy these to a new layer. With Charlie showing as a background layer, rotate the newly pasted points to the back of Charlie's head. Copy the points back to Charlie's main layer. Create polygons from the new points and the edge of Charlie's face. Knife through the new polygons twice. Select the points created through knifing and use the 'Move' tool in the 'Top' view to make Charlie's head more round. Select, mirror and weld the polygons that form the side of Charlie's head to create the other side. Weld the back seam and weld these new polygons onto Charlie's neck. Select the top row of points. Press the '=' key to hide all the other geometry. Use the point tool to create points for the top of Charlie's head. Highlight sets of four points and use 'Make Pol' to turn the selection into a polygon. Press the '\' key to show the full geometry again. Now highlight the polygons that will form Charlie's hair. Use 'Smooth Shift' to move this polygon set out. It only remains to use the drag and move tools to create the final shape for the geometry.

If everything has worked out, then you should have the geometry featured in Figure 5.11.

Creating a more cartoon style character

Although Charlie is a caricature she is quite lifelike. We are now going to create a character that is much less realistic. The development of a

Figure 5.10 Joining Charlie's head to the body.

Figure 5.11 The Charlie model finished without textures.

Real-time 3D Character Animation with Visual C++

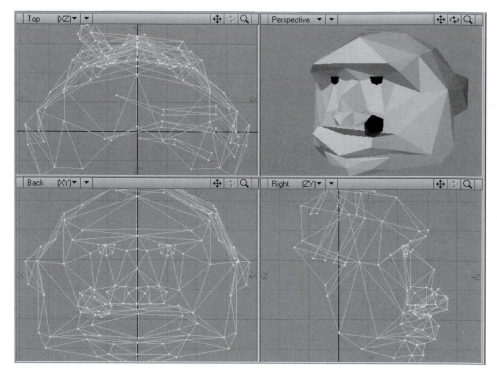

Figure 5.12 Creating Gerald's head.

character is a complex and highly personal exercise. I highly recommend sketching before starting any modelling. Feeling for form with a pencil is a much faster process than creating geometry.

In this chapter we have looked at the creation of two meshes using Lightwave 6.5. With low polygon meshes, artists have to make a compromise between the geometry they would like to use to create their characters and the geometry that current computers can transform and render at 25 frames per second. At the time of writing, the new generation of games consoles and graphics cards is allowing 50k poly scenes where previously we had 5k scenes. But even with 50k polys there is still a huge compromise over TV or film rendered CGI. Here 500k scenes are usual and 1m plus poly scenes not that unusual. But we still want our characters to look great. We can create the illusion of much more geometry by using textures on our characters intelligently. Figure 5.14 shows the Gerald mesh with textures added. Loading 'Gerald.t3d' into Toon3D Creator allows you see this textured mesh animating. Gerald in full colour looks so much better than the simple

Figure 5.13 Gerald's full mesh.

Figure 5.14 Gerald with textures.

smooth shaded mesh. In the next chapter we will look at how we can create, load and use textures on our characters.

Summary

Most readers who will come at real-time 3D from a coder's perspective will find the content of this chapter provides an insight into the skills of the artists who create the meshes that their code transforms and renders. Hopefully you found the techniques interesting and are encouraged to create your own meshes. The techniques described, although exclusively from the Lightwave perspective, can be applied to other modelling packages that focus on polygonal modelling.

6 Texture mapping

Since we are exploring real-time animation we are limited in the number of polygons we can draw in a scene fast enough to provide the illusion of movement. Computers and graphics cards get faster and so this limit rises steadily. Most computers on the market will cope easily with 5000 polygons, 50 times per second. Nevertheless, if you have three characters and a set then 5000 is a difficult limit to work with, rarely allowing more than 1500 polygons per character. Just to model a convincing face will usually take at least 3000 polygons. So how do we work around this limitation. The answer is texture mapping. By applying a carefully produced bitmap to the polygons we can add the illusion of considerably more detail. Figure 6.1 shows how the same mesh looks when drawn as a wireframe, as a smooth shaded mesh and as a textured mesh. The textured mesh looks much more convincing. To see the mesh moving check out 'Examples\Chapter06\Dancer.html'. Right click and choose 'smooth shaded' to view the same animation without textures and 'wireframe' to view the animation in wireframe format. In this chapter we are going to look at how to load the bitmaps into memory, how to copy this pixel data to OpenGL in a format it will understand and how to map these bitmaps onto the polygons in the mesh.

Loading a windows bitmap

There are many types of bitmap file; in the desktop publishing arena the Tiff (Tagged Image File Format) is amongst the most common. On the Internet, Jpeg (Joint Photographic Experts Group) and Gif (Compuserve format) are used most because of the compression inherent in the formats. Computer graphics experts often use Tga (Targa) files. But on the Windows platform the most ubiquitous bitmap format is a 'bmp' file. These files are sometimes called 'Dibs' (Device Independent Bitmaps) by computer buffs. Bitmap files all provide a way of storing an array of pixel

Figure 6.1 The improved rendering of a textured mesh.

data. All bitmap files have some kind of header that describes how the pixel data are stored in the file, the bitmap width, height and colour depth being the most important information. Colour depth describes how the colour data are presented. A 'bmp' file comes in six formats: 1 bit per pixel, so the bitmap contains simply a black and white picture; 4 bits per pixel, so the bitmap can contain at most 16 colours; 8 bits per pixel, allowing 256 colours; 16 bits per pixel, sometimes called High Color; 24 bits per pixel, allowing a choice of up to 16.7 million colours; and 32 bits per pixel, where the extra 8 bits of information per pixel are used to store an alpha (mask) in greyscale format. In this explanation we will look at loading a 24 bits per pixel image.

Windows bitmaps come in two flavours, RGB and RLE. The latter type uses a simple kind of compression, Run Length Encoding. Instead of saving the colour for each pixel, the file saves the colour for the pixel and how many consecutive pixels in a line use this colour. If you are using bitmaps with large areas of flat colour then RLE files can be quite a lot smaller than RGB files. For real-time 3D animation purposes RLE is not

Real-time 3D Character Animation with Visual C++

really worth the additional effort. Some bitmap editors allow the option to save a 'bmp' file as either RGB or RLE and I advise choosing the RGB alternative. I like Paint Shop Pro, which is fairly cheap but provides all the tools you will need when manipulating bitmaps.

RGB bmp files are delightfully simple to use because the pixel data are stored in as simple a way as possible. Before we examine the pixel data, let's look at the file header which describes how the pixel data are stored.

```
typedef struct tagBITMAPFILEHEADER {
    WORD bfType;
    DWORD bfSize;
    WORD bfReserved1;
    WORD bfReserved2;
    DWORD bfOffBits;
} BITMAPFILEHEADER;
```

'bfType' defines the file as a bitmap file if it contains the number 0x4D42, which is ASCII for 'BM'. Assuming this test is passed then we can check the size of the file using 'bfSize' and how many bytes to skip to find the pixel data using 'bfOffBits'. Subtracting bfOffBits from 'bfSize' gives the total size in bytes of the pixel data. If the checks are passed then we can be assured that the next section of the file will be a BITMAPINFOHEADER.

```
typedef struct tagBITMAPINFOHEADER{
    DWORD biSize;
    LONG biWidth;
    LONG biHeight;
    WORD biPlanes;
    WORD biBitCount
    DWORD biCompression;
    DWORD biSizeImage;
    LONG biXPelsPerMeter;
    LONG biYPelsPerMeter;
    DWORD biClrUsed;
    DWORD biClrImportant;
} BITMAPINFOHEADER;
```

We will use the 'biWidth', 'biHeight' and 'biBitCount' members. 'biWidth' and 'biHeight' give the sizes of the bitmap in pixels and 'biBitCount' gives the colour depth in bits per pixel. Since 'bmp' files sometimes use a palette to define colour values, our loader is designed to accommodate

this by converting the BITMAPINFOHEADER into another structure called a BITMAPINFO, which combines a BITMAPINFOHEADER with a palette containing initially just a single palette entry. If we were creating a 256 colour bitmap then we would allocate memory for 256 entries in the 'bmiColors' array.

```
typedef struct tagBITMAPINFO {
    BITMAPINFOHEADER bmiHeader;
    RGBQUAD          bmiColors[1];
} BITMAPINFO;
```

Since we are only loading 24-bit, uncompressed files, we only need to read the pixel data directly into a buffer of the correct size. The code you will need to load this type of file is as follows:

```
// Load a Windows bitmap from an open file.
BOOL CBmp::Load(Cfile &bmpFile)
{
    BITMAPINFO *bmi = NULL;
    BYTE* bits = NULL;
    BITMAPINFOHEADER bmiHdr;

    //Get the current file position.
    DWORD fileStart = bmpFile.GetPosition();

    BITMAPFILEHEADER bmpFileHdr;
    int bytesRead;

    bytesRead = bmpFile.Read(&bmpFileHdr, ↵
      sizeof(BITMAPFILEHEADER));
    if (bytesRead != sizeof(BITMAPFILEHEADER)) {
        TRACE("CBmp::Load>> Failed to read file header");
        goto abortBmpLoad;
    }

    // Check that we have the magic 'BM' at the start.
    if (bmpFileHdr.bfType != 0x4D42) {
        TRACE("CBmp::Load>> Not a bitmap file");
        goto abortBmpLoad;
    }

    bytesRead = bmpFile.Read(&bmiHdr, sizeof(BITMAPINFOHEADER));
```

```
if (bytesRead != sizeof(BITMAPINFOHEADER)) {
    TRACE("CBmp::Load>> Failed to read BITMAPINFOHEADER");
    goto abortBmpLoad;
}

// Check that we got a real Windows DIB file.
if (bmpInfoHdr.biSize != sizeof(BITMAPINFOHEADER)) {
    TRACE("CBmp::Load>> File is not Windows bitmap");
    goto abortBmpLoad;
    }
}

// Check that the colour depth is 24 bit
if (bmpInfoHdr.biBitCount != 24) {
    TRACE("CBmp::Load>> Only 24 bit files are supported.");
    goto abortBmpLoad;
    }
}

int bitsSize = bmpFileHdr.bfSize - bmpFileHdr.bfOffBits;

//Create a new BITMAPINFO and copy the file header to it
bmi = new BITMAPINFO;
memcpy(bmi, &bmpFileHdr, sizeof(BITMAPINFOHEADER));
//Set the one colour in the palette to black
memset(bmi.bmiColors, 0, sizeof(RGBQUAD));

// Allocate the memory for the bits
bits = new BYTE[bitsSize];
if (!bits) {
    TRACE("CBmp::Load>> Out of memory for DIB bits");
    goto abortBmpLoad;
}

// Seek to the bits in the file.
bmpFile.Seek(fileStart + bmpFileHdr.bfOffBits, CFile::begin);

// Read the bits.
bytesRead = bmpFile.Read(bits, bitsSize);
if (bytesRead != bitsSize) {
    TRACE("CBmp::Load>> Failed to read bits");
    goto abortBmpLoad;
}
```

Real-time 3D Character Animation with Visual C++

```
        // Everything went OK.
        if (m_BMI != NULL) delete m_BMI;
        m_BMI = bmi;
        if (m_bits != NULL) delete [] m_bits;
        m_bits = bits;
        return TRUE;

    abortBmpLoad: // Something went wrong.
        if (bmi) delete bmi;
        if (bits) delete [] bits;
        return FALSE;
    }
```

That is all that is necessary to load a 24-bit uncompressed Windows bitmap. To test the result of the load, use StretchDIBits:

```
int StretchDIBits(
    HDC hdc,                    // handle to device context
    int XDest,                  // x-coordinate of dest
    int YDest,                  // y-coordinate of dest
    int DWidth,                 // width of destination rectangle
    int DHeight,                // height of destination rectangle
    int XSrc,                   // x-coordinate of source
    int YSrc,                   // y-coordinate of source
    int SWidth,                 // width of source rectangle
    int SHeight,                // height of source rectangle
    CONST VOID *bits,           // address of bitmap bits
    CONST BITMAPINFO *bmi,      // address of bitmap data
    UINT usage,                 // usage flags
    DWORD op                    // raster operation code
    );
```

To display your bitmap, use the device context from the paint event for your view and call StretchDIBits with destination and source parameters set.

```
StretchDIBits(pDC->GetSafeHdc(),  // Device context handle
    0, 0, m_width, m_height,        // Destination x, y, width,
                                    // height
    0, 0, m_width, m_height,        // Source x, y, width, height
```

```
    m_bits,                        // Pointer to bits
    m_bmi,                         // BITMAPINFO
    DIB_RGB_COLORS,                // Options
    SRCCOPY);                      // Raster operation code (ROP)
```

Loading a TGA file

TGA files are similar to Windows bitmaps in that the pixel data in an uncompressed file are presented in a simple block. The header for a TGA is given here:

```
typedef struct stTGAHEADER
{
    BYTE   IdLength;             // Image ID Field Length
    BYTE   CmapType;             // Color Map Type
    BYTE   ImageType;            // Image Type
    WORD   CmapIndex;            // First Entry Index
    WORD   CmapLength;           // Color Map Length
    BYTE   CmapEntrySize;        // Color Map Entry Size
    WORD   X_Origin;             // X-origin of Image
    WORD   Y_Origin;             // Y-origin of Image
    WORD   ImageWidth;           // Image Width
    WORD   ImageHeight;          // Image Height
    BYTE   PixelDepth;           // Pixel Depth
    BYTE   ImagDesc;             // Image Descriptor
} TGAHEADER;
```

We are interested mainly in the 'ImageWidth', 'ImageHeight' and 'PixelDepth' members. In this sample we are only considering the case of loading an uncompressed 24-bit file. In the sample code for Toon3D you will find details for loading 8- and 32-bit compressed and uncompressed TGA files if you need this facility.

Given an open file, we start by reading the file header. A TGA file can have a comment about the file following the header. The TGAHEADER member IdLength gives the length in bytes of this comment and in the sample code we simply skip over it. Because we are only supporting 24-bit uncompressed files, we check for this by referring to the 'CmapType', which should be 0 to indicate no colour palette; 'PixelDepth' should be 24 and the 'ImageType' should be TGA_RGB. The file could be compressed in just the same way as a Windows bitmap is compressed, i.e. by using run length encoding; if this was the case then the

'ImageType' member of the header would be set to TGA_RLE. The values for these constants are stored in the 'tga.h' file, which is part of the Toon3D source code. The storage width of a TGA file is aligned so that the number of bytes used to store a line is always divisible by 4. This is called DWORD alignment. The simplest way to DWORD align the width is to add 3 to the width and zero out bits 0 and 1 of the value. Any number that is divisible by 4 will have 0 in bits 0 and 1. We can zero bits 0 and 1 by bitwise And-ing the number with the complement of 3, a number that has every bit set apart from bits 0 and 1. Then we create a BYTE buffer to store our pixel data and read the image data one scan line at a time.

```
BOOL CTGA::Load(CFile &tgaFile)
{
  TGAHEADER tgaHdr;
  int bytesRead;

  bytesRead = tgaFile.Read( &tgaHdr, sizeof(TGAHEADER));
  if (bytesRead != sizeof(BITMAPFILEHEADER)) {
        TRACE("CTGA::Load>> Failed to read file header");
        return FALSE;
  }

  // Skip image ID
  f.Seek(tgaHdr.IdLength,CFile::current);

  if (tgaHdr.CmapType != 0 || tgaHdr.PixelDepth!=24 ||
     tgaHdr.ImageType != TGA_RGB){
        TRACE("CTGA::Load>> Only 24 bit RGB files are supported.");
        return FALSE;
  }

  int width = tgaHdr.ImageWidth * 3;
  width = (width + 3) & ~3; //DWORD align
  BYTE *bits = new BYTE[width * tgaHdr.ImageHeight];

  if (!ReadImage(tgaFile, tgaHdr, bits)){
        if (m_hdr) delete m_hdr;
        m_hdr = NULL;
        if (m_bits) delete [] m_bits;
        m_bits = NULL;
        delete [] bits;
        return FALSE;
```

```
    }else{
        if (m_hdr) delete m_hdr;
        m_hdr = new TGAHEADER;
        memcpy( m_hdr, &tgaHdr, sizeof(TGAHEADER));
        if (m_bits) delete [] m_bits;
        m_bits = bits;
    }

    return TRUE;
}
```

The Load function uses the call to ReadImage to actually access the pixel data. The function is very simple, just moving through the data one scan line at a time. A TGA file can have the *x* and *y* values reversed in some cases and the function checks whether the *y* values are flipped. A Windows bitmap is usually stored so that the last scan line is the first and if you regularly work with such files then you may want to force the TGA file to load flipped.

```
BOOL CTGA::ReadImage(CFile &f, BYTE *buffer, TGAHEADER &hdr)
{
  int swidth = hdr.ImageWidth * 3;

  // Bits 5 of the Image Descriptor byte control the ordering of
  // the pixels we check whether we are upside down
  BOOL yReversed = ((hdr.ImagDesc & 32) == 32);
  BYTE *bits;

  for (int y=0; y<hdr.ImageHeight; y++){
      if (yReversed){
        bits = GetPixelAddress(0, y, hdr, buffer);
      }else{
        bits = GetPixelAddress(0, Height-y-1, hdr, buffer);
      }
      if (tgaFile.Read(bits, swidth)!=swidth) return FALSE;
  }
  return TRUE;
}
```

The 'ReadImage' function uses a call to 'GetPixelAddress', which returns the position in the BYTE array for a particular pixel address.

```
BYTE * CTGA::GetPixelAddress(int x, int y, TGAHEADER &hdr, BYTE↵
  *bits)
{
  int swidth,i;
  // Make sure it's in range and if it isn't return zero.
  if ((x >= hdr.ImageWidth)||(y >= hdr.ImageHeight)||(x<0)||(y<0))
      return NULL;

  // Calculate the scan line storage width.
  swidth = hdr.ImageWidth * 3;
  swidth = (swidth + 3) & ~3; //DWORD align
  return (BYTE*)(bits + (hdr.ImageHeight-y-1) * swidth + x*3);
}
```

Both Windows bitmaps and TGA files are simple to understand and use.

Loading a Jpeg file

A Jpeg file is much more complicated and to load the file you must use a library that provides the necessary code. Even then the techniques are rather complex, but they are worth using when file size is an issue. In the final chapter of the book we look at distributing real-time 3D character animation on the Internet; if this is your aim then Jpeg files are the best option for the texture maps that will be used in the animation. In the sample code for loading Jpeg files I make use of some code that was originally written by Chris Losinger and makes the loading and saving of Jpeg files much simpler. As usual, the full source code is included as part of the Toon3D source code. To load a Jpeg file we use many calls to the Jpeglib library. This is provided in the Toon3D source code folder. It must be added to your project along with the header file 'jpeglib.h' if you intend to use this sample code. In the code Chris wrote, he breaks the job into stages:

1 First, we must allocate and initialize a decompression object and the error routines that the library is going to use.
2 We supply the source file to the decompression object.
3 Next we read the Jpeg file header.
4 If necessary, we could set various decompression options.
5 Now it is safe to start the decompression.
6 With the decompression object initialized, we can read the actual pixel data into a scan line buffer and store the results of the decompression.

7 Having read all the scan lines, we can finish the decompression.
8 Finally, we destroy the decompressor, which releases any allocated memory.

There are many details that you need to be aware of if you intend to write your own code and you would be advised to read the IPG docs carefully. Alternatively, you could simply take the code presented here and use it directly. It doesn't give you as much control, but it will load most Jpeg files and return an RGB buffer.

```cpp
BYTE *CJpeg::Load(CString fileName, UINT &width, UINT &height)
{
  // basic code from IJG Jpeg Code v6 example.c
  width=0;
  height=0;

  // This struct contains the JPEG decompression parameters and
  // pointers to working space (which is allocated as needed by
  // the JPEG library).

  struct jpeg_decompress_struct cinfo;

  // We use our private extension JPEG error handler.
  // Note that this struct must live as long as the main JPEG
  // parameter struct, to avoid dangling-pointer problems.

  struct my_error_mgr jerr;
  FILE * infile=NULL;          // source file
  JSAMPARRAY buffer;           // Output row buffer
  int row_stride;              // physical row width in output buffer
  char buf[250];

  // In this example we want to open the input file before doing
  //anything else, so that the setjmp() error recovery below can
  //assume the file is open.
  //VERY IMPORTANT: use "b" option to fopen() if you
  //are on a machine that requires it in order to read binary files.

  if ((infile = fopen(fileName, "rb")) == NULL) {
      TRACE("CJpeg::Load>> Can't open jpeg file");
      return NULL;
  }
```

```cpp
// Step 1: allocate and initialize JPEG decompression object
//We set up the normal JPEG error routines, then override
//error_exit.

cinfo.err = jpeg_std_error(&jerr.pub);
jerr.pub.error_exit = my_error_exit;

// Establish the setjmp return context for my_error_exit to use.
if (setjmp(jerr.setjmp_buffer)) {
    // If we get here, the JPEG code has signaled an error.
    // We need to clean up the JPEG object, close the input file,
    //and return.
    TRACE("CJpeg::Load>> Problem with Jpeg file");
    jpeg_destroy_decompress(&cinfo);

    if (infile!=NULL) fclose(infile);
    return NULL;
}

// Now we can initialize the JPEG decompression object.
jpeg_create_decompress(&cinfo);

// Step 2: specify data source (eg, a file)
jpeg_stdio_src(&cinfo, infile);

// Step 3: read file parameters with jpeg_read_header()
(void) jpeg_read_header(&cinfo, TRUE);

// We can ignore the return value from jpeg_read_header since
//(a) suspension is not possible with the stdio data source, and
//(b) we passed TRUE to reject a tables-only JPEG file as an error.

// Step 4: set parameters for decompression

// In this example, we don't need to change any of the defaults set by
//jpeg_read_header(), so we do nothing here.

// Step 5: Start decompressor
(void) jpeg_start_decompress(&cinfo);
// We can ignore the return value since suspension is not possible
//with the stdio data source.
```

```
// We may need to do some setup of our own at this point before
//reading the data. After jpeg_start_decompress() we have the
//correct scaled output image dimensions available, as well as
//the output colormap if we asked for color quantization.
//In this example, we need to make an output work buffer of the right
//size.

// get our buffer set to hold data
BYTE *dataBuf;
//DWORD align the storage width
int swidth = (cinfo.output_width * cinfo.output_components + 3) &↵
  ~3;

/////////////////////////////////////////////////////////////
// alloc and open our new buffer
dataBuf = new BYTE[swidth * cinfo.output_height];

if (dataBuf==NULL) {
    TRACE("Cjpeg::Load>> Out of memory");
    jpeg_destroy_decompress(&cinfo);
    fclose(infile);
    return NULL;
}

// how big is this thing gonna be?
width = cinfo.output_width;
height = cinfo.output_height;

//JSAMPLEs per row in output buffer
row_stride = cinfo.output_width * cinfo.output_components;

// Make a one-row-high sample array that will go away when done with
//image
buffer = (*cinfo.mem->alloc_sarray)
    ((j_common_ptr) &cinfo, JPOOL_IMAGE, row_stride, 1);

// Step 6: while (scan lines remain to be read)
//           jpeg_read_scanlines(. . .);
// Here we use the library's state variable cinfo.output_scanline
//as the loop counter, so that we don't have to keep
//track ourselves.
```

```
BYTE *bits;

while (cinfo.output_scanline < cinfo.output_height) {
    jpeg_read_scanlines(&cinfo, buffer, 1);
    //Copy scan line to dataBuf
    memcpy(&dataBuf[swidth * cinfo.output_scanline,
        buffer, row_stride);
}

// Step 7: Finish decompression

(void) jpeg_finish_decompress(&cinfo);
// We can ignore the return value since suspension is not possible
//with the stdio data source.

//Step 8: Release JPEG decompression object
//This is an important step since it will release a good deal of
//memory.
jpeg_destroy_decompress(&cinfo);

// After finish_decompress, we can close the input file.
//Here we postpone it until after no more JPEG errors are possible,
//so as to simplify the setjmp error logic above.

fclose(infile);

// At this point you may want to check to see whether any corrupt-data
//warnings occurred (test whether jerr.pub.num_warnings is
//nonzero).

return dataBuf;
}
```

A Jpeg RGB buffer is not guaranteed to be DWORD aligned, so you may want to copy each scan line into a DWORD aligned buffer if you are using the buffer as a Windows bitmap type. Also, the pixel data will not be provided last scan line first, so another useful utility will be code to flip the buffer vertically. The final utility that you may use is to flip the red and blue components, because again Windows stores the data the opposite way round. All these utility functions are available in the Toon3D source code and are very easy to write for yourself.

Assigning pixel data to the OpenGL texture engine

We now have a DWORD aligned, vertically flipped BGR buffer. The next step is to provide this pixel data to OpenGL. Texture images are defined with **glTexImage2D**.

```
void glTexImage2D( GLenum target, GLint level, GLint components,
GLsizei width, GLsizei height, GLint border, GLenum format,
GLenum type, const GLvoid *pixels );
```

The arguments describe the parameters of the texture image, such as height, width, width of the border and number of colour components provided. The last three arguments describe the way the image is represented in memory. For our purposes, we define the format as GL_BGR_EXT and the type as GL_UNSIGNED_BYTE, which is the way that a Windows bitmap is stored in memory. Data are read from *pixels* as a sequence of unsigned bytes. These values are grouped into sets of three values because we have chosen GL_BGR_EXT as the format.

Table 6.1

Level	Width	Height
0	128	64
1	64	32
2	32	16
3	16	8
4	f8	4
5	4	2
6	2	1

OpenGL can use several versions of a texture depending on the scale of that texture on the screen. When using the function glTex-Image2D, we define which level of detail we are supplying using the level parameter. OpenGL uses textures that are exact powers of 2 in width and height. If a bitmap is 128 × 64, then the potential levels of detail are as shown in Table 6.1.

If you intend to use multiple levels of detail then you can create all these in one go using the GLU function gluBuild2Dmipmaps.

```
int gluBuild2DMipmaps( GLenum target, GLint components,
GLint width, GLint height, GLenum format, GLenum type,
const void * data );
```

The parameters have the same effect as glTexImage2D.

When creating a texture we first get a texture ID number using glGenTextures, so that we can restore this texture as the current texture in OpenGL. glGenTextures simply creates an ID number, no pixel data are created. We also use this ID to destroy the texture when we have finished using it. Having created a texture ID we then make this the current texture using glBindTexture. The next step is to set up the pixel storage alignment and what we want to do if the texture does not fit the area it is mapped to. Should we repeat the image up and down and across, or should the edge of the image be used as a colour? We also specify how OpenGL will scale the image. Since we are writing a real-time application we want the fastest method of scaling, which is to use the nearest pixel to the one we want. Another method would be to blend pixels, but this takes longer and is not really suited to real-time applications. The final option in the sample code fragment is how to use the texture with the current lighting model. I prefer to blend the texture with the existing surface colour. If you make the colour for any textured surface white, then this gives you the lit texture.

Having set up all the parameters, we can now exchange our pixel buffer with OpenGL using either glTexImage2D or gluBuild2Dmipmaps depending on your choice of levels of detail.

```
//Create a texture id and make it current
glGenTextures(1, &texID);
glBindTexture (GL_TEXTURE_2D, texID);

//Set DWORD alignment
glPixelStorei (GL_UNPACK_ALIGNMENT, 4);

//Set width repeat option
if (widthRepeat){
  glTexParameteri (GL_TEXTURE_2D, GL_TEXTURE_WRAP_S, GL_REPEAT);
}else{
  glTexParameteri (GL_TEXTURE_2D, GL_TEXTURE_WRAP_S, GL_CLAMP);
}
```

```
//Set height repeat option
if (heightRepeat){
  glTexParameteri (GL_TEXTURE_2D, GL_TEXTURE_WRAP_T, GL_REPEAT);
}else{
  glTexParameteri (GL_TEXTURE_2D, GL_TEXTURE_WRAP_T, GL_CLAMP);
}

//Set scaling functions to fastest possible
glTexParameteri (GL_TEXTURE_2D, GL_TEXTURE_MAG_FILTER,↵
  GL_NEAREST);
glTexParameteri (GL_TEXTURE_2D, GL_TEXTURE_MIN_FILTER,↵
  GL_NEAREST);

//Set enviroment option to modulate with surface colour
glTexEnvf (GL_TEXTURE_ENV, GL_TEXTURE_ENV_MODE, GL_MODULATE);

if (useMipMaps){
  gluBuild2DMipmaps (GL_TEXTURE_2D,          //target
                    GL_RGB,                  //components
                    pic.GetWidth(),          //width
                    pic.GetHeight(),         //height
                    GL_BGR_EXT,              //format
                    GL_UNSIGNED_BYTE,        //type
                    pic.GetBitsAddress());//data
}else{
  glTexImage2D(GL_TEXTURE_2D,          //target
                0,                      //level
                GL_RGB,                 //components
                pic.GetWidth(),         //width
                pic.GetHeight(),        //height
                0,                      //border
                GL_BGR_EXT,             //format
                GL_UNSIGNED_BYTE,       //type
                pic.GetBitsAddress());//data
}
```

When working with textures in OpenGL, you must delete any that you have finished using. This is done using a call to

```
glDeleteTextures(1, &texID);
```

If your texture IDs are stored in an array of integers, then you can delete several textures in one function call.

```
int texID[10], n;
.....
//Allocate all texture objects and store each id in the array
//texID, n defines the total
.....
//Use the textures
.....
//Clean up
glDeleteTextures(n, texID);
```

To ensure that your code is working, try mapping a single bitmap to a single four-sided polygon. Use the technique above to create and assign a texture object. Enable textures using glEnable(GL_TEXTURE_2D). In the render event for your code simply draw the textured polygon using

```
glBegin(GL_QUAD)
  glRGB(255, 255, 255);
  glNormal3d(0, 0, 1);
  //first vertex
  glTexCoord2f(0.0f, 0.0f);
  glVertex3d(-1.0, 1.0, 0,0);
  //second vertex
  glTexCoord2f(1.0f, 0.0f);
  glVertex3d(1.0, 1.0, 0,0);
  //third vertex
  glTexCoord2f(1.0f, 1.0f);
  glVertex3d(1.0, -1.0, 0,0);
  //fourth vertex
  glTexCoord2f(0.0f, 1.0f);
  glVertex3d(-1.0, -1.0, 0,0);
glEnd
```

We are getting closer to being able to display a textured mesh. The next step is to provide a way of mapping our pixel data onto our mesh. For this we will need to create coordinates for each vertex in a textured polygon to define what part of a bitmap the vertex uses.

Generating texture coordinates

Generating the texture coordinates can be done using the texture size, centre and mapping type. Toon3D stores the texture coordinates in the POLYGON structure, inside an indexed array of type TVEC.

```
typedef struct stTEXVEC{
  float u,v;
}TEXVEC;
typedef struct stPOLYGON{
  int numverts;
  double normal[3];
  double nx, ny, nz;//Rotated normal
  int p[4];
  TEXVEC tc[4];//texture coordinates
  int srf;
}POLYGON;
```

It is common practice to refer to texture coordinates as (*u, v*), where *u* is a number from 0 to 1 that defines a position across the bitmap texture from 0 to texture width in pixels, and *v* is a number between 0 and 1 that defines a position down the bitmap texture from 0 to texture height in pixels. The first step in creating the texture coordinates involves choosing the mapping type. Let's look at the principal texturing methods.

Planar mapping

Planar mapping takes an image and projects it parallel down one of the axes. If the axis is *z*, then the coordinates are applied with the *x*-axis running left to right and the *y*-axis running up and down. One method of defining a mapping is to iterate through all the polygons in a mesh that use the current textured surface and store a vector which defines the bottom, left, near position, and another vector that stores the top, right, distant position. The first vector stores all the minimum values for the texture coordinates and the second the maximum values. The two vectors define a bounding box for the texture. A third vector is used to define the overall size by subtracting the minimum values from the maximum.

If we are mapping down the *z*-axis, then we need to take each vertex in each polygon in turn and derive a (*u, v*) value for this vertex based on the *x* and *y* values of the vertex. Since we know the overall size of the textured area, we can scale the current coordinates by subtracting the minimum vector from the current vertex coordinates and dividing the result by the texture size vector. With a *z*-axis mapping we only need to work with the *x* and *y* components of the vectors. With a *y*-axis mapping we would work with the *x* and *z* components, and an *x*-axis mapping would use the *y* and *z* components. Here is a code snippet that deals with a single polygon. You will need to call this function for each polygon.

```
switch (tex->axis){
  case MAP_X_AXIS:
      for (i=0; i<ply->numverts; i++){
          pt=&pts[ply->p[i]];
          ply->tc[i].u = (pt->z - tex->min.z)/tex->size.z;
          ply->tc[i].v = (pt->y - tex->centre.y)/tex->size.y;
      }
      break;
  case MAP_Y_AXIS:
      for (i=0; i<ply->numverts; i++){
          pt=&pts[ply->p[i]];
          ply->tc[i].u = (pt->x - tex->min.x)/tex->size.x;
          ply->tc[i].v = (pt->z - tex->centre.z)/tex->size.z;
      }
      break;
  case MAP_Z_AXIS:
      for (i=0; i<ply->numverts; i++){
          pt=&pts[ply->p[i]];
          ply->tc[i].u = (pt->x - tex->min.x)/tex->size.x;
          ply->tc[i].v = (pt->y - tex->centre.y)/tex->size.y;
      }
      break;
}
```

Figure 6.2 The image map used in the cylindrical and spherical mapping examples.

Cylindrical mapping

Cylindrical mapping is a little more complex than planar mapping, since we need to wrap a 2D image around on itself. Again, we first need to know which axis we are using. Let us consider what happens when the image is wrapped around the y-axis. First, we need to know where this vertical line is centred in the x and z directions. In the same manner as the planar example, we step through each polygon in the object that uses this surface, and for each polygon we step through the vertices one by one.

To determine the centre we interate through all the polygons and create a minimum and maximum vector defining a bounding box. The size is found by deleting the minimum from the maximum and the centre is found by halving the size and adding it to the minimum vector.

The first step in determining the texture coordinates is to create a vector from the texture's centre to the current vertex. Viewing the object from above and looking down, we need to determine a value from the texture image for each vertex in the object. The problem is principally a 2D one; from the x and z values we need to create a value between 0 and 1 that chooses a point from the image between 0 and the width in pixels of the image. In order to decide this value we will need to determine the angle, looking straight down from above, between the z-axis and the vector we have created. The trigonometric function tan is a ratio of the length of the opposite side over the adjacent side to an angle. Imagine a right angled triangle with the x value of the vector as one side and the z value as another. In this case the tangent of the angle is given by the length along the z-axis divided by the length along the x-axis. If we know the value of the tangent of an angle, then we can calculate the angle by using the inverse function arctan. The arctan function gives values from 0 to $2 \times \pi$. We need values from 0 to 1, so we must scale the result by dividing by 2π. Therefore, in order to calculate the u value from the texture, that is how far across the bitmap, we need to determine the angle from the length of the two known sides of the triangle using the arctan function.

A simple cylindrical map will wrap a texture once around the object. Toon3D allows this wrap to be tiled so that a single image maps an arbitrary number of times around the object. If the image should only map to 60° then repeat, then the wrap would be six times, 360/60. Equally, the wrap could be less than one; if the wrap was 0.5, then in a full wrap around the object, only half the texture image width would be used. We need to take this width wrap into consideration when determining the texture coordinate. All trig functions use radians, where

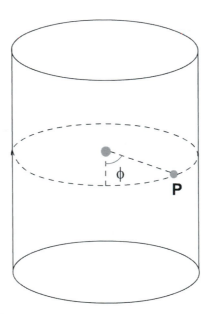

Figure 6.3 Calculating the u values for a cylindrical texture map.

2π radians are equivalent to 360°. The distance across the texture map is given by the product of the width wrap and the current angle, ϕ, divided by 2π. This is capped to between 0 and 1.0 using a while loop.

Calculating the v value is the same as planar mapping, although in this sample we use the centre of the texture as the origin point not the minimum vector, so we need to add 0.5 back to the *v* value to centre the result. Here is a code snippet that shows how to generate the coordinates for a cylindrical image mapping around the *y*-axis:

```
for (i=0; i<ply->numverts; i++){
    pt=&oi->pts[ply->p[i]];
    vec.x = pt->x - tex->centre.x;
    vec.y = pt->y - tex->centre.y;
    vec.z = pt->z - tex->centre.z;

    //Calculate the u coordinate
    u = (float)(atan2(vec.x,vec.z)/PI2);
    u *= tex->widthwrap;
    //Cap to 0 < u < 1
    while (u>=1.0) u-=1.0;
    while (u<0) u+=1.0;
```

Real-time 3D Character Animation with Visual C++

```
//Calculate the v coordinate
v = vec.y/tex->size.y + 0.5;
ply->tc[i].u = u;
ply->tc[i].v = v;
}
```

Figure 6.4 shows the result of wrapping the texture shown in Figure 6.2 twice around a cylinder in the *y*-axis.

Figure 6.4 Example of cylindrical image mapping.

Spherical mapping

The final type of basic mapping is spherical. In this type of mapping we need to wrap the image in two directions. Calculations for the principal axis are exactly the same as for cylindrical mapping. Wrapping around towards the poles of the sphere is handled differently. We need to consider another angle. Using the vector we have created from the texture centre to the current vertex, we normalize this vector to unit length. We now effectively have a hypotenuse that is of length 1. That means the *y* value is the sine of the angle θ. Using the inverse function arcsin will return the angle from the *y* value of the vector.

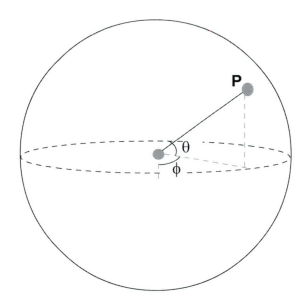

Figure 6.5 Generating spherical coordinates.

Toon3D allows for the width wrapping and the height wrapping to be set. In this way, a single texture can be tiled around the sphere's principal and minor axes.

This code snippet shows how to generate spherical texture coordinates having previously defined the texture centre and size as described for the planar and cylindrical examples:

```
for (i=0;i<ply->numverts;i++){
    pt=&oi->pts[ply->p[i]];
    vec.x=pt->x-tex->centre.x;
    vec.y=pt->y-tex->centre.y;
    vec.z=pt->z-tex->centre.z;

    //Calculate the u coordinate
    u = (float)(atan2(vec.x,vec.z)/PI2);
    u*=tex->widthwrap;
    while (u>=1.0) u-=1.0;
    while (u<0) u+=1.0;

    //Calculate the v coordinate
    vec.y /= sqrt(vec.x*vec.x + vec.y*vec.y +
                            vec.z*vec.z);
    v = (asin(vec.y)*tex->heightwrap)/PI + 0.5;
```

```
        while (v>=1.0) v-=1.0;
        while (v<0) v+=1.0;
        ply->tc[i].x=(float)u;
        ply->tc[i].y=(float)v;
    }
```

Figure 6.6 shows an example of this mapping.

Figure 6.7 illustrates a potential problem. When generating coordinates this way, it is possible to have a polygon that has a high value, say 0.87 for one side, and a value for the other side that is very low, say 0.0. The left image in the diagram shows the result of this. The entire texture image is mapped to the central polygons. In reality, we want the polygon to map

Figure 6.6 Example of spherical image mapping.

Figure 6.7 Problems with mapping.

Real-time 3D Character Animation with Visual C++

from 0.87 to 1.0. The simplest solution to this is to test polygons for a high range and to add one to the low value if a high range is found. The right image in the diagram shows the result of this simple fix.

UV mapping

The final option for texture mapping is to allow the artist total control over how to map the vertices. Many CGI packages provide a way to achieve this end and it is the user interface that is the complex issue. As you have learned, any form of mapping generates (u, v) coordinates. You may wish to create your own interface to allow the generation of mapping data. One technique is to start with a basic mapping and then to draw the mesh flat over the texture and allow the artist to move vertices with point manipulation tools. If you had a split screen then you could show the results of the mapping as the artist edits the vertices.

Displaying the result

Then we can either blend the texture with the current colour or apply it directly. If we are blending with the current colour then it is usually best to set the colour to plain white. When painting a polygon we must inform OpenGL of the current vertex location, the normal and the texture coordinates for this vertex. Remember that a vertex can be shared in several polygons. One of the polygons that shares the vertex may have a different texture. For this reason it is the polygon that is used as the storage medium for texture coordinates, not the vertex.

A short code snippet that will paint a textured polygon stored in the previously created texture object defined by the number 'texID' is as follows:

```
texID = ply->tex;
glBindTexture(GL_TEXTURE_2D, texID);
glRGB(255,255,255);
glMaterialfv(GL_FRONT, GL_SPECULAR, ply->srf.spec);
glBegin(GL_TRIANGLES);
  while(ply->tex == texID){
     pt=&pts[ply->p[0]];
     glNormal3d(pt->mx, pt->my, pt->mz);
     glTexCoord2f(ply->tc[0].u, ply->tc[0].v);
     glVertex3d(pt->wx, pt->wy, pt->wz);
```

```
        //second vertex
        pt=&pts[ply->p[1]];
        glNormal3d(pt->mx, pt->my, pt->mz);
        glTexCoord2f(ply->tc[1].u, ply->tc[1].v);
        glVertex3d(pt->wx, pt->wy, pt->wz);
        //third vertex
        pt=&oi->pts[ply->p[2]];
        glNormal3d(pt->mx, pt->my, pt->mz);
        glTexCoord2f(ply->tc[2].u, ply->tc[2].v);
        glVertex3d(pt->wx, pt->wy, pt->wz);
        ply++;
    }
glEnd();
```

Now you have the armoury to display fully textured meshes.

Summary

There are many details to consider in this chapter, and if any of them are handled incorrectly in your code then you are likely to experience the frustration of no texturing on your meshes. You are advised to work through the code samples carefully. Create a Windows bitmap loader first and then make sure it works by displaying the results of the load using a Windows API call such as StretchDIBits. Once your bitmap loader is working, try mapping it directly to a single four-sided polygon as suggested. This proves that the pixel storage and unpacking methods are correctly set and that the texture environment parameters are defined. Then try mapping a single planar texture to a mesh by using the code fragments to define the texture coordinates; if everything is working correctly then you should have a textured mesh. The texture will move with your mesh as it moves.

7 Setting up a single mesh character

If your character was a jointed robot then you could set it up so that each individual part that moves is a separate object. Then you will need some way of informing your transformation code that a bicep is connected to a shoulder, a forearm is connected to the bicep and a hand is connected to the forearm. In this chapter we will consider how you can set up hierarchies of objects so that rotating and transforming the object will affect not only the object itself, but also those other objects that are connected to it. But we need to go further than this; we want to be able to deform a character so that the rendered result will appear as a single mesh. If we attempt to display an organic character using separate objects for each section, the result will either appear as though the sections overlap, or that the sections appear to be separated. To display organic characters effectively in your real-time render engine, we need to be able to move certain vertices in a mesh and not others.

Whatever deformation system we use we need to be able to rotate and transform a section of a mesh using some form of control object. There are several ways in which this can be achieved; this chapter looks at some possible methods. One method described takes a complete mesh that is the render target, and then uses sections cut from the object as controls. These controls will affect how the animation engine deforms the full mesh. The render engine will not display the controls, just the full mesh. Before we consider this option we will look at the leading alternative method, bones, and discuss why some implementations of bones have severe performance penalties when applied to real-time rendering engines. We will consider how we can implement a bones-based system using control objects, which can be readily imported from key modelling software. We will consider hierarchies of objects where the parent of an object affects its animation. Finally, as hardware develops apace we will look at how the single mesh deformations we are considering are suitable for real-time rendering systems that use some form of subdivision.

How bone deformation systems work

If you are aware of CGI developments over the last 10 years, then you will know that bone deformation systems have been a key feature of the leading 3D animation packages. The real-time industry has until very recently looked on in awe as these rendering-based packages provided more and more sophisticated tools for single mesh deformation. What we want for our render engine is something that allows us to deform certain vertices in a mesh using a control object. In other words, something rather like the way a modeller application lets us select a bunch of points from a mesh and deform just that set of points. Bones are one way of doing just that. First, you create a single mesh that you wish to deform, and then you add some kind of skeleton to this mesh. Some software requires you to assign certain vertices in the mesh to each bone in the skeleton. Other software uses the location of the bone and its strength to influence how each vertex in a mesh is deformed by each bone.

The problems behind bone deformation

All calculations that your engine performs take some processor time. The ideal deformation system only considers each vertex once. In a bone deformation system that uses weights, a single bone has a zone of influence that has a blurred edge. In a central area vertices are very influenced by this bone, in the outer area the influence falls off until it has no influence at all. This type of system is great for rendering software because it allows the animator maximum control over the way a single mesh is deformed. Admittedly, this comes at the price of some major set-up headaches! In a real-time engine this method is not great because it can and often does result in an engine that has to consider every point in a mesh for every bone. A fairly simple but common hierarchy for a biped is as follows:

Hips
 Torso
 Neck
 Head
 Hair
 Left Shoulder
 Left Bicep
 Left Forearm
 Left Wrist
 Left Hand

Right Shoulder
Right Bicep
Right Forearm
Right Wrist
Right Hand
Left Thigh
Left Calf
Left Ankle
Left Foot
Left Toe
Right Thigh
Right Calf
Right Ankle
Right Foot
Right Toe

In this hierarchy there are 25 possible bones. In a simple low polygon single mesh character you may have 1000 vertices. If each of these 1000 vertices is acted on by 25 bones, then there are 25 000 calculations to perform rather than just 1000. This is 25 times as many calculations to do than we would prefer. Our real-time engine needs much more focus over which vertices are deformed by which bone. But, suppose that no vertex is acted on by more than one bone. This can lead to some very unwanted artefacts. Let's consider how the mesh at a knee joint may behave if each vertex in the mesh is controlled by a single bone. As the joint rotates, the vertices at the back of the knee that influence the calf can end up overlapping the vertices for the thigh (see Figure 7.1). This can lead to very bad nipping. At a distance this may be acceptable, but close up to

Figure 7.1 How vertex selection can result in poor quality rendering.

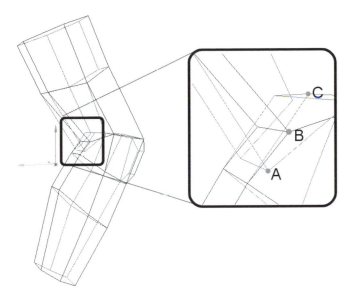

Figure 7.2 Using point blending.

camera this technique definitely lacks the finesse that customers expect. Therefore, our system wants the ability for vertices to be influenced by more than one bone, without suffering a significant performance penalty.

Figure 7.2 illustrates how point blending can eliminate the unwanted nipping when deforming a single mesh character. If you look closely you will see that vertex B from the leg mesh is created from a combination of the vertex location of vertex A from the thigh control and vertex C from the calf control. This very focused control over vertex locations using controls, where more than one control can affect a single vertex, is the aim of our deformation system. Then it becomes the job of the artist to minimize the number of vertices that are deformed by more than one control.

One possible solution to bone deformation systems

One way to achieve this level of control is to dynamically create a set of vertices from a list of point indices that relate to your target mesh. An example may help (see Figure 7.3).

Here we have a very simple mesh, with just 12 vertices. We want a bone deformation system that allows Bone01 to deform vertices 1–8 and Bone02 to deform vertices 5–12. In this system both bones deform vertices 5–8, Bone01 alone deforms vertices 1–4 and Bone02 alone

Figure 7.3 A two bone set-up with some basic overlapping.

deforms vertices 9–12. So the list of point indices for Bone01 is simply {1, 2, 3, 4, 5, 6, 7, 8} and the list for Bone02 is {5, 6, 7, 8, 9, 10, 11, 12}. In a more complex example, the vertex numbers would not be so obvious and the list could easily be {2, 34, 72, 123, 125, 212, 216, 321, 322, 333, 469} or any other arbitrary list from the mesh; nevertheless, the principle of the system remains the same. As the program initializes the data, Bone01 is created in memory. The software creates an array of eight pointers to vertices 1–8 from the single mesh. Bone02 dynamically creates the set of vertices that point to vertices 5–12 from the single mesh. The single mesh is informed that it is no longer responsible for its own deformations using a weight flag for each vertex. A possible type definition for the vertices in the single mesh is:

```
typedef stMESHVERTEX{
    double ox,oy,oz;   //Original vertex location
    double wx,wy,wz;   //World transformed vertex location
    int weight;        //0 = vertex transformed by mesh
                       //n = vertex transformed by n
                       // controls
}MESHVERTEX;
```

We ensure that the weight parameter is set to zero on creation of the single mesh, indicating that the mesh itself is responsible for the

deformation of each vertex. As each bone is created, if it is going to influence a vertex from the single mesh then it adds one to the weight for this vertex. When we are deforming the single mesh object and find that the weight parameter is greater than zero, then a bone must be deforming the vertex. If the weight parameter is 2 then two bones are deforming the vertex, if the weight parameter is 3 then three bones are deforming the vertex, and so on.

Now, in our transformation loop, we first need to zero the world vertex locations for each vertex in the single mesh object. Then we deform the vertices pointed to by Bone01 summing the value with the existing world value of the vertex. Because this is the first bone the existing value will have each component (wx, wy, wz) set to 0.0. Having set the vertex locations for Bone01, the software moves on to Bone02. If the scene was more complex then we would simply iterate through all the bones in the scene until all transformations were complete. At this stage, vertices 1–4 and 9–12 are already in their correct location because they have weights of one. Vertices 5–8 are now set to the sum of the location of the vertex in Bone01 and the vertex in Bone02. What we actually require is the average of these two, which we can simply derive by dividing the x, y and z values for the vertex by its weight; in this simple example the weight will be 2. We need to check whether a vertex has a weight greater than 1 and if so divide by its weight to get the correct location for all vertices in an object that are being controlled in this way. This simple bone deformation system has the merit that it has very little redundancy; all the calculations performed are necessary for the required display. The problem with the system is that as a developer you need to be able to import geometry from a modeller package such as 3DS, Maya or Lightwave into your application while retaining point index references for your bone assignments. This is not easily achieved. How do you decide which vertices are those in the arm and which in the neck, etc.? One way would be to write your own plug-in for Lightwave or 3DS that creates a list of point indices from a point selection and use this when creating your bones. See Chapter 10 for how you could do just this for Lightwave. But there is an alternative that shares the benefits of performance while allowing you to continue to use just simple geometry for import and export, rather than requiring you to familiarize yourself with yet another SDK.

An alternative to bone deformation

This alternative works in just the same way as the previously suggested bone deformation system, the difference being the way that the point

Real-time 3D Character Animation with Visual C++

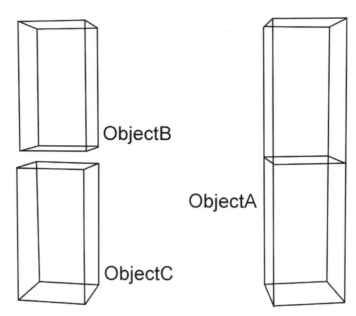

Figure 7.4 Objects required for the Bendypoints system.

selection from the target mesh is defined. Going back to the 12 vertices example, we create three objects in the modelling program, as shown in Figure 7.4.

Here ObjectA is the target mesh, ObjectB is an object made up of the polygons formed from vertices 1–8 of ObjectA and ObjectC is made up of the polygons formed from vertices 5–12 of ObjectA. Each of these is a simple object so can obviously be saved to disk if you are using Lightwave, or will appear as a mesh object in a scene file when exported in ASCII format in 3DS. We will look in later chapters at how to get access to this geometry, but suffice it to say that it is possible. When we set up a scene in our development engine we want to be able to say that objects B and C are actually control objects for A and do not need to be displayed. Similarly, since every vertex in A is being controlled by another object, there is no requirement to transform mesh A itself, since this will only be overridden by the control objects. In the application program Toon3D Creator provided on the CD we can set up this simple scene. But before we do, let's look at the way that Toon3D creates the linkage between the control vertices and the target mesh vertices by point location.

```
typedef struct stPOINT3D{
    double ox,oy,oz;   //Modelled points
    double nx,ny,nz;   //Original normal
```

```
    double mx,my,mz;    //Rotated normal
    double wx,wy,wz;    //Rotated points
    int weight;         //0 vertex transformed by mesh
                        //n vertex transformed by n controls
}POINT3D;

//================================================================
//AssignControlPoints

//bobj is the target single mesh object
//This function looks for a link between the vertex locations in this
//object and those in the target mesh bobj. It creates an array of
//m_numpoints POINT3D pointers which can be used to deform the target
//mesh.
//================================================================
BOOL CToon3DObject::AssignControlPoints(CToon3DObject *bobj)
{
    //Delete any existing m_vptr array
    if (m_vptr) delete [] m_vptr;
    //Creates m_numpoints POINT3D pointers
    m_vptr=new POINT3D*[m_numpoints];
    if (!m_vptr) return FALSE; //Probably means a memory error

    POINT3D *pt;   //pt is used to step through this controls points
    POINT3D *bpt;// bpt is used to step through the target points
    int count=0; //Incremented as point assignment occurs

    pt = m_pts;   //m_pts is the point array for this control

    //Step through control points
    for (int i=0;i<m_numpoints;i++){
        bpt = bobj->m_pts;
        for (int j=0;j<bobj->m_numpoints;j++){
            if (pt->x==bpt->x && pt->y==bpt->y &&
                pt->z==bpt->z){
                    //Control and target points match
                    bpt->weight++;
                    ptindex[i]=bpt;
                    count++;
                    break;
            }
            //Step on to next target point
            bpt++;
```

```
        }
        //Step on to next control point
        pt++;
    }
    if (count!=m_numpoints){
        //If all control points are not found in the target mesh
        //then this function returns FALSE
        TRACE("CLWScene::AssignControlPoints>>
            Not all points in control object found in Bendy
            target\n");
        delete [] ptindex;
        ptindex=NULL;
        return FALSE;
    }

    return TRUE;
}
```

This function is designed to fail if all the vertices in the control are not found in the target. This is not essential and you could have a situation where the same control deforms points in two different meshes, but this gets rather complicated to set up and usually simple solutions are the best.

If you are near your computer and have installed the CD software, then run Toon3D Creator and open the project file Chapter07/Bendy-points01.t3d. This contains the objects illustrated. These are ridiculously simple so that the concept is conveyed; the mesh can be as complex as the target hardware can cope with.

Creating a hierarchy for controlling your single mesh character

The first thing to do is to notice that ObjectC is parented to ObjectB. This is achieved by right clicking on the object in the tree control on the left of the main application window. In the pop-up menu that is displayed select 'properties'. In the dialog box that is generated select the parent object by name from the combo box list. When an object is parented to another object it takes on the world position, rotation and scale of the parent. The object can then be animated from this new position and orientation, but will move with respect to the parent. The location and orientation of the parent becomes the new origin for the object. An object can have just one parent, but an object can be the parent of many other objects.

Real-time 3D Character Animation with Visual C++

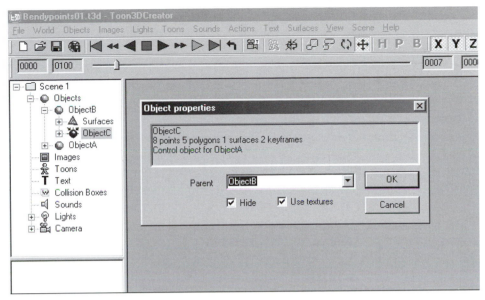

Figure 7.5 Selecting the parent object in Toon3D Creator.

We will look now at how the object is transformed and rotated in Toon3D. The first thing to be aware of is that the parent of an object must have already been rotated in order for the code to work. So the overall transformation loop must begin by iterating through all objects in the scene that have no parent. In the transformation loop for these parentless objects, we need to transform any objects that have the current object as a parent. As an example, let's take part of the hierarchy that we considered earlier:

```
Torso
    Neck
        Head
    Left Shoulder
        Left Bicep
            Left Forearm
                Left Hand
    Right Shoulder
        Right Bicep
            Right Forearm
                Right Hand
```

In our scene we need to be able to individually control each of these objects. All code examples use a C++ class called CToon3DObject. (The

Microsoft convention of adding a C to the class name is adopted throughout this book, for the principle of adding 'm_' member variable is sometimes used.) For editing convenience we use a linked list for the object class. Each object has a pointer to a CToon3DObject called 'm_next'. In the constructor for the object this is set to NULL, indicating that the object is the last in the list. We also use a class called CToon3DScene that has a member variable called m_ObjectList, which is a CToon3DObject. We use a CToon3DObject rather than a pointer to an object so that the list is always valid. The first member in the list is only used as a place holder, it contains no geometry. A scene is effectively empty if m_ObjectList.next is NULL. Referring back to the hierarchy, there is no requirement that this appears in the order of the hierarchy, i.e. 'Torso' does not have to be first, followed by 'Neck'. The list of objects in the scene may well appear as shown in Table 7.1.

Table 7.1 Object list and parents

Object	Parent	Next pointer
m_ObjectList	NULL	Left Shoulder
Left Shoulder	Torso	Left Bicep
Left Bicep	Left Shoulder	Neck
Neck	Torso	Torso
Torso	NULL	Right Shoulder
Right Shoulder	Torso	Right Bicep
Right Bicep	Right Shoulder	Head
Head	Neck	Left Forearm
Left Forearm	Left Bicep	Left Hand
Left Hand	Left Forearm	Right Forearm
Right Forearm	Right Bicep	Right Hand
Right Hand	Right Forearm	NULL

Our transformation code starts with a function called 'UpdateAllObjects'. A pointer to m_ObjectList.m_next is created if this is NULL, then the list is empty and we have nothing to transform. In this example m_ObjectList.next points to the object called 'Left Shoulder'; this object has 'Torso' as a parent so we can skip this object for the time being, since we are looking for objects with no parent. We skip past 'Left Bicep' and 'Neck' also until we get to 'Torso'. This object has no parent. So we transform this object and then call a function called 'UpdateChildObjects' passing the 'Torso' object as a parameter. 'UpdateChildObjects' has

another pointer to the object list. Starting again at the beginning of the list, we are now looking for objects that have 'Torso' as a parent. In this example the first object in the list, 'Left Shoulder', has 'Torso' as a parent. The next step is to transform 'Left Shoulder' and then from this function call 'UpdateChildObjects', only this time with 'Left Shoulder' as the parameter. In this next call to 'UpdateChildObjects', 'Left Bicep' has 'Left Shoulder' as a parent. So we transform 'Left Bicep' and call 'UpdateChildObjects' with 'Left Bicep' as the parameter. This is repeated for 'Left Forearm' and 'Left Hand'. At this stage the nested function calls are:

```
UpdateAllObjects()
    UpdateChildObjects('Torso')
        UpdateChildObjects('Left Shoulder')
            UpdateChildObjects('Left Bicep')
                UpdateChildObjects('Left Forearm')
                    UpdateChildObjects('Left Hand')
```

The key to using recursive functions is to ensure they return, otherwise your code will hang in an endless loop. The function 'UpdateChildObjects' returns when the entire scene list has been searched and the next pointer is 'NULL'. In the example, 'UpdateChildObjects' for 'Left Hand' the entire scene list will be searched and no children of 'Left Hand' found. Having got to the object 'Right Hand' in the list, the function returns because the 'next' pointer for 'Right Hand' is NULL. The function call 'UpdateChildObjects' using 'Left Forearm' as a parameter having found the child object 'Left Hand' and ensured that it is updated continues looking at the object list by examining 'Right Forearm' and 'Right Hand', at which stage the list has been traversed and now this function returns. Ultimately, all the calls to 'UpdateChildObjects' return and the function pointer is back in 'UpdateAllObjects', where the remainder of the object list is traversed, finding no other objects with no parent. In this way, we ensure that all objects are transformed, but that the parent of an object is transformed first.

The order of updating for the list described in Table 7.1 will be

```
UpdateAllObjects()
    UpdateChildObjects('Torso')
        UpdateChildObjects('Left Shoulder')
            UpdateChildObjects('Left Bicep')
                UpdateChildObjects('Left Forearm')
                    UpdateChildObjects('Left Hand')
```

Real-time 3D Character Animation with Visual C++

```
            UpdateChildObjects('Neck')
               UpdateChildObjects('Head')
        UpdateChildObjects('Right Shoulder')
            UpdateChildObjects('Right Bicep')
               UpdateChildObjects('Right Forearm')
                  UpdateChildObjects('Right Hand')
```

Only the call to UpdateChildObjects with 'Torso' as the parameter finds more than one object in the object list that needs updating. The remainder of the objects are the parents of at most one object. If the hierarchies of objects in your scene remain constant after loading, then you could eliminate some of the function call overheads by changing the order of objects in the scene so that a parent is transformed before a child simply by traversing the object list once. In this simple example, this would be achieved by ordering the list as in Table 7.2.

Table 7.2 Object list and parents suitable for once-through transformations

Object	Parent	Next pointer
m_ObjectList	NULL	Torso
Torso	NULL	Left Shoulder
Left Shoulder	Torso	Left Bicep
Left Bicep	Left Shoulder	Left Forearm
Left Forearm	Left Bicep	Left Hand
Left Hand	Left Forearm	Neck
Neck	Torso	Head
Head	Neck	Right Shoulder
Right Shoulder	Torso	Right Bicep
Right Bicep	Right Shoulder	Right Forearm
Right Forearm	Right Bicep	Right Hand
Right Hand	Right Forearm	NULL

A development engine with objects being added and moved around would probably lend itself to the recursive 'UpdateChildObjects' option, whilst a runtime engine where speed of execution is the highest priority would be more suited to the once-through list that is guaranteed to be in a suitable ordering.

```
void CToon3DDoc::UpdateAllObjects()
{
    if (!m_selScene) return;
    CToon3DObject *obj=m_selScene->m_ObjectList.m_next;
    POINT3D *pt;

    //Zero any bendy objects world points
    while(obj){
        if (obj->m_type == OBJECT_TYPE_TARGET){
            pt=&obj->m_pts;
            for (int i=0;i<obj->m_numpoints;i++){
                pt->mx=0.0; pt->my=0.0; pt->mz=0.0;
                pt->wx=0.0; pt->wy=0.0; pt->wz=0.0;
            }
            pt++;
        }
        obj=obj->m_next;
    }

    //Do the real transforming
    obj=m_selScene->m_ObjectList.next;
    while(obj){
        if (obj->m_parent==NULL){
            obj->SetTime(m_selScene->m_curtime);
            obj->Transform();
            UpdateChildObjects(obj, m_selScene->m_curtime);
        }
        obj=obj->m_next;
    }

    //Divide any bendy point objects vertices by vertex weights
    obj=m_selScene->m_ObjectList.next;
    while(obj){
        if (obj->m_type == OBJECT_TYPE_TARGET){
            pt=&obj->m_pts;
            for (int i=0;i<obj->m_numpoints;i++){
                if (pt->w){
                    pt->wx/=pt->w; pt->mx/=pt->w;
                    pt->wy/=pt->w; pt->my/=pt->w;
                    pt->wz/=pt->w; pt->mz/=pt->w;
                }
            }
```

Real-time 3D Character Animation with Visual C++

```
            pt++;
        }
        obj=obj->m_next;
    }
}

void CToon3DDoc::UpdateChildObjects(CToon3DObject *parent, ↵
  double time)
{
    if (!m_selScene) return;
    CToon3DObject *obj=m_selScene->objList.m_next;

    while(obj){
        if (obj->m_parent==parent){
            obj->SetTime(time);
            obj->Transform();
            UpdateChildObjects(obj, time);
        }
        obj=obj->m_next;
    }
}
```

A CToon3DObject has an integer value called m_type that sets the type of the object. It can be:

OBJECT_TYPE_NULL	An object with a single vertex used as a type of simple control
OBJECT_TYPE_NORMAL	A standard object
OBJECT_TYPE_CONTROL	A control object for a bendy object
OBJECT_TYPE_MORPH	A morph object used to deform a mesh
OBJECT_TYPE_TARGET	A target object deformed by control objects

Notice in the code how the world vertex and normal positions for each vertex in an object that is being deformed by controls are zeroed at the beginning of the transformations and divided through by weights at the end. This ensures the correct display with the minimum of redundancy. Notice also that the code includes a call to the member function of 'CToon3DObject', 'SetTime'. This is where the animation data for an object are used to set the position, orientation and scale at a certain time in a scene or action. In the next chapter on keyframe animation, we will look at this function call in detail.

How pivot point locations affect the animation

Parent objects are important in the way that a complex set of geometry is animated and deformed. Another important consideration is the location around which the object rotates. By default, an object rotates about the origin {0.0, 0.0, 0.0}. But we may wish an object to rotate about another location. See Figure 7.6 to see how the pivot point of an object influences how a 30° rotation of the pitch affects the object's position with respect to its parent. Rotating the calf with the pivot at the ankle has an undesirable effect of distorting the thigh.

Figure 7.6 The effect of varying the pivot location of an object.

To ensure that a child object is located in the correct position and orientation with respect to its parent, we must first ensure that its pivot point is in the correct location. Then we must rotate and transform the pivot point location using the parent's transformation matrix. The rotation matrix for the parent must have been previously calculated and stored in the *m_right*, *m_up* and *m_forward* member variables of the parent object. Each of these member variables is a VECTOR, the declaration of which is shown in the code segment below. The rotation matrix is

$$\mathbf{M} = \begin{bmatrix} Rx & Ux & Fx \\ Ry & Uy & Fy \\ Rz & Uz & Fz \end{bmatrix} \quad \mathbf{v} = \begin{bmatrix} x \\ y \\ z \end{bmatrix}$$

where *R* is shorthand for *m_right*, *U* is shorthand for *m_up* and *F* relates to *m_forward*.

A vertex is transformed using this matrix as follows:

Mv = {$Rx*x + Ux*y + Fx*z, Ry*x + Uy*y + Fy*z, Rz*x + Uz*y + Fz*z$}

The full code to align the object to its parent involves subtracting the parent's pivot point from the current position for the object, then scaling this vector by the parent's scale. This vector is rotated and transformed using the parent's rotation matrix and location. Finally, the object's scale is multiplied by the parent's scale.

```
typedef struct stVECTOR{
    double x,y,z;
}VECTOR;

void CToon3DObject::AlignToParent(){
    VECTOR pp;
    //Store the simple position before alignment for editing
    //purposes
    StorePos();
    if (m_parent){
        //Transform position if the object has a parent:
        //Note parent must have been transformed first
        pp.x=(m_pos.x - m_parent->m_piv.x) *
                m_parent->m_scale.x;
        pp.y=(m_pos.y - m_parent->m_piv.y) *
                m_parent->m_scale.y;
        pp.z=(m_pos.z - m_parent->m_piv.z) *
                m_parent->m_scale.z;
        m_pos.x = m_parent->m_right.x * pp.x +
            m_parent->m_up.x * pp.y +
            m_parent->m_forward.x * pp.z + m_parent->m_pos.x;
        m_pos.y = m_parent->m_right.y * pp.x +
            m_parent->m_up.y * pp.y +
            m_parent->m_forward.y * pp.z + m_parent->m_pos.y;
        m_pos.z = m_parent->m_right.z * pp.x +
            m_parent->m_up.z * pp.y +
            m_parent->m_forward.z * pp.z + m_parent->m_pos.z;
        //Adjust scale
        m_scale.x *= m_parent->m_scale.x;
        m_scale.y *= m_parent->m_scale.y;
        m_scale.z *= m_parent->m_scale.z;
    }
}
```

Figure 7.7 Single character mesh and control objects.

Having considered such a simple object and how it can be deformed using just two control objects, let us look at how the character we created in Chapter 5 can be set up using this methodology. Figure 7.7 shows both the final mesh and the control objects that are used to deform it.

The full hierarchical list for this mesh and its controls is:

Hips
 Torso
 Neck
 Head
 Hairbit1
 Hairbit2
 Hairbit3
 Hairbit4
 Left Shoulder
 Left Bicep
 Left Forearm
 Left Wrist
 Left Hand
 Left Index Finger
 Left Fingers
 Left Thumb

 Right Shoulder
 Right Bicep
 Right Forearm
 Right Wrist
 Right Hand
 Right Index Finger
 Right Fingers
 Right Thumb
 Left Thigh
 Left Calf
 Left Ankle
 Left Foot
 Left Toe
 Right Thigh
 Right Calf
 Right Ankle
 Right Foot
 Right Toe

This extends the original hierarchy to give control over the fingers in the hand and to allow for the girl's long hair to swing as she dances. All the control objects are carefully parented and the positions of their pivot points chosen to reflect the body part they represent. Low polygon characters are the norm at the time of writing, but many real-time developers are starting to look at how to use the next generation of graphics cards and consoles to better effect. Some computers are capable of transforming and displaying just 2000 textured polygons the 15 times a second minimum you need to give smooth animation. Other computers can display 20 000 textured polygons 50 times a second. We need a scalable solution so that those with better hardware get a better looking display, while not excluding those many customers using last year's model graphics cards or consoles.

Looking ahead to subdivision surfaces

One way we can do just this is to use subdivision surfaces. In a later chapter we will look at how we can implement subdivision surfaces. For now we will simply look at the concept. We have an engine that can deform a mesh, but what if we regard that mesh as simply a control mesh? This mesh is not intended to be displayed; the vertices and

No Sub division	Sub division 1	Sub division 2
542 vertices	2161 vertices	4858 vertices
1078 polygons	4312 polygons	9702 polygons

Figure 7.8 Smoothing the object with subdivision.

edges it contains represent the basis of how to make a model, not the model itself. In code we can take each triangle and split it into four triangles by dividing each edge into two, or split the triangle into nine by dividing each edge by 3, or divide each triangle into n^2 triangles by dividing each edge by n, using an algorithm to position the new vertices to result in a smoother looking mesh. Figure 7.8 shows the effect of doing just this using the Lightwave 6.5 subdivision option.

There are many options to subdivision. Some methods retain the shape of the control mesh with better accuracy than others. You can see from the diagram that the method adopted by Lightwave has the effect of shrinking the mesh so that the arms and legs appear slimmer. The artist modelling the original cage can accommodate for this when creating the original geometry, designing the cage so that the subdivided mesh looks correct at the expense of the control cage. In Chapter 15 we explore the options for subdivision and look at the full implementation of one system, butterfly subdivision. This method uses interpolation, so the rendered subdivided mesh uses vertices from the original cage in addition to the added vertices. Using butterfly subdivision with a subdivision of zero, the rendered mesh and the control mesh are the same. With a subdivision of 1 it has a slight swelling effect for a convex polygonal mesh, which can be controlled to a certain degree using a weight parameter. Overall, butterfly subdivision has the effect, with relatively low polygon cages, of retaining the shape of the original more accurately.

Real-time 3D Character Animation with Visual C++

Summary

If you have followed the text from the beginning then your real-time engine has developed considerably. The engine has moved on from displaying a single polygon so that now we are able to display a complex mesh with textures. In this chapter we learned how to deform this mesh using control objects defined in a hierarchical object list. The control can be created using a list of point indices from the mesh object or using section objects cut from the mesh. We learnt how important it is to have a logical hierarchy of objects in a scene. When displaying characters it is essential that moving the body has an effect on the head and arms. Moving the hips should have an effect on every part of the body. Hierarchies are the way that you can inform your transformation engine of the connection between the motion of one object and that of objects that are connected to it.

We also considered how to display your characters on different displays using subdivision surfaces so that a super deluxe computer has a smoother, higher resolution display than a less capable machine, without the requirement for the artists on a real-time project having to create totally unique geometry for each level of computer.

We are beginning to consider how the structure of our code must be formed to allow for object lists. Later, this will be extended to include lists for lights, cameras, morph objects, images and surface attributes. With this level of control and sophistication, we are at last ready to put some motion into the characters. In the next chapter we will finally begin to animate the characters we have so carefully created.

8 Keyframe animation

Animation is magic. Creating static imagery by any means, drawing, painting, sculpture or CGI, is interesting and the results can often be arresting and full of emotion, but they are not magic. Animation is magic. Seeing the results of your labours come to life, walking, talking or fighting, as is the case with far too many computer games, generates the buzz of excitement that is the real reward for the hard work. If you are new to animation then seeing your character move for the first time will be a huge kick. If you intend to do some animation of your own and you are starting from scratch, I recommend using as much reference material as you can. You will be particularly interested in the section about using live action. This chapter covers essentially two topics. We look at animation from the artist's perspective and we look at it from the programmer's viewpoint. Since this book is essentially for programmers, you may be surprised at the coverage of the artists' concerns, but if you intend to write software that will be used by artists then you need to know their problems before you can provide the solutions. Otherwise, you provide solutions to non-existent problems and no solution to their real problems.

Principles of animation

Most people know that animation is made up from a series of static images that are changed rapidly before the viewer, who, being unable to detect the change of image, reads the result as a moving sequence. Animation uses a limitation of our eyes, persistence of vision. Our eyes are terrific at detecting movement but there is a finite limit to how quickly we can view a changing scene. In the nineteenth century, lots of toys were invented that exploit this limitation. It was discovered that if you flash a series of static images quickly enough then the result appears to our eyes as a moving scene. These early devices included 'Zoetropes' and 'Praxinoscopes'. A Zoetrope is a short, wide cylinder that has a series of

Figure 8.1 A Zoetrope.

slots cut in the perimeter. A strip of images is placed inside the cylinder. The cylinder is free to rotate about a central axis (see Figure 8.1). The viewer looks through the slots. Since they can only see inside the cylinder when a slot whizzes past the eye, they don't see the strip of images inside as a blur. The viewer sees the strip as a series of static pictures that appear to change from one picture to the next as it is viewed first through one slot then the next as the cylinder rotates. The slots have the effect of freezing the rotational motion so that we don't see as image one swings around to the position of image two; instead, we seem to see image one change into image two. This fast changing of the pictures gives the illusion of movement.

A Praxinoscope uses mirrors to achieve the same result. The eye can only see the pictures when they are aligned to the mirror. The result is that the pictures do not seem to be rotating, they seem to be changing, giving the illusion of movement.

These early Victorian parlour toys helped lead to the invention of cinema. The illusion of movement when a film is projected comes from the film having 24 separate pictures for every second of screen time. This sequence of pictures is displayed in order by anchoring the film in a static gate for around one fiftieth of a second. Then a shutter swings across blocking the light; while the light is blocked the film is released from the static gate, advanced a frame and re-anchored. Once the film is again static, the shutter swings back allowing light to shine through the celluloid again. If this flashing of the light is set at a speed below 12 times a second then flickering is detected by most viewers. Early films were shot at low

frame rates (pictures per second) and then projected manually, with the projectionist responsible for hand cranking the projector. If the projectionist wound the handle too slowly then flickering would be very obvious and led to films sometimes being called the 'flicks'. When sound came to the movies, the low frame rates of the silent films had to be increased. Movie sound is recorded optically down the edge of the film as a waveform. In order to be able to modulate the human voice, this waveform has to have a large number of peaks and troughs in a short space. It was found that, with the technology that existed in the late 1920s, a frame rate of 24 times per second was the optimum. However, you will find that the illusion of movement starts with frame rates around eight per second; the movement looks ever smoother up to around 50 frames per second (fps). Above 50 fps, there is little improvement discerned by most viewers. TV animation is often done on 'twos'; that is, instead of displaying 30 fps they use 15 and show each picture for two frames. In countries where the TV system is PAL, the frame rate is 25 fps. Here, movies are shown slightly speeded up over the original shooting speed of 24 fps. In the US, the TV frame rate for NTSC is 30 fps. When showing a movie it is elaborately converted from the original display rate of 24 fps to the transmission rate of 30 fps using specialized telecine equipment.

For the real-time animation we are intent on producing, we will target a display rate of 25 fps. To create the movement we want, we can create 25 new positions for the model for each second. If a character consists of 17 segments and the position, scale and orientation of these segments are stored 25 times a second, that would be a lot of data, and a lot of work. We want a system that lets us store an important position every, say, half second interval and lets the computer work out where the model should be in the intervening frames. That is exactly what keyframe animation involves. In the next two chapters we will look at how to extract this keyframe data from Lightwave and 3DS scene files. But in this chapter we will look at how we will store the data in our application and how to interpolate the result. Then we will look at how we can generate some animation data ourselves using the supplied software, Toon3D Creator, and the sample models.

How to store the animation data

We need the ability to animate the position, scale and orientation of an object. The position is defined by three scalar values, *x*, *y* and *z*. The scale is defined by three scalar values, which we will refer to as *sx*, *sy* and *sz*, for the scale in the *x*-, *y*- and *z*-axes. The orientation of the

object can be stored in one of several ways including Euler angles, angle axis or quaternions.

If the orientation is stored as Euler angles, then three scalar values are used to hold the rotation of the object in the x-, y- and z-axes. We use heading (h) to define the rotation in the y-axis, pitch (p) for the rotation about the x-axis and bank (b) for the rotation about the z-axis. As we know from Chapter 1, Euler angles describe a unique orientation only if we know the order in which the rotations are applied. Euler angle rotation suffers from the distinct disadvantage that gimbal lock occurs when a rotation through 90° maps one axis onto another. If the order in which rotations are applied is *HPB*, heading, pitch then bank problems can arise with a rotation of 90° in the pitch. The effect of this rotation is to map the z-axis onto the y-axis; consequently, heading rotations about y seem to be the same as bank rotations about z. This problem is very frustrating for animators. For much of the last 5 years I have been running a company where we use Lightwave for TV animation. Lightwave up to version 5.6 used Euler angles to store and interpolate the orientation. Sometimes animators can get very annoyed with their monitors when it seems impossible to bend a character into the orientation that they want. At this point they become very aware of the problems of gimbal lock. Thankfully, this annoying problem can be avoided with version 6+ of Newtek's otherwise excellent software.

If the orientation is stored as angle axis, then four scalar values are used. Three define a vector that describes the axis about which a rotation takes place. The fourth value defines the angle of rotation about this axis. This method has the advantage that it does not suffer from gimbal lock. The final alternative is to use quarternions. This rather exotic mathematical device is the method of choice for interpolating orientation in many computer games because it is computationally more efficient and gives pleasing results.

As well as the ability to store the position, scale and orientation, we need to store the time during the animation that we wish this to occur. We could store the position, scale and orientation all together for a particular time interval. But if we want total control over the way the character animates, it is better that each channel of position, scale and orientation is stored separately with its own time parameter. Using totally separate channels ensures that interpolating a channel does not suffer from the artefacts of another channel. Suppose that the x position moves smoothly over the interval of 2 seconds. During this interval, the object rotates in a complex fashion using keys at one third of a second intervals. If all channels are stored for a key value, then the x position is stored at one third of a second intervals. It will be more difficult to ensure a smooth

Real-time 3D Character Animation with Visual C++

movement in the *x*-axis with the six keyframes that will be created, rather than using just two keys for the *x* movement.

Interpolating by frame and time

Every single one of our objects, whether they are in motion or not, will need a keyframe defining for all motion channels at time zero. We will define a key channel as

```
typedef struct stKEYCHANNEL{
    float time;
    float value;        //Actual magnitude
    float tn, bs, ct;   //Tension, bias and continuity
    int linear;         //Flag to indicate that the key is linear
}KEYCHANNEL
```

If we can consider each channel independently then the code problem becomes how to interpolate a single channel. Suppose a particular channel has five key positions. We have five values for time and five floating-point values. Figure 8.2 shows a plot of these five points; the points are joined using straight lines. This method of linear interpolation is extremely easy to do. Between any two keyframes, *K*1 and *K*2, the value of a point *P* at time *t* is given by

$$P = K1.\text{value} + ((t - K1.\text{time})/(K2.\text{time} - K1.\text{time}))*(K2.\text{value} - K1.\text{value})$$

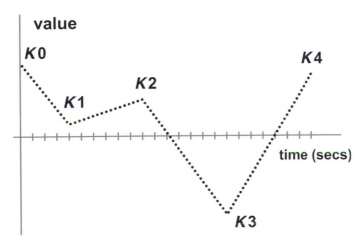

Figure 8.2 *Linear interpolation of five key values against time.*

Real-time 3D Character Animation with Visual C++

But the results of this crude method will be very jerky. This is because the curve joining the points is not smooth. The technical description of this is that it lacks G1 and C1 continuity. A curve has G0 continuity if it is connected at the key positions, K_n, and has G1 continuity if the tangent at this point for both the segment $K_{n-1} \rightarrow K_n$ and segment $K_n \rightarrow K_{n+1}$ is in the same direction but not necessarily of the same magnitude. For a curve to have C1 continuity, the tangents must be in the same direction and of the same magnitude. For the curve we are considering, we have a value changing against time. If you are familiar with calculus then you will know that differentiating a curve gives a new curve that represents the way the slope of the original curve changes with time. For a smooth curve we need C1 continuity as it bends through the key positions. There are many possible contenders for such a curve. The standard technique is to use a different curve between each pair of key positions. To ensure that the curve is smooth through the key positions, we need to consider the slope or tangent to the curve for the end of one segment and the beginning of the next. The slopes must be in the same direction and of the same magnitude to ensure a smooth transition. Figure 8.3 shows the result of using piecewise cubic curves with and without the matching of tangents for the curve leading up to the key position and the curve following the key position.

That's all well and good, but how do we define a cubic that is guaranteed to go through the key positions. The problem comes down to a familiar problem for computer graphics generally, one of curve fitting. Some curve-fitting options do not go through the actual key positions so would not be suitable. A curve that is guaranteed to go through the key

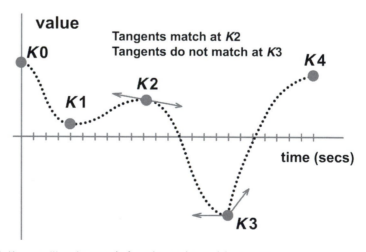

Figure 8.3 Key position tangents for piecewise cubic curves.

positions is described as interpolating. One curve that is suited to the problem is a Hermite, named after the mathematician. Again, we need to consider this in a piecewise fashion, joining just two key positions with each curve. We want to have control over the key position tangents, so the variant of a Hermite curve that we will use is the Kochanek–Bartels or TCB form. TCB stands for tension, continuity and bias. Any readers familiar with Lightwave 3D will know that this form was the only motion curve available until version 6. Adjusting the TCB parameters has the effect of altering the tangent for the curve at the key positions. Now to find a point P at time t on the curve between key positions $K1$ and $K2$, we find tangent vectors $T1$ for the beginning of the curve and $T2$ for the end of the curve. To find these tangent vectors, we first calculate scale factors relating the interval to the sum of the interval and the preceding interval and the sum of the interval and the following interval.

$$S1 = (K2.\text{time} - K1.\text{time})/(K2.\text{time} - K0.\text{time})$$
$$S2 = (K2.\text{time} - K1.\text{time})/(K3.\text{time} - K1.\text{time})$$

$$T1 = S1*(1 - K1*tn)(1 + K1*bs)(1 + K1*ct)(K1.\text{value} - K0.\text{value})$$
$$\quad + (1 - K1*tn)(1 - K1*bs)(1 - K1*ct)(K2.\text{value} - K1.\text{value})$$
$$T2 = (1 - K2*tn)(1 + K2*bs)(1 - K2*ct)(K2.\text{value} - K1.\text{value})$$
$$\quad + S2*(1 - K2*tn)(1 - K2*bs)(1 + K2*ct)(K3.\text{value} - K2.\text{value})$$

If $K1$ is the first key position then $K0$ does not exist. In this case $T1$ is

$$T1 = (1 - K1*tn)(1 - K1*bs)(1 - K1*ct)(K2.\text{value} - K1.\text{value})$$

If $K2$ is the last key position then $T2$ becomes

$$T2 = (1 - K2*tn)(1 + K2*bs)(1 - K2*ct)(K2.\text{value} - K1.\text{value})$$

The next stage of our curve-fitting procedure is to calculate the Hermite coefficients at the actual time. We are dealing here with a parametric curve where the parameter t varies between 0 and 1. Now you may well have two key positions with time values of 6.3 and 9.87. But we need to scale this interval to 1.0. This is very easily done. Suppose we want to know the value for t at time 7.8. First, we subtract the start time of the interval and then calculate the segment duration.

$$t' = 7.8 - 6.3 = 1.5$$
$$\text{dur} = 9.87 - 6.3 = 3.57$$

Now we simply need to know what 1.5 is as a proportion of 3.57. When the time is 6.3 this method will give *t* as 0 and when the time is 9.87, *t* will be 1.0. But at time 7.8, *t* is given by

$$t = 1.5/3.57 = 0.42$$

The Hermite coefficients are defined as:

$$h_0 = 2t^3 - 3t^2 + 1$$
$$h_1 = -2t^3 + 3t^2$$
$$h_2 = t^3 - 2t^2 + t$$
$$h_3 = t^3 - t^2$$

Finally, we are able to calculate the actual value at time *t*:

$$Q(t) = h_0*K1.\text{value} + h_1*K2.\text{value} + h_2*T1 + h_3*T2$$

Notice that when $t = 0$, $h_0 = 1$, $h_1 = 0$, $h_2 = 0$ and $h_3 = 0$, and at $t = 1$, $h_0 = 0$, $h_1 = 1$, $h_2 = 0$ and $h_3 = 0$. Hence at $t = 0$ the value for the curve is

$$Q(0) = 1*K1.\text{value} + 0*K2.\text{value} + 0*T1 + 0*T2 = K1.\text{value}$$

And at $t = 1$ the value for the curve is

$$Q(1) = 0*K1.\text{value} + 1*K2.\text{value} + 0*T1 + 0*T2 = K2.\text{value}$$

So the curve goes through the key positions just as we planned.

Having calculated the tangents at each end of a curve segment we can interpolate the curve.

Now that we know the theory, let's look at how to implement this. In the source code for Toon3D Creator, you will see that all the key positions for an object are stored as arrays in member variables of the CToon3DObject class. We also use an array that stores the total number of keys in each channel.

```
KEYCHANNEL *anim[9];
int keytotal[9];

void CToon3DObject::SetTime(double time, int channel)
{
  //Test for parameters out of range
  if (channel<0 || channel>8 || !anim[channel]) return;
```

```
if (keytotal[channel] == 1){
    //Set directly no interpolation require if only one key
    SetChannel(channel, anim[channel][0].value);
    return;
}
if (time < anim[channel][0].time){
    //Set directly no interpolation require if time is before first
    //key
    SetChannel(channel, anim[channel][0].value);
    return;
}

if (time > anim[channel][keytotal[channel] - 1].time){
    //Set directly no interpolation required if time after last key
    SetChannel(channel,
        anim[channel][keytotal[channel] - 1]->value);
    return;
}

//Must be within range lets find the section under consideration
int key=0;

for (int i = 0;i < keytotal[channel]; i++){
    if (time <= anim[channel][i].time){
        key = i;
        break;
    }
}
if (time == anim[channel][key].time){
    //Set directly no interpolation require if at a key time
    SetChannel(channel, anim[channel][key].value);
    return;
}

--key;
//Interpolation required
double t, tt, ttt, h0, h1, h2, h3, T1, T2;
double dur, mag, S1, S2;

//Calculate the section duration and magnitude for key and key + 1
dur = anim[channel][key + 1].time - anim[channel][key].time;
mag = anim[channel][key + 1].value - anim[channel][key].value;
```

```
if (anim[channel][key + 1].linear){
    //Straight linear interpolation
    result = anim[channel][key].value +t * mag;
}else{
    //Hermite interpolation required
    //Calculate 0 <= t <= 1
    t=(time – anim[channel][key].time) / dur;

    //Calculate t squared as tt, and t cubed as ttt
    tt=t*t; ttt=t*tt;

    //Calculate the Hermite coefficients
    h0 = 2 * ttt – 3 * tt + 1.0;
    h1 = -2 * ttt + 3 * tt;
    h2 = ttt – 2*tt +t;
    h3 = ttt – tt;

    //Calculate tangents
    if (key==0){
        //First key
        T1 = (1.0 – anim[channel][key].tn) *
            (1.0 – anim[channel][key].ct) *
            (1.0 – anim[channel][key].bs) * mag;
    }else{
        S1 = dur /
            (anim[channel][key + 1].time – anim[channel][key –↵
             1].time)
        T1 = S1 * (1.0 – anim[channel][key].tn) *
            (1.0 + anim[channel][key].ct) *
            (1.0 + anim[channel][key].bs) *
         (anim[channel][key].value – anim[channel[key – 1].value) +
            (1.0 – anim[channel][key].tn) *
            (1.0 – anim[channel][key].ct) *
            (1.0 – anim[channel][key].bs) * mag;
    }
    if (key == (keytotal[channel] – 3)){
        //last section
        T2 = (1.0 – anim[channel][key + 1].tn) *
            (1.0 + anim[channel][key + 1].ct) *
            (1.0 – anim[channel][key + 1].bs) * mag;
    }else{
        S2 = dur /
```

```
            (anim[channel][key + 2].time - anim[channel][key].↵
              time);
        T2 = S2 * (1.0 - anim[channel][key + 1].tn) *
              (1.0 + anim[channel][key + 1].ct) *
              (1.0 - anim[channel][key + 1].bs) * mag +
              (1.0 - anim[channel][key].tn) *
              (1.0 - anim[channel][key].ct) *
              (1.0 + anim[channel][key].bs);
          (anim[channel][key + 2].value - anim[channel[key + 1].↵
            value);
      }

      result = h0 * anim[channel][key] +
              h1 * anim[channel][key + 1].value + h2 * T1 + h3 * T2;
    }
  SetChannel(channel, result);
}
```

Using quaternions to interpolate the orientation

If we choose to use Euler angles as the storage parameter for orientation
but we want to use quaternions for the interpolation, then we need a way
to swap between Euler angles and quaternions. The benefit is that this
type of interpolation results in a smoother animation of the orientation of
an object than using Hermite curve fitting, justifying the additional work.
 The quaternion derived from Euler angles is given by:

$$q = qh\ qp\ qb$$

where

$$qh = [\cos(h/2), (\sin(h/2), 0, 0)]$$
$$qp = [\cos(p/2), (0, \sin(p/2), 0)]$$
$$qb = [\cos(b/2), (0, 0, \sin(b/2))]$$

Now we can create a function that converts Euler angles to a
quaternion. First we need to define a structure to hold a quaternion:

```
typedef struct stQUATERNION{
    double w, x, y, z;
}QUATERNION;
```

Recall that to multiply a quaternion we use the following rules:

$$q1\,q2 = [w1\,w2 - v1 \bullet v2, \; v1 \times v2 + w1\,v2 + w2\,v1]$$

Therefore,

$$\begin{aligned}
qhqpqb = [&\cos(h/2)\cos(p/2)\cos(b/2) - \sin(h/2)\sin(p/2)\sin(b/2), \\
&(\cos(h/2)\sin(p/2)\sin(h/2)\sin(p/2) + \cos(b/2)\cos(p/2)\sin(h/2), \\
&\cos(b/2)\cos(h/2)\sin(p/2) - \cos(p/2)\sin(h/2)\sin(h/2)\sin(p/2), \\
&\cos(b/2)\sin(h/2)\sin(p/2) + \cos(h/2)\cos(p/2)\sin(b/2))]
\end{aligned}$$

Leading to this function:

```
void EulerAnglesToQuaternion( double h, double p,
                                double b, QUATERNION &q){
    double h, p, b, ch, cp, cb, sh, sp, sb;

    h = euler.h / 2.0;
    p = euler.p / 2.0;
    b = euler.b / 2.0;

    ch = cos(h);
    cp = cos(p);
    cb = cos(b);

    sh = sin(h);
    sp = sin(p);
    sb = sin(b);

    q.w = ch * cp * cb      - sh * sp * sb;
    q.x = ch * sp * sh * sp + cb * cp * sh;
    q.y = cb * ch * sp      - cp * sh * sh * sp;
    q.z = cb * sh * sp      + ch * cp * sb;
}
```

Now to interpolate a rotation we use spherical linear interpolation or SLERP. The beauty of using quaternions is that the number of calculations used for the interpolation of rotations is significantly reduced. The code necessary to take the quaternions generated by Euler-AnglesToQuaternions, and create an interpolated path, is as follows:

```cpp
//==============================================================
//SlerpQuaternions
//start and end are the quaternion key positions. t is a time factor
//between 0 and 1.The result is returned in result
//==============================================================
Void SlerpQuaternions(QUATERNION &start, QUATERNION &end,
                        double t, QUATERNION &result){
    double theta, ct, st, scalestart, scaleend;

    //Calculate the cosine using the vector dot product of start
    //and end
    ct = start.w * end.w + start.x * end.x +
        start.y * end.y + start.z * end.z;

    //If ct is less than 0 then we need to adjust the signs to
    //ensure that we are taking the shortest route.
    if ( ct < 0.0){
        theta = acos(-ct);
        st = sin(theta);
        startscale = sin((1.0 -t) * theta) / st;
        endscale = sin(t * theta) / st;
        result.w = startscale * start.w - endscale * end.w;
        result.x = startscale * start.x - endscale * end.x;
        result.y = startscale * start.y - endscale * end.y;
        result.z = startscale * start.z - endscale * end.z;
    }else{
        theta = acos(ct);
        st = sin(theta);
        startscale = sin((1.0 -t) * theta) / st;
        endscale = sin(t * theta) / st;
        result.w = startscale * start.w + endscale * end.w;
        result.x = startscale * start.x + endscale * end.x;
        result.y = startscale * start.y + endscale * end.y;
        result.z = startscale * start.z + endscale * end.z;
    }
}
```

The only remaining task is to generate a matrix from the new quaternion. For this we can use the knowledge that the rotation matrix will look like this:

$$R = \begin{bmatrix} 1 - 2y^2 - 2z^2 & 2xy - 2wz & 2xz + 2wy \\ 2xy + 2wz & 1 - 2x^2 - 2z^2 & 2yz + 2wx \\ 2xz - 2wy & 2yz - 2wx & 1 - 2x^2 - 2y^2 \end{bmatrix}$$

The code for converting a quaternion into a rotation matrix is therefore given by this function:

```
//==============================================================
//QuaternionToMatrix

//Takes quaternion q and generates a rotation matrix stored in the
//three vectors right, up and forward
//==============================================================
void QuaternionToMatrix(QUATERNION &q,
                        VECTOR &right, VECTOR &up, VECTOR↵
                        &forward){
  double xx, yy, zz, xy, wz, xz, wy, yz, wx;

  xx = q.x * q.x; yy = q.y * q.y; zz = q.z * q.z;
  xy = q.x * q.y; wz = q.w * q.z; xz = q.x * q.z;
  wy = q.w * q.y; yz = q.y * q.z; wx = q.w * q.x;

  right.x = 1 - 2 * yy - 2 * zz;
  right.y = 2 * xy - 2 * wz;
  right.z = 2 * xz + 2 * wy;

  up.x = 2 * xy + 2 * wz;
  up.y = 1 - 2 * xx - 2 * zz;
  up.z = 2 * yz - 2 * wx;

  forward.x = 2 * xz - 2 * wy;
  forward.y = 2 * yz + 2 * wx;
  forward.z = 1 - 2 * xx - 2 * yy;
}
```

Try out the sample for this chapter, which illustrates the difference between a rotation done using Hermite interpolation of the Euler angles

and the same rotation interpolated using quaternions. The Euler angle rotation appears very messy by comparison with the quaternion rotation. Pressing 'q' switches to quaternion calculations and pressing 'e' switches to Euler angle interpolation. Pressing the 'm' key steps between the possible alternatives for Euler angles, rotating through *HPB*, *HBP*, *PHB*, *PBH*, *BHP* and *BPH*. Quaternions, in actual fact, represent a path across a four-dimensional sphere, but if like me you find such concepts difficult to visualize, then you will just have to accept the results of the maths rather than the justification for its use. It is very difficult to specify a rotation directly using quaternions, so many programs use either Euler angles or angle axis for the interactive display in a development environment and quaternions for interpolation.

Using Toon3D Creator for keyframe animation

Now that we have the ability to create keyframes and are also able to interpolate these key positions, we need some data. Run Toon3D Creator, where you can experiment with animation paths. Selecting an object in the tree control makes it the active selection. The buttons in the toolbar allow you to switch between translation, rotation, scaling or sizing modes. Moving the mouse while pressing the left mouse key will translate, rotate or scale in the *x*- and *z*-axes. Moving the mouse and pressing the right button allows you to translate, rotate or scale in the *y*-axis. Axes can be excluded using the toolbar buttons. See Figure 8.4, where the toolbar

Figure 8.4 Toon3D Creator toolbar buttons.

buttons are named, and Appendix A for a more detailed description of how to use Toon3D Creator.

The slider control moves through time. If under File/Preferences the option for Autokey Create is chosen, then every translate, rotate or scale will either create or adjust a keyframe. If this option is not checked then you will need to press the Enter key to confirm an adjustment to an object. We will go through the process of creating an action for the character we developed in Chapter 5. Open the project 'Chapter08/Walk01.t3d'. Here you will find the character with no animation created. Select one of the user views and adjust the view so that the character appears side on (see Figure 8.5).

We are going to create a walk. Toon3D Creator uses frame values to define time. By default the number of frames in a second is set to 25; you can adjust this to a different setting in the properties for a scene, which is reached by right clicking on the scene in the tree control. We want our walk to loop, that is having moved the left leg and the right through a single stride the action can be repeated indefinitely. In order to achieve a loop, it is essential that the start and end orientations of all the objects that make up our character are the same. Because of the hierarchy of this

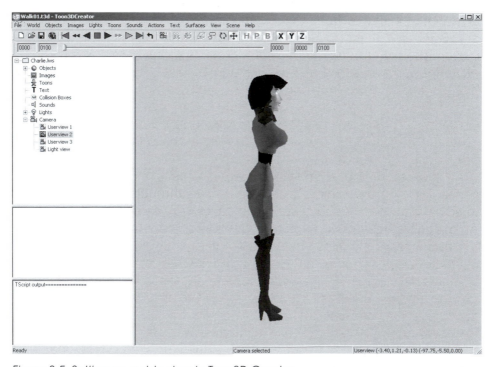

Figure 8.5 Setting up a side view in Toon3D Creator.

Real-time 3D Character Animation with Visual C++

character the top-level object is the hips. Select 'CharlieHips' in the tree control and bank them slightly so that Charlie's right hip is raised. We are going to make frame 1 of this action the position where Charlie has her right leg off the ground. Now make a keyframe at frame 12 with Charlie's hips banked so that Charlie's left hip is raised. Finally, copy the position from frame 1 to frame 25 by going to frame 1, pressing the Enter key and typing 25 in the dialog box that is generated. If you use the play button you should get Charlie twisting from side to side. But her legs and arms twist in exactly the same way as her hips, not very convincing! The next step is to create a user view that is close to directly overhead. Do this in user view 2. Imagine Charlie walking, the principal keys are the stride when her leg is extended forwards and the passing position when her leg is bent and lifted. So far, we have put the rotation of the hips for the passing position. But in order not to fall, at the passing position her body weight should be more or less over the leg that will remain on the ground. To achieve this, move Charlie's hips slightly to her left when her right hip is raised and slightly to her right when her left hip is raised. The next stage is to add keyframes at 6 and 18 for the stride. As Charlie's right leg swings forward her hips will rotate, so their heading goes slightly clockwise viewed from above. Put this rotation in on frame 6. As Charlie's left leg swings forward her hips will rotate, so their heading goes slightly anticlockwise viewed from above. Put this rotation in at frame 18. The hips are attached to the feet by bones that do not extend, so that as the leg moves forward and the back leg stretches, the hips have to come down. Move them down a little at frames 6 and 18. Test the playback by using the play button. More movement but still nothing like a walk. You will find that viewing an animation in its entirety rather than concentrating on a single position will give better results. If you are having trouble then open 'Chapter08/Walk02.t3d', where this preliminary animation has already been done.

At this stage, the animation of the hips is complete. Now we will concentrate on the torso. As the hips move through their rotations the torso aims to keep the body upright and facing in the direction of the walk. An exaggerated walk can be created where the rotations of the torso are the opposite of the hips. Because Charlie is so clearly not a realistic character we will choose the exaggerated option. Rotate Charlie's body at frames 1, 6, 12 and 18 to be the opposite of the hips. When the hips are banked left the torso banks right and when the hips are rotated clockwise the hips are rotated anticlockwise. When frame 1 is complete remember to copy it to frame 25. If you are regularly using the playback button then feel free to change the frame range values to 1 to 24 so that after displaying frame 24 the playback head skips back to 1. We are making 1

Real-time 3D Character Animation with Visual C++

and 25 the same, so we do not want to display both frames as this will result in the appearance of a slight hesitation in the action. Having sorted the orientation of the hips and torso we can adjust the head. This needs rotating at 1, 6, 12 and 18 so that it is always upright and facing forward. You should now have a character that seems to have some bendiness.

It is now time to rotate the thighs. Starting with the right thigh rotate it so that it is at about 30° to the horizontal at frame 1. Then it swings slightly down to frame 6. It should be straight down at frame 12 and at the maximum swing back at frame 18. Repeat with the left thigh, which should be straight down on frame 1, maximum back on frame 6, 30° of horizontal forward on frame 12 and slightly down from there on frame 18. Playback should now be looking more like a walk. Now we come to the calves. Rotate the right calf so that it is pointing back and down on frame 1, nearly in line with the thigh on frame 6, and pretty much in line with the thigh on frames 12 and 18. A little extra bend on frame 18 should help. The left calf should be straight on frame 1, a little bent on frame 6, pointing back and down on frame 18 and in line with the thigh on frame 18. For all the objects in the legs make sure that you remember to copy the leg positions from frame 1 to frame 25. For the feet, make sure when they are on the floor they stay in line with the floor for as much of the time interval as possible. You may find that on the maximum stride if you have the foot tilted up a frame before the leg

Figure 8.6 Key positions in Charlie's exaggerated walk.

goes down and then tilted down in line with the floor a frame after the foot goes down, then it will give the walk a great deal of weight.

So we come to the shoulders and arms. They need to swing opposite to the legs. When the right leg is forward and the left leg back, the left arm should be forward and the right arm back. Just as putting the snap movement in the feet gives it weight, you can embellish a walk by putting some flipping wrist action into the hands. As the hand swings forward the hands need to be rotated down from the forearm; when they swing back they need to be rotated up in relation to the forearm. If you put the key change a frame before the maximum swing and a frame after, then the hands flip through the orientation quickly at the extremes of rotation. This results in a more dynamic action. You should by now have a fairly good walk. Walks are hard to get right; they need to be symmetrical, the movement of the right side echoed exactly by the left. If you get the timings or rotations of one side different from the other then you will get a limp. The final walk described here can be seen by opening 'Chapter08\Walk03.t3d'.

Using live action reference

For animation to be effective, you need to ensure that the character's weight is in the right place and that the timing of an action is convincing. One of the best ways to get this right is to refer to real life. Drawn animators have used live action reference to assist in drawing and timing problems since animation began. If you have access to a video camera, then film yourself doing a character's action. By repeatedly viewing the result you will have a very good idea of the timings of an action and the shapes that the character gets into throughout the action. Even better than using just one camera is to use two. By positioning the video cameras so that the front and side of an action can be seen, you will have all the information about an action that you could desire. If you are in the position to digitize your video, possibly you have used videocams to generate the video, so it will already be on your computer. If you use a camcorder then you will need to use a digitizing card. DV cameras are increasingly common and Firewire cards that let you import DV into a PC are relatively inexpensive. If you can get both video clips into your computer then position two AVI windows on your desktop. You can then match the orientation of the video clips in two user views in your animation software. Having two views of the action helps you decide on an orientation even if the rotation is in line with the camera view and so the overall effect is difficult to judge. Now as you create an animation you can

scroll through the video clips at the same time. Check for details like the orientation of the hands and the fingers; you may be surprised what you discover from the video clips.

Setting up looping actions

When we created Charlie's walk we were careful to ensure that the orientation for the beginning of the action was repeated at the end. In order for actions to loop effectively, the end must be almost exactly like the start but not quite the same. The easiest way to achieve a seamless loop is to copy the key position at frame 1 of an action to the frame after the last frame of an action. Then exclude this frame from the loop. By so doing, interpolation from the next to last key to the last is effectively the same as interpolating between the next to last key and the first, so the actions loop.

Interpolating between actions

Since real-time character animation is generated at runtime, there are often instances where one action must blend seamlessly into another. You can do this in two ways. You could have a common position that all actions can go back to and ensure that a switch between actions only ever occurs when the character is in this position. In practice, this is hard to achieve. It is very difficult to have a keyframe from a walk appear as part of a swim and vice versa. If every action has start from standing and return to standing link sequences then you are adding to the development time. The easiest way is to create an interpolation between two key positions as required at runtime. One way to achieve this is to store the current position of the object and the destination position and interpolate between the two.

 Two simple functions that do just that are given below. SetTweenKeys stores the start position and end position and is used by Tween as the source and target positions for the interpolation.

```
//============================================================
//SetTweenKeys

//Used by Tween. It stores the current position, scale and↵
orientation
//and a target position, scale and orientation.
//============================================================
```

```
void CToon3DObject::SetTweenKeys(double targetTime,↵
  CToon3DObject *objList)
{
  SetTime(curtime);
  //Use RestorePos because we need to store positions before
  //AlignToParent
  RestorePos();
  tpos[0].x=pos.x; tpos[0].y=pos.y; tpos[0].z=pos.z;
  trot[0].x=rot.x; trot[0].y=rot.y; trot[0].z=rot.z;
  tscale[0].x=scale.x; tscale[0].y=scale.y; tscale[0].z=scale.z;
  SetTime(time);
  RestorePos();
  tpos[1].x=pos.x; tpos[1].y=pos.y; tpos[1].z=pos.z;
  trot[1].x=rot.x; trot[1].y=rot.y; trot[1].z=rot.z;
  tscale[1].x=scale.x; tscale[1].y=scale.y; tscale[1].z=scale.z;

  CToon3DObject *obj=objList;
  //Recursively update all child objects
  while(obj){
      if (obj->parent==this) obj->SetTweenKeys(frame,objList);
      obj=obj->next;
  }
}

//===============================================================
//Tween
//Use the positions stored by SetTweenKeys in tpos[0] and tpos[1]
//and the tweenTime parameter to create a linear interpolation
//between the position, scale and orientation at tpos[0] and that
//at tpos[1]
//===============================================================
void CToon3DObject::Tween(double tweenTime, double duration,
                CToon3DObject *objList,
      VECTOR *toonpos, VECTOR *toonrot, VECTOR *toonscale)
{
  double time = tweenTime / duration, oneminustime = 1.0 - time;
  if (toonpos){
      pos.x=tpos[0].x * oneminustime + tpos[1].x * time + toonpos->x;
      pos.y=tpos[0].y * oneminustime + tpos[1].y * time + toonpos->y;
      pos.z=tpos[0].z * oneminustime + tpos[1].z * time + toonpos->z;
  }else{
      pos.x=tpos[0].x * oneminustime + tpos[1].x * time;
```

```
        pos.y=tpos[0].y * oneminustime + tpos[1].y * time;
        pos.z=tpos[0].z * oneminustime + tpos[1].z * time;
    }

    if (toonrot){
        rot.x=trot[0].x * oneminustime + trot[1].x * time + toonrot->x;
        rot.y=trot[0].y * oneminustime + trot[1].y * time + toonrot->y;
        rot.z=trot[0].z * oneminustime + trot[1].z * time + toonrot->z;
    }else{
        rot.x=trot[0].x * oneminustime + trot[1].x * time;
        rot.y=trot[0].y * oneminustime + trot[1].y * time;
        rot.z=trot[0].z * oneminustime + trot[1].z * time;
    }

    if (toonscale){
        scale.x=(tscale[0].x * oneminustime +
                tscale[1].x * time)*toonscale->x;
        scale.y=(tscale[0].y * oneminustime +
                tscale[1].y * time)*toonscale->y;
        scale.z=(tscale[0].z * oneminustime +
                tscale[1].z * time)*toonscale->z;
    }else{
        scale.x=tscale[0].x * oneminustime + tscale[1].x * time;
        scale.y=tscale[0].y * oneminustime + tscale[1].y * time;
        scale.z=tscale[0].z * oneminustime + tscale[1].z * time;
    }
    AlignToParent();
    Transform();
    CToon3DObject *obj=objList;
    while(obj){
        if (obj->parent==this){
            obj->Tween(tweenTime,duration,objList);
        }
        obj=obj->next;
    }
}
```

Using this blending makes a huge difference to the way an interactive game appears. Rather than jumping disconcertingly between actions, they blend seamlessly.

Summary

Bringing your geometry to life with animation has a timeless appeal. In this chapter we looked at various options for keyframe animation. First, we considered how to store the data and then we looked at interpolating the data. We looked in detail at one way to create smooth animations using Kochanek–Bartels (TCB) curves. We also considered an alternative way of interpolating the orientation of an object using quaternions. Finally, we looked at putting this theory into practice with a tutorial on creating an animated walk.

9 Inverse kinematics

For many real-time applications the actions of the characters will be created before the application is run and the interactive game code will select the most suitable action for a particular stage of the game. This provides an effective game style, but what happens when a character needs to reach further than the stored action in order to pick up an item? It would be good if the final position of the character's hand could be determined just by providing a world location for the hand and letting the code determine the orientations of the hand, forearm, bicep, shoulder, torso and hips, that are needed to achieve this goal. Inverse Kinematics (IK) provide this solution and can be a useful addition to any game code engine. Anchoring feet or any other part of the character can be done using IK solutions. If a character has a fall action that relies on falling on a flat floor, but instead because of the game location the floor is uneven, then IK can be used with collision detection to ensure that the character's final position relates to the game location.

In this chapter we will look first at how IK developed out of robotics. In the next section we will look at how to determine the orientation for a single link and then a double link analytically. We will look at the problems for calculating the position of an IK chain with more than two links. Following on from the problems associated with analytical solutions, we will look at how iterative or numerical solutions can be used to find IK solutions for chains with more than two links. Finally, we will look at how IK can be blended with forward kinematics so that pre-stored actions can be used alongside IK solutions.

How IK developed out of robotics

The principle of an inverse kinematics solution to a motion problem is that, given a position in world space and the end point of a linked chain (end effector), determine the rotations that have to be applied to the linked

Target

Figure 9.1 Using an IK solution to make a character's hand reach a goal.

chain in order that the end effector reaches the goal. Most of the study of this problem stems from robotics. In the car industry, robot arms have been used for many years to do repetitive jobs on a production line. Spot welding is a good example. The position of a required weld is known to a high degree of accuracy because the bodywork is on a conveyor belt and the relationship between the car body and the robot arm can be carefully measured. Since the car design is also known to a high degree of accuracy, the location of, for example, 12 weld points along a seam can be plotted in world locations. The problem the engineers were left with was how to position the spot welder on the end of a robot arm in these 12 positions. This is just the same problem we have when positioning our virtual characters, only this time the problem has a real world setting. Robot arms can be moved using pneumatics, d.c. servos or stepper motors. Each joint can be rotated in one or more directions. A single joint that rotates in the heading, pitch and bank is described as having three degrees of freedom (3 DOF). For an object to be completely free moving, it must have six degrees of freedom (6 DOF). This is achieved by allowing translations in addition to rotation. Most robot arms are fixed at the base, so they have three degrees of freedom. For this reason they cannot always achieve a goal. The engineers have to ensure that the relative positioning of the car body in relation to the robot is such that the targets can all be reached. There are numerous papers on techniques to derive the orientation of the links in the chain based on a target location, a few of which are mentioned in Appendix C.

Calculating the orientation for a single link IK chain

Before we explore more complex solutions we will look first at the simplest possible case, an IK chain consisting of a single link. In the 2D version of

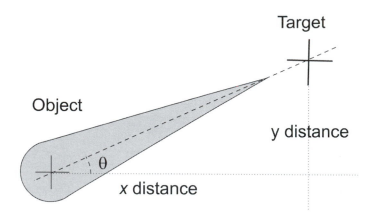

Figure 9.2 A single link IK chain.

this problem we have a target position indicated in Figure 9.2 using a cross. We also have a single link object. We want to orientate the object so that it points towards the cross. To achieve this we have only to calculate the value of θ, the rotation angle. This is an exercise in simple trigonometry. We know the *x* distance to the target is target *x* minus object *x* and the *y* distance can calculated the same way. The *y* distance divided by the *x* distance gives the tangent of the angle, so the simple solution is found by calculating the inverse of the tangent of the *y* distance divided by the *x* distance.

The simple solution to this problem is

$$\theta = \operatorname{atan}(y\text{distance}/x\text{distance})$$

The demo for this can be run by selecting Chapter09/Ikdemo.exe and selecting 'Single Link' from the menu.

Calculating the orientations for a double link IK chain

By adding a single extra link, the problem becomes much more complex. Consider Figure 9.3; the intention is to calculate both θ values based on the position of the target. Assuming we know the length of each link (Length1 and Length2), we can state that

$$\text{Pivot2}.x = \text{Pivot1}.x + \text{Length1}*\cos(\theta_1)$$
$$\text{Pivot2}.y = \text{Pivot1}.y + \text{Length1}*\sin(\theta_1)$$

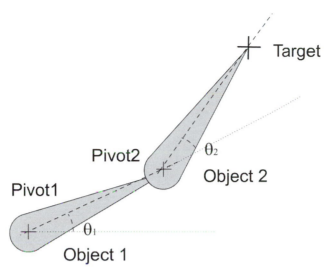

Figure 9.3 A double link IK chain.

Target.x = Pivot2.x + Length2*cos$(\theta_1 + \theta_2)$
Target.y = Pivot2.y + Length2*sin$(\theta_1 + \theta_2)$

which implies that

Target.x = Pivot1.x + Length1*cos(θ_1) + Length2*cos$(\theta_1 + \theta_2)$
Target.y = Pivot1.x + Length1*sin(θ_1) + Length2*sin$(\theta_1 + \theta_2)$

The aim is to invert this equation and express the θ values using the known values. Assuming we are keeping the pivot point of the first link stationary, we already know the value of Pivot1.

Using the trigonometric identities

cos$(\theta_1 + \theta_2)$ = cos(θ_1)cos(θ_2) − sin(θ_1)sin(θ_2)
sin$(\theta_1 + \theta_2)$ = cos(θ_1)sin(θ_2) + sin(θ_1)cos(θ_2)

We can restate the equations as

Target.x = Pivot1.x + Length1*cos(θ_1) + Length2*(cos(θ_1)cos(θ_2)
 − sin(θ_1)sin(θ_2))
Target.y = Pivot1.x + Length1*sin(θ_1) + Length2*(cos(θ_1)sin(θ_2)
 + sin(θ_1)cos(θ_2))

Another useful trigonometric identity is

cos$^2(\theta)$ + sin$^2(\theta)$ = 1

By squaring both sides of the equations and adding them together, the equation can be carefully rearranged to give

$$\cos(\theta_2) = \frac{Target.x^2 + Target.y^2 - Length1^2 - Length2^2}{2*Length1*Length2}$$

Therefore,

$$\theta_2 = a\cos\left(\frac{Target.x^2 + Target.y^2 - Length1^2 - Length2^2}{2*Length1*Length2}\right)$$

So, all we have to do now is find θ_1. Looking at Figure 9.4, we can use two additional angles to help to find θ_1.

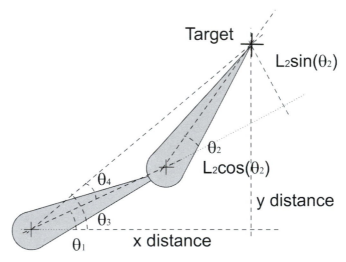

Figure 9.4 How to find θ_1.

$$\theta_1 = \theta_3 - \theta_4$$

Finding θ_3 is the same problem as the single link solution given above

$$\theta_3 = atan(y distance/x distance)$$

Looking at the triangle formed from the pivot of object 2, the target and the right angle indicated, we can express the lengths of the two sides as

$$Length2*\cos(\theta_2) \text{ and } Length2*\sin(\theta_2)$$

Therefore, the triangle that includes θ_4 has sides

Length2*sin(θ_2) and Length2*cos(θ_2) + Length1

The angle θ_4 is found using the inverse tangent of the ratio of these lengths:

$$\theta_4 = \text{atan}\left(\frac{\text{Length2*sin }(\theta_2)}{\text{Length1} + \text{Length2*cos }(\theta_2)}\right)$$

You could even reduce the number of trig function calls by using the tan identity for $\tan(\theta_1 - \theta_2)$:

$$\tan(\theta_1 - \theta_2) = (\tan(\theta_1) - \tan(\theta_2))/(1 + \tan(\theta_1)\tan(\theta_2))$$

If the target is beyond the reach of the current chain, the exercise reduces to the single link one. The child object will have zero rotation or rotation that orientates it to the direction of the parent in a more general solution. The parent object can be rotated as in the single link solution.

The code for the double link solution is shown below. The code makes use of a *CLink* class that stores the current orientation for a link and the rotation matrix. The *CLink* class is a linked list with a parent member variable.

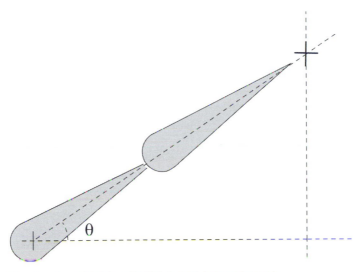

Figure 9.5 *Rotating the objects with the target beyond reach.*

```
void CLink::CreateMatrix()
{
    //HPB
    double ch,sh,cp,sp,cb,sb;
    ch = cos(rot.x); sh = sin(rot.x);
    cp = cos(rot.y); sp = sin(rot.y);
    cb = cos(rot.z); sb = sin(rot.z);

    right.x   = ch*cb-sh*sp*sb;
    right.y   = -cp*sb;
    right.z   = -sh*cb-ch*sp*sb;
    up.x      = ch*sb+sh*sp*cb;
    up.y      = cp*cb;
    up.z      = -sh*sb+ch*sp*cb;
    forward.x= sh*cp;
    forward.y= -sp;
    forward.z= ch*cp;

    if (parent){
        //Concatentate the parents rotation matrix which must already
        //have been calculated, otherwise the positions will be in
        //error
        double t1,t2,t3;
        t1 = parent->right.x*right.x + parent->up.x*right.y
            + parent->forward.x*right.z;
        t2 = parent->right.y*right.x + parent->up.y*right.y
            + parent->forward.y*right.z;
        t3 = parent->right.z*right.x + parent->up.z*right.y
            + parent->forward.z*right.z;
        right.x = t1; right.y = t2; right.z = t3;
        t1 = parent->right.x*up.x + parent->up.x*up.y
            + parent->forward.x*up.z;
        t2 = parent->right.y*up.x + parent->up.y*up.y
            + parent->forward.y*up.z;
        t3 = parent->right.z*up.x + parent->up.z*up.y
            + parent->forward.z*up.z;
        up.x = t1; up.y = t2; up.z = t3;
        t1 = parent->right.x*forward.x + parent->up.x*forward.y
            + parent->forward.x*forward.z;
        t2 = parent->right.y*forward.x + parent->up.y*forward.y
            + parent->forward.y*forward.z;
        t3 = parent->right.z*forward.x + parent->up.z*forward.y
```

```
                + parent->forward.z*forward.z;
        forward.x = t1; forward.y = t2; forward.z = t3;
        pos.x = parent->length * parent->right.x + parent->pos.x;
        pos.y = parent->length * parent->right.y + parent->pos.y;
        pos.z = parent->length * parent->right.z + parent->pos.z;
    }
    for (int i=0; i<4; i++){
        dispts[i].x = orgpts[i].x * right.x + orgpts[i].y * up.x
                    + orgpts[i].z * forward.x + pos.x;
        dispts[i].y = orgpts[i].x * right.y + orgpts[i].y * up.y
                    + orgpts[i].z * forward.y + pos.y;
        dispts[i].z = orgpts[i].x * right.z + orgpts[i].y * up.z
                    + orgpts[i].z * forward.z + pos.z;
    }
}
```

To solve the double link problem the demo uses the following function:

```
void CIKDemoDoc::SolveDoubleLink()
{
    double sin2, cos2, totallength, x, y, tan1;
    CLink *link1, *link2;

    if (links.next->next){
        link1 = links.next;
        link2 = link1->next;
    }else{
        return;
    }

    //Check solution is possible
    x = target.x - link1->pos.x;
    y = -target.y - link1->pos.y;
    totallength = sqrt(x*x + y*y);
    if (totallength < (link1->length + link2->length)){
        cos2 = (x * x +y *y - link1->length * link1->length -
            link2->length * link2->length)/
            (2 * link1->length * link2->length);
        link2->rot.z = acos(cos2);
        sin2 = sin(link2->rot.z);
        tan1 = (-(link2->length * sin2 * x) + ((link1->length +
            (link2->length * cos2)) *y))/
```

```
                    ((link2->length * sin2 *y) + ((link1->length +
                    (link2->length * cos2)) * x));
        link1->rot.z = atan(tan1);
    }else{
        //Just use the single link solution
        x = target.x - link1->pos.x;
        y = -target.y - link1->pos.x;
        link1->rot.z = atan(y/x);
        if (x<0) link1->rot.z = PI + link1->rot.z;
        link2->rot.z = 0.0;
    }
    link1->CreateMatrix();
    link2->CreateMatrix();

    CString str;

    str.Format("(%4.2f, %4.2f)", x,y);
    SetStatus(str);
}
```

Limitations for the analytical approach for multiple link chains

In Figure 9.6, you can see that there are two valid ways of achieving the orientations necessary to reach the target. This problem stems from using

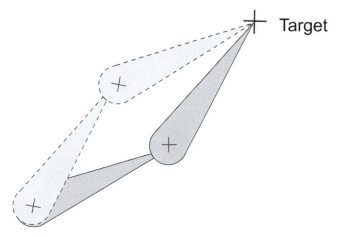

Figure 9.6 IK problems often have more than one solution.

Real-time 3D Character Animation with Visual C++

the square of the equations in the solution. Whenever a square is used the root has two solutions, one positive, the other negative. Each solution is valid and leads to one or other of the solutions in the figure. The effect of this in a double link chain is fairly minimal, but can still lead to a disturbing snapping when the software analysis trips from one solution to the other. You could attempt to minimize the rotation change and take the minimum solution, and this can help. A fully general solution using analysis that is robust in all circumstances can prove elusive even with a double link chain. Adding a single additional link doubles the possible solutions, a three-link chain having four possible valid solutions.

A four-link chain has eight solutions. A hips, torso, shoulder, bicep, forearm, hand chain with six links will have 32 possible solutions. The software is very likely to snap between solutions and this will lead to poor quality animations. We need a way out of this dilemma.

Using an iterative technique to determine orientations for a multiple link IK chain

The way we will study here was first presented by Chris Welman in his masters thesis on IK as an extension to work developed by Li-Chun Tommy Wang and Chih Cheng Chen in an IEEE paper 'Transactions on Robotics and Automation'. The technique is called Cyclic Coordinate Descent. The principal algorithm is as follows:

1 Set a loop counter to zero.
2 Start with the last link in the chain.
3 Rotate this link to point towards the target.
4 Move down the chain and repeat step 2.
5 When the base object is reached, determine if the target has been reached or a loop limit has been reached. If so exit, if not increment loop counter and repeat from step 2.

This algorithm has the benefit of simplicity and can be easily implemented.

To derive the angle θ, we go back to the familiar methods of using vectors. Remember that the dot product of vectors is given by

$$\mathbf{a} \bullet \mathbf{b} = |\mathbf{a}||\mathbf{b}|\cos(\theta) \text{ where } |\mathbf{a}| = \sqrt{(a \bullet x^2 + a \bullet y^2)} \text{ and } |\mathbf{b}| = \sqrt{(b \bullet x^2 + b \bullet y^2)}$$

Therefore, the angle θ is given by

$$\theta = \mathrm{acos}(\mathbf{a} \bullet \mathbf{b}/|\mathbf{a}||\mathbf{b}|)$$

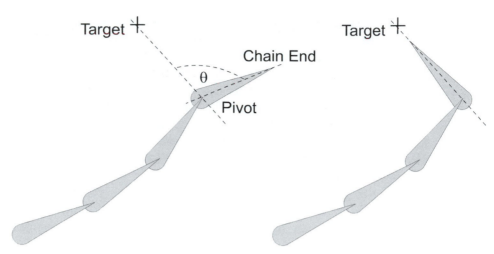

Figure 9.7 Rotating the last link using the Cylic Coordinate Descent technique for IK solutions.

Unfortunately, the angle does not imply direction and we are interested in both the angle and the direction. Since the cross product of two vectors gives a perpendicular vector, we can use this to determine the direction. By extending the vectors from two to three dimensions, we then have a *z* value. The sign of this *z* value will give the direction in which to rotate.
 If

a = (*a.x*, *a.y*, 0) and **b** = (*b.x*, *b.y*, 0)

then

a × **b** = (*a.y*∗0 − 0∗*b.y*, 0∗*b.x* − *a.x*∗0, *a.x*∗*b.y* − *a.y*∗*b.x*)

We are only interested in the sign of the third term. So the sign of

a.x∗*b.y* − *a.y*∗*b.x*

defines the direction of rotation.
 When using the algorithm, we start by iterating through the link chain to find the last link. We then create unit vectors from the pivot point of the link to the chain end and from the pivot point to the target. The inverse cosine of the dot product of these two vectors gives the angle of rotation and the third term of the result of the three-value vector cross product gives the direction of rotation. We generate a rotation matrix using this information and record the current chain end position.

Real-time 3D Character Animation with Visual C++

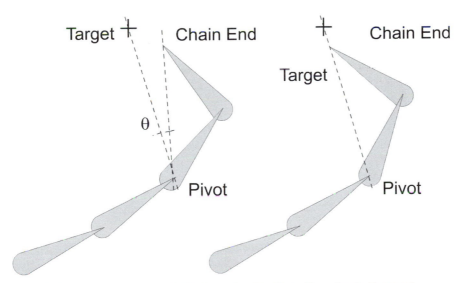

Figure 9.8 Rotating the intermediate link using the Cylic Coordinate Descent technique for IK solutions.

We then move one link down the chain and determine new vectors from the pivot point of the new link to the chain end and target and repeat the dot product and cross product calculations. We then create a rotation matrix and calculate the new location for the chain end. This procedure is repeated until the base object is rotated. At this point we determine if we are close enough to the target to exit the function. If not, we must repeat the procedure. It is possible that the target cannot be reached. The function needs to ensure that under such circumstances the program does not enter an infinite loop. A simple technique to avoid this is to limit the looping to a certain number of times; if this is exceeded then the function exits.

If the total length of the links is less than the distance to the target, then the goal can never be achieved and it can be useful to add this condition to the code. Under these circumstances we return to the problem of orientating a single link, the base link, and setting all other links to zero rotation.

The code for the Cyclic Coordinate Descent method is as follows:

```
void CIKDemoDoc::SolveMultiLink()
{
    CLink *link = links.next, *lastlink, *tmplink;
    int loopcount = 0;
    double x, y, totallength, linkslength = 0.0, dotprod;
```

```
double mag, theta, sign, sqdist;
VECTOR pe, pt;

//Check solution is possible
x = target.x - link->pos.x;
y = -target.y - link->pos.y;
totallength = sqrt(x*x + y*y);

//Find the last link and links length
while (link->next){
    linkslength += link->length;
    lastlink = link;
    link = link->next;
}

if (totallength < linkslength){
    //Calculate Cyclic Coordinate Descent solution
    link = lastlink;
    while(link && loopcount<20){
        //Calculate current endeffector position
        endeffector.x = lastlink->length * lastlink->right.x +
                        lastlink->pos.x;
        endeffector.y = lastlink->length * lastlink->right.y +
                        lastlink->pos.y;

        //Calculate the squared distance from end effector to
        //target
        x = target.x - endeffector.x;
        y = target.y - endeffector.y;
        sqdist = x*x + y*y;
        if (sqdist < 0.1) break;

        //Calculate pivot to target vector
        pt.x = target.x - link->pos.x;
        pt.y = target.y - link->pos.y;
        pt.z = 0;

        //Calculate pivot to end effector vector
        pe.x = endeffector.x - link->pos.x;
        pe.y = endeffector.y - link->pos.y;
        pe.z = 0;
```

```
//Convert to unit vectors
mag = sqrt(pt.x * pt.x + pt.y * pt.y);
pt.x/=mag; pt.y/=mag;
mag = sqrt(pe.x * pe.x + pe.y * pe.y);
pe.x/=mag; pe.y/=mag;

//Calculate dot product
dotprod = pe.x * pt.x + pe.y * pt.y;

//Calculate cross product for direction
sign = pe.x * pt.y - pe.y * pt.x;

if (sign > 0.0){
    theta = -acos(dotprod);
}else{
    theta = acos(dotprod);
}
link->rot.z += theta;

//Set matrices for current link and all children
tmplink = link;
while(link){
    link->CreateMatrix();
    link = link->next;
}
link = tmplink;

//Move on to next link
if (link==links.next){
    loopcount++;
    link = lastlink;
}else{
    link = link->parent;
}
    }
}else{
    //Just use the single link solution
    link = links.next;
    x = target.x - link->pos.x;
    y = -target.y - link->pos.x;
    link->rot.z = atan(y/x);
    if (x<0) link->rot.z = PI + link->rot.z;
```

```
        while (link->next){
            link = link->next;
            link->rot.z = 0.0;
        }
    }

    link = links.next;

    while(link){
        link->CreateMatrix();
        link = link->next;
    }
}
```

Setting joint limits and bending strengths

In the previous section, the ease of rotation at each joint was the same. Because the algorithm starts at the end of the chain, this favours the rotation of the later links. It may be that you would prefer most of the rotation to come from the middle of the chain. If we only allow some links to rotate by less than 100 per cent of the optimum rotation we can favour certain links. In our four-link chain we could have a scale value for the angle of rotation set to 0.3, 0.1, 0.5, 0.6 starting from the root object. In this way, the second link up the chain has a greater influence on the way the goal is reached.

Another technique to ensure that rotations are applied as intended is to limit the maximum rotation. If a link is locked so that beyond certain minimum and maximum rotation it cannot move, then this forces the rotation of a chain to reach a goal, so it is handled in a way that feels correct. A good example of this is our knee joints. The joint is capable of rotating around 140° back from straight, but cannot rotate forward. If the software allowed forward rotations then a walk would seem very awkward to the viewer.

Blending IK solutions with forward kinematic animation

There are many times when you will want to switch from a forward kinematic solution to a motion problem, to an IK solution. Suppose a character places a hand temporarily on a fixed surface such as a table or wall. The hand should appear to be stationary on the surface. If the body

continues to move then this is an ideal candidate for an IK solution. A few seconds later the character may be running around. As soon as the hand leaves the surface the animation will be better handled by a forward kinematic solution. What we need to be careful about is that the two solutions blend well visually. One technique is to calculate two solutions until the hand is within bounds that could leave the wall.

By calculating both solutions we can determine when the hand would move away using the forward kinematics solution. At this stage, we need to blend the IK solution into the forward kinematic solution. We can use a progressively changing weight to determine the final outcome. If we set the blend to be over 1 second and blendtime is the number of seconds that have elapsed during the blend, then the two solutions are based on

```
IK * (1 - blendtime) + FK * blendtime
```

As soon as *blendtime* exceeds 1.0, we can stop calculating the IK solution and rely solely on the forward kinematic animation.

Summary

IK solutions can be calculated in sufficient time to be applicable to real-time engines for character animation. By using IK the stored animations can be extended and do not represent as great a limitation on interactivity. Using Cyclic Coordinate Descent, the IK solution is quite robust and efficiently calculated. Combining forward and inverse kinematics gives the maximum flexibilty. Using joint strengths allows the developer to make some parts of the model appear more supple than others to the viewer.

10 Importing geometry and animation from Lightwave 3D

No man is an island as the saying goes, and this is undoubtedly true of real-time character animation. In order to produce effective real-time character animation you are likely to need to use many application programs as tools. The kinds of tools you will need are likely to include: a good bitmap editor such as Paint Shop Pro to create the texture maps that are so essential for the look of low polygon characters; a level editor to create the real-time content; and a modelling program. In this chapter we look in detail at how we can use data created by one important tool, Lightwave 3D, in our own application.

Lightwave 3D scene files are simple text files that define how objects appear and animate in a scene. In this chapter we look in detail at the scene file and how to extract the animation data. Lightwave 3D object files are binary files containing point, polygon and surface data. This chapter covers in detail how to parse such a file and extract the information necessary to display the geometry.

Lightwave overview

Lightwave splits the CGI animation process into two distinct stages: modelling and animating. Because of this Lightwave has two main application programs, 'Modeler' and 'Layout'. The data created in 'Modeler' comprise a binary file that contains information about a model's vertices, polygons and surfaces. This file can contain other information that a model may use that can be provided by plug-ins or extensions to the Lightwave dataset that may appear later. Any parsing engine we create must be able to skip this additional information.

A Lightwave scene file is a text file that contains a list of all objects used in a scene, the animation they perform, any plug-ins they use, the lights used and their animation, the camera and its animation, and finally user display settings. Parsing a scene file involves reading the text file and

loading any objects that are described along with the animation these objects perform. In order to use a scene file we need to be able to load an object file, so we will begin our examination of importing Lightwave data by looking at how to read and load an object file.

Importing a Lightwave object file

First we are going to create a new class *CLWObject*; this class will contain all the information about an object that we will use: points, polygons and surface data. Initially, we will start with a stripped down application that will load a single object and allow the user to rotate the object. In terms of surface data we will simply load the colour of a surface. Later we will look at the Toon3D source code to learn how to extract texture information. The rationale behind splitting the process up is that the more code in an application, the more difficult it is to learn from this source in order to apply the techniques to your own application. When loading the full data out of a Lightwave object file for a low polygon application, the main complexity lies in the parsing of the surface data. For this reason we look at the problem in two stages, basic object geometry and then surface details.

One of the best features of Lightwave 3D is the documentation available. Lightwave 3D has a free and very useful mailing list which I encourage the interested reader to become a part of (see the information at the end of the book for further details). A Lightwave 3D file uses the IFF file format that was used extensively on the Commodore Amiga. This file format uses a chunk format. A chunk starts with a four-letter code that describes what the chunk is about, followed by an integer value that defines the length of the code. A parser first reads the chunk ID and the chunk length, checks whether it understands this chunk and if it does then reads the chunk. If it does not understand the chunk, then the parser uses the chunk length to tell the file pointer to skip the next section, where it can then happily read the next chunk. So here is how the first chunk in a Lightwave 6+ file looks:

```
 F   O   R   M           340  L   W   O   2
46  4F  52  4D  00  00  01  54  4C  57  4F  32
```

First we find four characters that define the file as an IFF 'FORM'. Then 4 bytes that are the length of the file minus 8 bytes. The final part of the header chunk is the form type, which for a Lightwave 6 object file will contain the four characters 'LWO2'; the 'O' stands for object, it

is not a number. The only thing we have to be careful of here is that the byte ordering in a Lightwave file is in Motorola order. This is not the same as the byte ordering on an Intel machine, so if you are creating a parser on an Intel machine then you will have to change the byte order.

The following shows three functions you can use when reading short, int and floating-point values from a file that uses Motorola, sometimes also called network, byte ordering. Each function uses the same strategy. The function returns true or false depending on whether there was a file read error. For a short we declare a 2-byte buffer, for an int or float we use a 4-byte buffer. There are two parameters passed to the function: a file pointer and a reference to a variable of the type we are reading. In addition to creating an appropriately sized buffer, we also create a character pointer that is initialized to the address of the variable reference passed to the function. Then we read either 2 or 4 bytes from the file, returning false if there was a read error. Finally, we flip the contents of the buffer, storing the result in the passed variable using the character pointer we created.

```
BOOL CLWObject::ReadShort(FILE *fp, unsigned short &s)
{
  char buf[2], *cs = (char*)&s;

  if (fread(&buf, 2, 1, fp)!=1) return FALSE;
  cs[0]=buf[1]; cs[1]=buf[0];

  return TRUE;
}

BOOL CLWObject::ReadInt(FILE *fp, int &i)
{
  char rd[4], *ci = (char*)&i;

  if (fread(rd,4,1,fp)!=1) return FALSE;
  ci[0]=rd[3]; ci[1]=rd[2]; ci[2]=rd[1]; ci[3]=rd[0];

  return TRUE;
}

BOOL CLWObject::ReadFloat(FILE * fp, float &f)
{
  char rd[4], *cf = (char*)&f;
```

```
    if (fread(rd,4,1,fp)!=1) return FALSE;
    cf[0]=rd[3]; cf[1]=rd[2]; cf[2]=rd[1]; cf[3]=rd[0];

    return TRUE;
}
```

Assuming that we have read the file header and the file is of suitable format, we can start to read the chunk headers. To read a chunk header, we read the 4-byte identifier and the chunk length. Below is a function that will do just this. We pass a file pointer, a buffer that must be at least four characters long, and an integer reference to the function. Again, the function returns false if there was a file read error. We store the chunk identifier and length in passed variables. When navigating a chunk we need to read an additional byte from the file if the length of a chunk is odd, because all chunks start on an even byte boundary.

```
BOOL CLWObject::ReadChunkHeader(FILE *fp, char *buf, int &i)
{
    //Read header
    if (!fread(buf,4,1,fp)) return FALSE;
    //Read sub chunk length
    if (!ReadInt(fp,i)) return FALSE;
    return TRUE;
}
```

Lightwave also uses sub-chunks; these are read in exactly the same way as reading a standard chunk, except that the length of the sub-chunk is stored in a short integer. The function call for reading a sub-chunk header is as follows:

```
BOOL CLWObject::ReadSubChunkHeader(FILE *fp, char *buf, USHORT &s)
{
    //Read header
    if (!fread(buf,4,1,fp)) return FALSE;
    //Read sub chunk length
    if (!ReadShort(fp,s)) return FALSE;
    return TRUE;
}
```

Now that we have an armoury of function calls for navigating a Lightwave object file, we will look at the structure of the parser. We want to create a structure that is easily extendable. All Lightwave files have a

certain format. Having read the initial header, we will read a TAGS chunk where a list of string values are stored that can be referred to later in the file. Following this chunk will be a LAYR chunk, defining the start of a layer. The Lightwave object format can store several object layers, each effectively a self-contained mesh. A single LAYR chunk will contain point, polygon and surface data for that layer. So we can structure our reader to have an overall function that will read an entire file. This function will contain a switch statement that looks for a TAG or LAYR chunk. Any other chunk can be ignored and skipped by seeking through the file by the amount returned in the length variable passed to the ReadChunkHeader function. The function is given below. The loop is exited when the function call ReadChunkHeader returns false to indicate a file error.

```cpp
BOOL CLWObject::ReadObjectFile(FILE *fp){
  char buf[4];
  int length;

  while (1){
      if (!ReadChunkHeader(fp, buf, length)) break;
      if (strncmp(buf, "TAGS", 4)==0){
          if (!ReadTags(fp, length)) return FALSE;
          continue;
      }
      if (strncmp(buf, "LAYR", 4)==0){
          if (!ReadLayer(fp)) return FALSE;
          continue;
      }
      if (length%2){
          //Skip one extra byte if odd length chunk
          fseek(fp, length+1, SEEK_CUR);
      }else{
          fseek(fp, length, SEEK_CUR);
      }
  }
  return TRUE;
}
```

Reading the tags chunk is simply a case of reading a series of zero terminated strings until the read count reaches the length of the chunk. A function call that will read a zero terminated string from a Lightwave object file is shown below. The function takes a file pointer, a character buffer, a reference to a count variable and the length of the passed buffer. If the

function fails to read a full zero terminated string then it returns false. This can be because of either a file read error or because the length of the buffer passed to the function was insufficient to store the string being read. The function returns the read string in the character buffer 'buf'. If the size of a string is odd then we need to read another byte from the file, since all strings start on an even byte boundary.

```
BOOL CLWObject::ReadString(FILE *fp, char *buf, int &count,
                           int buflength){
  count = 0;
  while(1){
        if (fread(&buf[count], 1, 1, fp)!=1) return FALSE;
        if (buf[count++]==0) break;
        if (count==buflength) return FALSE;
  }
  //Align to even byte boundary
  if (count%2) fseek(fp, 1, SEEK_CUR);
  //Don't include final zero in count
  count--;

  return TRUE;
}
```

To read the tag chunk simply call ReadString repeatedly until the length of the chunk is reached. The length of the string is returned in the passed count variable. Store all the strings in an array. They will be needed when reading a surface chunk.

Reading a layer section

The content of a layer is finished when the end of a file is reached or another LAYR chunk is found. Let's examine a simple unit cube file to see how the data for a layer are stored.

```
FORM 340 LWO2
  TAGS 8 "Default"
  LAYR 18
   0 0 0.0 0.0 0.0 ""
   PNTS 96
        −0.5 −0.5 −0.5
         0.5 −0.5 −0.5
```

```
              0.5 −0.5 0.5
             −0.5 −0.5 0.5
             −0.5 0.5 −0.5
              0.5 0.5 −0.5
              0.5 0.5 0.5
             −0.5 0.5 0.5
BBOX 24
             −0.5 −0.5 −0.5
              0.5 0.5 0.5
POLS 64
             FACE
             4 0 1 2 3
             4 0 4 5 1
             4 1 5 6 2
             4 3 2 6 7
             4 0 3 7 4
             4 4 7 6 5
PTAG 28
               SURF
               0 0
               1 0
               2 0
               3 0
               4 0
               5 0
SURF 42
             "Default"
             ""
             COLR 14
                   0.78431 0.78431 0.78431
                   0
             DIFF  6
                   1.0 0
```

As can be seen from the above, a layer contains chunks that describe the data for the points (PNTS), bounding box (BBOX), polygons (POLS), polygon tag information (PTAG) and surfaces (SURF). For a layer section we will use the following function; this returns if it finds another layer, so in this simple application only the first layer in a file will return any object geometry. If you wish to extend this then you will need to create a list of objects and have the overall document do the reading, creating new objects in the object list as new layer chunks are encountered.

```
BOOL CLWObject::ReadLayer(FILE *fp){
  char buf[4];
  int length;

  while(1){
      if (!ReadChunkHeader(fp, buf, length)) return FALSE;
      if (strncmp(buf, "PNTS", 4)==0){
          if (!LoadPoints(fp, length)) return FALSE;
      }
      if (strncmp(buf, "POLS", 4)==0){
          if (!LoadPoints(fp, length)) return FALSE;
      }
      if (strncmp(buf, "PTAG", 4)==0){
          if (!LoadPTag(fp, length)) return FALSE;
      }
      if (strncmp(buf, "SURF", 4)==0){
          if (!LoadSurface(fp, length)) return FALSE;
      }
      if (strncmp(buf, "LAYR", 4)==0) break;
  }
  return TRUE;
}
```

The point list always precedes the polygon list, so we will examine this first.

A point chunk is identified with the chunk identifier 'PNTS'; the length of a point chunk gives the number of points, since each point is defined by three floating-point values and a floating-point value uses 4 bytes. To get the number of points in a chunk, divide the length of the PNTS chunk by 12. For convenience in the sample code, I have defined a VECTOR structure:

```
typedef struct stVECTOR{
  float x, y, z;
}VECTOR;
```

A CLWObject has a member variable 'pts' that is a pointer to a VECTOR. The class also includes a member variable 'numpoints', which is used to ensure that we do not try to use points outside the range of those created. In the 'LoadPoints' function we create an array of VECTOR quantities. Then up to the 'length' of the file we keep calling the 'ReadFloat' function to read each component of the VECTOR structure.

One slight surprise is that the *z* orientation for a Lightwave model is the inverse of that expected by OpenGL, so we flip the *z* value to ensure consistency between the Lightwave interface display and our OpenGL display. As long as there are no file read errors, the function returns the number of points read. If there is a file read error then the function returns zero.

```cpp
int CLWObject::LoadPoints(FILE *fp, int length)
{
    int numpts, count;
    VECTOR *pt;

    numpts = length/12;
    pts = new VECTOR[numpts];;
    if (!pts) return 0;

    count=0;
    pt = pts;

    while(count<length){
        if (!ReadFloat(fp, pt->x)) return 0;
        if (!ReadFloat(fp, pt->y)) return 0;
        if (!ReadFloat(fp, pt->z)) return 0;
        pt->z = -pt->z;
        pt++;
        count+=12;
    }
    numpoints=numpts;

    //Align to even boundary
    if (length%2) fseek(fp,1,SEEK_CUR);

    //Must have gone OK
    return numpts;
}
```

Having created an array of points we next create an array of polygons. A polygon is defined as having a certain number of vertices; in our simple application this value is restricted to three or four. Vertices are indicated by the index into the point array. Surface information is stored as an index into the surface array. Polygon chunks can also define sub-patch polygons, so we check first that we are dealing with a regular polygon list

by reading the first four characters after the chunk header. If this is 'FACE' then we are dealing with a conventional polygon; in this limited application we return 0 to indicate an error if this is a subdivision patch list.

We then read the polygons one at a time. We cannot determine the number of polygons from the length of the chunk because a polygon can contain *n* number of vertices. A different number of vertices will use a different amount of storage in the file. So we must allocate memory dynamically. In the sample application memory is allocated as each polygon is created. Then the contents of the existing polygon array are copied and the old array deleted. Finally, the member variable 'plys' is set to point to the new memory area. Another common way to allocate memory dynamically is to double the storage each time, so that initially you allocate enough for a single polygon, then 2, 4, 8, 16, 32, etc. This saves time but is less efficient in terms of storage. Since a loader is called infrequently, it seems that efficient memory storage wins out over speed.

The definition of a polygon that we use in the application is as follows:

```
typedef struct stPOLYGON{
   int numverts;        //Number of vertices
   int p[4];            //Index into the point array of the vertices
   int srfID;           //Index into the surface array of the surface
   float nx, ny, nz;    //Normal for this polygon
}POLYGON;
```

For every polygon we store the normal in the three float values, *nx*, *ny* and *nz*. The function to load all the polygons in a 'POLS' chunk is shown below:

```
int CLWObject::LoadPolygons(FILE *fp, int length)
{
   int r,count;
   char buf[4];

   numpolygons=0;
   if (fread(buf, 1, 4, fp)!=1) return 0;
   if (strncmp(buf, "FACE", 4)!=0) return 0;
   count = 4; //bytes read so far

   while(count<length){
        r = AddPolygon(fp);
```

Real-time 3D Character Animation with Visual C++

```
        if (r==0) return 0;
        count+=r;
    }

    if (length%2) fseek(fp, 1, SEEK_CUR);
    return numpolygons;
}
```

The 'LoadPolygons' function calls 'AddPolygon' every time it encounters a new polygon. A polygon is defined as a vertex total 'n' and then n indices into the points list. The vertex total has to have the top 6 bits of a 16-bit short integer masked out, since these are reserved for flags used by non-standard polygons. The only use currently defined for these is to store curve information. In the function we use a bitwise 'and' to zero out the top 6 bits. Then we create storage for the current number of polygons plus one extra. The existing polygon array is copied if it exists and a pointer to a polygon is set to point to the last one in the array. This last polygon is where we will store the data for the polygon being read. We read the number of vertices and read each vertex from the file. If the value of the vertex index is less than 4 then we can store the value; if it exceeds 4 then in this simple application we simply ignore the higher vertices. In a more sophisticated application you could choose to create a new polygon for vertices above 4, but you need to create a versatile function if it is able to cope with any polygon it receives. The problem stems from concave polygons. If a polygon is convex then it can easily be tripled, turned into triangles, by joining vertex 0 to n and $n + 1$, as n goes from 1 to the number of vertices minus 2. If, however, a polygon is concave then this technique can result in a group of triangles that draw outside the range of a polygon. It is highly recommended that when exchanging data between a CGI application and your own application you use just triangles. In this way, non-planar polygons are avoided and you also avoid any problems over concave polygons, since a triangle must be convex. In the function we store the value of the number vertices if it is below 5. If it is above 5 then the result is capped to 4. Finally, the function returns the number of bytes that have been read from the file while adding the current polygon.

```
int CLWObject::AddPolygon(FILE * fp)
{
    int j;
    unsigned short s, numverts;
    POLYGON *ply;
```

```
if (!ReadShort(fp, numverts)) return 0;

numverts &= 0x3FF;   //Mask high 6 bits

//Update Polygon storage
ply = new POLYGON[numpolygons + 1];
if (!ply) return 0;
if (plys){
    memcpy(ply, plys, sizeof(POLYGON) * numpolygons);
    delete [] plys;
}
plys = ply;
ply = &ply[numpolygons];

for (j=0;j<numverts;j++){
    if (!ReadShort(fp,s)) return 0;
    if (j<4) ply->p[j]=(int)s;
}

ply->numverts = (numverts<5)?numverts:4;
ply->srfID = 0;
numpolygons++;

return numverts * 2 + 2; //Size of polygon
}
```

Notice that we zero the index for the surface when creating a polygon. The actual value for the surface ID is found from the PTAG chunk. This chunk can store several features of a polygon; in this stripped down application we use only one, the SURF section. In the SURF section of a PTAG chunk we read a polygon index and the surface index that this polygon uses. The actual index points to the string variable we stored from the TAGS chunk. To find the actual surface we load a surface and check its name against the TAG chunk.

For example:

```
TAGS
"Default"
"BackFace"
"YellowPlastic"
"BlueMetal"
```

```
SURF
"BlueMetal"
....

SURF
"YellowPlastic"
```

Despite finding 'BlueMetal' first, the index in the PTAG chunk for the surface would be 3. A surface with the name 'Default' would have an index of 0 in the PTAG chunk.

```
BOOL CLWObject::LoadPTags(FILE *fp, int length)
{
  int count, length;
  USHORT plyID, srfID;
  char buf[4];

  fread(buf, 4, 1, fp);
  if (strncmp(buf, "SURF", 4)!=0){
      fseek(fp, length, SEEK_CUR);
      return TRUE;
  }

  count = 4;

  while (count<length){
      if (!ReadShort(fp, plyID)) return FALSE;
      if (!ReadShort(fp, srfID)) return FALSE;
      if (plyID<numpolygons){
          plys[plyID].srfID = srfID;
      }
      count += 4;
  }

  return TRUE;
}
```

The surface chunk is by far the most complex chunk in most object files. Many of the features of the surface chunk can be ignored by a real-time application. In this simple application we use just two features, the colour and the name of the surface. In common with the points list and the polygon list, we declare a structure called SURFACE to store the data.

```
typedef struct stSURFACE{
  BYTE red, green, blue;
  char name[40];
}SURFACE;
```

A surface chunk contains many sub-chunks. We will read just the
COLR chunk that defines the base colour. After reading the name for the
surface and skipping the name of the parent of this surface, we go into a
loop reading through the sub-chunks until the length of the surface chunk
is reached.

```
BOOL CLWObject::LoadSurface(FILE* fp, int length)
{
  char buf[4], name[80];
  int i, length, count;
  float f;
  unsigned short sublength, e;
  SURFACE *srf;
  while(1){
    srf = new SURFACE[numsurfaces+1];
    if (srfs){
      memcpy(srf, srfs, numsurfaces * sizeof(SURFACE));
      delete [] srfs;
    }
    srfs = srf;
    srf = &srfs[numsurfaces];
    numsurfaces++;

    //Read name
    if (!ReadString(fp, srf->name, count, 39)) return FALSE;

    //Read parent name
    ReadString(fp, name, count, 79);

    //Read sub-chunks
    while (count<length){
      if (!ReadSubChunk(buf, sublength, fp)) return FALSE;
      count += 6; //Sizeof a subchunk header
      if (strncmp(buf, "COLR", 4)==0){
        //Found colour
        if (!ReadFloat(fp, f)) return FALSE;
        srf->red = (BYTE)(f * 255.0f);
```

```
                            if (!ReadFloat(fp, f)) return FALSE;
                            srf->green = (BYTE)(f * 255.0f);
                            if (!ReadFloat(fp, f)) return FALSE;
                            srf->blue = (BYTE)(f * 255.0f);
                            if (!ReadShort(fp, e)) return FALSE;
                            if (e!=0){
                                AfxMessageBox("Colour envelopes not supported");
                                return FALSE;
                            }
                            count += sublength;
                            continue;
                        }
                        //If we got to here then the chunk was
                        // not found so skip by byte aligned sublength
                        if (sublength%2){
                            fseek(fp, sublength+1, SEEK_CUR);
                            count += (sublength+1);
                        }else{
                            fseek(fp, sublength, SEEK_CUR);
                            count += sublength;
                        }
                    }
                }
            }

            return TRUE;
        }
```

The simple application LWLoader in the examples for this chapter on the CD should load most Lightwave 6 files. The application makes no attempt to scale the view to the size of the object, so if the object is much smaller than 5 units high or much bigger then it will appear either too small or two big on the screen. A couple of suitably sized objects can be found in the Objects folder for this chapter.

More about surfaces

Toon3D uses many more features of the surface chunk and we will look now at how these are loaded and how we use the details stored in the object file to assign complex textures to our polygons. This function call is suitable for LWO1 objects created with Lightwave 5+. Many of the same features are found in the surface sub-chunks in an LW02 file created with

Lightwave 6+; for full documentation on LWO2 sub-chunks, see the details at the end of this book.

COLR LWO1 files store colours as 1-byte integers for red, green and blue.
VDIF A floating-point value that stores the diffuse level.
VLUM A floating-point value that stores the luminous level.
VSPC A floating-point value that stores the specular level.
VTRN A floating-point value that stores the transparency level.
CTEX A colour texture we read whether the mapping is planar, cylindrical or spherical.
TIMG If we encountered a texture then we can read the filename for the bitmap.
TWRP A flag indicating whether a texture tiles.
TSIZ The overall size of a texture used by planar and cylindrical mapping.
TCTR The centre of the texture.
TFP0 Used to store special data about a texture, we use it simply for the width repeat total.
TFP1 Used to store special data about a texture, we use it simply for the height repeat total.

Using these sub-chunks we can create a fully textured object. Lightwave until version 6 did not store any texture coordinates in an object or scene file. Anyone parsing a pre 6 file has to generate the texture coordinates themselves. The more detailed surface loader is as follows:

```
BOOL CLWObject::LoadSurface(FILE* fp, int length)
{
  char buf[5], nm[128];
  int r, count, index;
  unsigned short s;
  SURFACE *srf = &srfs[index];
  float flt;

  if (index>=numsurfaces) return FALSE; //Index out of range

  //Read name
  ReadString(fp, nm, count, 127);

  index=0;
  //Try to find the name
```

Real-time 3D Character Animation with Visual C++

```
while(strcmp(tag[index], nm)){
    index++;
    if (index>=numsurfaces) return FALSE; //Surface name not found
}
srf = &srfs[index];

//Set some default values
srf->diffuse=1.0f;
srf->transparency=0.0f;

//Read sub-chunks
while (count<length){
    if (!ReadSubChunk(buf,s,fp)) return FALSE;
    count+=(s + 6);
    if (strcmp(buf,"COLR")==0){
        //Found colour
        r=fread(buf,4,1,fp); if (r!=1) return FALSE;
        srf->r=buf[0]; srf->g=buf[1]; srf->b=buf[2];
        continue;
    }
    if (strcmp(buf,"VDIF")==0){
        ReadFloat(fp,srf->diffuse);
        continue;
    }
    if (strcmp(buf,"VLUM")==0){
        ReadFloat(fp,flt);
        if(flt>0.0f)srf->flag+=SRF_FLAG_LUMINOUS;
        continue;
    }
    if (strcmp(buf,"VSPC")==0){
        ReadFloat(fp,srf->specular);
        continue;
    }
    if (strcmp(buf,"SMAN")==0){
        ReadFloat(fp,flt);
        continue;
    }
    if (strcmp(buf,"VTRN")==0){
        //Found transparency
        ReadFloat(fp,srf->transparency);
        continue;
    }
```

```
if (strcmp(buf,"FLAG")==0){
    //Found flag
    ReadShort(fp,srf->flag);
    continue;
}
if (strcmp(buf,"TFP0")==0){
    //Found algorithmic texture parameter 0
    if (srf->tex) ReadFloat(fp,srf->tex->widthwrap);
    continue;
}
if (strcmp(buf,"TFP1")==0){
    //Found algorithmic texture parameter 1
    if (srf->tex) ReadFloat(fp,srf->tex->heightwrap);
    continue;
}
if (strcmp(buf,"CTEX")==0){
    if (srf->tex==NULL) srf->tex=new TEXTURE;
    if (!srf->tex) return FALSE;
    srf->tex->texID=0;//Default
    srf->tex->tiling=(2<<16)+2;//Default
    srf->tex->centre.x=0.0;
    srf->tex->centre.y=0.0;
    srf->tex->centre.z=0.0;
    srf->tex->size.x=1.0;
    srf->tex->size.y=1.0;
    srf->tex->size.z=1.0;
    fread(nm,s,1,fp); nm[s]=0;
    if (strcmp(nm,"Planar Image Map")==0)
        srf->tex->type=TEX_PLANAR;
    if (strcmp(nm,"Cylindrical Image Map")==0)
        srf->tex->type=TEX_CYLINDRICAL;
    if (strcmp(nm,"Spherical Image Map")==0)
        srf->tex->type=TEX_SPHERICAL;
    continue;
}
if (strcmp(buf,"TIMG")==0){
    //Read name
    fread(srf->tex->name,s,1,fp);
    continue;
}
if (strcmp(buf,"TWRP")==0){
    ReadInt(fp,srf->tex->tiling);
```

```
            continue;
        }
        if (strcmp(buf,"TFLG")==0){
            ReadShort(fp,srf->tex->flag);
            continue;
        }
        if (strcmp(buf,"TSIZ")==0){
            ReadFloat(fp,srf->tex->size.x);
            ReadFloat(fp,srf->tex->size.y);
            ReadFloat(fp,srf->tex->size.z);
            srf->tex->size.z=-srf-tex->size.z;
            continue;
        }
        if (strcmp(buf,"TCTR")==0){
            ReadFloat(fp,srf->tex->centre.x);
            ReadFloat(fp,srf->tex->centre.y);
            ReadFloat(fp,srf->tex->centre.z);
            srf->tex->centre.z=-srf->tex->centre.z;
            continue;
        }
        //If we got to here then the chunk was not found so skip by s
        fseek(fp,s,SEEK_CUR);
    }

    return TRUE;
}
```

Generating texture coordinates

Most CGI packages store texture coordinates in the file. Lightwave until version 6 stored details about the texture coordinates but forced the developer to recreate the texture coordinates from this information. In this section we will look at how to generate texture coordinates from the details that Lightwave provides.

Generating the texture coordinates can be done using the texture size, centre and mapping type. Toon3D stores the texture coordinates in the POLYGON structure, inside an indexed array of type TVEC. As we know from the texture mapping chapter, it is common practice to refer to texture coordinates as (u, v), where u is a number from 0 to 1 that defines a position across the bitmap texture from 0 to texture width in pixels, and v is a number between 0 and 1 that defines a position down the bitmap texture from 0 to texture height in pixels. The first step in creating the

texture coordinates involves checking the mapping type and using the flag member of the surface variable to switch to the appropriate axis. Let's look at the principle texturing methods.

Planar mapping

As we know from Chapter 6, planar mapping takes an image and projects it parallel down one of the axes. If the axis is *z*, for a planar texture then the coordinates are applied with the *x*-axis running left to right and the *y*-axis running up and down. For each polygon we loop through the vertices. The actual texture coordinates are found by subtracting the texture centre from the current point, then dividing by the size of the texture. This will result in texture coordinates that run from −0.5 to 0.5 assuming that automatic sizing was used in Lightwave to determine the texture size and centre. When automatic sizing is used, Lightwave loops through all the polygons in a scene that uses the current surface; for each vertex in a polygon it stores the maximum and minimum values. Then it subtracts the minimum from the maximum to get the size, divides this by 2 and adds back the minimum to define the centre. OpenGL uses texture coordinates that run from 0.0 to 1.0, so we add 0.5 to the calculation to re-centre the texture suitable for OpenGL.

```
switch (tex->flag & 0x07){
//Only axis bits are supported. Flag bits are
//7  NU
//6  AntiAlias
//5  PixelBlend
//4  Negative Image
//3  World Coord
//2  Z axis
//1  Y axis
//0  X axis
case 1://X axis
    for (i=0; i<ply->numverts; i++){
        pt=&pts[ply->p[i]];
        ply->tc[i].u = ((float)pt->z - tex->centre.z)/
            tex->size.z + 0.5f;
        ply->tc[i].v = ((float)pt->y - tex->centre.y)/
            tex->size.y + 0.5f;
    }
    break;
case 2://Y axis
```

```
        for (i=0; i<ply->numverts; i++){
            pt=&pts[ply->p[i]];
            ply->tc[i].u=((float)pt->x - tex->centre.x)/
                tex->size.x + 0.5f;
            ply->tc[i].v=((float)pt->z - tex->centre.z)/
                tex->size.z + 0.5f;
        }
        break;
    case 4://Z axis
        for (i=0; i<ply->numverts; i++){
            pt=&pts[ply->p[i]];
            ply->tc[i].u=((float)pt->x - tex->centre.x)/
                tex->size.x + 0.5f;
            ply->tc[i].v=((float)pt->y - tex->centre.y)/
                tex->size.y + 0.5f;
        }
        break;
    }
```

Cylindrical and spherical mapping

For the principles of cylindrical and spherical mapping, refer to Chapter 6.

UV mapping

Beginning with Lightwave 6, an object file can contain UV texture coordinates. UV mapped textures use vertex maps, defined in the object file as a VMAP sub-chunk of type TXUV to hold the U and V texture coordinates. TXUV VMAPs have a dimension of 2. A very simple VMAP chunk that defines the u, v texture coordinates for one polygon of a cube. Vertex 2 will use texture coordinates (0, 0), vertex 3 uses coordinates (1, 0), vertex 6 uses coordinates (0, 1) and vertex 7 uses coordinates (1, 1). In this example the full texture is mapped to the polygon.

```
VMAP 58
    TXUV
    2
    "UV Texture"
    2  0.0  0.0
    3  1.0  0.0
    6  0.0  1.0
    7  1.0  1.0
```

This VMAP chunk is used by a SURF chunk which is defined as using UV mapping. In the following example you can see the differences between an LWO1 object and an LWO2 object. A SURF chunk still has multiple sub-chunks, but these have changed subtly. First, we have a name, followed by the name of the parent of the surface. COLR defines the rgb colour of a surface; these values have changed for 1-byte integers to floating-point values. DIFF gives the diffuse level and SPEC the specularity. If a texture map is applied then it is defined in a BLOK chunk.

The first field of the BLOK header (the IMAP sub-chunk) is called an *ordinal string*. When multiple textures are applied to a surface channel, the ordinal string determines the order in which they're evaluated. Object readers can sort BLOKs by using 'strcmp' to compare the ordinal strings.

The rest of the BLOK header identifies which surface channel the texture layer modifies, the layer's opacity, whether it is enabled, whether its output is inverted, and what the default axis is. The sub-chunks following the TMAP are specific to IMAP layers. The AXIS sub-chunk overrides the default in the IMAP header. The IMAG sub-chunk contains a CLIP index that identifies the image. CLIP chunks work rather like TAGS chunks in that they define an indexed list of string values. They are formatted as follows:

```
CLIP 30
     1
     STIL 20
     "Images/testbars.iff"
```

A full description of the UV SURF chunk follows:

```
SURF 348
   "UVExample"
   " "
   COLR 14    0.78431  0.78431  0.78431  0
   DIFF 6     1.0  0
   SPEC 6     0.0  0
   BLOK 286
      IMAP 50
         "\x80"
         CHAN 4    COLR
         OPAC 8    0  1.0  0
         ENAB 2    1
```

```
    NEGA 2    0
    AXIS 2    1
TMAP 104
    CNTR 14    0.0  0.0  0.0
         0
    SIZE 14    1.0  1.0  1.0  0
    ROTA 14    0.0  0.0  0.0  0
    FALL 16    0  0.0  0.0  0.0  0
    OREF 8     "(none)"
    CSYS 2     0
PROJ 2     5
AXIS 2     2
IMAG 2     1
WRAP 4     1  1
WRPW 6     1.0  0
WRPH 6     1.0  0
VMAP 12    "UV Texture"
AAST 6     1  1.0
PIXB 2     1
STCK 6     0.0  0
TAMP 6     1.0  0
```

Although most of these chunks can safely be ignored, we still have a complete TMAP sub-chunk. A TMAP sub-chunk defines a texture's centre, size and rotation, which for a UV chunk is really unnecessary. The value in PROJ (projection) has changed from 0 (planar) to 5 (UV), and a VMAP sub-chunk identifies the TXUV VMAP by name.

Lightwave scene files

Lightwave stores everything to do with an object in the object file. We have looked at how to read this binary file to get the geometry and surface details. Lightwave uses scene files to store the hierarchy of objects, how they animate, the lights used to display these objects and the movement of the camera. A scene file is simply a text file.

We will look first at a Lightwave scene file that displays a single unit cube, positioned at the origin and not rotated. The cube rotates through 360° between frame 1 and frame 50. The scene uses a single distant light and the camera points down the z-axis towards the cube. The camera is raised slightly above the ground and is pointing down towards the cube. All scene files start with a configuration section.

Figure 10.1 Lightwave 6 – unit cube scene.

Reading the configuration section

The first line defines this text file as a Lightwave Scene file and the following line gives the version number. Lightwave 6 uses a scene file version number of 3. A Lightwave scene file has a start frame and end frame which are declared in the file as 'FirstFrame' and 'LastFrame'. When using the software it is possible to render every frame or every second frame or skip more than one frame when moving through the frames; the 'FrameStep' value gives the amount of frames to move on by for each rendered frame. Previews in Lightwave can use a different start and end frame, which are defined by 'PreviewFirstFrame' and 'PreviewLastFrame'. When previews are created the renderer moves on by 'PreviewFrameStep' amount as each frame is finished. 'Current-Frame' defines the frame that was being viewed when the file was saved. 'FramesPerSecond' gives the relationship between frame values and time. For the sample file the configuration section is given below:

```
LWSC
3

FirstFrame 1
LastFrame 60
FrameStep 1
PreviewFirstFrame 0
PreviewLastFrame 60
PreviewFrameStep 1
CurrentFrame 50
FramesPerSecond 25
```

Reading an object layer section

The objects that are used in a file are defined using 'LoadObjectLayer'. Since a single object can contain multiple layers, the integer value following the 'LoadObjectLayer' declaration defines which of these layers to load where multiple layers are present.

```
LoadObjectLayer 1 Objects/UnitCube.lwo
```

The remainder of the line is a path from the content directory to the object file. When parsing the scene file you would now need to load and parse this file to get at the object geometry and surface data. In the next chapter we will look at the way 3DS approaches the same problem and discover that 3DS chooses to store everything in a single file.

```
ShowObject 6 3
```

This next line declares the object visibility inside the application. Lightwave allows the animator to view an object as wireframe, smooth shaded or textured, or turn off the object's visibility altogether. When creating animations this is a useful feature since it improves update performance and can remove some clutter from the display when editing. The second of the two integer values defines the wireframe colour from a limited set of colours that Lightwave uses for objects displayed in wireframe format.

```
ObjectMotion
NumChannels 9
Channel 0
```

```
{ Envelope
  1
  Key 0 0 0 0 0 0 0 0 0
  Behaviors 1 1
}
Channel 1
{ Envelope . . . . . .
```

The next section when parsing an object layer involves reading the 'ObjectMotion'. The first line after 'ObjectMotion' declares the number of channels involved in the motion. Lightwave uses nine channels, three for position, three for orientation and three for scale.

```
ObjectMotion
NumChannels 9
Channel 0
{ Envelope
  nkeys
  Key value time smoothing p1 p2 p3 p4 p5 p6
  Behaviors pre post
  Key ...
}
Channel 1
{ Envelope ...
```

When parsing a channel the values found are:

- **nkeys** – the number of keys.
- **value** – the key value.
- **time** – the time in seconds.
- **smoothing** – the curve type, an index into the pop-up list on the graph editor, currently
 0 TCB (Kochanek–Bartels)
 1 Hermite
 2 Bezier
 3 Linear
 4 Stepped
- **Curve parameters**
 p1 Tension
 p2 Continuity
 p3 Bias
 p4 Incoming tangent

p5 Outgoing tangent

p6 Reserved

- **pre**, **post** – pre- and post-behaviours, an index into the graph editor pop-up, currently

0 Reset

1 Constant

2 Repeat

3 Oscillate

4 Offset Repeat

5 Linear

The only remaining line guaranteed to be in an object layer section is

ShadowOptions 7

This defines whether the object receives and casts shadows. The integer value is based on a combination of bit position flags.

Table 10.1

Bit position	Description
0	Self shadow
1	Cast shadow
2	Receive shadow

Other sections can be present in an object layer section and one that is often used is the value for Parent.

```
ParentItem 10000000
```

This is defined as a 32-bit hex value. The first character defines the parent type. It could be

```
1 = object
2 = light
3 = camera
4 = bone
```

The remaining values are simply an index into the number of that type in the scene file. In the example the parent would be the first object found in the scene file.

Reading the lights section

Lightwave uses a global ambient value which is defined in the lights section using floating-point values for colour.

```
AmbientColor 1 1 1
AmbientIntensity 0.25
```

Each light that is found follows a line containing 'AddLight'. The motion of a light is read in the same way as the motion of an object.

```
AddLight
LightName Light
ShowLight 1 5
LightMotion
NumChannels 9
Channel 0
{ Envelope
  1
  Key -2 0 0 0 0 0 0 0
  Behaviors 1 1
}
Channel 1
{ Envelope. . ..
```

Light colour and intensity are defined as floating-point values. The 'LightType' value is an index value that can be

```
LightColor 1 1 1
LightIntensity 1
AffectCaustics 1
LightType 0
ShadowType 1
```

Reading the camera section

The camera section uses motion that can be read in the same way as an object; only six channels are present, the values for scale are not used.

```
AddCamera
CameraName Camera
```

```
ShowCamera 1 2
CameraMotion
NumChannels 6
Channel 0
{ Envelope
  1
  Key 0 0 0 0 0 0 0 0
  Behaviors 1 1
}
Channel 1
{ Envelope . . ..
```

To match the way a scene appears in Lightwave, you will need to take into consideration the 'ZoomFactor' when creating a projection. 'Zoom-Factor' defines the angle of view of a camera. In Toon3D the match is made with this code. This was created in true trial and error fashion, but has proved to be fairly representative of most values of 'ZoomFactor':

```
zf = camera->zoomFactor;
fAspect=(GLfloat)m_width/(GLfloat)m_height;
fovy=(GLfloat)((sin((90.0/zf)*DEG2RAD)*90.0+90.0/zf)/2.0);
glMatrixMode(GL_PROJECTION);
glLoadIdentity();
//Field of view, near and far planes
gluPerspective(fovy,fAspect,0.1f,2000.0f);
}
```

```
ZoomFactor 3.2
MotionBlur 0
```

Rendering options

You may choose to use or ignore the rendering options. Backdrop colours can be useful. Toon3D brings in the grid size values, since these are useful in an interactive design environment.

```
ResolutionMultiplier 1.0
FrameSize 640 480
PixelAspect 1
MaskPosition 0 0 640 480
ApertureHeight 0.015
```

```
Antialiasing 0
AdaptiveSampling 1
AdaptiveThreshold 0.1
FieldRendering 0

SolidBackdrop 1
BackdropColor 0 0 0
ZenithColor 0 0.1569 0.3137
SkyColor 0.4706 0.7059 0.9412
GroundColor 0.1961 0.1569 0.1176
NadirColor 0.3922 0.3137 0.2353
FogType 0
DitherIntensity 1
AnimatedDither 0

RenderMode 2
RayTraceEffects 0
DataOverlayLabel
FullSceneParamEval 0

ViewConfiguration 0
DefineView 0
ViewMode 5
ViewAimpoint 0 0 0
ViewRotation -17.2 18 0
ViewZoomFactor 4

GridNumber 80
GridSize 0.2
CameraViewBG 0
ShowMotionPath 1
ShowFogRadius 0
ShowFogEffect 0
ShowSafeAreas 0
ShowFieldChart 0

CurrentObject 0
CurrentLight 0
CurrentCamera 0
GraphEditorFavorites
{ GraphEd_Favorites
}
```

Real-time 3D Character Animation with Visual C++

Summary

Lightwave presents the developer with the best documentation of all the leading CGI packages. It also has a very useful mailing list that affords developers almost direct access to the key Lightwave programmers. For these reasons, it is the author's favourite development application. In this chapter we looked at how we can read Lightwave object files to access geometry and texture data, and at how to extract motion and hierarchy information from a Lightwave scene file.

11 Importing geometry and animation from 3DS Max

Getting information about the file format for 3DS Max has proved very difficult. No doubt once this book is published someone will point me in the right direction, but I have tried many user groups without success. There are some limited and unreliable documents available for the '3DS' format, but very little about Max. In the end, I decided to derive the information I required from an ASCII export of a 3DS Max scene file. 3DS Max differs from Lightwave by combining geometry, surface and motion into a single file, and provides the option to export this as a plain text file. In this chapter we will look at getting the geometry, surface and motion data out of this file.

An ASCII export of a static cube scene

To export from Max in ASCII format choose 'Export as text' from the export sub-menu.

Having saved the scene off, you will have created a scene with an 'ASE' extension. We will look at how to parse a scene containing a single cube. Any ASE parser needs to check the file to make sure that this is in the correct format. The first line of any ASE file contains the tag '*3DSMAX_ ASCIIEXPORT'. In a parser we first confirm this before moving on. If the line does not contain this tag then it is not a suitable ASE file and your parser can return FALSE, to indicate an import error or return a numerical value indicating the type of error.

```
*3DSMAX_ASCIIEXPORT 200
```

The next line in any ASE file is a comment containing the export version number and the date and time of exporting. If you want to retain this information then you could store it; most parsers will simply ignore it.

Figure 11.1 Exporting a scene from Max.

```
*COMMENT "AsciiExport Version 2.00 – Sun Apr 08 23:21:17 2001"
```

An ASE file is structured using opening and closing braces, { and }. At the root level the tags you find are SCENE, MATERIAL_LIST, GEOM-OBJECT and CAMERAOBJECT. Any section can contain an unlimited number of subsections. Any parser must work within a section and not read beyond it when parsing the file. The first section you will find in most ASE files is the SCENE section.

The SCENE section

The SCENE section contains tags SCENE_FILENAME, SCENE_FIRST-FRAME, SCENE_LASTFRAME, SCENE_FRAMESPEED, SCENE_TICKSPERFRAME, SCENE_BACKGROUND_STATIC, SCENE_AMBI-ENT_STATIC, SCENE_BACKGROUND_ANIM and SCENE_AMBIENT_ANIM. The first three of these are self-explanatory. SCENE_FRAMESPEED stores the frames per second value. SCENE_TICKSPER-FRAME is unique to Max. In 3DS Max, time values are stored as integers,

but instead of storing frame 20, for example, as the numerical value 20, the value is stored as 20 * SCENE_TICKSPERFRAME. If SCENE_ TICKSPERFRAME is 160 then the stored value for frame 20 will be

$$20 \times 160 = 3200$$

The tag SCENE_BACKGROUND_STATIC stores the background colour in RGB format. Each value is stored as a floating-point value with the maximum value of a colour component being represented by 1.0 and the minimum value being represented by 0.0. The tag SCENE_AMBIENT_ STATIC stores the global ambient lighting level as an RGB value stored in the same way as the background colour tag. Both the background colour and the ambient level can change over time; if this is the case then the tags SCENE_BACKGROUND_ANIM and SCENE_AMBIENT_ANIM will be present. We will look at parsing an animation section later in this chapter.

```
*SCENE {
    *SCENE_FILENAME "Box.max"
    *SCENE_FIRSTFRAME 0
    *SCENE_LASTFRAME 100
    *SCENE_FRAMESPEED 30
    *SCENE_TICKSPERFRAME 160
    *SCENE_BACKGROUND_STATIC 0.0000  0.0000  0.0000
    *SCENE_AMBIENT_STATIC 0.0431  0.0431  0.0431
}
```

The MATERIAL_LIST section

As is so often the case with CGI data structures, the materials section is the most complex to parse. It contains many subsections that need to be individually handled. When parsing a MATERIAL_LIST section I did a lot of guessing; if any reader is aware of errors then please contact me by mailing nik@toon3d.com. An update will be available for readers at toon3d.com/book; this will contain updated source code as it becomes available and will address any errors that are pointed out.

When parsing the material list, the first tag is MATERIAL_COUNT. This gives a numerical value of the total number of materials in the list. At the root of the MATERIAL_LIST section the only other tag is MATERIAL, followed by an integer giving the material number. The MATERIAL section is a subsection of MATERIAL_LIST. A MATERIAL subsection uses a large

number of tags; the ones we will examine are MATERIAL_NAME, MATERIAL_CLASS, MATERIAL_AMBIENT, MATERIAL_DIFFUSE, MATERIAL_SPECULAR, MATERIAL_SHINE, MATERIAL_SHINE-STRENGTH, MATERIAL_TRANSPARENCY, MATERIALS_WIRESIZE, MATERIAL_SELFILLUM, MAP_DIFFUSE, NUMSUBMTLS and SUB-MATERIAL. MATERIAL_NAME is self-explanatory. MATERIAL_CLASS indicates whether this material contains sub-materials or not. A value of 'Multi/Sub-Object' indicates sub-materials will be present, whilst a value of 'Standard' indicates that the material contains only the base values. When we read the polygon list each polygon has an integer indicating which material to use. In addition, an object is given a material integer. For a material that contains no sub-materials, the integer defines the base material and will be zero. For a material that contains sub-materials, the integer defines the sub-material to use.

The material tags MATERIAL_AMBIENT, MATERIAL_DIFFUSE and MATERIAL_SPECULAR define RGB values for the ambient, diffuse and specular components. MATERIAL_SHINE and MATERIAL_SHINE-STRENGTH are used along with the specular component to define the glossiness of a surface. MATERIAL_TRANSPARENCY defines the transparency, with 0.0 being opaque and 1.0 being totally transparent. MATERIAL_WIRESIZE is used by the editor to indicate the wireframe line width. MATERIAL_SELFILLUM indicates the luminance level for this surface.

The tag MAP_DIFFUSE contains another subsection contained within opening and closing braces. A map subsection contains a great deal of information and we will look at this later in the chapter.

When a material contains sub-materials the total number is defined using the NUMSUBMTLS tag. Each sub-material is defined using a SUBMATERIAL tag containing a consecutively numbered integer starting at zero. 3DS Max can contain an unlimited number of nested sub-materials. When reading a sub-material the tags are the same as the base MATERIAL.

```
*MATERIAL_LIST {
    *MATERIAL_COUNT 1
    *MATERIAL 0 {
        *MATERIAL_NAME "Box"
        *MATERIAL_CLASS "Multi/Sub-Object"
        *MATERIAL_AMBIENT 0.1000  0.1000  0.1000
        *MATERIAL_DIFFUSE 0.5000  0.5000  0.5000
        *MATERIAL_SPECULAR 0.9000  0.9000  0.9000
        *MATERIAL_SHINE 0.2500
```

```
*MATERIAL_SHINESTRENGTH 0.0500
*MATERIAL_TRANSPARENCY 0.0000
*MATERIAL_WIRESIZE 1.0000
*NUMSUBMTLS 6
*SUBMATERIAL 0 {
    *MATERIAL_NAME "BoxTexture"
    *MATERIAL_CLASS "Standard"
    *MATERIAL_AMBIENT 0.1791  0.0654  0.0654
    *MATERIAL_DIFFUSE 0.5373  0.1961  0.1961
    *MATERIAL_SPECULAR 0.9000  0.9000  0.9000
    *MATERIAL_SHINE 0.2500
    *MATERIAL_SHINESTRENGTH 0.0500
    *MATERIAL_TRANSPARENCY 0.0000
    *MATERIAL_WIRESIZE 1.0000
    *MATERIAL_SHADING Blinn
    *MATERIAL_XP_FALLOFF 0.0000
    *MATERIAL_SELFILLUM 0.0000
    *MATERIAL_FALLOFF In
    *MATERIAL_XP_TYPE Filter
    *MAP_DIFFUSE { . . .
```

Reading a MAP subsection

A MAP subsection has several tags. We will only consider MAP_NAME and BITMAP. Other values are available if you are using multi-texture blends and *u*, *v* offsets from the stored texture coordinates. MAP_NAME supplies a human readable name for this map. BITMAP defines the bitmap source of this map. A map does not have to be bitmap based, it can be procedural.

```
*MAP_DIFFUSE {
    *MAP_NAME "BoxGridMap"
    *MAP_CLASS "Bitmap"
    *MAP_SUBNO 1
    *MAP_AMOUNT 1.0000
    *BITMAP "boxgridmap.tga"
    *MAP_TYPE Screen
    *UVW_U_OFFSET 0.0000
    *UVW_V_OFFSET 0.0000
    *UVW_U_TILING 1.0000
    *UVW_V_TILING 1.0000
```

```
*UVW_ANGLE 0.0000
*UVW_BLUR 1.0000
*UVW_BLUR_OFFSET 0.0000
*UVW_NOUSE_AMT 1.0000
*UVW_NOISE_SIZE 1.0000
*UVW_NOISE_LEVEL 1
*UVW_NOISE_PHASE 0.0000
*BITMAP_FILTER Pyramidal
}. . .
```

Reading a GEOMOBJECT section

The next root level tag to consider is GEOMOBJECT. The tags we will look at are NODE_NAME, NODE_PARENT, NODE_TM, MESH and MATERIAL_REF. The NODE_NAME tag is a simple string giving the object name. NODE_PARENT indicates the parent of this object by name reference. MATERIAL_REF is an integer value into the material list. NODE_TM and MESH are subsections that we will look at individually.

```
*GEOMOBJECT {
    *NODE_NAME "Box"
    *NODE_PARENT "BoxParent"
    *NODE_TM {. . .
    }
    *MESH {. . .
    }
    *PROP_MOTIONBLUR 0
    *PROP_CASTSHADOW 1
    *PROP_RECVSHADOW 1
    *MATERIAL_REF 0
}
```

Reading a NODE_TM section

The NODE_TM section defines the position of the object. The tags TM_ROW0 to TM_ROW3 supply the matrix for the object in 4×4 format with the last column missing. TM_ROW0 to TM_ROW2 give the 3×3 rotation matrix and TM_ROW3 gives the translation. Orientations in 3DS Max are provided as angle axis. TM_ROTAXIS supplies the rotational axis and



TM_ROTANGLE gives the angle in radians. Scale is provided as three component values using the TM_SCALE tag.

```
*NODE_TM {
    *NODE_NAME "Box"
    *INHERIT_POS 0 0 0
    *INHERIT_ROT 0 0 0
    *INHERIT_SCL 0 0 0
    *TM_ROW0 0.0000  1.0000  0.0000
    *TM_ROW1 0.0000  0.0000  1.0000
    *TM_ROW2 1.0000  0.0000  -0.0000
    *TM_ROW3 -48.7847  -1.1912  2.4400
    *TM_POS -48.7847  -1.1912  2.4400
    *TM_ROTAXIS -0.5774  -0.5774  -0.5774
    *TM_ROTANGLE 2.0944
    *TM_SCALE 1.0000  1.0000  1.0000
    *TM_SCALEAXIS 0.0000  0.0000  0.0000
    *TM_SCALEAXISANG 0.0000
}
```

Reading the MESH section

The MESH section contains the tags MESH_NUMVERTEX, MESH_NUMFACES, MESHVERTEX_LIST, MESH_FACE_LIST, MESH_NUMTVERTEX, MESH_TVERTLIST, MESH_NUMCVERTEX, MESH_CVERTLIST and MESH_NORMALS. MESH_NUMVERTEX, MESH_NUMFACES, MESH_NUMTVERTEX and MESH_NUMCVERTEX are all single integer values giving the total number of vertices, polygons, texture vertices and colour vertices respectively. The other values are subsections defining the content of the lists.

```
*MESH {
    *TIMEVALUE 0
    *MESH_NUMVERTEX 8
    *MESH_NUMFACES 12
    *MESH_VERTEX_LIST {. . .
    }
    *MESH_FACE_LIST {. . .
    }
    *MESH_NUMTVERTEX 12
```

```
*MESH_TVERTLIST {. . .
}
*MESH_NUMCVERTEX 0
*MESH_NORMALS {. . .
}
```

Reading the vertex list

There will be MESH_NUMVERTEX lines in a MESH_VERTEX_LIST subsection. Each line contains a MESH_VERTEX tag, followed by an index for the current vertex and then three values defining the (*x, y, z*) value of the vertex.

```
*MESH_VERTEX_LIST {
    *MESH_VERTEX  0  -48.7847  -51.1912  -47.5600
    *MESH_VERTEX  1  -48.7847   48.8088  -47.5600
    *MESH_VERTEX  2  -48.7847  -51.1912   52.4400
    *MESH_VERTEX  3  -48.7847   48.8088   52.4400
    *MESH_VERTEX  4   51.2153  -51.1912  -47.5601
    *MESH_VERTEX  5   51.2153   48.8088  -47.5601
    *MESH_VERTEX  6   51.2153  -51.1912   52.4399
    *MESH_VERTEX  7   51.2153   48.8088   52.4399
}
```

Reading the face list

The MESH_FACE_LIST subsection contains MESH_NUMFACES lines. Each line starts with a MESH_FACE tag followed by an index value for the current face. The remainder of a line contains values for A, B, C, AB, BC, CA, MESH_SMOOTHING, MESH_MTLID. A, B and C give indices into the vertex list for this triangle. All polygons in 3DS are triangles. MESH_ SMOOTHING defines which sets of polygons are to be smoothed together. MESH_MTLID defines an integer value. The full GEOMOBJECT of which MESH_FACE_LIST is a subsection contains a MATERIAL_REF tag. This is an index into the global level material list. If the material referred to is of class 'Multi/Sub Object' then the value of MESH_MTLID refers to the sub-material index. If the material is of class 'Standard' then the index refers to the root of the material.

```
*MESH_FACE_LIST {
  *MESH_FACE  0:    A:    0 B:    2 C:    3 AB:    1 BC:  1 CA:
                0        *MESH_SMOOTHING 2      *MESH_MTLID 1
  *MESH_FACE  1:    A:    3 B:    1 C:    0 AB:    1 BC:  1 CA:
                0        *MESH_SMOOTHING 2      *MESH_MTLID 1
  *MESH_FACE  2:    A:    4 B:    5 C:    7 AB:    1 BC:  1 CA:
                0        *MESH_SMOOTHING 3      *MESH_MTLID 0
  *MESH_FACE  3:    A:    7 B:    6 C:    4 AB:    1 BC:  1 CA:
                0        *MESH_SMOOTHING 3      *MESH_MTLID 0
  *MESH_FACE  4:    A:    0 B:    1 C:    5 AB:    1 BC:  1 CA:
                0        *MESH_SMOOTHING 4      *MESH_MTLID 4
  *MESH_FACE  5:    A:    5 B:    4 C:    0 AB:    1 BC:  1 CA:
                0        *MESH_SMOOTHING 4      *MESH_MTLID 4
  *MESH_FACE  6:    A:    1 B:    3 C:    7 AB:    1 BC:  1 CA:
                0        *MESH_SMOOTHING 5      *MESH_MTLID 3
  *MESH_FACE  7:    A:    7 B:    5 C:    1 AB:    1 BC:  1 CA:
                0        *MESH_SMOOTHING 5      *MESH_MTLID 3
  *MESH_FACE  8:    A:    3 B:    2 C:    6 AB:    1 BC:  1 CA:
                0        *MESH_SMOOTHING 6      *MESH_MTLID 5
  *MESH_FACE  9:    A:    6 B:    7 C:    3 AB:    1 BC:  1 CA:
                0        *MESH_SMOOTHING 6      *MESH_MTLID 5
  *MESH_FACE 10:    A:    2 B:    0 C:    4 AB:    1 BC:  1 CA:
                0        *MESH_SMOOTHING 7      *MESH_MTLID 2
  *MESH_FACE 11:    A:    4 B:    6 C:    2 AB:    1 BC:  1 CA:
                0        *MESH_SMOOTHING 7      *MESH_MTLID 2
}
```

Reading the texture vertex list

The MESH_TVERTLIST contains MESH_NUMTVERTS lines. Each line begins with the tag MESH_TVERT followed by the index of the current vertex. The next two values give (u, v) values for the vertex. Connecting these data to a polygon is done using the MESH_TFACELIST.

```
*MESH_TVERTLIST {
    *MESH_TVERT 0    0.0000    0.0000    0.0000
    *MESH_TVERT 1    1.0000    0.0000    0.0000
    *MESH_TVERT 2    0.0000    1.0000    0.0000
    *MESH_TVERT 3    1.0000    1.0000    0.0000
    *MESH_TVERT 4    0.0000    0.0000    0.0000
    *MESH_TVERT 5    1.0000    0.0000    0.0000
```

```
    *MESH_TVERT 6      0.0000    1.0000    0.0000
    *MESH_TVERT 7      1.0000    1.0000    0.0000
    *MESH_TVERT 8      0.0000    0.0000    0.0000
    *MESH_TVERT 9      1.0000    0.0000    0.0000
    *MESH_TVERT 10     0.0000    1.0000    0.0000
    *MESH_TVERT 11     1.0000    1.0000    0.0000
}
```

Reading the texture face list

The MESH_TFACELIST contains MESH_NUMTFACES lines. Each line begins with the tag MESH_TFACE followed by the index of the current vertex. The next three values give integer indices from the texture vertex list. The integer value for a texture face and the integer value for a face refer to the same polygon, so you can connect the texture coordinate values to the actual polygon and vertex data.

```
*MESH_TFACELIST {
    *MESH_TFACE 0      9    11    10
    *MESH_TFACE 1     10     8     9
    *MESH_TFACE 2      8     9    11
    *MESH_TFACE 3     11    10     8
    *MESH_TFACE 4      4     5     7
    *MESH_TFACE 5      7     6     4
    *MESH_TFACE 6      0     1     3
    *MESH_TFACE 7      3     2     0
    *MESH_TFACE 8      4     5     7
    *MESH_TFACE 9      7     6     4
    *MESH_TFACE 10     0     1     3
    *MESH_TFACE 11     3     2     0
}
```

Reading the normals list

The MESH_NORMALS subsection contains MESH_NUMFACES mini-sections that define the face and vertex normals for each face. To parse this subsection read the MESH_FACENORMAL section; this contains an index for the current face and a vector defining the unit length normal. Three MESH_VERTEXNORMAL lines follow each MESH_FACENOR-MAL. The MESH_VERTEXNORMAL line contains an index defining the index of the vertex, followed by a vector defining the unit length normal.

```
*MESH_NORMALS    {
    *MESH_FACENORMAL 0    0.0000    0.0000    -1.0000
        *MESH_VERTEXNORMAL 0    0.0000    0.0000    -1.0000
        *MESH_VERTEXNORMAL 2    0.0000    0.0000    -1.0000
        *MESH_VERTEXNORMAL 3    0.0000    0.0000    -1.0000
    *MESH_FACENORMAL 1    0.0000    0.0000    -1.0000
        *MESH_VERTEXNORMAL 3    0.0000    0.0000    -1.0000
        *MESH_VERTEXNORMAL 1    0.0000    0.0000    -1.0000
        *MESH_VERTEXNORMAL 0    0.0000    0.0000    -1.0000
    *MESH_FACENORMAL 2    0.0000    0.0000    1.0000
        *MESH_VERTEXNORMAL 4    0.0000    0.0000    1.0000
        *MESH_VERTEXNORMAL 5    0.0000    0.0000    1.0000
        *MESH_VERTEXNORMAL 7    0.0000    0.0000    1.0000
    *MESH_FACENORMAL 3    0.0000    0.0000    1.0000
        *MESH_VERTEXNORMAL 7    0.0000    0.0000    1.0000
        *MESH_VERTEXNORMAL 6    0.0000    0.0000    1.0000
        *MESH_VERTEXNORMAL 4    0.0000    0.0000    1.0000
    *MESH_FACENORMAL 4    0.0000    -1.0000    0.0000
        *MESH_VERTEXNORMAL 0    0.0000    -1.0000    0.0000
        *MESH_VERTEXNORMAL 1    0.0000    -1.0000    0.0000
        *MESH_VERTEXNORMAL 5    0.0000    -1.0000    0.0000
    *MESH_FACENORMAL 5    0.0000    -1.0000    0.0000
        *MESH_VERTEXNORMAL 5    0.0000    -1.0000    0.0000
        *MESH_VERTEXNORMAL 4    0.0000    -1.0000    0.0000
        *MESH_VERTEXNORMAL 0    0.0000    -1.0000    0.0000
    *MESH_FACENORMAL 6    1.0000    0.0000    0.0000
        *MESH_VERTEXNORMAL 1    1.0000    0.0000    0.0000
        *MESH_VERTEXNORMAL 3    1.0000    0.0000    0.0000
        *MESH_VERTEXNORMAL 7    1.0000    0.0000    0.0000
    *MESH_FACENORMAL 7    1.0000    0.0000    0.0000
        *MESH_VERTEXNORMAL 7    1.0000    0.0000    0.0000
        *MESH_VERTEXNORMAL 5    1.0000    0.0000    0.0000
        *MESH_VERTEXNORMAL 1    1.0000    0.0000    0.0000
    *MESH_FACENORMAL 8    0.0000    1.0000    0.0000
        *MESH_VERTEXNORMAL 3    0.0000    1.0000    0.0000
        *MESH_VERTEXNORMAL 2    0.0000    1.0000    0.0000
        *MESH_VERTEXNORMAL 6    0.0000    1.0000    0.0000
    *MESH_FACENORMAL 9    0.0000    1.0000    0.0000
        *MESH_VERTEXNORMAL 6    0.0000    1.0000    0.0000
        *MESH_VERTEXNORMAL 7    0.0000    1.0000    0.0000
        *MESH_VERTEXNORMAL 3    0.0000    1.0000    0.0000
    *MESH_FACENORMAL 10    -1.0000    0.0000    0.0000
```

```
            *MESH_VERTEXNORMAL 2    -1.0000    0.0000    0.0000
            *MESH_VERTEXNORMAL 0    -1.0000    0.0000    0.0000
            *MESH_VERTEXNORMAL 4    -1.0000    0.0000    0.0000
         *MESH_FACENORMAL 11   -1.0000    0.0000    0.0000
            *MESH_VERTEXNORMAL 4    -1.0000    0.0000    0.0000
            *MESH_VERTEXNORMAL 6    -1.0000    0.0000    0.0000
            *MESH_VERTEXNORMAL 2    -1.0000    0.0000    0.0000
      }
   }
```

When parsing a GEOMOBJECT, that covers the most important subsections.

Reading a CAMERA section

A 3DS Max file can contain multiple cameras. A camera has a name and type defined by NODE_NAME and CAMERA_TYPE. A camera has a NODE_TM subsection which defines the default position, scale and orientation. The NODE_TM subsection was described in the GEOM-OBJECT section. A camera object also has a CAMERA_SETTINGS subsection that contains the tags TIMEVALUE, CAMERA_NEAR, CAM-ERA_FAR, CAMERA_FOV and CAMERA_TDIST. CAMERA_NEAR and CAMERA_FAR describe the near and far clipping distances for OpenGL renders. The most important tag is CAMERA_FOV, which describes the field of view angle in radians.

```
*CAMERAOBJECT {
   *NODE_NAME "Camera01"
   *CAMERA_TYPE Free
   *NODE_TM {.  .  .
   }
   *CAMERA_SETTINGS {
      *TIMEVALUE 0
      *CAMERA_NEAR 0.0000
      *CAMERA_FAR 1000.0000
      *CAMERA_FOV 0.7854
      *CAMERA_TDIST 160.0000
   }
}
```

Reading a LIGHT section

When reading the light section, we get the usual NODE_NAME and NODE_TM tags to define the name and default position, orientation and scale. A light has a type; the basic ones are 'Directional', 'Position' or 'Spot'. A light section then has tags to indicate whether to use shadows, whether the light is active, the shape of a spotlight cone and the source of the light's ambient level; these are defined by the tags LIGHT_SHADOWS, LIGHT_USELIGHT, LIGHT_SPOTSHAPE and LIGHT_USE-GLOBAL respectively. Most of the settings for a light are contained in the subsection LIGHT_SETTINGS. This subsection will supply the colour of the light via the LIGHT_COLOR tag and the intensity of the light using the LIGHT_INTENS tag. The settings subsection provides many other details for working with shadow maps or projection maps, which we will not be using in the real-time parser.

```
*LIGHTOBJECT {
    *NODE_NAME "FDirect01"
    *LIGHT_TYPE Directional
    *NODE_TM {. . .
    }
    *LIGHT_SHADOWS Off
    *LIGHT_USELIGHT 1
    *LIGHT_SPOTSHAPE Circle
    *LIGHT_USEGLOBAL 0
    *LIGHT_ABSMAPBIAS 0
    *LIGHT_OVERSHOOT 0
    *LIGHT_SETTINGS {
        *TIMEVALUE 0
        *LIGHT_COLOR 1.0000  1.0000  1.0000
        *LIGHT_INTENS 1.0000
        *LIGHT_ASPECT 1.0000
        *LIGHT_HOTSPOT 43.0000
        *LIGHT_FALLOFF 45.0000
        *LIGHT_TDIST 240.0000
        *LIGHT_MAPBIAS 1.0000
        *LIGHT_MAPRANGE 4.0000
        *LIGHT_MAPSIZE 512
        *LIGHT_RAYBIAS 0.0000
    }
}
```

Reading an ANIMATION section

A GEOMOBJECT, CAMERAOBJECT and LIGHTOBJECT can all contain a TM_ANIMATION subsection. This subsection contains tags CONTROL_POS_BEZIER, CONTROL_ROT_TCB and CONTROL_SCALE_BEZIER. A bezier section describes a curve in bezier format and a TCB section contains a curve in TCB format.

CONTROL_POS_BEZIER is itself a subsection; within this section are lines that contain the tag CONTROL_BEZIER_POS_KEY followed by 11 values. The first value is the frame value multiplied by the value found in the SCENE_TICKSPERFRAME tag in the SCENE section. To get this as a frame value, simply divide by the SCENE_TICKEPERFRAME value. The next three values are a vector giving the position of the object at this frame. The next six values give the tangents at the start and end of a curve section as a three-component vector. The last value always seems to be zero, but is probably some type of control flag.

A CONTROL_ROT_TCB subsection describes a TCB curve. Each line in this section contains a CONTROL_TCB_ROT_KEY tag followed by 10 values. The first value is the frame value multiplied by SCENE_TICKSPERFRAME. Then three values that give the rotation axis. A single value gives the rotation angle, leaving five values. Trials suggest that these values are tension, continuity and bias and two values that remain a mystery.

This leaves the CONTROL_SCALE_BEZIER subsection. In this subsection, each line begins with the tag CONTRL_BEZIER_SCALE_KEY followed by no less than 15 values. The first value is the frame value multiplied by SCENE_TICKSPERFRAME. Then a vector follows with the x, y, z scale. Values 5–7 give the scale axis and value 8 the scale angle. The incoming tangent is given by values 9–11 and the outgoing by values 12–14. The final value serves the same purpose as the last value in the CONTROL_POS_BEZIER subsection, which I think is to provide some kind of control flag.

```
*TM_ANIMATION {
 *NODE_NAME "Sphere"
 *CONTROL_POS_BEZIER {
  *CONTROL_BEZIER_POS_KEY 0  0.4590  1.9079  48.0766  0.0000
  *CONTROL_BEZIER_POS_KEY 4000  0.4590  94.4473  48.1007  0.0000
          -0.0164  -0.0001  0.0000  0.0164  0.0001  0
  *CONTROL_BEZIER_POS_KEY 4160  0.4590  97.0334  48.1247  0.0019
          -0.0153  0.0015  -0.0019  0.0153  -0.0015  0
  *CONTROL_BEZIER_POS_KEY 6880  -92.0482  97.0334  -31.8995
          0.0196  0.0000  -0.0181  -0.0196  -0.0000  0.0181  0
```

```
    *CONTROL_BEZIER_POS_KEY 9600  -106.2602  97.0334  146.6617
           -0.0456  0.0000  -0.0301  0.0456  -0.0000  0.0301  0
    *CONTROL_BEZIER_POS_KEY 12000  110.8874  97.0334  143.4107
           -0.0460  -0.0000  0.0097  0.0460  0.0000  -0.0097  0
    *CONTROL_BEZIER_POS_KEY 16000  -1.1630  97.0334  48.6045
           0.1021  0.0000  0.0377  0.0000  0.0000  0.0000  0
  }
  *CONTROL_ROT_TCB {
    *CONTROL_TCB_ROT_KEY 0  1.0000  0.0000  0.0000  0.0000  0.0000
           0.0000  0.0000  0.0000  0.0000
    *CONTROL_TCB_ROT_KEY 4000  -0.0000  1.0000  -0.0000  1.8309
           0.0000  0.0000  0.0000  0.0000  0.0000
    *CONTROL_TCB_ROT_KEY 12000  0.0000  -1.0000  0.0000  1.2898
           0.0000  0.0000  0.0000  0.0000  0.0000
  }
  *CONTROL_SCALE_BEZIER {
    *CONTROL_BEZIER_SCALE_KEY 0  1.1700  1.1700  1.1700  0.0000
           0.0000  0.0000  0.0000  0.0000  0.0000  0.0000
           -0.0001  -0.0001  -0.0001  0
    *CONTROL_BEZIER_SCALE_KEY 9600  0.6061  0.6061  0.6061  0.0000
           0.0000  0.0000  0.0000  0.0001  0.0001  0.0001
           0.0000  0.0000  0.0000  0
  }
}
```

Implementing a 3DS ASCII parser

To parse a 3DS ASE file we will use a C3DSAscii class. Before getting into the details of parsing individual sections, we will implement three useful functions to help when reading the file. The file uses matching curly braces to contain subsections. The purpose of the function GetSection-End is to locate the file position of the closing brace. The function takes an MFC class CStdioFile as the sole parameter. This class is a wrapper for a standard text file. The function starts by initializing two variables, *start* records the file position when the function is called and *count* is set to one, indicating that one opening curly brace has been read. The function is designed to be used after reading the opening curly brace. After this initialization, the function enters an infinite loop with two exit conditions. The first exit condition occurs if an attempt to read from the file using ReadString returns FALSE. If this occurs then the matching end curly brace is not present and so the data are not in a suitable format or

the file is corrupted. Either way the function returns −1 to indicate an error after showing a message box. The other exit condition occurs if the value *count* reaches zero. The variable count is incremented if { is found in the string read from the file and decremented if } is found. If *count* reaches zero the variable *end* is used to record the file position. Then the loop is exited and the file is returned to the original position using the variable *start*.

```
int C3DSAscii::GetSectionEnd(CStdioFile &file)
{
    CString line;
    int end, start = file.GetPosition(), count=1; //First brace⏎
      assumed while(1){
        if (!file.ReadString(line)){
            AfxMessageBox("Matching brace not found in file,⏎
              wrong data format");
            end = -1;
            break;
        }
        if (line.Find("{")!=-1) count++;
        if (line.Find("}")!=-1) count-;
        if (!count){
            end = file.GetPosition();
            break;
        }
    }
    //Return file position back to initial location
    file.Seek(start,CFile::begin);
    return end;
}
```

Each line in an ASE file contains tokens separated by either spaces or tabs. The purpose of the utility function *ParseTokens* is to take a string stored in an MFC CString and a string array defined as TOKENS and to split the string up into substrings stored in the TOKEN array. Because we could try to write to an index in the array out of bounds, the final parameter used in the *ParseTokens* function is *maxtokens*, defining the TOKEN limit. The first step is to clear any white space characters at the beginning or end of the *line* string. Then the function enters a loop examining each character in the line string in turn. If the character is a space or a tab then we have found the end of a substring. The loop first gets the next character to be examined. If this is not a space or a tab then it is added

to the current token string. If it is a space or tab then the current token string has a terminating zero added to the end. Then we move through the line string until no more spaces or tabs are found. The gap between tokens can contain multiple spaces, which need to be removed. If some spaces or tabs are removed in this loop then we need to back up the character index, *i*, by one so that when the loop is incremented in the 'for' statement it points to the correct next character. Then the token count is incremented and tested against the value for maximum tokens. If the token count equals the maximum tokens then the function returns because the token count is a zero index count. The loop uses a variable *string* to bypass the parsing of spaces if this is a token nested between inverted commas.

```cpp
int C3DSAscii::ParseTokens(CString &line, TOKEN *tokens, int↵
  maxtokens)
{
    char c;
    int count = 0, index = 0, tmp;
    BOOL string = FALSE;

    line.TrimLeft();
    line.TrimRight();

    for(int i=0; i<line.GetLength(); i++){
        c = line.GetAt(i);
        if ((c==' '&&!string)||c=='\t'){
            if (index){
                tokens[count].name[index]=0;
                count++;
                tmp = i;
                while(line.GetAt(tmp)==' '|| line.GetAt(tmp)=='\t')↵
                  tmp++;
                if (tmp!=i) i=tmp-1;
                if (count>=maxtokens) return count;
                index = 0;
            }
        }else{
            if (c=='"'){
                string=(string)?FALSE:TRUE;
            }else{
                tokens[count].name[index++]=c;
            }
        }
```

```
            }
        }
        tokens[count].name[index]=0;
        return count + 1;
    }
```

A final utility function for parsing ASE files is the function *FindToken* that iterates through the file looking for a specific token that is supplied.

```
BOOL C3DSAscii::FindToken(CStdioFile &file, CString &line, const⏎
    char *token, int start, int end)
{
    if (start!=-1) file.Seek(start,CFile::begin);
    while(1){
        if (!file.ReadString(line)) return FALSE;
        if (line.Find(token)!=-1) break;
        if (end!=-1 && file.GetPosition()>(UINT)end) return FALSE;
    }
    return TRUE;
}
```

The top level loop for parsing an ASE file

When dealing with an ASE file we need to first open a text file, then check the first line for the tag 3DSMAX_ASCIIEXPORT. If this is not present, then this is not a suitable file and any parsing must be abandoned. If this is an appropriate file then the function *Load* enters an infinite loop checking for the tags SCENE, MATERIAL_LIST, GEOMOBJECT, CAMERAOBJECT and LIGHTOBJECT. In the loop, a single line is read from the file until the end of the file is reached; at this stage the loop is exited. Each tag is handled by a separate function, which we will examine later. If the loading is successful then the next part of this function is to set up the parent pointers based on the parent name loaded in the *ReadObject* function. An ASE file does not necessarily contain a light; if no light is loaded then a default light is created using the function *CreateDefaultLight*.

```
BOOL C3DSAscii::Load(CString &filename)
{
    CStdioFile file;
    CString line;
```

```
try{
    file.Open(filename,CFile::modeRead);
}
catch(CFileException e){
    AfxMessageBox("3DS ASCII import error: problem opening↵
      file");
    return FALSE;
}
file.ReadString(line);
if (line.Find("3DSMAX_ASCIIEXPORT")==-1){
    AfxMessageBox("3DS ASCII Import error: Unexpected header↵
      line");
    return FALSE;
}
while(1){
    if (!file.ReadString(line)) break;
    if (line.Find("SCENE ")!=-1){
        if (!ReadSceneInfo(file)) return FALSE;
        continue;
    }
    if (line.Find("MATERIAL_LIST")!=-1){
        if (!ReadMaterialList(file)) return FALSE;
        continue;
    }
    if (line.Find("GEOMOBJECT")!=-1){
        if (!ReadObject(file)) return FALSE;
        continue;
    }
    if (line.Find("CAMERAOBJECT")!=-1){
        if (!ReadCamera(file)) return FALSE;
        continue;
    }
    if (line.Find("LIGHTOBJECT")!=-1){
        if (!ReadLight(file)) return FALSE;
        continue;
    }
}
//Assign parent pointers using loaded parent names
CToon3DObject *obj = objList.next, *tmpobj;

while(obj){
    if (obj->parentname!="noparent"){
```

```
            tmpobj = objList.next;
            while(tmpobj){
                if (tmpobj->name == obj->parentname){
                    obj->parent = tmpobj;
                    break;
                }
                tmpobj = tmpobj->next;
            }
            if (!obj->parent){
                line.Format("%s parent object %s not found in object↵
                  list",
                    LPCTSTR(obj->name), LPCTSTR(obj->parentname));
                AfxMessageBox(line);
                obj->parentname = "noparent";
            }
        }
        obj = obj->next;
    }
    if (!lightList.next) CreateDefaultLight();

    file.Close();
    return TRUE;
}
```

Reading the SCENE section

When reading the SCENE section we first make use of the function *GetSectionEnd* to find the matching end brace. Then the function enters a loop which has the exit condition that the file position exceeds the value returned by the *GetSectionEnd* function. The scheme for most of the readers is the same, read the next line and search for certain expected tags. If a tag is found then process it using *ParseTokens*; if it is a simple single line tag or a subroutine or if it is a complex multi-line section. The SCENE section contains no subsections unless background colour or ambient animation is implemented.

```
BOOL C3DSAscii::ReadSceneInfo(CStdioFile &file)
{
    CString line;
    TOKEN tokens[5];
    int start, end;
```

```
start = file.GetPosition();
end = GetSectionEnd(file);

while(file.GetPosition()<(UINT)end){
    file.ReadString(line);
    if (line.Find("SCENE_FILENAME")!=-1){
        if (ParseTokens(line,tokens,5)<2) return FALSE;
        strcpy(name,tokens[1].name);
        continue;
    }
    if (line.Find("SCENE_FIRSTFRAME")!=-1){
        if (ParseTokens(line,tokens,5)<2) return FALSE;
        firstframe = atoi(tokens[1].name);
        continue;
    }
    if (line.Find("SCENE_LASTFRAME")!=-1){
        if (ParseTokens(line,tokens,5)<2) return FALSE;
        lastframe = atoi(tokens[1].name);
        continue;
    }
    if (line.Find("SCENE_FRAMESPEED")!=-1){
        if (ParseTokens(line,tokens,5)<2) return FALSE;
        fps = atoi(tokens[1].name);
        continue;
    }
    if (line.Find("SCENE_TICKSPERFRAME")!=-1){
        if (ParseTokens(line,tokens,5)<2) return FALSE;
        ticksperframe = (double)atoi(tokens[1].name);
        continue;
    }
    if (line.Find("SCENE_BACKGROUND_STATIC")!=-1){
        if (ParseTokens(line,tokens,5)<4) return FALSE;
        bgCol.x = (float)atof(tokens[1].name);
        bgCol.y = (float)atof(tokens[2].name);
        bgCol.z = (float)atof(tokens[3].name);
    }
    if (line.Find("SCENE_AMBIENT_STATIC")!=-1){
        if (ParseTokens(line,tokens,5)<4) return FALSE;
        ambient.x = (float)atof(tokens[1].name);
        ambient.y = (float)atof(tokens[2].name);
        ambient.z = (float)atof(tokens[3].name);
    }
```

```
        if (line.Find("SCENE_BACKGROUND_ANIM")!=-1){
          AfxMessageBox("Background colour animation is not↵
            supported in this importer");
        }
        if (line.Find("SCENE_AMBIENT_ANIM")!=-1){
          AfxMessageBox("Ambient colour animation is not↵
            supported in this importer");
        }
      }
      return TRUE;
    }
```

Reading the MATERIAL_LIST section

A MATERIAL_LIST section contains the tag MATERIAL_COUNT, which
gives the number of materials in the list, followed by MATERIAL_COUNT
materials. In the function to read the MATERIAL_LIST the start and end
of the section are stored in variables *start* and *end*. MATERIAL_COUNT
is found using the *FindToken* function. If MATERIAL_COUNT is found and
the *ParseToken* function returns at least two tokens when splitting the line
into tokens, then the current materials can be deleted and the material
count stored in the variable *materialCount*. The next step is to allocate
memory for the materials. We use a MATERIAL structure which is simply
a wrapper for a SURFACE structure. Then we use the function
ReadMaterial to read each of the *materialCount* materials.

```
BOOL C3DSAscii::ReadMaterialList(CStdioFile &file)
{
    CString line;
    int start,end,i;
    TOKEN tokens[3];

    start = file.GetPosition();
    end = GetSectionEnd(file);

    if (!FindToken(file, line, "MATERIAL_COUNT", start, end))↵
      return FALSE;
    if (ParseTokens(line, tokens, 3)<2) return FALSE;
    DeleteMaterials();
    materialCount = atoi(tokens[1].name);
```

```
    if (materialCount) {
       materials = new MATERIAL[materialCount];
       memset(materials, 0, sizeof(MATERIAL)*materialCount);
       if (!materials) return FALSE;
       for (i=0; i<materialCount; i++) {
          if (!ReadMaterial(file, i)) return FALSE;
       }
    }
    return TRUE;
 }
```

The *ReadMaterial* function takes two parameters, the ASE file and the current material number. The first step is to build a string of the form MATERIAL *n*, where *n* is the current material number. If the token is found then we get the section end and enter a loop that is terminated when the file position exceeds the section end. In the loop we read and parse the tokens MATERIAL_NAME, MATERIAL_DIFFUSE, MATERIAL_SPEC-ULAR, MATERIAL_TRANSPARENCY, MAP_DIFFUSE and NUM-SUBMTLS. Most of these tags are easy to follow involving a call to *ParseTokens* and then a conversion of the tokens to integers or floats. MAP_DIFFUSE is itself a subsection, but since this parser only accesses the BITMAP file name it is read directly. First, a new texture is created and initialized to zero. Then a search is made for the token BITMAP. If the token is found then the filename is stored in the TEXTURE structure. The token NUMSUBMTLS gives the number of sub-materials in the current material. If this is found then memory is allocated for these sub-materials and then each sub-material is read using the *ReadSubMaterial* function.

```
BOOL C3DSAscii::ReadMaterial(CStdioFile &file, int matnum)
{
  CString line,tmp;
  int start,end;
  TOKEN tokens[5];

  if (matnum>(materialCount-1)) return FALSE;
  tmp.Format("MATERIAL %i",matnum);
  if (!FindToken(file, line, (LPCTSTR)tmp)) return FALSE;
  start = file.GetPosition();
  end = GetSectionEnd(file);

  while(file.GetPosition()<(UINT)end){
```

```
file.ReadString(line);
if (line.Find("MATERIAL_NAME")!=-1){
  if (ParseTokens(line, tokens, 5)<2) return FALSE;
  strcpy(materials[matnum].mat.name,tokens[1].name);
  continue;
}
if (line.Find("MATERIAL_DIFFUSE")!=-1){
  if (ParseTokens(line, tokens, 5)<4) return FALSE;
  strcpy(materials[matnum].mat.name,tokens[1].name);
  materials[matnum].mat.diffuse=1.0;
  materials[matnum].mat.r=(BYTE)(atof(tokens[1].name)*255.0);
  materials[matnum].mat.g=(BYTE)(atof(tokens[2].name)*255.0);
  materials[matnum].mat.b=(BYTE)(atof(tokens[3].name)*255.0);
  continue;
}
if (line.Find("MATERIAL_SPECULAR")!=-1){
  if (ParseTokens(line, tokens, 5)<4) return FALSE;
  materials[matnum].mat.specular=(float)atof(tokens[1].name);
  continue;
}
if (line.Find("MATERIAL_TRANSPARENCY")!=-1){
  if (ParseTokens(line, tokens, 5)<2) return FALSE;
  materials[matnum].mat.transparency=(float)atof(tokens[1].↵
    name);
  continue;
}
if (line.Find("MAP_DIFFUSE")!=-1){
  materials[matnum].mat.tex = new TEXTURE;
  if (!materials[matnum].mat.tex) return FALSE;
  memset(materials[matnum].mat.tex, 0, sizeof(TEXTURE));
  if (!FindToken(file, line, "BITMAP")) return FALSE;
  if (ParseTokens(line, tokens, 5)<2) return FALSE;
  strcpy(materials[matnum].mat.tex->name,tokens[1].name);
  continue;
}
if (line.Find("NUMSUBMTLS")!=-1){
  if (ParseTokens(line, tokens, 5)<2) return FALSE;
  materials[matnum].numsubmtls = atoi(tokens[1].name);
  materials[matnum].submat =
      new SURFACE[materials[matnum].numsubmtls];
  //Initialise the data
  memset(materials[matnum].submat, 0,
```

```
            sizeof(SURFACE) * materials[matnum].numsubmtls);
        for(int i=0; i<materials[matnum].numsubmtls; i++){
            if (!ReadSubMaterial(file, matnum, i)) return FALSE;
        }
        continue;
    }
  }
  return TRUE;
}
```

Reading a sub-material is just the same as reading a material, except we search for the tags SUBMATERIAL *n*, where *n* is the number of the current sub-material. The MATERIAL structure contains the member submat that is allocated memory for NUMSUBMTLS SURFACE structures. Sub-materials nested into sub-materials are not allowed with this parser and will force a message box to be displayed.

```
BOOL C3DSAscii::ReadSubMaterial(CStdioFile &file, int matnum, int↵
  submatnum)
{
    CString line,tmp;
    int start,end;
    TOKEN tokens[5];
    SURFACE *srf = &materials[matnum].submat[submatnum];

    tmp.Format("SUBMATERIAL %i", submatnum);
    if (!FindToken(file, line, (LPCTSTR)tmp)) return FALSE;
    start = file.GetPosition();
    end = GetSectionEnd(file);

    while(file.GetPosition()<(UINT)end){
        file.ReadString(line);
        if (line.Find("MATERIAL_NAME")!=-1){
            if (ParseTokens(line, tokens, 5)<2) return FALSE;
            strcpy(srf->name, tokens[1].name);
            continue;
        }
        if (line.Find("MATERIAL_DIFFUSE")!=-1){
            if (ParseTokens(line, tokens, 5)<4) return FALSE;
            strcpy(materials[matnum].mat.name,tokens[1].name);
            srf->diffuse=1.0;[1].name)*255.0);
            srf->g = (BYTE)(atof(tokens[2].name)*255.0);
```

```
                         srf->b = (BYTE)(atof(tokens[3].name)*255.0);
                         continue;
                     }
                     if (line.Find("MATERIAL_SPECULAR")!=-1){
                         if (ParseTokens(line, tokens, 5)<4) return FALSE;
                         srf->specular = (float)atof(tokens[1].name);
                         continue;
                     }
                     if (line.Find("MATERIAL_TRANSPARENCY")!=-1){
                         if (ParseTokens(line, tokens, 5)<2) return FALSE;
                         srf->transparency = (float)atof(tokens[1].name);
                         continue;
                     }
                     if (line.Find("MAP_DIFFUSE")!=-1){
                         srf->tex = new TEXTURE;
                         if (!srf->tex) return FALSE;
                         memset(srf->tex, 0, sizeof(TEXTURE));
                         if (!FindToken(file,line,"BITMAP")) return FALSE;
                         if (ParseTokens(line, tokens, 5)<2) return FALSE;
                         strcpy(srf->tex->name, tokens[1].name);
                         continue;
                     }
                     if (line.Find("NUMSUBMTLS")!=-1){
                         AfxMessageBox("3DS Loading error::
                                 Only a single layer of sub materials allowed");
                         return FALSE;
                     }
                 }
             file.Seek(start, CFile::begin);

             return TRUE;
         }
```

Reading the GEOMOBJECT section

We have read some basic details about the scene and the material list,
now we can read the geometry. In the class C3DSAscii, the function
ReadObject is used whenever the token GEOMOBJECT is found. This
function looks for the tokens NODE_NAME, NODE_PARENT, NODE_TM,
MESH, TM_ANIMATION, MATERIAL_REF and WIREFRAME_COLOR.

The token NODE_NAME is followed by the name of the object. The token NODE_PARENT is followed by the name of the parent. The token NODE_TM is a subsection read with the separate function *ReadNodeTM*. The token MESH is read with the function *ReadMesh*. The token TM_ ANIMATION is read with the function *ReadAnimation*. The token MATE-RIAL_REF gives a single index into the MATERIAL_LIST for this object's surface data. The token WIREFRAME_COLOR provides a single colour surface for objects with no surface data.

```cpp
BOOL C3DSAscii::ReadObject(CStdioFile &file)
{
    CString line, tmp;
    int start, end, index;
    TOKEN tokens[5];
    CToon3DObject *obj = &objList;

    while(obj->next) obj = obj->next;
    obj->next = new CToon3DObject;
    obj = obj->next;
    if (!obj) return FALSE;

    start = file.GetPosition();
    end = GetSectionEnd(file);

    while(file.GetPosition()<(UINT)end){
        file.ReadString(line);
        if (line.Find("NODE_NAME")!=-1){
            if (ParseTokens(line,tokens,5)<2) return FALSE;
            obj->name=tokens[1].name;
            continue;
        }
        if (line.Find("NODE_PARENT")!=-1){
            if (ParseTokens(line, tokens, 5)<2) return FALSE;
            obj->parentname = tokens[1].name;
            continue;
        }
        if (line.Find("NODE_TM")!=-1){
            if (!ReadNodeTM(file, obj)) return FALSE;
            continue;
        }
        if (line.Find("MESH ")!=-1){
            if (!ReadMesh(file, obj)) return FALSE;
            continue;
```

Real-time 3D Character Animation with Visual C++

```
        }
        if (line.Find("TM_ANIMATION")!=-1){
            if (!ReadAnimation(file,obj)) return FALSE;
            continue;
        }
        if (line.Find("MATERIAL_REF")!=-1){
            if (ParseTokens(line,tokens,5)<2) return FALSE;
            index = atoi(tokens[1].name);
            if (!AssignSurfaces(obj, index)) return FALSE;
        }
        if (line.Find("WIREFRAME_COLOR")!=-1){
            if (ParseTokens(line,tokens,5)<4) return FALSE;
            //Create a single coloured surface
            if (obj->srfs) delete [] obj->srfs;
            obj->srfs=new SURFACE;
            obj->numsurfaces=1;
            obj->srfs->diffuse=1.0;
            obj->srfs->tex=NULL;
            obj->srfs->transparency=0.0;
            obj->srfs->flag=0;
            strcpy(obj->srfs->name,"Colour");
            obj->srfs->specular=0.0;
            obj->srfs->r=(BYTE)atoi(tokens[1].name);
            obj->srfs->g=(BYTE)atoi(tokens[2].name);
            obj->srfs->b=(BYTE)atoi(tokens[3].name);
            for (int i=0;i<obj->numpolygons;i++){
                obj->plys[i].srf=0;
            }
        }
    }
    obj->hide = FALSE;

    return TRUE;
}
```

The token MATERIAL_REF returns a single integer and when reading a polygon we get a single integer that defines the surface. If an object contains multiple surfaces then these will be represented by the sub-materials of that object; if the material is a basic material then the material can be set directly. The application Toon3D uses an object level surface list rather than global level, so after reading the MATERIAL_REF the appropriate surfaces are duplicated in a format expected by Toon3D.

```
BOOL C3DSAscii::AssignSurfaces(CToon3DObject *obj, int index)
{
    if (materials[index].numsubmtls){
        obj->srfs = new SURFACE[materials[index].numsubmtls];
        if (!obj->srfs) return FALSE;
        obj->numsurfaces = materials[index].numsubmtls;
        memcpy(obj->srfs, materials[index].submat,
                    sizeof(SURFACE)*obj->numsurfaces);
        for (int i=0; i<materials[index].numsubmtls; i++){
            //Copy any textures that we need
            if (materials[index].submat[i].tex){
                obj->srfs[i].tex = new TEXTURE;
                memcpy(obj->srfs[i].tex,
                    materials[index].submat[i].tex,↵
                    sizeof(TEXTURE));
            }
        }
        for (i=0; i<obj->numpolygons; i++){
            if (obj->plys[i].srf>obj->numsurfaces) return FALSE;
        }
    }else{
        obj->srfs = new SURFACE;
        if (!obj->srfs) return FALSE;
        if (materials[index].mat.tex){
            obj->srfs->tex = new TEXTURE;
            memcpy(obj->srfs->tex,
                    materials[index].mat.tex, sizeof(TEXTURE));
        }
        obj->numsurfaces = 1;
        memcpy(obj->srfs, &materials[index].mat, sizeof(SURFACE));
        for (int i=0; i<obj->numpolygons; i++){
            obj->plys[i].srf=0;
        }
    }

    return TRUE;
}
```

The default scale, position and orientation for the object is read from the NODE_TM section by the function ReadNodeTM. The function is quite straightforward except that the axes used in 3DS are different from those used by Toon3D. To get the orientation back, the *z* and *y* components are

flipped and the direction of the *z* component is inverted. Orientation in 3DS is stored in angle axis format. Since Toon3D uses Euler angles we need to convert angle axis to Euler using the function AngleAxisToEuler.

```cpp
BOOL C3DSAscii::ReadNodeTM(CStdioFile &file, CToon3DObject *obj)
{
    CString line;
    int start,end;
    TOKEN tokens[5];
    VECTOR rotaxis;
    double rotangle;

    start = file.GetPosition();
    end = GetSectionEnd(file);

    while(file.GetPosition()<(UINT)end){
        file.ReadString(line);
        if (line.Find("TM_POS ")!=-1){
            if (ParseTokens(line,tokens,5)<4) return FALSE;
            //Swap z andy and flip the z
            obj->spos.x = atof(tokens[1].name);
            obj->spos.y = atof(tokens[3].name);
            obj->spos.z =-atof(tokens[2].name);
        }
        if (line.Find("TM_SCALE ")!=-1){
            if (ParseTokens(line,tokens,5)<4) return FALSE;
            obj->sscale.x = atof(tokens[1].name);
            obj->sscale.y = atof(tokens[3].name);
            obj->sscale.z = atof(tokens[2].name);
        }
        if (line.Find("TM_ROTAXIS ")!=-1){
            if (ParseTokens(line,tokens,5)<4) return FALSE;
            rotaxis.x = atof(tokens[1].name);
            rotaxis.y = atof(tokens[3].name);
            rotaxis.z = atof(tokens[2].name);
        }
        if (line.Find("TM_ROTANGLE")!=-1){
            if (ParseTokens(line,tokens,5)<2) return FALSE;
            rotangle = atof(tokens[1].name);
        }
    }
    AngleAxisToEuler(rotaxis, rotangle, obj->srot);
    obj->CreateKey(0);

    return TRUE;
}
```

The principle behind the AngleAxisToEuler function is to create a rotation matrix, then use inverse trig functions to extract the Euler angles. Recall that a rotation matrix formed from *HPB* rotations is defined as

$$HPB = \begin{bmatrix} \cos(h)\cos(b) - \sin(h)\sin(p)\sin(b) & \cos(h)\sin(b) + \sin(h)\sin(p)\cos(b) & \sin(h)\cos(p) \\ -\cos(p)\sin(p) & \cos(p)\cos(b) & -\sin(p) \\ -\sin(h)\cos(b) - \cos(h)\sin(p)\sin(b) & -\sin(h)\sin(b) + \cos(h)\sin(p)\cos(b) & \cos(h)\cos(p) \end{bmatrix}$$

If each term of this is given a name based on the row and column, then we get the matrix

$$\begin{bmatrix} m00 & m01 & m02 \\ m10 & m11 & m12 \\ m20 & m21 & m22 \end{bmatrix}$$

Comparing terms, we can see that $m12 = -\sin(p)$. Hence, $p = \text{asin}(-m12)$. From term $m10$ we have $m10 = -\cos(p)\sin(p)$. Therefore, $m10 = m12\cos(p)$. Hence, $\cos(p) = m10/m12$.

We can use this to find the heading using term $m02$:

$m02 = \sin(h)\cos(p)$; therefore, $m02 = \sin(h)*(m10/m12)$
$\sin(h) = (m02*m12)/m10$; hence, $h = \text{asin}((m02*m12)/m10)$

Using the same value for $\cos(p)$ and term $m11$, we can derive the b value:

$m11 = \cos(p)\cos(b)$; therefore, $m11 = \cos(b)*(m10/m12)$
$\cos(b) = (m11*m12)/m10$; hence, $b = \text{acos}((m11*m12)/m10)$

The function uses this derivation to get the appropriate values for *H*, *P* and *B*.

```
void C3DSAscii::AngleAxisToEuler(const VECTOR &rotaxis, const ↵
  double &rotangle, VECTOR &euler)
{
    double c = cos(rotangle);
    double s = sin(rotangle);
    double omc = 1.0 - c;
    double m02, m10, m11, m12;

    m11 = c + rotaxis.y*rotaxis.y*omc;
```

```
double tmp1 = rotaxis.x*rotaxis.y*omc;
double tmp2 = rotaxis.z*s;
m10 = tmp1 - tmp2;

tmp1 = rotaxis.x*rotaxis.z*omc;
tmp2 = rotaxis.y*s;
m02 = tmp1 - tmp2;
m12 = tmp1 + tmp2;

if (m10==0.0) m10=0.00000001;// Avoid division by zero
tmp1 = m12/m10;

euler.x = asin(-m12);
euler.y = asin(m02 * tmp1);
euler.z = acos(m11 * tmp1);
}
```

Reading the MESH section

The MESH section contains the tags MESH_NUMVERTEX, MESH_VERTEX_LIST, MESH_NUMFACES, MESH_FACE_LIST, MESH_NUMTVERTS, MESH_TVERTLIST, MESH_NUMTVFACES, MESH_TFACELIST and MESH_NORMALS. MESH_NUMVERTEX, MESH_NUMFACES, MESH_NUMTVERTS and MESH_NUMTVFACES are all single integer values giving the number of vertices, faces, texture vertices and textured faces respectively. Each of the lists is handled by a dedicated function call that we will examine in turn. Reading the normals section is handled by the function *ReadNormals*.

```
BOOL C3DSAscii::ReadMesh(CStdioFile &file, CToon3DObject *obj)
{
    CString line;
    int start,end, numtverts, numtvfaces;
    TOKEN tokens[5];
    TEXVEC *tvert = NULL;

    start = file.GetPosition();
    end = GetSectionEnd(file);

    while(file.GetPosition()<(UINT)end){
        file.ReadString(line);
```

```cpp
if (line.Find("MESH_NUMVERTEX")!=-1){
    if (ParseTokens(line,tokens,5)<2) goto meshabort;
    obj->numpoints=atoi(tokens[1].name);
    obj->pts=new POINT3D[obj->numpoints];
    if (!obj->pts) return FALSE;
    continue;
}
if (line.Find("MESH_VERTEX_LIST")!=-1){
    if (!ReadVertexList(file,obj)) goto meshabort;
    continue;
}
if (line.Find("MESH_NUMFACES")!=-1){
    if (ParseTokens(line,tokens,5)<2) goto meshabort;
    obj->numpolygons=atoi(tokens[1].name);
    obj->plys=new POLYGON[obj->numpolygons];
    if (!obj->plys) return FALSE;
    continue;
}
if (line.Find("MESH_FACE_LIST")!=-1){
    if (!ReadFaceList(file,obj)) goto meshabort;
    continue;
}
if (line.Find("MESH_NUMTVERTEX")!=-1){
    if (ParseTokens(line,tokens,2)<2) goto meshabort;
    numtverts = atoi(tokens[1].name);
    if (numtverts){
        tvert = new TEXVEC[numtverts];
        if (!tvert) return FALSE;
        continue;
    }
}
if (line.Find("MESH_TVERTLIST")!=-1){
    if (!ReadTextureVertices(file, tvert, numtverts)) goto↵
      meshabort;
    continue;
}
if (line.Find("MESH_NUMTVFACES")!=-1){
    if (ParseTokens(line,tokens,2)<2) goto meshabort;
    numtvfaces = atoi(tokens[1].name);
}
if (line.Find("MESH_TFACELIST")!=-1){
    if (!ReadTFaceList(file, obj, tvert, numtvfaces)) goto↵
      meshabort;
    continue;
```

```
            }
            if (line.Find("MESH_NORMALS")!=-1){
                if (!ReadNormals(file, obj)) goto meshabort;
                continue;
            }
        }
    if (tvert) delete [] tvert;
    return TRUE;
  meshabort:
    if (tvert) delete [] tvert;
    return FALSE;
}
```

The vertex list contains MESH_NUMVERTEX lines each describing a single vertex. The value read from MESH_NUMVERTEX is stored in the variable obj → numponts. Before reading each line the entire vertex array is set to zero values using a simple memset call. Then the function uses a 'for' loop to iterate through all the points in the object storing the values read from the file. To orientate the values read from the ASE file to the coordinate space used by Toon3D, the *y* and *z* values are flipped and the *z* value inverted.

```
BOOL C3DSAscii::ReadVertexList(CStdioFile &file, CToon3DObject↵
  *obj)
{
    CString line,tmp;
    int start,end;
    TOKEN tokens[5];

    start = file.GetPosition();
    end = GetSectionEnd(file);
    memset(obj->pts,0,sizeof(POINT3D)*obj->numpoints);

    for (int i=0; i<obj->numpoints; i++){
        if (!FindToken(file,line,"MESH_VERTEX ",-1,end)) return↵
          FALSE;
        if (ParseTokens(line,tokens,5)<5) return FALSE;
        //Swap z and y and flip the z
        obj->pts[i].x = atof(tokens[2].name);
        obj->pts[i].y = atof(tokens[4].name);
        obj->pts[i].z =-atof(tokens[3].name);
    }
    return TRUE;
}
```

The face list follows a similar pattern to the vertex list. First, the polygon array is set to zero value then the function enters a 'for' loop reading obj → numpolygons lines from the file. All 3DS polygons are triangles, so the numverts member is set to 3 and the value of the fourth vertex set to −1. The polygon order is flipped because Toon3D expects counter-clockwise polygons to be forward facing and 3DS expects clockwise polygons. The index of the vertices for the current polygon are read from the file.

```
BOOL C3DSAscii::ReadFaceList(CStdioFile &file, CToon3DObject *obj)
{
    CString line,tmp;
    int start,end;
    TOKEN tokens[20];

    start=file.GetPosition();
    end=GetSectionEnd(file);
    memset(obj->plys,0,sizeof(POLYGON)*obj->numpolygons);

    for (int i=0;i<obj->numpolygons;i++){
        if (!FindToken(file,line,"MESH_FACE ",-1,end)) return
          FALSE;
        if (ParseTokens(line,tokens,20)<17) return FALSE;
        //Counter clockwise order
        obj->plys[i].p[3] = -1;
        obj->plys[i].numverts = 3;
        obj->plys[i].p[0] = atoi(tokens[3].name);
        obj->plys[i].p[2] = atoi(tokens[5].name);
        obj->plys[i].p[1] = atoi(tokens[7].name);
        obj->plys[i].srf = atoi(tokens[17].name);
    }
    return TRUE;
}
```

3DS stores the value of texture coordinates in a special list of texture vertices. This list is read using the ReadTextureVertices function. Each line in a MESH_TVERTLIST section contains a MESH_TVERT tag followed by the index for this texture vertex and three floating-point values. Standard 2D bitmap textures only use the first two floating-point values. The first value is the *u* component and the second the *v*.

```
*MESH_TVERTLIST {
        *MESH_TVERT 0  0.0000  1.0000  0.0000
        *MESH_TVERT 1  0.0625  1.0000  0.0000
```

```
*MESH_TVERT 2   0.1250   1.0000   0.0000
*MESH_TVERT 3   0.1875   1.0000   0.0000
    . . .
}
```

When reading the list the function enters a loop. The exit condition for the loop is the file location exceeding the end of the list. For each iteration of the loop we find the next MESH_TVERT token and then parse this line. The token array will contain the index of the vertex in array value one, the *u* component in array value two and the *v* component in array value three.

```
BOOL C3DSAscii::ReadTextureVertices(CStdioFile &file, TEXVEC↵
  *tvert, int count)
{
    CString line;
    int start, end, index;
    TOKEN tokens[5];

    start = file.GetPosition();
    end = GetSectionEnd(file);

    while(file.GetPosition()<(UINT)end){
        if (!FindToken(file,line,"MESH_TVERT",-1,end)) return↵
          FALSE;
        if (ParseTokens(line,tokens,5)<5) return FALSE;
        index = atoi(tokens[1].name);
        if (index > count) return FALSE; //Index out of range
        tvert[index].u = (float)atof(tokens[2].name);
        tvert[index].v = (float)atof(tokens[3].name);
    }
    return TRUE;
}
```

To make use of the texture vertices we have to read the textured face list. Toon3D uses a POLYGON structure that includes texture coordinates. When reading the textured face list we assign these coordinates directly.

```
*MESH_TFACELIST {
    *MESH_TFACE 00   17   18
    *MESH_TFACE 11   18   19
```

```
     *MESH_TFACE 22  19  20
     *MESH_TFACE 33  20  21
     *MESH_TFACE 44  21  22
     .  .  .
}
```

The MESH_TFACELIST section contains MESH_NUMTVFACES lines. Each line starts with a MESH_TFACE tag, followed by four integer values. The first is the face index, then the texture vertex indices for this face in counter-clockwise order. To process this information, we read each vertex in turn and apply the appropriate texture vertex from the passed texture vertex array to the polygon's texture vertices stored in the POLYGON structure member tc.

```
BOOL C3DSAscii::ReadTFaceList(CStdioFile &file, CToon3DObject↵
*obj, TEXVEC *tverts, int count)
{
    CString line;
    int start, end, plyindex, p[3], index;
    POLYGON *ply;

    start = file.GetPosition();
    end = GetSectionEnd(file);

    while (file.GetPosition()<(UINT)end){
        if (!FindToken(file,line,"MESH_TFACE",-1,end)) return↵
          FALSE;
        if (ParseTokens(line,tokens,5)<5) return FALSE;
        plyindex = atoi(tokens[1].name);
        if (plyindex>obj->numpolygons) return FALSE;
        ply = &obj->plys[plyindex].
        index = atoi(tokens[2].name);
        ply->tc[0].u = tverts[index].u;
        ply->tc[0].v = tverts[index].v;
        index = atoi(tokens[3].name);
        ply->tc[2].u = tverts[index].u;
        ply->tc[2].v = tverts[index].v;
        index = atoi(tokens[4].name);
        ply->tc[1].u = tverts[index].u;
        ply->tc[1].v = tverts[index].v;
    }
    return TRUE;
}
```

Real-time 3D Character Animation with Visual C++

The MESH_NORMAL section contains MESH_NUMFACES mini-sections. Each mini-section contains a MESH_FACENORMAL line and three MESH_VERTEXNORMAL lines. The face normal defines the normal for the face and the vertex normals the normals for the face vertices. Each line follows the familiar pattern of tag, index, vector. When parsing the function reads the index and applies the data to the normal stored in the POLYGON and POINT3D structures.

```
*MESH_NORMALS {
    *MESH_FACENORMAL 0 -0.0388 0.1949 0.9800
        *MESH_VERTEXNORMAL 0 0.0000 0.0000 1.0000
        *MESH_VERTEXNORMAL 1 -0.0225 0.4185 0.9079
        *MESH_VERTEXNORMAL 2 -0.1809 0.3781 0.9079
    *MESH_FACENORMAL 1 -0.1104 0.1653 0.9800
        *MESH_VERTEXNORMAL 0 0.0000 0.0000 1.0000
        *MESH_VERTEXNORMAL 2 -0.1809 0.3781 0.9079
        *MESH_VERTEXNORMAL 3 -0.3118 0.2801 0.9079
    . . .
}
```

```
BOOL C3DSAscii::ReadNormals(CStdioFile &file, CToon3DObject *obj)
{
    CString line, tmp;
    int i, j, start, end, index, plyindex;
    TOKEN tokens[5];

    start = file.GetPosition();
    end = GetSectionEnd(file);

    //Set default value
        for (i=0;i<obj->numpoints;i++){
        obj->pts[i].weight = 1;
        obj->pts[i].nx = 0.0;
        obj->pts[i].ny = 1.0;
        obj->pts[i].nz = 0.0;
    }

    while (file.GetPosition()<(UINT)end){
        if (!FindToken(file, line, "MESH_FACENORMAL", -1, end))↵
          return FALSE;
        if (ParseTokens(line,tokens,5)<5) return FALSE;
        plyindex = atoi(tokens[1].name);
```

```
if (plyindex>obj->numpolygons){
    tmp.Format("Face index %i(%i)
               out of range when reading normals list.",
        index,obj->numpolygons);
    AfxMessageBox(tmp);
    return FALSE;
}

//Set the face normal
obj->plys[plyindex].normal[0] = atof(tokens[2].name);
obj->plys[plyindex].normal[1] = atof(tokens[4].name);
obj->plys[plyindex].normal[2] =-atof(tokens[3].name);

//Now read the three vertex normals
for (j=0;j<3;j++){
    if (!FindToken(file,line,"MESH_VERTEXNORMAL",-1,↵
      end)) return FALSE;
    if (ParseTokens(line,tokens,5)<5) return FALSE;
    index = obj->plys[plyindex].p[atoi(tokens[1].name)];
    if (index>obj->numpoints) return FALSE;
    obj->pts[index].nx = atof(tokens[2].name);
    obj->pts[index].ny = atof(tokens[4].name);
    obj->pts[index].nz =-atof(tokens[3].name);
}
}
return TRUE;
}
```

All the animation in Toon3D uses TCB curves. ASE files include Bezier curves. This simple animation reader makes no attempt to convert Bezier curves to TCB, it simply takes the raw data. Curve smoothing is ignored. Since Bezier curves are not interpolating, that is they do not usually go through the control points, the results will be in error. I leave it for you to create a good Bezier to TCB converter. It would probably be better to add a flag to the interpolator in the engine to say whether the data are in TCB or Bezier format and then interpolate using a different mechanism rather than attempt to convert the curves. A full read would then need to handle the incoming and outgoing tangents in the Bezier handler and the scale axis and scale angle components in a scale key value.

A CONTROL_POS_BEZIER line consists of

Token	Value
0	CONTROL_BEZIER_POS_KEY
1	Frame multiplied by TICKSPERFRAME
2–4	Control position
5–7	Incoming tangent
8–10	Outgoing tangent
11	Control flag

A CONTROL_ROT_TCB line consists of

Token	Value
0	CONTROL_TCB_ROT_KEY
1	Frame multiplied by TICKSPERFRAME
2–5	Rotation axis
6	Rotation angle
7	Tension
8	Continuity
9	Bias
10–11	Unknown

A CONTROL_SCALE_BEZIER line consists of

Token	Value
0	CONTROL_BEZIER_SCALE_KEY
1	Frame multiplied by TICKSPERFRAME
2–4	Control position
5–7	Scale axis
8	Scale angle
9–11	Incoming tangent
12–14	Outgoing tangent
15	Control flag

```
*TM_ANIMATION {
    *NODE_NAME "Sphere"
    *CONTROL_POS_BEZIER {
        *CONTROL_BEZIER_POS_KEY 0    0.4590    1.9079    48.0766↵
        0.0000    0.0000    0.0000    0.0000    0.0298    -0.0001 0
        . . .
    }
    *CONTROL_ROT_TCB {
```

```
    *CONTROL_TCB_ROT_KEY 0    1.0000    0.0000    0.0000↵
        0.0000    0.0000    0.0000    0.0000    0.0000    0.0000
    . . .
    }
    *CONTROL_SCALE_BEZIER {
        *CONTROL_BEZIER_SCALE_KEY 0    1.1700    1.1700    1.1700↵
            0.0000    0.0000    0.0000    0.0000    0.0000    0.0000↵
            0.0000    -0.0001    -0.0001    -0.00010
    . . .
    }
}
```

In this simplified parser we simply get at the main control values and store these directly.

```
BOOL C3DSAscii::ReadAnimation(CStdioFile &file, CToon3DObject↵
  *obj)
{
    CString line;
    int start,end, frame;
    TOKEN tokens[5];
    VECTOR rotaxis;
    double rotangle;

    start = file.GetPosition();
    end = GetSectionEnd(file);

    while (file.GetPosition()<(UINT)end){
        if (!file.ReadString(line)) return FALSE;
        if (line.Find("CONTROL_BEZIER_POS_KEY")!=-1){
            if (ParseTokens(line,tokens,5)<5) return FALSE;
            frame = (int)(atof(tokens[1].name)/ticksperframe);
            obj->SetFrame(frame);
            //Swap z andy and flip the z
            obj->spos.x = atof(tokens[2].name);
            obj->spos.y = atof(tokens[4].name);
            obj->spos.z =-atof(tokens[3].name);
            obj->CreateKey(frame);
        }
        if (line.Find("CONTROL_TCB_ROT_KEY")!=-1){
            if (ParseTokens(line,tokens,5)<5) return FALSE;
```

```
                  frame = (int)(atof(tokens[1].name)/ticksperframe);
                  obj->SetFrame(frame);
                  rotaxis.x = atof(tokens[2].name);
                  rotaxis.y = atof(tokens[4].name);
                  rotaxis.z = atof(tokens[3].name);
                  rotangle = atof(tokens[5].name);
                  AngleAxisToEuler(rotaxis, rotangle, obj->srot);
                  obj->CreateKey(frame);
              }
          if (line.Find("CONTROL_BEZIER_SCALE_KEY")!=-1){
                  if (ParseTokens(line,tokens,5)<5) return FALSE;
                  frame = (int)(atof(tokens[1].name)/ticksperframe);
                  obj->SetFrame(frame);
                  obj->sscale.x = atof(tokens[2].name);
                  obj->sscale.y = atof(tokens[3].name);
                  obj->sscale.z = atof(tokens[4].name);
                  obj->CreateKey(frame);
              }
          }
      return TRUE;
  }
```

Reading the CAMERAOBJECT section

A camera section is easily read. The important elements are the NODE_
TM, which is the same as the data for an object, and the CAMERA_FOV
component that sets up whether this is a long lens or wide angle.

```
BOOL C3DSAscii::ReadCamera(CStdioFile &file)
{
    CString line;
    int start,end;
    TOKEN tokens[5];
    double fov;

    start = file.GetPosition();
    end = GetSectionEnd(file);

    while(file.GetPosition()<(UINT)end){
        file.ReadString(line);
```

```
    if (line.Find("NODE_TM")!=-1){
        if (!ReadCameraNodeTM(file)) return FALSE;
    }
    if (line.Find("CAMERA_FOV")!=-1){
        if (ParseTokens(line, tokens, 5)<2){
            fov = atof(tokens[1.name);
            camera.zoomFactor = fov * 5;
        }
    }
}
camera.CreateKey(0);

return TRUE;
}
```

Reading the LIGHTOBJECT section

A light section contains the familiar NODE_NAME and NODE_TM tags. In a simple parser you will probably want to read the LIGHT_TYPE tag, LIGHT_COLOR, LIGHT_INTENS and the LIGHT_TDIST.

```
*LIGHTOBJECT {
    *NODE_NAME "Fspot02"
    *LIGHT_TYPE Target
    *NODE_TM {
        . . .
    }
    . . .
    *LIGHT_SETTINGS {
        *TIMEVALUE 0
        *LIGHT_COLOR 1.0000 1.0000 1.0000
        *LIGHT_INTENS 1.0000
        *LIGHT_TDIST 240.0000
        . . .
    }
    *TM_ANIMATION {
        . . .
    }
}
```

Summary

This chapter and the source code should get you started on a more comprehensive parser for 3DS ASE files. If you are using Bezier curves for your animation then ASE files will provide the curve in the format you want. You will almost certainly have to adjust your axes when coming out of 3DS to suit OpenGL. One of the major differences between 3DS files and Lightwave is the scale of objects. A default cube tends to have dimensions around 100 per side, while Lightwave has a side dimension of 1.0. This is not a major problem, but it can be a little confusing at first. You may import an object and be inside it because it is so big in relation to your camera and scene. Similarly, you may find that the object is so small you cannot find it.

12 Motion capture techniques

The early pioneers of animation spent a lot of time studying motion. Some chose to film the actors performing the motions that they were intending to animate. In this way, the complexity of the actions could be analysed frame by frame. Some animators went even further and simply traced this motion directly onto their animation paper. This technique, known as roto-scoping, was the basis of the animation of both Snow White and Prince Charming in the legendary Disney film.

Roto-scoping has a digital equivalent, motion capture or mocap for short. Many animation purists dislike roto-scoping and for largely the same reason they also dislike mocap. The reasoning behind their prejudice is that a very well drawn animation scene has a dynamic that roto-scoping can never achieve, simply because the human body is not capable of the dynamics involved. Since mocap files are captured from the performance of a real being, they can also suffer from this limitation. When working with digital data like mocap files, however, animators can be provided with tools that allow them to use their skills to enhance the data. Using such tools the animator can enjoy all the benefits inherent in mocap, which provides a plausible illusion of life, while not suffering from the problems of stiffness that can be a disappointing side-effect of roto-scoping. In this chapter we are going to look first at the principal methods used to capture motion data. We will look at how with a little engineering

Figure 12.1 A drawn roto-scoped sequence.

and some simple electronics it is possible to create a motion capture suit very cheaply. Then we will look at a particular type of motion capture file, the Biovision Hierarchy (BVH) file, which is often used as a means of saving and exchanging motion files. We will look at creating a BVH viewer and applying some sample BVH files to a single mesh character. Finally, we will look at how to enhance motion capture files by using both Inverse Kinematics and secondary animation channels. Mocap is regularly used in games because it makes the low polygon digital actors seem very lifelike. The techniques are quite simple and well worth studying.

Capturing motion

The principle behind all motion capture methods is essentially the same. An actor is placed in a suit of some description and then they perform an action. Throughout the actors' performance, the position of their limbs is scanned up to 50 times a second and recorded to a file. In order to assess the effectiveness of the motion, it is often applied in real-time to a low-resolution version of the target model using a suitable application program. Filmbox from Kaydara is a popular tool for real-time viewing.

Figure 12.2 Filmbox being used to provide real-time feedback of a mocap session.

Real-time 3D Character Animation with Visual C++

When trying to determine the location and orientation of an actor, there are three basic techniques: optical, magnetic and mechanical.

Optical

Optical suits use two or more cameras and highly reflective markers on an actor's suit. The location of the cameras relative to each other is set to a high degree of accuracy. Motion tracking software follows each marker from a single camera viewpoint. Motion tracking is a form of pattern recognition. Software scans the bitmap of a single frame from a video camera. Then the next bitmap in the video sequence is scanned trying to locate the same pattern. The location of the marker on the bitmap defines a ray emanating from the camera, which goes through the marker and then disappears off to infinity. Using the second and often a third camera, the marker is tracked from other camera angles. Each camera provides a line from the camera to infinity. Software can then determine the intersection of these lines and using the knowledge of the camera world position provide an x, y, z location in world space for a marker for each frame of video. At certain times in the video sequences, markers will be hidden due to the angle of the camera in relation to the performer; this is described as occlusion. At such times knowledge of the topography of markers on the performer helps the software to provide a best estimate of marker location. This type of error checking can make optical motion capture a very accurate form of analysis. Other benefits of optical capture are the low cost of additional markers and the lack of restrictions to the

Figure 12.3 Optical motion capture.

performer. A major disadvantage is the requirement for a dedicated studio or a high set-up time and the high cost of the systems.

Magnetic

Magnetic motion capture uses the movement of a sensor in a magnetic field. The sensors provide both position and orientation. An actor is provided with a suit that houses several sensors, usually located on a major body part (bicep, forearm, hand, etc.). The actor then performs within the confines of three scanning devices. Software then calculates the location and orientation of each sensor. If the software is also provided with knowledge of the sensors' hierarchy as applied to the actor, a very effective motion capture solution can be determined. Magnetic motion capture suffers because the actors are limited to the region between the scanners and are encumbered by sensors and either cables or wireless transmitters. The scanning region is significantly less than the area available to optical capture. However, a major benefit of magnetic capture over optical is the lack of occlusion. Each sensor can be relied on to provide an uninterrupted stream of good data.

Mechanical

A mechanical suit is a rigid arrangement of joints that are located around the actor. Unlike the previous optical and magnetic captures, which

Figure 12.4 Magnetic motion capture.

Real-time 3D Character Animation with Visual C++

determine the location of certain points in 3D space, mechanical motion capture principally determines the orientation. When animating a character using keyframe animation, an animator will spend most of the time rotating joints. A mechanical suit works in much the same way. To record the rotation in a single direction requires a potentiometer, a variable resistor. This simple electronic device is used to control the volume of your hi-fi. Varying the resistance has the effect of varying the voltage. We can use an analogue to digital (A/D) converter to convert this changing voltage into a numerical value. With a little simple scaling this can be converted into an orientation value for this joint. To allow a joint to move in all directions we need three potentiometers for each joint, one to record the heading, pitch and bank. A full suit uses around 50 potentiometers, which all have to be tracked around 25 times per second. The root of the hierarchy of a character is usually the hips, and this single part of the skeleton chain must be tracked for position and orientation. Unlike the other parts of the skeleton, the position and orientation cannot be calculated using a rigid outer skeleton and potentiometers. Instead, we must use some form of sensor that calculates exact position and orientation in world space. Absolute position and orientation of the hips is often calculated using a digital inertial gyroscope. A major disadvantage of mechanical capture is the weight of the suit, which can restrict the motion of the actor. An important advantage is the range of capture available. Mechanical suits usually have a range more than ten times that of the previously described methods.

When deciding on an option it is a balance between the cost of the capture and the current requirements. A mechanical method over long distances is likely to be the best option. If the actor wants to feel the least encumbered then optical will be the way to go. If fine accuracy over short distances is required then magnetic will provide the best option.

Making a simple mocap suit

The simplest and cheapest technique for capturing data is to make your own mechanical suit. Although a full body suit is complicated to engineer, you can get some very effective motion capture data using just upper body movements.

Figure 12.5 Mechanical motion capture.

Just as a puppet can be controlled with rods, so too can a CGI character. The upper body capture device uses one axis of rotation at the collar, three at the shoulder, one at the elbow, three at the wrist, three at the base of the spine and three at the neck. Since we have two arms the following hierarchy is created:

Hips
 Torso (three potentiometers)
 Left Shoulder (one potentiometer)
 Left Bicep (three potentiometers)
 Left Forearm (one potentiometer)
 Left Wrist (three potentiometers)
 Right Shoulder (one potentiometer)
 Right Bicep (three potentiometers)
 Right Forearm (one potentiometer)
 Right Wrist (three potentiometers)

Figure 12.6 A simple upper body capture device.

A total of 19 potentiometers. A simple eight-channel A/D converter can be multiplexed to scan 32 channels if we use a simple 4-to-1 selector. Such a selector is fed by the PC using two output lines. The output lines select one of four inputs to the A/D converter. By using three four-input multiplexers we can choose any of the input channels. Creating the suit requires a little engineering skill. The most complex part is creating a joint with three potentiometers. Figure 12.7 shows an arrangement that has proven to work effectively.

Once you have created the upper body input device illustrated and connected the electronics, you will need to set each channel to the appropriate scale values. First, you will need a simple application program that can input a segmented character that is divided into the same hierarchy as the upper body input device. For each segment you will need to record the voltage derived from the A/D converter at extremes of rotation.

For each joint, calibration involves placing your model into the default relaxed position and then capturing the voltages for each joint at this position. Store both the current joint orientation and the voltage. Now rotate the upper body device to the maximum for a single Euler angle for a single joint. If we think of the shoulder and the amount this can move in bank, then it would reach a maximum when directly rotated upwards. Move the digital model to this position using mouse movement inputs, then connect the

Figure 12.7 A three-potentiometer joint.

model's orientation to the voltage being recorded for the shoulder bank potentiometer. At this stage you have a direct link between the digital output of a single potentiometer from the input device and the orientation of the bank for the shoulder. If you repeat this for each potentiometer you will have a full suit calibration. Having set this once, save it to a file that can be reloaded.

Since the equipment you will use is likely to differ depending on available resources, the presentation is deliberately an overview, but in the following section we will look at how a particular A/D converter was used to provide the continuously scanned input for an upper body real-time character suitable for use at exhibitions and shows. It is possible to link an upper body input device with jaw movers that are created in just the same way.

By allowing two operators to provide the input you can capture in real-time to a file or straight for display the motion of a dynamic character. This type of input device, being relatively low cost and easy to set up, is ideally suited for exhibition and show use.

Capturing data with your mocap suit

Potentiometers and voltage are linked by the important relation $V = IR$, where V is voltage, I is current and R is resistance. The following section is based on the low cost 12-bit A/D converter from Computer Boards (tel.: +1–508–261–1123). The board CIO-DAS08/Jr-AO provides eight digital inputs and outputs, eight analogue inputs and two analogue outputs. Since we are using a multiplexer we can use the digital output lines to

Figure 12.8 Pinout for a 4051 multiplexer.

drive the multiplexer. A simple multiplexer that provides all the facilities we need is a 4051 IC.

By setting the appropriate inputs to this device, we can cause the inputs to the A/D converter to be directed from one of eight different sources. For an eight-channel device, this gives a potential 64 inputs, sufficient for a full body suit if required.

An A/D converter card is often set to port 0x300 on a PC. Ports 0x300−0x31F are designated for prototype cards and this type of card fits into this description. The base address of the card can be set using DIP switches if this address is unsuitable. The card has the address registers shown in Table 12.1.

By connecting each potentiometer as shown in Figure 12.8, we can send a signal between −5 V and +5 V to one channel of the A/D converter.

Table 12.1 Registers on the CIO-DAS08/Jr-AO card

Address	Read function	Write function
Base	A/D bits 9–12 (LSB)	None
Base + 1	A/D bits 1 (MSB)−8	Start 12-bit A/D conversion
Base + 2	A/D status and MUX address	Set A/D channel
Base + 3	Digital input, 8 bits	Digital output, 8 bits
Base + 4		D/A 0 LSB
Base + 5		D/A 0 MSB
Base + 6		D/A 1 LSB
Base + 7		D/A 1 MSB

To read a single potentiometer we need to ensure that the multiplexer is scanning the appropriate inputs by setting the digital output using port Base + 3. Because the A/D converter is much slower than most PCs, we need to ensure that the port is correctly set before continuing. We do this using a very simple delay routine. The variable writedelay is user settable to suit a particular machine.

```
void CADConvert::SetMultiplexer(short value)
{
    value &= 0xFF;
    _outp(baseaddress + 3, value);
    int delay = writedelay;
    while(delay) delay-;
}
```

Having set the appropriate input scanner, we can get the value of a channel by first writing the channel we require to the output port Base + 2. Then we wait to see if the channel is correctly set by scanning the A/D status at the input port Base + 2. The highest bit of this input indicates that the card is ready for a conversion to take place. Since the card could be offline, we check that this is not the case using a simple counter. If a count is exceeded then it is presumed that a hardware error has occurred.

If all is well, then we start a conversion using the output register (Base + 1). Then we wait again for conversion to complete with the same precaution in case the card goes offline. When the conversion is complete, the two input registers (Base and Base + 1) contain the full 12-bit A/D value. To form the 12-bit value, we have to combine the two values. The most significant 8 bits are in register Base + 1; if we shift these four to the left and bitwise and them with the contents of register Base shifted four right because the high order bits are stored in bits 4–7, then we will have the full 12 bits in a single *short* variable *advalue*.

Table 12.2 Analogue to digital input registers

Bits	7	6	5	4	3	2	1	0
Base	A/D 9	A/D 10	A/D 11	A/D 12	X	X	X	X
Base + 1	A/D 8	A/D 7	A/D 6	A/D 5	A/D 4	A/D 3	A/D 2	A/D 1

```cpp
short CADConvert::GetChannel(int index)
{
    BYTE hb,lb,res;
    int i;
    short advalue;

    //Write channel
    _outp(baseaddress + 2, index);

    //Wait for convert ready
    i=0;
    res=1;
    while (res){
        res = _inp(baseaddress + 2) & 0x80;
        i++;
        if (i>1000){
            AfxMessageBox("A/D card not ready. Timed out.");
            return -1;
        }
    }

    //Start conversion
    _outp(baseaddress + 1, 1);

    //Wait for conversion to complete
    i=0;
    res=1;
    while (res){
        res = _inp(baseaddress + 2) & 0x80;
        i++;
        if (i>1000){
            AfxMessageBox("A/D card not ready. Timed out.");
            return -1;
        }
    }

    //Read high and low bytes
    hb = _inp(baseaddress + 1);
    lb = _inp(baseaddress);
    advalue =((short)hb << 4) + (lb>>4);

    return advalue;
}
```

To use the input device to drive a model requires the calibration previously outlined. In this code segment we use the following variables to define the rotation limits:

`AdminH`	numerical value from the A/D conversion when the suit is at minimum heading
`minH`	numerical minimum rotation value for the Euler angle heading for the current object
`AdminP`	numerical value from the A/D conversion when the suit is at minimum pitch
`minP`	numerical minimum rotation value for the Euler angle pitch for the current object
`AdminB`	numerical value from the A/D conversion when the suit is at minimum bank
`minB`	numerical minimum rotation value for the Euler angle bank for the current object
`AdmaxH`	numerical value from the A/D conversion when the suit is at maximum heading
`maxH`	numerical maximum rotation value for the Euler angle heading for the current object
`AdmaxP`	the numerical value from the A/D conversion when the suit is at maximum pitch
`maxP`	numerical maximum rotation value for the Euler angle pitch for the current object
`AdmaxB`	the numerical value from the A/D conversion when the suit is at maximum bank
`maxB`	numerical maximum rotation value for the Euler angle bank for the current object
`mcChannelH`	lowest 4 bits A/D channel, highest 4 bits multiplexer channel for heading
`mcChannelP`	lowest 4 bits A/D channel, highest 4 bits multiplexer channel for pitch
`mcChannelB`	lowest 4 bits A/D channel, highest 4 bits multiplexer channel for bank

Using these values we can determine the current orientation by setting the multiplexer and A/D channel. We then read the value from the current channel. If the A/D minimum value is less than the maximum value, the orientation will be given by first setting the limits to with bounds. Then the current channel orientation is

Real-time 3D Character Animation with Visual C++

$$rot = \frac{(ADvalue - Admin)}{(ADmax - ADmin)} * (max - min) + min$$

In the following function, we calculate this value for each channel for an object:

```
void CToonObject::ADRotate()
{
    CADConvert adcon;
    short s,c,m;

    if (mcChannelH > -1){
        c = mcChannelH & 0xF;
        m = (mcChannelH & 0xF0)>>4;
        adcon.SetMultiplexer(m);
        s = adcon.GetChannel(c);
        if (ADminH<ADmaxH){
            if (s<ADminH) s=ADminH;
            if (s>ADmaxH) s=ADmaxH;
            rot.x=((double)(s-ADminH)/(double)(ADmaxH-
                ADminH))*(maxH-minH) + minH;
        }else{
            if (s>ADminH) s=ADminH;
            if (s<ADmaxH) s=ADmaxH;
            rot.x=((double)(ADminH-s)/(double)(ADminH-
                ADmaxH))*(maxH-minH) + minH;
        }
    }
    if (mcChannelP>-1){
        c=mcChannelP & 0xF;
        m=(mcChannelP & 0xF0)>>4;
        adcon.SetMultiplexer(m);
        s=adcon.GetChannel(c);
        if (ADminP<ADmaxP){
            if (s<ADminP) s=ADminP;
            if (s>ADmaxP) s=ADmaxP;
            rot.y=((double)(s-ADminP)/(double)(ADmaxP-
                ADminP))*(maxP-minP) + minP;
        }else{
            if (s>ADminP) s=ADminP;
```

```
        if (s<ADmaxP) s=ADmaxP;
        rot.y=((double)(ADminP-s)/(double)(ADminP-
            ADmaxP))*(maxP-minP) + minP;
    }
}
if (mcChannelB>-1){
    c=mcChannelB & 0xF;
    m=(mcChannelB & 0xF0)>>4;
    adcon.SetMultiplexer(m);
    s=adcon.GetChannel(c);
    if (ADminB<ADmaxB){
        if (s<ADminB) s=ADminB;
        if (s>ADmaxB) s=ADmaxB;
        rot.z=((double)(s-ADminB)/(double)(ADmaxB-
            ADminB))*(maxB-minB) + minB;
    }else{
        if (s>ADminB) s=ADminB;
        if (s<ADmaxB) s=ADmaxB;
        rot.z=((double)(ADminB-s)/(double)(ADminB-
            ADmaxB))*(maxB-minB) + minB;
    }
}
}
```

A few cheap components and a little hard work and you will have a simple input device for real-time performance. If you extend the software to store the inputs during a capture session, then you will be able to replay the capture later.

The same principles used for input on this real-time suit can be used in tandem with keyframe animation. When setting the pose for a CG character, it can sometimes be useful to have a real mannequin that you can pose, then capture the joint angles. If we use friction joints on the suit described, then this can form the basis of a mannequin input device for setting model poses. Mannequin model input devices of this type were used on the CGI mould-breaking film *Jurassic Park*.

Exchanging motion capture data

Any motion captured from a motion capture input device will need to be supplied in a form suitable for your application. If you are using one of the major CGI packages then you may find that you are able to input certain

motion types. The program 'Filmbox' from Kaydara allows you to input several mocap formats, edit the data and then output to a standard CG package format such as 3DS, Soft, Maya or Lightwave. One of the standard formats for mocap data is the Biovision Hierarchy (BVH) file. In the next section we will look at the way the file is presented and then look at creating a simple viewer for these raw motion files.

Understanding a BVH file

A Biovision Hierarchy file comes in two sections. First, the hierarchy, the structure and size of the object. Then the motion data. Here is a typical short file.

```
HIERARCHY
ROOT Hips
{
    OFFSET    0.00    0.00    0.00
    CHANNELS 6 Xposition Yposition Zposition Zrotation Xrotation⏎
      Yrotation
    JOINT Chest
    {
        OFFSET    0.00    5.21    0.00
        CHANNELS 3 Zrotation Xrotation Yrotation
        JOINT Neck
        {
            OFFSET    0.00    18.65    0.00
            CHANNELS 3 Zrotation Xrotation Yrotation
            JOINT Head
            {
                OFFSET    0.00    5.45    0.00
                CHANNELS 3 Zrotation Xrotation Yrotation
                End Site
                {
                    OFFSET    0.00    3.87    0.00
                }
            }
        }
        JOINT LeftCollar
        {
            OFFSET    1.12    16.23    1.87
            CHANNELS 3 Zrotation Xrotation Yrotation
```

```
        JOINT LeftUpArm
        {
            OFFSET    5.54    0.00    0.00
            CHANNELS 3 Zrotation Xrotation Yrotation
            JOINT LeftLowArm
            {
                OFFSET    0.00   -11.96    0.00
                CHANNELS 3 Zrotation Xrotation Yrotation
                JOINT LeftHand
                {
                    OFFSET    0.00    -9.93    0.00
                    CHANNELS 3 Zrotation Xrotation Yrotation
                    End Site
                    {
                        OFFSET    0.00    -7.00    0.00
                    }
                }
            }
        }
    }
JOINT RightCollar
{
    OFFSET   -1.12    16.23    1.87
    CHANNELS 3 Zrotation Xrotation Yrotation
    JOINT RightUpArm
    {
        OFFSET   -6.07    0.00    0.00
        CHANNELS 3 Zrotation Xrotation Yrotation
        JOINT RightLowArm
        {
            OFFSET    0.00   -11.82    0.00
            CHANNELS 3 Zrotation Xrotation Yrotation
            JOINT RightHand
            {
                OFFSET    0.00   -10.65    0.00
                CHANNELS 3 Zrotation Xrotation Yrotation
                End Site
                {
                    OFFSET    0.00    -7.00    0.00
                }
            }
        }
    }
```

```
                    }
                }
            }
        JOINT LeftUpLeg
        {
            OFFSET    3.91    0.00    0.00
            CHANNELS 3 Zrotation Xrotation Yrotation
            JOINT LeftLowLeg
            {
                OFFSET    0.00   -18.34    0.00
                CHANNELS 3 Zrotation Xrotation Yrotation
                JOINT LeftFoot
                {
                    OFFSET    0.00   -17.37    0.00
                    CHANNELS 3 Zrotation Xrotation Yrotation
                    End Site
                    {
                        OFFSET    0.00   -3.46    0.00
                    }
                }
            }
        }
        JOINT RightUpLeg
        {
            OFFSET   -3.91    0.00    0.00
            CHANNELS 3 Zrotation Xrotation Yrotation
            JOINT RightLowLeg
            {
                OFFSET    0.00   -17.63    0.00
                CHANNELS 3 Zrotation Xrotation Yrotation
                JOINT RightFoot
                {
                    OFFSET    0.00   -17.14    0.00
                    CHANNELS 3 Zrotation Xrotation Yrotation
                    End Site
                    {
                        OFFSET    0.00   -3.75    0.00
                    }
                }
            }
        }
    }
```

Real-time 3D Character Animation with Visual C++

```
MOTION
Frames: 22
Frame Time: 0.033333
```

-5.59	39.43	-41.18	1.01	-1.24	-4.17	-9.62	30.14	. . .	
-5.59	40.23	-37.53	1.89	-0.09	-5.66	-13.75	28.31	. . .	
-5.52	40.60	-33.76	1.68	0.88	-5.73	-15.61	26.12	. . .	
-5.41	40.36	-29.91	0.34	1.12	-4.58	-15.14	24.38	. . .	
-5.23	39.50	-26.02	-1.42	0.26	-3.17	-13.66	23.81	. . .	
-5.00	38.27	-22.20	-2.25	-1.38	-2.35	-13.14	24.44	. . .	
-4.76	37.16	-18.58	-1.42	-2.91	-2.23	-14.53	25.73	. . .	
-4.54	36.51	-15.17	0.14	-3.53	-2.53	-16.24	26.61	. . .	
-4.35	36.41	-11.82	0.93	-3.37	-2.82	-16.31	27.12	. . .	
-4.22	36.67	-8.40	0.81	-3.23	-2.67	-14.83	28.41	. . .	
-4.15	36.82	-4.88	0.50	-3.26	-2.33	-12.87	29.56	. . .	
-4.16	36.86	-1.27	0.09	-3.43	-1.89	-10.65	30.58	. . .	
-4.23	36.81	2.40	-0.38	-3.68	-1.39	-8.32	31.45	. . .	
-4.34	36.72	6.11	-0.85	-3.98	-0.88	-6.02	32.13	. . .	
-4.49	36.62	9.85	-1.29	-4.28	-0.42	-3.89	32.59	. . .	
-4.66	36.55	13.59	-1.66	-4.54	-0.05	-2.07	32.83	. . .	
-4.85	36.55	17.31	-1.92	-4.68	0.18	-0.69	32.85	. . .	
-5.03	36.64	20.98	-2.03	-4.67	0.22	0.12	32.71	. . .	
-5.20	36.88	24.60	-1.95	-4.43	0.01	0.21	32.43	. . .	
-5.35	37.30	28.14	-1.65	-3.91	-0.48	-0.60	32.05	. . .	
-5.47	37.93	31.57	-1.05	-3.06	-1.31	-2.53	31.62	. . .	
-5.55	38.75	35.00	0.01	-2.04	-2.72	-6.05	31.01	. . .	

Following the token HIERARCHY we read the ROOT object for the file. When parsing the file we can retain the name of this element by reading the string that follows ROOT. Everything that follows belonging to ROOT is contained within matching braces. The first line after the opening brace gives the offset for this element and then the next line gives the channels for this element. In my experience this will be six channels for a ROOT element and three for a JOINT element, but this is from files I have worked with rather than from a full specification for the data format. The order of the rotation channels can differ and should be checked. Within the braces of the ROOT element can be any number of JOINT elements, which in turn have a name, OFFSET and CHANNEL specification. JOINT elements can contain an unlimited number of nested sub JOINT elements.

After the HIERARCHY section you will find the MOTION section. The token MOTION is followed immediately by the number of frames in the

motion and the increment for a single frame expressed in seconds. The remainder of the file contains the actual motion. Each subsequent line in the file gives the channel value for every channel in the order that they were given in the HIERARCHY section of the file. In this instance with six channels of Hips being given first followed by three channels for the Chest, the first nine values for each motion line will give the *Xposition*, *Yposition*, *Zposition*, *Zrotation*, *Xrotation* and *Yrotation* for the *Hips* followed by the *Zrotation*, *Xrotation* and *Yrotation* for the *Chest*. Remember that when orientation is defined using Euler angles, it is important that the order of rotation is maintained. If the order of rotation channels is *X, Y, Z*, then rotation order must be *X, Y, Z*. Similarly, if the order of rotation channels is *Z, X, Y*, then rotation order must be *Z, X, Y*.

Creating a BVH viewer

In creating any parser there are two parts. First, we must read and create a skeleton. In the sample code we use a *CBone* class to hold the data for each element. Since the sample code is an MFC application it used the Document/View architecture. The Document contains a *CBone* variable called *bones*. The *CBone* class is a singly linked list. Each member of the class contains a *next* member variable that is a pointer to a *CBone* element and a *parent* member variable is also a *CBone* pointer. Both these pointers are initialized to NULL by the constructor. When parsing a file for each ROOT or JOINT, a bone is added and the offset and channels are initialized. When dealing with a hierarchical file a recursive function is the best solution. Since any bone can have only a single parent, we need only to set the parent in the recursive function call. When using a recursive function there has to be an exit condition otherwise the function will never return. In the following function which sets the hierarchy the exit condition is the file position of the closing brace for the current ROOT or JOINT section. Once this point is reached the function returns.

```
BOOL CBVHViewerDoc::LoadBVHHierarchy(CBone *parent, CStdioFile⏎
   &bvhfile, int endpos)
{
    //This function is called recursively
    //The function returns when the current file position for the
    //bvhfile exceeds the supplied parameter endpos
    CBone *bone;
```

```
CString braceline, line, name;
int filepos, strpos;

//If the function is called with a zero value for endpos then
//this value is set to the file length of bvhfile
if (!endpos) endpos = bvhfile.GetLength();

//The file is scanned to find the next ROOT or JOINT element
//If ROOT or JOINT is not found then the funciton returns FALSE
while(1){
    if (!bvhfile.ReadString(line)) return FALSE;
    filepos = bvhfile.GetPosition();
    if (filepos > endpos) return TRUE;

    strpos = line.Find("ROOT");
    if (strpos!=-1){
        name = line.Right(line.GetLength() - 5 - strpos);
        break;
    }

    strpos = line.Find("JOINT");
    if (strpos!=-1){
        name = line.Right(line.GetLength() - 6 - strpos);
        break;
    }
}

//Add the new item
bone = bones.AddBone(name, parent);
if (!bone) return FALSE;

//Allow for finding end brace by storing current brace line and
//Altering the opening brace to a closing brace
bvhfile.ReadString(braceline);
strpos = braceline.Find('{');
if (strpos==-1) return FALSE;
braceline.SetAt(strpos, '}');

bone->SetOffset(bvhfile);
bone->SetChannels(bvhfile);
filepos = bvhfile.GetPosition();
```

```
//Find matching brace
while (1){
    if (!bvhfile.ReadString(line)) return FALSE;
    if (line == braceline) break;
}

endpos = bvhfile.GetPosition();
bvhfile.Seek(filepos, CFile::begin);

while (filepos<endpos){
    //Recusrsively call this function using new endpos and with
    //current bone as parent
    LoadBVHHierarchy(bone, bvhfile, endpos);
    filepos = bvhfile.GetPosition();
}

return TRUE;
}
```

The first call to *LoadBVHHierarchy* with the ROOT object uses a NULL pointer as the parent parameter and sets the 'endpos' to zero. The function recognizes a zero value for 'endpos' as indicating that the entire file should be searched. When this occurs 'endpos' is set to the current file length.

Having loaded a set of bones and initialized the hierarchy, offset and number and type of motion channels, we can go on to load the motion. As we learnt in the previous section, the motion section is preceded by a single line that contains the upper case word MOTION. The following function goes on to read the number of frames and the frame duration, and store these values in member variables of the document class. Assuming all went well to this stage, we are ready to create storage for the key values. We leave this task to the bones themselves. Each bone knows how many channels are used for the bone and so can assign the appropriate key storage. In the *BVHViewer* project we have both position keys represented as vectors and rotation keys represented as vectors. A bone can have just position, just rotation or both position and rotation. If any problems occurred allocating storage, then the current bones are cleared and the function returns.

Finally, we have the data structure and storage to read in the motion capture data. Each line of the file contains one set of key values. To allocate the correct value to the appropriate bone and channel we go

Real-time 3D Character Animation with Visual C++

through the bones in the order in which they were allocated by using the next member variable. We first read the next line and create a character pointer to this line. The *CBone* class contains a member function *SetKey* that takes the current frame and the character pointer as parameters. It returns the position of the character pointer after the appropriate number of channel values for the current bone have been read from the file. If the returned pointer is NULL then the current bones are cleared and the function returns. At this stage we have loaded all the data from the file and it can be closed.

```
void CBVHViewerDoc::OnFileOpen()
{
    //Initialise an open file dialog box
    CFileDialog dlg(TRUE, "bvh", NULL, OFN_HIDEREADONLY |↵
      OFN_OVERWRITEPROMPT,
        "Biovision Hierarchy Files (*.bvh)|*.bvh|All Files↵
        (*.*)|*.*||");
    CString str = AfxGetApp()->GetProfileString("Settings",↵
      "BVHLoad","C:\\");
    dlg.m_ofn.lpstrInitialDir = str;
    dlg.m_ofn.lpstrTitle="Load a Biovision file";

    if (dlg.DoModal()==IDCANCEL) return;

    int pos;

    //Clear any existing animation
    frames = 0;
    bones.ClearAll();

    CStdioFile file(dlg.GetPathName(), CFile::modeRead);

    //Recursively load the file
    if (LoadBVHHierarchy(NULL, file, 0)){
        //Store new path
        str = dlg.GetPathName();
        pos = str.ReverseFind('\\');
        if (pos!=-1) str=str.Left(pos);
        AfxGetApp()->WriteProfileString("Settings",↵
          "BVHLoad",str);
    }
```

```
//Load the motion
//Look for the MOTION key word if it is not found before the end
//of the file then the current bone hierarchy is cleared and the
//function returns.
while (1){
    if (!file.ReadString(str)){
        bones.ClearAll();
        return;
    }
    if (str.Find("MOTION")!=-1) break;
}

//Read frame total and frame time
file.ReadString(str);
str = str.Right(str.GetLength()-7);
frames = atoi(LPCTSTR(str));

file.ReadString(str);
str = str.Right(str.GetLength()-11);
frametime = atof(LPCTSTR(str));

CBone *bone = bones.next;
char *cp;

//For each bone create storage for the key values
while(bone){
    if (!bone->CreateKeys(frames)){
        bones.ClearAll();
        return;
    }
    bone = bone->next;
}

//Store the keys into all active channels available
for (int i=0; i<frames; i++){
    file.ReadString(str);
    cp = str.GetBuffer(0);
    bone = bones.next;
    while (bone){
        cp = bone->SetKey(i, cp);
```

```
        if (!cp && bone->next){
            bones.ClearAll();
            return;
        }
        bone = bone->next;
    }
}

    SetTitle(dlg.GetFileTitle());
}
```

The next step is to display the file contents moving. We start a timer that has an increment defined by the member variable frametime. Since windows timers use a millisecond parameter, we convert the floating-point value into an integer millisecond value by multiplying the value by 1000 and taking the integer part. The purpose of the timer function call is to transform the object. We can achieve this by updating the current frame value. If this exceeds the total number of frames then frame is reset to zero. Then each bone is transformed starting with the top level parent. A parent object updates all its children using a recursive function call, until

Figure 12.9 The BVHViewer application displaying a walk action.

all the bones have been repositioned. The skeleton is then drawn by drawing a line from the child to its parent.

Applying BVH files to your single mesh characters

A BVH file stores most data via Euler angle orientations. If you want to apply these data to your own model then you need top know the default position of the character. In many instances this will be standing upright with arms outstretched. Some files, however, record the default position as arms down to the side. If you are going to apply the motion to your own object, then you must either model the character to suit the default location of the mocap data or alternatively be able to conform your model at frame zero to the mocap position and then apply the rotational motion on top of the current orientation.

If the rotation matrix for an object at position zero is **A** and the rotation matrix for the motion capture data at frame n is **B**, then the combination of the two matrices will be **AB**. To record this to your scene file as Euler angles you will need to extract the rotation angles from this matrix. If in your application you normally apply the rotations in *HPB* order then in BVH terms this is *Z*rotation followed by *X*rotation and finally *Y*rotation. This leads to the following matrix:

$$\mathbf{AB} = \begin{bmatrix} aa & ab & ac \\ ba & bb & bc \\ ca & cb & cc \end{bmatrix}$$

$$HPB = \begin{bmatrix} \cos(h)\cos(b) - \sin(h)\sin(p)\sin(b) & \cos(h)\sin(b) + \sin(h)\sin(p)\cos(b) & \sin(h)\cos(p) \\ -\cos(p)\sin(p) & \cos(p)\cos(b) & -\sin(p) \\ -\sin(h)\cos(b) - \cos(h)\sin(p)\sin(b) & -\sin(h)\sin(b) + \cos(h)\sin(p)\cos(b) & \cos(h)\cos(p) \end{bmatrix}$$

Notice that the final term of the second row is $-\sin(p)$. So we can find the pitch by looking at the arcsin of this value:

$$p = \mathrm{asin}(-bc)$$

Since we know $-\sin(p)$, we know that $-bc = \sin(p)$. Using this information with term *ba* gives

$$ba = bc \times \cos(p)$$

Hence,

$$\cos(p) = ba/bc$$

Using this information, term *ac* can supply the heading value:

$$[ac = (ba/bc)\sin(h)]$$

Hence,

$$\left[\sin(h) = \frac{ac*bc}{ba} \right]$$

Therefore,

$$\left[h = \text{asin}\left(\frac{ac*bc}{ba} \right) \right]$$

Finally, we can use the fact that $bb = \cos(p)\cos(b)$ to find the value of bank. Substituting *ba/bc* for $\cos(p)$, we have

$$[bb = (ba/bc)\cos(b)]$$

Hence,

$$\left[\cos(b) = \frac{bb*bc}{ba} \right]$$

Therefore,

$$\left[b = \text{acos}\left(\frac{bb*bc}{ba} \right) \right]$$

Now to apply the data to your model you simply need to create a dialog box that will map the elements in the mocap file to the segments in your character. By reorientating the data with respect to frame zero for your model the alignment can be achieved. This is often a trial and error task. You may find that the data give a bow-legged character, in which case

Real-time 3D Character Animation with Visual C++

Figure 12.10 Using a dialog box to connect mocap data with a segmented model.

rotate the character at frame zero so the legs are not as splayed. When the mocap data are applied the character's legs will appear more upright.

Enhancing mocap

There are two fundamental problems with mocap data. First, mocap data are difficult to edit. The other fundamental problem is that the data are restricted by the ability of a human to perform an action. We will look at solutions to both these problems.

Working with mocap data

With a key value every frame the data are very dense. If you want to adjust a keyframe then you will create a sudden jolt because there is a key value on the preceding and following frames. One way out of this problem is to use curve-fitting techniques. This subject is very dense in terms of

Real-time 3D Character Animation with Visual C++

the mathematical presentation and is unfortunately beyond the scope of this book. However, with the emphasis on providing useful tools for animators, one way out is to let the user recreate the curve visually. If the data for a single channel are presented as a graph and the user can create an approximation to this graph by clicking and dragging keyframe markers on the graph, then in a large majority of cases this will provide just the method required to simplify the data sufficiently to allow them to edit the animation.

Avoiding human limitations

The restrictions on the data that are the natural consequence of environment of the capture can be eliminated in two ways. First, the timings of certain sections can be adjusted. By setting a starting time, an end time and a new target end time, the data can either be spaced out or compressed. This can add considerably to the dynamics of a scene. The other method to enhance a human performance is to add extended targets on top of the existing action. Suppose the position of the hips is driven not only by the mocap data, but also by a secondary animation layer. In this secondary layer you can add keyframes in just the same way you would with straightforward keyframing and these keys can be interpolated using the techniques described in Chapter 8. Now your character can jump higher and faster than any human ever could. This dynamism greatly improves mocap scenes and is well worth adding to any animation tools.

Blending motions

You may have a mocap scene that is a great walk and another that is a stop and turn. You can easily blend these actions by setting a start frame and a blend length, then iterating through the data slowly blending one action into the next.

Implement IK

The motion of your character and the actual mocap data may be in some ways incompatible. The length of legs and arms may mean that certain restrictions have to be set in order to map the data effectively to your character. IK offers the best solution to most of these problems. If the

Real-time 3D Character Animation with Visual C++

rotations in the mocap data are not sufficient for your character to walk because they have very short stubby legs that rotate in a very exaggerated way to achieve the goals, then by forcing them to conform to an IK target the data are tweaked to suit your model. Most mocap data are suitable in their raw form only for characters that are similar in limb lengths to humans. IK can provide a way out of this dilemma.

Summary

Mocap is a great way to create realistic actions. By enhancing the data the restrictions can easily be removed from the motion and animators given free rein to create the scenes they desire. Mocap data provide an excellent raw resource for the animator and if handled as valuable reference rather than always used in their raw form then these data should be an essential part of any CG animator's armoury.

13 Collision detection

If you are simply creating animated demos then collision detection is not an issue. But as soon as your characters are under user control they can easily walk through walls. It is your job as the programmer to stop this happening without interrupting the flow of the game. Collision detection can be handled in very complex ways using particularly heavy going mathematical approaches. In this chapter we are going to look at some of the simpler ways of handling collisions. First, we will look at a real world problem and some simple solutions to it using easy to code bounding boxes. Next we will look at how basic bounding boxes can introduce errors and how we can deal with these. Then we will look at how many collision detection problems can be reduced from a 3D to a 2D problem, greatly simplifying the code and speeding up the implementation. If you are dealing with a fighting game then basic bounding box collision detection with the two full figure fighting characters is not going to give enough information for your game logic; we will look at how the full mesh can be handled in sections to get finer control over collision detection. Finally, we will look at how to handle basic collisions with the background. When a character is running near a wall, it is better to align the character to run along the wall than to stop the character when the angle of collision between the character and the wall is very small.

A real world problem

To introduce the problems involved in collision detection, let's look at a real world problem. Figure 13.1 shows a single mesh character running down a tunnel. The scene character contains 994 polygons and the set contains 529 polygons. The aim is to avoid the character running through the walls. The most complex approach would be to get down to the individual polygon level and calculate any intersections between

Figure 13.1 A single mesh character running down a tunnel.

polygons. This would be very time consuming and for much of the time totally unnecessary. The first stab at a solution to this problem involves using axis-aligned bounding boxes (AABBs). The advantage of AABBs is that they are easily handled. The screen grab is from the supplied Toon3D application; the example can be found in Examples/Chapter13 as file Bug01.t3d. In Toon3D the developer can position and create axis-aligned collision boxes and then set up actions to handle the response when a collision occurs between two bounding boxes. The bounding boxes for the set are static, while the bounding box for the character is created from the minimum and maximum vertices for the mesh at each time increment. Since the processor handles the transformation of the character it is easy to determine which are the minimum and maximum vertices in a mesh. Set the minimum and maximum vertices to the first vertex values for x, y and z. As you iterate through the vertices, if a component value is less than the current minimum, then update the minimum, and if a component value is greater than the maximum, then update the maximum.

```
...
//Get first vertex
pt = obj->pts;
//Initialise the bounding box
obj->bbmin.x = pt.x;
obj->bbmin.y = pt.y;
obj->bbmin.z = pt.z;
obj->bbmax.x = pt.x;
obj->bbmax.y = pt.y;
obj->bbmax.z = pt.z;

for (i=0; i<obj->numpoints; i++){
    //Transformation code
    ...
    //Update bounding box min and max
    if (pt.x<obj->bbmin.x) obj->bbmin.x = pt.x;
    if (pt.y<obj->bbmin.y) obj->bbmin.y = pt.y;
    if (pt.z<obj->bbmin.z) obj->bbmin.z = pt.z;

    if (pt.x>obj->bbmax.x) obj->bbmax.x = pt.x;
    if (pt.y>obj->bbmax.y) obj->bbmax.y = pt.y;
    if (pt.z>obj->bbmax.z) obj->bbmax.z = pt.z;

    pt++;
}
...
```

Once you have your bounding boxes you can check if one bounding box is inside another. Since the bounding boxes are aligned along their axes this is very simply done. If the character's bounding box, defined by *bbmin*, *bbmax*, is inside the test bounding box, defined by *testbbmin*, *testbbmax*, then the following conditional evaluates to true:

```
if (bbmin.x<testbbmax.x && bbmax.x>testbbmin.x &&
    bbmin.y<testbbmax.y && bbmax.y>testbbmin.y &&
    bbmin.z<testbbmax.z && bbmax.z>testbbmin.z)
```

An alternative to testing for intersections is to force a bounding box to remain totally inside another. If a contained bounding box goes outside another, then the following conditional evaluates to true:

```
if (bbmin.x>testbbmin.x || bbmax.x>testbbmax.x ||
    bbmin.y>testbbmin.y || bbmax.y>testbbmax.y ||
    bbmin.z>testbbmin.z || bbmax.z>testbbmax.z)
```

Figure 13.2 Simple axis-aligned collision detection.

With this simple checking we can contain our character within an area and test for more specific collisions within that zone. If you set up each collision box to have a specific numerical value, then your code can easily determine how to react. We add a box that the character can jump onto and give this a collision box that returns, for example, 12. Then in code we can tell that the character has bumped into the box if a 12 is returned from a collision testing routine. But which side was hit? You may want your character to react differently if the box is hit from the side, the top or the bottom. A side hit could result in a character falling over if the speed of the hit reaches a certain value or the character may simply have to enter a stationary animation cycle. A hit on the top may result in a bounce, again depending on the hit vector. To decide, we can use a vector from the character centre to the collision box centre. The component with the greatest absolute magnitude will give the collision direction that is the most marked visually. When an intersection of two bounding boxes occurs, one vertex must be completely inside the other bounding box; hence, all the axes are affected, but if we want to get the general feel of the collision the absolute biggest component of the collision vector gives a good starting point.

```
VECTOR bbcen, bbtestcen, a, tmp;

//Find the bounding box centres
bbcen.x = (bbmax.x – bbmin.x)/2 + bbmin.x;
bbcen.y = (bbmax.y – bbmin.y)/2 + bbmin.y;
bbcen.z = (bbmax.z – bbmin.z)/2 + bbmin.z;

bbtestcen.x = (bbtestmax.x – bbtestmin.x)/2 + bbtestmin.x;
bbtestcen.y = (bbtestmax.y – bbtestmin.y)/2 + bbtestmin.y;
bbtestcen.z = (bbtestmax.z – bbtestmin.z)/2 + bbtestmin.z;

//Calculate vector from testbb to bb
a.x = bbtestcen.x – bbcen.x;
a.y = bbtestcen.y – bbcen.y;
a.z = bbtestcen.z – bbcen.z;
```

```
//Find component with greatest magnitude
tmp.x = a.x*a.x;
tmp.y = a.y*a.y;
tmp.z = a.z*a.z;

if (tmp.x > tmp.y){
    if (tmp.x>tmp.z){
        if (a.x>0){
            //Hit on right of bounding box
            ...
        }else{
            //Hit on left of bounding box
            ...

        }
    }else{
        if (a.z>0){
            //Hit on front of bounding box
            ...
        }else{
            //Hit on rear of bounding box
            ...

        }
    }
}else{
    if (tmp.y>tmp.z){
        if (a.y>0){
            //Hit on top of bounding box
            ...
        }else{
            //Hit on base of bounding box
            ...

        }
    }else{
        if (a.z>0){
            //Hit on front of bounding box
            ...
        }else{
            //Hit on rear of bounding box
            ...

        }
    }
}
```

Your scene will have bounding boxes that will never collide. The first rule of real-time applications is only calculate what is essential. If a bounding box can never collide with another, then do not test them for collisions. The axis-aligned bounding box approach gives a good first check for a collision. It is fairly low in the computational hit apart from one major flaw; graphics cards are increasingly able to do all the transformations, relieving the processor of this computationally expensive work. The maximum and minimum vertex bounding box approach is rather reliant on the processor doing the transformation work, so that you can derive the world values for maximum and minimum values for the character's bounding box in world coordinates. You can get around this problem by having a fixed bounding box that you transform using the graphics hardware matrix which you can get from OpenGL after setting up the camera location. You can then use this matrix to transform just the two vertices in the fixed bounding box.

An alternative approach to using bounding boxes for the basic collision testing is to use spheres centred on the collision targets.

To get a basic test for a collision you need only check that the distance from the character's bounding sphere centre to the centre of each collision sphere in the set is less than the combined radii of the two

Figure 13.3 Using bounding spheres.

spheres. The distance between any two points in 3D space is found by calculating a vector from one point to the next, starting at either end, then finding the square root of the sum of the squares of components of this vector.

```
double CalcDistance(VECTOR a, VECTOR b){
    VECTOR ab;

    ab.x = a.x - b.x;
    ab.y = a.y - b.y;
    ab.z = a.z - b.z;

    return sqrt(ab.x*ab.x + ab.y*ab.y + ab.z*ab.z);
}
```

Unfortunately, square root operations are computationally expensive. But, wait a minute, we don't actually need a distance, we are only interested in a condition, namely is sphere A intersecting with sphere B. For this we can use the squared distance and the combined radii squared, avoiding any use of square roots.

```
//a and b give the sphere centres, R and r give the sphere radii
typedef struct stSPHERE{
    double x,y,z;   //Centre
    double r;   //radius
}SPHERE;

BOOL DoSpheresIntersect(SPHERE a, SPHERE b){
    VECTOR ab;
    double sqdist, sqrad;

    //Vector from b to a
    ab.x = a.x - b.x;
    ab.y = a.y - b.y;
    ab.z = a.z - b.z;
    sqdist = ab.x*ab.x + ab.y*ab.y + ab.z*ab.z;

    //Combined radii squared
    sqrad = a.r*a.r + b.r*b.r;

    return (sqdist<sqrad);
}
```

Problems with axis-aligned bounding boxes and bounding spheres

The problem with axis-aligned bounding boxes and spheres is easily identified: accuracy. Collision detection accuracy is poor because the test areas do not conform accurately to the target geometry.

Figure 13.4 Problems with AABBs.

Figure 13.4 illustrates the problem. The bounding box between the character and the set is going to report a collision when clearly none has occurred. Now one approach is to have more and more bounding boxes, but at some stage you will be adding to the problem rather than simplifying it. Another approach is to use bounding boxes to get an indication whether a collision has occurred and if this is the case to analyse the collision in more detail. We will look at this further in a later section.

Another problem involves the fourth dimension of time. If the movement vector on a character is large, then it is possible that in a single move the character has hit and gone through an obstacle yet no collision is reported because at both the time positions calculated, no collision occurred.

Fortunately, this problem is easy to fix. If your character has a movement vector then this can be used to create a combined bounding box for the current time increment and the previous time increment.

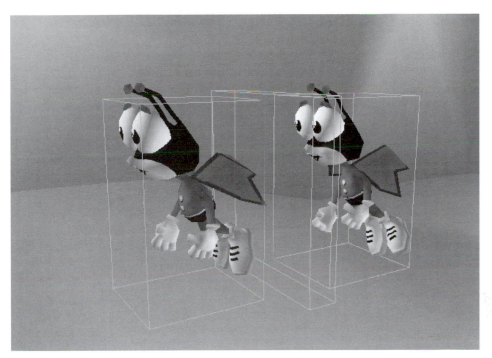

Figure 13.5 How time can affect collision detection.

```
if (move.x>0){
    bbmin.x -= move.x;
}else{
    bbmax.x += move.x;
}
if (move.y>0){
    bbmin.y -= move.y;
}else{
    bbmax.y += move.y;
}
if (move.z){
    bbmin.z -= move.z;
}else{
    bbmax.z += move.z;
}
```

This is such a simple fix that it is recommended that time is always considered. We will explore techniques for getting more accurate collision results in more detail in a later section.

Simplifying the problem

Surprisingly, many collision detection problems in 3D can be simplified to a 2D solution. If your character is wandering around a set where the floor is flat and the walls are fairly vertical, then collision detection can be reduced to detecting whether a single 2D polygon intersects another 2D polygon. Before we look at this general case, we can simplify the problem still further by looking at a single point inside a polygon. If the polygon is

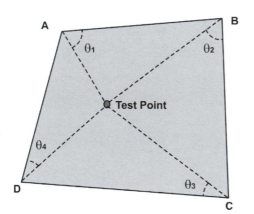

convex, then a point is inside this polygon if the dot product of a unit length vector from the point to each corner vertex in the polygon and a unit length vector from the same corner vertex to the adjacent vertex returns a value under 1.0. A dot product of two normalized vectors gives the cosine of the angle between the two vectors. The cosine curve runs from 1.0 to 0.0 for angle values of 0–90°.

Figure 13.6 *Determining whether a point is inside a polygon using the dot product method.*

Unfortunately, normalized vectors require a square root operation, which is computationally expensive. Another flaw in using this method is that the technique only works on convex polygons. An alternative approach that works with any arbitrary polygon uses the quadrant technique.

Divide the polygon into four quadrants centred on the test point. Start at the first edge in the polygon; if this edge crosses a quadrant boundary in a clockwise direction add 1 to a count, if the edge crosses a quadrant boundary in an anticlockwise direction then subtract 1 from your count. If the value of the count after iterating through all the edges in the polygon is either 4 or −4 then the point is inside the polygon. Figure 13.7 illustrates the concept; of points A–E, only point A gives a result of 4.

If the quadrants are labelled as in Figure 13.7 then the truth table for the updating of the count variable is as in Table 13.1.

Notice that the leading diagonal, where both ends of the edge are in the same quadrant, has no effect on the count and that quadrants cannot be reached across the diagonals. We can use the truth table to calculate the count value for vertex A:

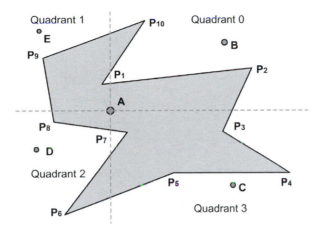

Figure 13.7 Using the quadrant method to determine whether a point is inside a polygon.

Table 13.1 Truth table of points inside a polygon using the quadrant method

$q1\backslash q2$	0	1	2	3
0	0	−1	X	1
1	1	0	−1	X
2	X	1	0	−1
3	−1	X	1	0

Edge	*Count*
P_1P_2	1
P_2P_3	2
P_3P_4	2
P_4P_5	2
P_5P_6	3
P_6P_7	2
P_7P_8	3
P_8P_9	4
P_9P_{10}	5
$P_{10}P_1$	4

Vertex A returns 4 as stated. But, if we try the same thing for vertex B we get a count of 3, so the vertex is not inside the polygon.

```
BOOL PointInPolygon(POINT &p, POLYGON &ply){
    int count = 0, q1, q2;
    EDGE *e;

    for (i=0; i<ply.numedges; i++){
        e = &ply.edge[i];
        //Get quadrant for first edge vertex
        if (e->a.y>p.y){
            q1 = (e->a.x>p.x)?0:1;
        }else{
            q1 = (e->a.x<p.x)?2:3;
        }
        //Get quadrant for second edge vertex
        if (e->b.y>p.y){
            q2 = (e->b.x>p.x)?0:1;
        }else{
            q2 = (e->b.x<p.x)?2:3;
        }

        if (q1!=q2){
            switch(q1){
            case 0:
                if (q2==1){
                    count-;
                }else{
                    count++;
                }
                break;
            case 1:
                if (q2==2){
                    count-;
                }else{
                    count++;
                }
                break;
            case 2:
                if (q2==3){
                    count-;
                }else{
```

```
                  count++;
               }
            break;
         case 3:
            if (q2==0){
               count-;
            }else{
               count++;
            }
            break;
         }
      }
   }

   return (count==4 || count==-4);
}
```

Another useful 2D technique is finding the nearest point on a line segment to an arbitrary point.

The two triangles AP'P and BP'P define the position of the point P' on the line segment AB. A simple technique to calculate the position of P' is to use the old favourite the dot product. If we are trying to get the angle at A then we can use two vectors. First, the line segment AB and, second, the vector AP. If we set these two vectors to unit length then the dot product AP' • AP returns the cosine of the angle between them. If this value is negative then the angle is greater than 90° and so the nearest point to the line segment AB is the point A itself. Similarly, at B, if the returned cosine is negative then the point P must be to the right of the line

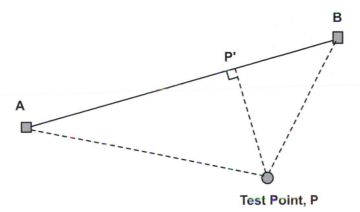

Figure 13.8 Finding the nearest point on a line segment to an arbitrary point.

segment and so B is the nearest point on the line segment to P. If both ends have positive cosines then we can use these cosines to return a linear ratio. If the cosine at A is large, then the angle is small and the angle at B nears 90°, then the nearest point to P on the line segment AB must be near the B end. We sum the two cosine values and set this as the denominator of a fraction; the numerator becomes the cosine of the start end. The point P is therefore found as follows.

Assuming that the unit vector in the direction AB is **A** and the unit vector in direction BA is **B**, unit vectors in the direction AP and BP are **N** and **M** respectively. Then

$$P' = A + AB * \left(\frac{A \cdot N}{A \cdot N + B \cdot M} \right)$$

Not a square root in sight, so computationally inexpensive!

Getting down to detail

If the basic bounding box test returns a likely collision, then you may need to determine whether the collision is actually taking place more precisely. One technique involves splitting up the mesh into smaller segments. If you are using a single mesh character driven by animated point sets, then you are already close to the segmenting you need. Simply check the axis-aligned bounding boxes for each segment in the character to see if a collision is taking place. If this level of accuracy is still not enough for your purposes, then you may want, finally, to get down to the polygon level to determine if a collision has occurred.

The standard technique at the polygon level is to attempt to find a separating plane between two objects. If there is a plane between two objects then clearly they do not intersect. The first stage in finding such a plane is to use all the faces in the collision target as the possible separating planes. To test whether a face can act as a separating plane, use the dot product of

Figure 13.9 Using segment bounding boxes.

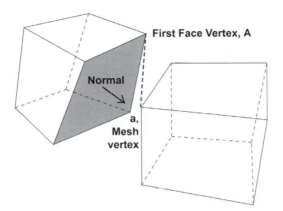

Figure 13.10 Finding a separating plane using object faces.

the face unit normal and a vector from a vertex on the face to each vertex on the colliding mesh. If this test is positive for every vertex then the face is a separating plane. If no face conforms to this test then a collision is unlikely but can still have occurred if, instead of a vertex from the colliding mesh being inside the collision object, an edge is.

To check this, we create a plane out of every edge in the collision target and every vertex in the colliding mesh. Having created this plane, we then check every other vertex in the colliding mesh with a normal of this test plane; if the dot product is consistently positive then no collision has occurred.

Unfortunately, the number of tests to confirm face level accuracy is huge and involves a large number of normalized vectors, using the computationally expensive square root operation. Also, the techniques only work on convex meshes. A way to reduce the calculations is to flag

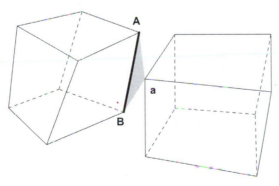

Figure 13.11 Finding a separating plane using object edges.

the collision so that it can be easily checked in the next time increment. Since the topology of a scene ensures that a collision is likely to occur over several time increments, this can make a huge difference to the number of tests required to confirm collisions. Another useful technique is to model a low resolution collision mesh that provides the accuracy required at a much reduced face, vertex count. As polygon meshes start to hit the 10 000 face level in a single character, it is usually unnecessary to calculate collisions to this level of refinement and a 300 face collision mesh will provide the necessary accuracy at a greatly reduced computational level.

Reacting to a collision

Most applications will handle collisions differently. The first thing to remember is that if your code starts an action as a collision occurs it does not want to be allowed to restart this action if the collision test is confirmed in the next time increment. If this is allowed to happen, then the character enters a jitter phase where it bounces between two positions. Better to let a collision-provoked action complete before testing collisions again. A

Figure 13.12 Aligning a character's action to a wall.

Real-time 3D Character Animation with Visual C++

common condition in a game involves a character running close to a collision boundary. If the character hits the wall at a glancing angle then it is better to rotate the character to align to the collision boundary than to stop the character abruptly as though it has hit the collision object straight on. To use these alignment techniques we need to know a movement vector. If we think of this as a 2D problem viewed from above then we can calculate how to conform the character to the collision object quite easily.

Summary

Collision detection can be a very complex subject. In this chapter we have concentrated on the simpler techniques using axis-aligned bounding boxes and bounding spheres. For most applications this, combined with segment level bounding box checks, will suffice. If your application requires a higher degree of accuracy then you must get down to the polygon level. The principal technique of checking for collisions to polygon accuracy involves finding a separating plane between two objects. The separating plane technique was covered in this chapter.

14 Using morph objects

In the preceding chapters we have looked at how to create and animate a single mesh character. The techniques described are adequate for body animation but using the same methods to animate facial animation can be difficult to set up and often involves repetition. If only we could model a frown, a smile and a scowl once and use this whenever the animation required it. Model once and use many times means we need a way to blend a mesh from one geometry to another. In many applications this involves using morph targets. Morph objects are the easiest solution to this complex geometrical problem.

Creating morph targets

You should have realized by now that my preferred CGI application program is Lightwave. Version 5 came with a tool called 'Morph Gizmo' that allowed the animator to create multiple versions of an object and blend between them. Each version of an object must have exactly the same number of points and if a point with index 100 was the left of the mouth then the point with index 100 in any morph target must also be the left of the mouth. The actual position of the point may change, but its position in the topology of the mesh must be the same.

Lightwave 6 allows the animator to store multiple morph targets within the same object file. These morph targets can be stored in groups, perhaps a group for the Left Eye, Right Eye, Mouth and Nose. Each group acts as a separate channel that can be handled independently. A real-time application must be aware of the time taken to calculate the locations of the target mesh. If you test the time taken to transform geometry and the time taken to paint it, you will probably find that transforming takes only 10 per cent of the time while the final painting and rasterizing takes about 90 per cent of the time. This means that if transforming takes even twice as long, it is only at most a 10 per cent hit in performance. As long as we do

Base Sad Worried Thoughtful Angry Happy

Figure 14.1 Morph targets for Girl mesh.

not use too many polygons then we should be able to use several morph target channels. In this chapter we will look first at how to extract the morph target data from a Lightwave object file. To test the samples run Toon3D and load 'Examples/Chapter14/Girl.t3d'.

Any object in Toon3D can have morph targets. To use morph targets you first create a morph controller. Click on the object that is to have morph targets in the tree view. Then right click to bring up the 'Objects' menu. From the objects menu select 'Create morph controller'. Select the morph controller in the tree view, right click and select Add Morph target. After adding the morph targets you can adjust the level of a target by selecting it and left dragging in the OpenGL view.

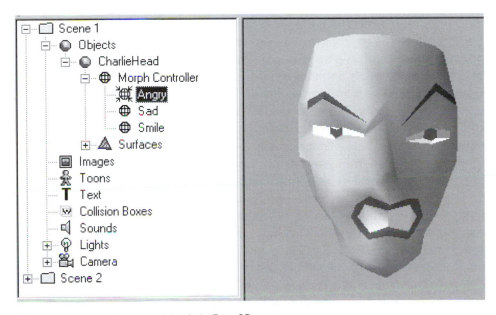

Figure 14.2 Using morph objects in Toon3D.

Figure 14.3 Charlie's head morph objects.

Alternatively, if you are loading a Lightwave 6 file that has embedded Endomorphs then the loader will automatically create a morph controller and assign each Endomorph as a new morph target.

Figure 14.3 shows the morph targets available in the head from the low resolution mesh created in Chapter 5. Even with a very low resolution mesh it is possible to convey some facial animation.

Extracting morph objects from a Lightwave 6 file

Lightwave stores morph targets as VMAP chunks within a LAYR chunk. If the basic structure of a Lightwave file is unfamiliar, then now may be a good time to review Chapter 10, which goes into Lightwave object files in much greater depth. VMAP chunks are used to store many different types of data that are attributable at the vertex level. Another VMAP chunk that is very useful in real-time applications gives the UV data for a texture. To accommodate using the same chunk for many different types of data, a VMAP chunk has a header that gives the type of the file and the dimension of the data applied to each vertex. If the VMAP chunk stores a morph target then the type will be either 'SPOT' or 'MORF'. The VMAP chunk has a dimension of 3; this means for each vertex there will be three floating-point values representing the (x, y, z) location of the vertex as used in the morph target. The vertex locations can be relative to the original vertex location if the chunk is of type 'MORF' or world locations if the chunk type is 'SPOT'. Since any morph target chunk is guaranteed to follow the base point list, we already know how many vertices an object has and the sample code stores this information in a member variable called 'numpoints'. The sample code makes use of a very simple structure called a 'MORPHITEM', which in turn uses a 'VECTORF' structure.

```
//A float type vector
typedef struct stVECTORF{
    float x, y, z;
}VECTORF;

//Used by the Cmorph class
typedef struct stMORPHITEM{
    char name[30];   //Used to store a user friendly name for the target
    VECTORF *pts;    //Vertex locations
    double level;    //Stores current level of morph target
}MORPHITEM;
```

The level member stores the currently used level for the morph target. This will be used when we look at blending the morph targets and interpolating across keyframes.

To load a morph target we allocate memory for the vertex locations to the 'pts' member of the 'MORPHITEM' structure. Then we read each vertex in turn. Each vertex uses a short to store the vertex index, and a float for the *x*, *y* and *z* values. If the chunk is of 'MORF' type, then we add the base value of the vertex to the read value. Lightwave uses Motorola or Network byte ordering and so we use the utility functions *ReadShort* and *ReadFloat* to read the actual data. These functions, described in Chapter 10, flip the byte ordering to Intel native.

```
BOOL CLW2Object::LoadVmap(FILE *fp, int length){
    char type[4];
    BOOL relative, ok = FALSE;
    float x, y, z;
    unsigned short dimension, vindex;

    //Check Vmap type only SPOT and MORF supported
    if (fread(type, 4, 1, fp) != 1) return FALSE;

    if (strncmp(type, "SPOT", 4) == 0){
        relative = FALSE;
        ok = TRUE;
    }

    if (strncmp(type, "MORF", 4) == 0){
        relative = TRUE;
        ok = TRUE;
    }
```

```cpp
if (!ok || !pts){
    //Skip over chunk
    fseek(fp, length - 4, SEEK_CUR);
    return TRUE;
}

//OK to load
if (!ReadShort(fp, dimension)) return FALSE;

int index, bytesread = 6;
char name[128];

//Read name of morph target
ReadString(fp, name, index, 127);
bytesread += index;

MORPHITEM mi;

//Allocate memory for the vertex locations
mi.pts = new VECTOR[numpoints];

//If object doesn't have a morph controller then create one
if (!morph){
    for (int i=0; i<numpoints; i++){
        mi.pts[i].x = pts[i].x;
        mi.pts[i].y = pts[i].y;
        mi.pts[i].z = pts[i].z;
    }
    morph = new CMorph(mi);
}

//Read each vertex until the length of the chunk is reached
while(bytesread < length){
    //Read vertex index
    if (!ReadShort(fp, vindex)) return FALSE;
    //Abort if vertex index is out of range
    if (vindex < 0 || vindex >= numpoints) return FALSE;
    //Read x,y, z values
    if (!ReadFloat(fp, x)) return FALSE;
    if (!ReadFloat(fp,y)) return FALSE;
    if (!ReadFloat(fp, z)) return FALSE;
    //Store value
```

```
        mi.pts[vindex].x = x;
        mi.pts[vindex].y =y;
        mi.pts[vindex].z = z;
        //If value is relative then add base value
        if (relative){
            mi.pts[vindex].x += pts[vindex].x;
            mi.pts[vindex].y += pts[vindex].y;
            mi.pts[vindex].z += pts[vindex].z;
        }
        //Each vertex uses 14 bytes = 2 (index) + 4(x) + 4(y) + 4(z)
        bytesread += 14;
    }
    //Add to morph controller
    morph->AddMorph(mi, name);

    delete [] oi.pts;

    return TRUE;
}
```

The final part of the code above uses a call to a *CMorph* class to store the actual read data within the morph member variable of the object class. We will look at how this class works in the next section.

Storing a morph target

The *CMorph* class stores the base object vertex locations and up to MAX_ MORPH_TARGETS morph targets. Each morph target is stored inside a 'MORPHITEM' structure, which is used to access the vertex locations and also to offer a friendly user name for a development interface and a current blend level. The function 'AddMorph' is used to allocate the vertex data. The member variable 'objcount' stores the number of morph targets that have been added. A call to 'AddMorph' will fail if a controller has not been created first. A controller stores the base level vertex locations and points to the vertices that define the object, so the morph object can alter these base vertices; this means that a morph object can deform the mesh before any other transformations are executed. As far as the object is concerned, the new vertex locations are as modelled. A controller is created using the constructor shown in the code below. After a controller is created, 'AddMorph' ensures that new memory is allocated for existing morph targets and one additional. The previous targets are copied to the

new array of 'MORPHITEM's and the new one is tagged on the end. If at some stage it is decided to remove the morph targets or maybe replace them with alternative targets, then the vertex locations stored in morphitem[0] should be copied back to the object. This restores the object as it was before the morph controller was added. Then the new morph controller can be added as required.

```
//The object info structure stores the geometry and surface data
//for the object
typedef struct stOBJECTINFO{
    int numpoints;
    int numpolygons;
    int numsurfaces;
    POINT3D *pts;
    POLYGON *plys;
    SURFACE *srfs;
}OBJECTINFO;

CMorph::CMorph(OBJECTINFO &oi){
    if (oi.numpoints){
        basepts = oi.pts;
        numpoints = oi.numpoints;
        morphitem[0].pts = new VECTORF[numpoints];
        if (morphitem.pts){
            for (int i=0; i<numpoints; i++){
            }
            memcpy(morphitem[0].pts, mi.pts,
                sizeof(VECTORF)*pointTotal);
        }
    }else{
        numpoints = 0;
        basepts = NULL;
        morphitem[0].pts = NULL;
    }
    strcpy(morphitem[0].name, "Controller");
    morphitem[0].level = 1.0;
    objcount = 1;
}

BOOL CMorph::AddMorph(MORPHITEM &mi, char *name)
{
```

```
if (!basepts){
    AfxMessageBox("Error: either no morph controller or base
            object has no vertex data.");
    return FALSE;
}

if (objcount == MAX_MORPH_TARGETS){
    AfxMessageBox("Error: Maximum number of morph objects
            reached");
    return FALSE;
}

//Create storage for existing and new meshes
MORPHITEM *mitem = new MORPHITEM[objcount + 1];
if (!mitem){
    AfxMessageBox("Error: No memory for morph target");
    return FALSE;
}

if (objcount){
    //Copy existing data
    memcpy(mitem, morphitem, sizeof(MORPHITEM)*objcount);
    delete [] morphitem;
    morphitem = mitem;
    mitem = &morphitem[objcount];
}

mitem->level = 0.0;
mitem->pts = new VECTOR[numpoints];
if (!mitem->pts) return FALSE;

memcpy(mitem->pts, mi.pts, sizeof(VECTOR)*numpoints);

strncpy(mitem->name, name, 29);

//Do we have any keyframes
if (keys) for (i=0;i<keytotal;i++) keys[i].level[objcount-↵
  1]=0.0;
++objcount;
return TRUE;
}
```

Figure 14.4 A morph target set.

Creating keyframes for the morph targets

To be useful we need a way to blend the targets together. One method involves assigning a blend level to each of the morph targets. If we have five targets and the blend level for each is set to zero, then we will have the base geometry displayed. If target A is ramped up to 100 per cent and all the other targets are set to zero blend, then we want the displayed geometry to be entirely as described by target A. If, however, target A is at 50 per cent and B is at 50 per cent, then we want to display a mesh that is part A and part B. Since each 'MORPHITEM' has a level member in the structure, we can set this level for each morph target. Suppose we have the situation given in Table 14.1.

We would expect to see a mesh that was mainly influenced by the vertex locations in the 'Angry' target, but a little influenced by the vertex locations in the 'Sad' target. The method adopted is to sum the current levels. If the sum is greater than 1.0 or 100 per cent, then we ignore the base mesh position and divide all the current levels by the total, so that the value of all the levels combined will represent a sum to 1.0 or 100 per cent. If the value is less than 1.0, then we give a value to the base mesh that pulls the total level up to 1.0. To show the mesh as influenced by the values given in Table 14.1, we calculate the total level as $0.3 + 0.8 = 1.1$. Since this value is greater than 1.0, we divide each morph target level by

Table 14.1 Sample morph levels

Target	Level	MORPHITEM index
Smile	0.0	1
Sad	0.3	2
Angry	0.8	3
Surprised	0.0	4

this total. Now to calculate the placement of a vertex we sum the products of target level and current vertex for each target with a level greater than zero. In the current example, only morphitems 2 ('Sad') and morphitems 3 ('Angry') have a level greater than zero, so the final placement of a vertex is given by:

```
pts[i].x = morphitem[2].pts[i].x*morphitem[2].level +↵
    morphitem[3].pts[i].x*morphitem[3].level
pts[i].y = morphitem[2].pts[i].y*morphitem[2].level +↵
    morphitem[3].pts[i].y*morphitem[3].level
pts[i].z = morphitem[2].pts[i].z*morphitem[2].level +↵
    morphitem[3].pts[i].z*morphitem[3].level
```

The function used to execute the blending is called 'Transform'.

```
BOOL CMorph::Transform()
{
    if (!basepts || !morphitem ) return FALSE;
    int i, j, n = 0;
    VECTOR *pts = basepts;
    double morphlevel[MAX_MORPH_TARGETS], totallevel = 0.0;

    for (i=1; i<objcount; i++){
        totallevel += morphitem[i].level;
    }

    if (totallevel>1.0){
        //No influence from base object
        morphlevel[0] = 0.0;
        for (i=1;i<objcount;i++){
            morphlevel[i] = morphitem[i].level/totallevel;
        }
    }else{
        //Influence of base object
        morphlevel[0] = 1.0-totallevel;
        for (i=1; i<objcount; i++){
            morphlevel[i] = morphitem[i].level;
        }
    }

    //Amend with objcount morph objects
    //basepts is a pointer to the vertices that will be rendered
```

Real-time 3D Character Animation with Visual C++

```
    pts = basepts;
    for(j=0; j<numpoints; j++){
        //Reset current vertex
        pts->x = 0.0; pts->y = 0.0; pts->z = 0.0;
        for (i=0; i<objcount; i++){
            //Sum product of vertex and level
            if (morphlevel[i] > 0.0){
                pts->x += morphitem[i].pts[j].x * morphlevel[i];
                pts->y += morphitem[i].pts[j].y * morphlevel[i];
                pts->z += morphitem[i].pts[j].z * morphlevel[i];
            }
        }
        //Move on to next vertex
        ++pts;
    }
    return TRUE;
}
```

Figure 14.5 Setting keyframes using Toon3D.

Keyframing morph targets

Now that we can blend our morph targets, the next stage is to store the result of the blending so that we can interpolate the result. The interpolation will use TCB curves, so any new keyframe must store the current levels for all the morph targets along with a time or frame value for the position. The flow of a TCB curve is adjusted by altering the tension, bias and continuity parameters, which are stored for each keyframe. Full details of TCB curves are given in Chapter 8. Because TCB curves attempt to smooth the flow of the curve around each key value, this can sometimes result in movement where no movement is intended. The linear flag informs the code that the movement between two key positions should be linear rather than smoothed. The main benefit of this flag is to ensure that static sections are static.

```
typedef struct stMORPHKEY{
    int frame;
    float time;
    float level[MAX_MORPH_TARGETS];
    int linear;
    float tn, bs, ct;//tension, bias and continuity
}MORPHKEY;
```

When creating a key value we need to take the current morph levels and a supplied frame or time value and amend, insert or add a keyframe. We amend a keyframe if there is already a key defined for this frame value. The development software Toon3D uses a combination of an integer value 'frame' and an integer value 'fps' to define the time value. Time is defined as frame/fps. Why not simply use time in seconds? The reason is that comparing floating-point values is not nearly as reliable as comparing integer values. It is easy in practice to end up creating a key at 1.04 seconds and another at 1.0401 seconds when the intention was to amend the key at 1.04 seconds. If the frames per second (fps) is 25 and the current frame is 26, then the time value is 1.04. If the intention is to amend the values at frame 26, then comparing 26 with a keyframe with the frame value set to 26 will ensure a one-to-one comparison. In the supplied code, a loop is used to check the current frame value against the current keyframes; if the current frame is less than a current keyframe then we need to insert the key before this existing keyframe. Since we are inserting a key we must allocate memory for the existing keyframes and one extra. Before inserting the key, the previous keys are copied to the new keyframe array. Then the keyframe is added and any keyframes that

follow are copied on the end. The final alternative for adding keyframes is to insert the key at the end of the current array. Here again memory is allocated for all the existing keyframes plus one extra. All the existing keyframes are copied to the new array and the new data are inserted on the end.

Suppose there are existing keyframes at frames 0, 20, 52, 64 and 78. If the function is called with frame value 20, then the existing keyframe that has a frame value of 20 is adjusted. If the function is called with the value 34 then it must be inserted between the keyframes at 0 and 20 and the keyframes at 52, 64 and 78. First, we allocate an array of six MORPHKEY values. The first two MORPHKEYS in the existing array are copied to the new array. Then the new data are assigned to MORPH-KEY[2]. Finally, the remaining MORPHKEYS are copied into the new array. The new array has keyframes at 0, 20, 34, 52, 64 and 78.

If the function is called with a frame value of 89, then the new keyframe must be added to the end of the array. Again, an array of six MORPHKEYS is created. This time, all the existing array is copied across and the new data are assigned to the last member of the array. The new array has keyframes at 0, 20, 52, 64, 78 and 89. The code for this function is as follows:

```
MORPHKEY *CMorph::CreateKey(int frame)
{
    if (keytotal==0){
        keys = new MORPHKEY;
        if (!keys){
            TRACE("CMorph::CreateKey>>Problem creating key zero\n");
            return NULL;
        }
        keytotal = 1;
        for (int i=0; i<objcount; i++) keys->level[i] = 0.0;
        //There must be a key at frame zero
        keys->time = 0.0f;
        keys->linear = 0;
        keys->tn = 0.0;
        keys->bs = 0.0;
        keys->ct = 0.0;
    }

    //Does the object have a key for this frame?
    MORPHKEY *key = keys,*ikey = NULL;
    int i;
```

```
for(i=0; i<keytotal; i++){
    if (key[i].frame == frame){
        //Adjust keyframe to new value
        for (i=0; i<objcount; i++)
            key->level[i] = morphitem[i].level;
        return &key[i];
    }
    if (key[i].frame>frame){
        //Create memory for existing keys plus one
        ikey = new MORPHKEY[keytotal + 1];
        if (!ikey){
            TRACE("CLight::CreateKey>>
                Problem creating keys\n");
            return NULL;
        }

        //Copy earlier keys
        if (i) memcpy(ikey, keys, sizeof(MORPHKEY)*i);
        ikey[i].frame = frame;

        //Insert new key
        for (i=0; i<objcount; i++)
            key->level[i] = morphitem[i].level;

        //Assign default parameters
        ikey[i].linear = 0;
        ikey[i].tn = 0.0;
        ikey[i].ct = 0.0;
        ikey[i].bs = 0.0;

        //Copy following keys
        if (i<keytotal){
            memcpy(&ikey[i+1], &keys[i],
                sizeof(MORPHKEY)*(keytotal-i));
        }
        keytotal++;

        //Clear old keys
        delete [] keys;

        //Point keys at new array
        keys = ikey;
        return &keys[i];
    }
}
```

```
//Must need a key at the end of the current list
ikey = new MORPHKEY[keytotal + 1];
if (!ikey){
    TRACE("CMorph::CreateKey>>Problem creating keys\n");
    return NULL;
}
memcpy(ikey, keys, sizeof(MORPHKEY)*keytotal);
ikey[keytotal].frame = frame;
for (i=0; i<objcount; i++) key->level[i] = morphitem[i].level;
ikey[keytotal].linear = 0;
ikey[keytotal].tn = 0.0;
ikey[keytotal].ct = 0.0;
ikey[keytotal].bs = 0.0;
keytotal++;
if (keys) delete [] keys;
keys = ikey;
return &keys[keytotal-1];
}
```

Interpolating the morph targets

The only remaining task is to interpolate between two morph keys. This is done in exactly the same way as the motion curves are handled for keyframe animation. Instead of interpolating three position values, three rotation values and three scale values, objcount morph level values are interpolated. To check out the interpolation method, refer to Chapter 8 on keyframing. Each *morphitem* represents a different channel and is handled independently. When keyframing you must make a choice with the way you handle your code. You could have a keyframe value and store levels for each morph target at this keyframe. Alternatively, you could assign a frame value and level to each channel. Independent channels are a little more awkward to handle and when animating the channels can sometimes seem more trouble than they are worth, but for maximum flexibility this method is obviously preferable. You pays your money and you takes your choice. If you want the flexibility that independently interpolated channels allow without the hassle, then another technique is to use morphing groups. This technique has a lot to recommend it.

Using multiple channels

If you want a character to say lines that synchronize to a soundtrack, then you must first record the dialogue, then use a sound editor to analyse the sound, calculating at what time the mouth must form the shapes that apply to particular phrases. If you have carefully modelled the mouth positions and are ready to create some breathtaking character animation, then it will be frustrating to know that if you want to raise the character's eyebrow or shut their eyes, you will have to model an entire set of heads with the eyes shut and all the different mouth positions. Without this set your model cannot both talk and blink at the same time. Not a very satisfactory state of affairs. This is when groups come to the rescue.

If you move a set of points around the mouth but make no movement at all to the eyes, then dealing with this set of targets independently of the eyes will have no effect on the eye movement. Similarly, a set of targets that move the vertex locations in the eyes and no other points can be handled independently. One way to achieve this is to create a subset of the mesh that includes point indices into the target mesh or pointers to vertices in the target mesh along with the morph targets' vertex locations. The vertex locations of the final mesh are a combination of the original vertex locations and the deformations created from interpolating the key positions for each group. This technique has much to commend it, since it gives the animator a great deal of control in a very intuitive way without any significant performance hit.

Summary

In this chapter we learned how to allow the animator to use carefully modelled shape animation within a real-time engine. Using morph targets allows animation at the vertex level in a highly controlled way and allows for the repetition of regularly used shapes. It doesn't suffer from a great performance hit, since we are dealing with transformations at the vertex level rather than the pixel level. A 2000-polygon character rarely uses more than 300 vertices in a face. The transformation of these 300 vertices takes a small fraction of the time it takes to paint a 640 × 480 pixel display. It is worth adding morph facilities to any character animation engine for no other reason than to allow for the manipulation of faces and hands.

15 Using subdivision surfaces

Real-time 3D applications are limited to relatively few polygons to describe a model. On some machines displaying 5000 triangles, 25–30 times a second is the limit of the processor and graphic card capabilities; on other systems, a 50 000-polygon limit could be achieved. How do we scale the display to suit the hardware? One popular technique is to use subdivision surfaces. Using this method the original polygonal mesh is used as the basis for the model. With one pass of subdivision every edge is divided in two, so that each triangle is replaced with four triangles. If the new vertices are placed simply at the mid-point of the edge then the surface would not be smoothed, but if we could devise a way of placing the vertices at the optimum place to smooth the mesh then the effect is a smoothly refined mesh. It is equally possible to subdivide the new mesh again, thereby replacing the original triangle with 16 new triangles. As you can see, each level of subdivision replaces the original triangles with four times the number of triangles, so the polygon count ramps up at a rate of 4^n, where n is the subdivision count. Subdividing four times gives $4^4 = 256$ times the original polygon count. A 1000-polygon character now has a staggering 256 000 polygons. For most real-time applications, one level of subdivision, or two at the most, will be the limit. So that is the principle, but the real cunning of any subdivision scheme is deciding where to place the new vertices. Let's look at the options.

An overview of subdivision

We must decide first whether the original vertices feature in the subdivided mesh or not. If we choose a scheme that retains the original vertices, then we know that the new surface will go through the original mesh. A scheme that retains the original vertices and adds to the vertex list is described as interpolating, while a scheme that creates all new vertices is called *approximating*. For low resolution meshes, this decision

Figure 15.1 Subdivision using a linear model, the butterfly model and the Catmull–Clark scheme.

can be very important. Figure 15.2 shows the effect of subdivision on a very low resolution mesh. The sample on the left uses butterfly subdivision, which is interpolating, while the sample on the right uses exactly the same control mesh, but this time the subdivision scheme is approximating. Interpolating subdivision has the effect of slightly swelling the original mesh if the original mesh is principally convex. Approximating subdivision shrinks the mesh; the fewer polygons in the original mesh, the more exaggerated this result. With a very low polygon control mesh, the subdivided mesh can differ greatly in volume and shape from the base. Approximating subdivision is the scheme used by Pixar for most of their

Figure 15.2 Using interpolating and approximating subdivision on a low polygon head.

animated characters. They subdivide the mesh until the size of a polygon is half a pixel, not a technique that real-time applications are likely to be capable of performing in the near future at rates of 25 times a second. In such high-end examples, the original source meshes will be denser than those used for real-time character animation. With a denser mesh the effect of shrinking is not as pronounced. The mesh created from approximating schemes tends to be smoother than that from interpolating and so it is suited to pre-rendered animation, but an interpolating scheme is more suited to a real-time application.

Triangles or quadrilaterals

For some schemes the algorithms can work on three- or four-sided polygons. Meshes with polygons containing more than four sides can be converted into a triangular mesh or a mesh that contains triangles and

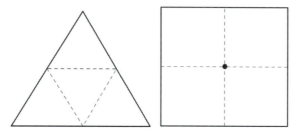

Figure 15.3 Subdividing triangles and quadrilaterals.

quadrilaterals. When subdividing a triangle, each edge has a new vertex added; consequently, three additional vertices are added and each triangle is converted to four triangles. When subdividing a quadrilateral, each edge has a new vertex added and an additional vertex is added to the centre of the mesh. Again, four polygons replace the original single quadrilateral. Figure 15.3 shows how polygons are added using triangles and quadrilaterals.

Catmull–Clark – an approximating scheme

Catmull–Clark surfaces use a quadrilateral control mesh and are approximating. Pixar uses Catmull–Clark surfaces for animated characters and variants of this subdivision are used in high-end CGI packages.

Real-time 3D Character Animation with Visual C++

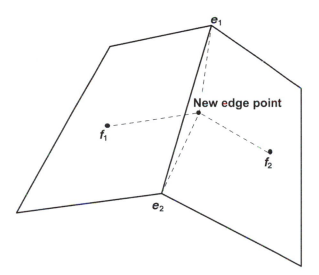

Figure 15.4 Adding a vertex edge using the Catmull–Clark subdivision scheme.

The scheme is quite simple to implement. Step 1: for each polygon, add a centre vertex that is the average of the four vertices in the polygon. Step 2: for each edge, add a new vertex that is positioned at the average of the edge end-points and the adjacent polygon vertices (see Figure 15.4 for an illustration of the vertices to consider).

The final step is to move the original vertices in the mesh using the following rule:

$$V = \frac{N - 2v}{N} + \frac{1}{N^2}\left(\sum_{i=0}^{N-1}(e_i + f_i)\right)$$

where V is new vertex location, v is the old vertex location, N is the vertex valence, e_i is the vertex in the original mesh indicated in Figure 15.5 and f_i is the vertex in the new mesh indicated in Figure 15.5.

This step introduces a new term, valence. The valence of a vertex is simply the number of edges that use that vertex. For a regular quadrilateral mesh the valence of each vertex will be four.

Because the original vertices are not part of the final mesh in a Catmull–Clark scheme, there are significantly more calculations to perform when subdividing. This computational expense and a resultant mesh that can be very different from the control mesh encourage us to use an interpolating scheme rather than an approximating scheme like Catmull–Clark.

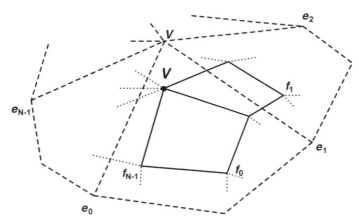

Figure 15.5 The vertices used to calculate a new vertex location using Catmull–Clark subdivision.

Butterfly subdivision – an interpolating scheme

The subdivision scheme we are going to explore in detail is the so-called modified butterfly scheme. This scheme works only on triangular meshes, so you must work with a triangular mesh or create a function to triple your mesh. Butterfly subdivision only works on a regular triangular mesh where each vertex is of valence six. This limitation would be beyond even the best low polygon modeller. The modified scheme works with vertices of any valence. The scheme was devised and presented at Siggraph in 1996 by Zorin, Schröder and Sweldens.

The first step in the subdivision is to add a new vertex for an edge. Since the scheme is interpolating, the end-points of the edge are going to be part of the final mesh and do not need repositioning. The location of the new vertex is affected by the valences of the end-points for the current edge. If both end-points have valence six, then the location of the new vertex is calculated using the following method.

The weighting of effect of each vertex is

$$a: \tfrac{1}{2} - w; \qquad b: \tfrac{1}{8} + 2w; \qquad c: -\tfrac{1}{16} - w; \qquad d: w$$

where w is a weighting value. Subdivision in Toon3D uses a value for w of 0.0125.

A vertex with valence other than six in this scheme is described as an *extraordinary vertex*. If one of the end-points of the edge is an extraordinary vertex and the other vertex has valence six, then we

Real-time 3D Character Animation with Visual C++

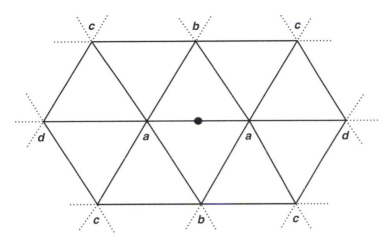

Figure 15.6 Ten-vertex stencil for new vertex assuming end-points have valence six.

calculate the location of the added vertex based solely on this extraordinary vertex. This seems intuitively strange, but the result is very effective. One of the authors of the original paper, Denis Zorin, justifies the choice of weighting on his website at www.mrl.nyu.edu/dzorin. If both end-points are extraordinary, then we calculate the location of the added vertex as the average of the position calculated using each extraordinary vertex.

The scheme used is:

Valence 3: $v: \frac{3}{4}; \quad e_0: \frac{5}{12}; \quad e_1: -\frac{1}{12}; \quad e_2: -\frac{1}{12}$

Valence 4: $v: \frac{3}{4}; \quad e_0: \frac{3}{8}; \quad e_1: 0, \, e_2: -\frac{1}{8}; \quad e_3: 0$

Valence 5 and 7 or more: $v: \frac{3}{4}; \quad e_i: \dfrac{\frac{1}{4} + \cos(2\pi i/N) + \frac{1}{2}\cos(4\pi i/N)}{N}$

where N is the valence.

Border vertices are handled differently from other vertices, taking all the weighting from adjacent border points. The new edge vertex is calculated using

$$V = \tfrac{9}{16}a + \tfrac{9}{16}b - \tfrac{1}{16}c - \tfrac{1}{16}d$$

Using this technique for border vertices ensures that the mesh doesn't pull away from any boundary edges.

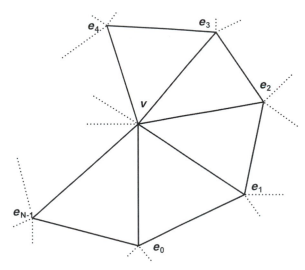

Figure 15.7 Identification of vertices in an extraordinary vertex in the modified butterfly scheme.

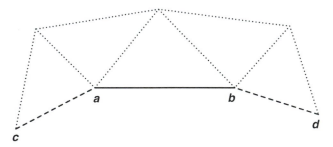

Figure 15.8 Identification of border vertices in the modified butterfly scheme.

Implementing modified butterfly subdivision

Having explained the theory, now for a practical guide to implementation. First, we need to know more about our mesh than just the vertices and polygons. We need to know about the edges in the mesh and we need to know how the vertices connect to other vertices. For this purpose we create two new structures, EDGE and POINTCON. EDGE stores both the indices of the end-points and the index of an added mid-point vertex. POINTCON stores the valence of the vertex, an ordered array of vertex indices stored in anticlockwise order and a flag to indicate whether this vertex is a border vertex. If the flag is set then this is a boundary vertex; if the border flag is set for both vertices in an edge then the edge must be

a boundary edge and so a mid-point must be added using the border edge equation given above, regardless of the vertex valences.

```
typedef struct stEDGE{
    unsigned short a,b;  //Indices of existing vertices
    unsigned short v;    //Index of the middle vertex
}EDGE;

typedef struct stPOINTCON{
    unsigned char valence;
    unsigned short p[MAX_VALENCE];
    unsigned char border;
}POINTCON;
```

The first step in any subdivision is to store the original mesh topology. This is stored in a new PATCHINFO structure.

```
typedef struct stPATCHINFO{
    POINT3D *pts;
    POLYGON *pchs;
    int numpoints;
    int numpatches;
}PATCHINFO;
```

This ensures that we can restore the original topology at any time.

```
//================================================================
//CreatePatchInfo

//Copies the original vertex and polygon information into a
//new data structure PATCHINFO. This is the same as a OBJECTINFO
//without any surface information. The purpose of the function
//is to allow the transformation engine to restore the original
//vertex and polygon structure after having rendered the subdivided
//mesh
//================================================================

BOOL CT3DObject::CreatePatchInfo()
{
    if (pi.pts) delete [] pi.pts;
    if (pi.pchs) delete [] pi.pchs;
    pi.pts = new POINT3D[oi.numpoints];
```

```
        if (!pi.pts) return FALSE;
        memcpy(pi.pts, oi.pts, sizeof(POINT3D) * oi.numpoints);
        pi.numpoints = oi.numpoints;
        pi.pchs = new POLYGON[oi.numpolygons];
        if (!pi.pchs) return FALSE;
        memcpy(pi.pchs, oi.plys, sizeof(POLYGON) * oi.numpolygons);
        pi.numpatches = oi.numpolygons;
        return TRUE;
}
```

Having stored the original topology we now want to analyse the topology of the mesh. To this end, the code used to examine the mesh is given below. For each vertex in the mesh we scan all the polygons in the mesh and if the current vertex, *v*, is used then we add a pointer to this polygon to the local array *plyscan* and update a counter of added polygons. Having traversed all the polygons in the mesh, we have an array of *plycount* POLYGON pointers called *plyscan*. The next stage in the process is to attempt to create an ordered list of vertices using just the *plycount* polygons in the *plyscan* array. Regarding the current vertex as a central point, we can store the vertices in the first polygon in the *plyscan* array.

The vertex indices are stored in the POINTCON members *p*[0] and *p*[1]. Now that the first polygon has been added plyscan[0] can be set to NULL, to indicate that this polygon has been considered. The next step is

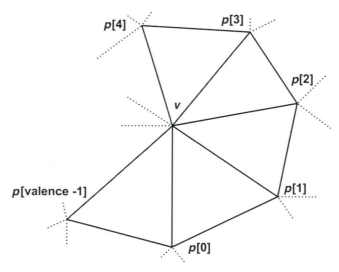

Figure 15.9 Identifying the appropriate vertices to create an anticlockwise ordering.

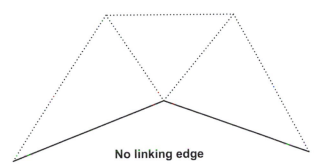

No linking edge

Figure 15.10 Identifying boundary vertices.

to find a polygon in the *plyscan* array that has the edge (v, $p[1]$), where v is the current vertex index ('ptindex' in the sample code) and $p[1]$ is the index shown in the code as 'vindex'. If this edge is found, then we can add the remaining vertex in the triangle as the next member of our connectivity array and update the search edge. If it is not found, then we can assume that this is a boundary vertex. We store the current count so that we can reorder the array later. A border vertex must have two edges that do not form a continuous link; Figure 15.10 indicates how this must be so. If we have found the gap, then setting our search to any other polygon in the scanned array should result in a continuous link. Then we place the vertices we found before restarting at the end of the newly found vertices. In this way, the edges defined by (v, $p[0]$) and (v, $p[N-1]$), where N is the valence, must be boundary edges.

```
//===============================================================
//CreateConnectivityArray

//Used by SubDivide.
//===============================================================
BOOL CT3DObject::CreateConnectivityArray(POINTCON *con){
    POLYGON *plyscan[MAX_VALENCE],*ply;
    int i, ptindex, plyindex, plycount, count, vindex;
    unsigned short p[MAX_VALENCE];
    POINTCON *ptcon = con;
    BOOL found,rev;

  for(ptindex=0; ptindex<oi.numpoints; ptindex++){
    //Scan through all polygons to find ones that
    //have a point index with value ptindex and
    //store them in the plyscan array.
```

```
ply = oi.plys;
plycount = 0;
for(i=0;i<oi.numpolygons;i++){
  if (ply->numverts!=3){
    AfxMessageBox("Sub division can only be
      applied to triangular meshes");
    ClearPatchInfo();
    return FALSE;
  }
  if (ply->p[0]==ptindex || ply->p[1]==ptindex || ply->p[2]==↵
    ptindex){
    plyscan[plycount++] = ply;
  }
  ply++;
}

if (plycount){
  //Add first scanned polygon
  if (plyscan[0]->p[0]==ptindex){
    ptcon->p[0] = plyscan[0]->p[2];
    ptcon->p[1] = plyscan[0]->p[1];
  }
  if (plyscan[0]->p[1]==ptindex){
    ptcon->p[0] = plyscan[0]->p[0];
    ptcon->p[1] = plyscan[0]->p[2];
  }
  if (plyscan[0]->p[2]==ptindex){
    ptcon->p[0] = plyscan[0]->p[1];
    ptcon->p[1] = plyscan[0]->p[0];
  }
  ptcon->valence = 2;
  ptcon->border = 1;
  vindex = ptcon->p[1];
  plyscan[0] = NULL;
  count = plycount-1;

  while(count){
    //Scan for edge ptindex>>vindex
    found = FALSE;
    for(plyindex=1; plyindex<plycount; plyindex++){
      ply = plyscan[plyindex];
      if (!ply) continue;
      if (ply->p[0] == ptindex){
```

```
      if (ply->p[2] == vindex){
        if (ply->p[1]!=ptcon->p[0]){
          ptcon->p[ptcon->valence++] = ply->p[1];
        }else{
          ptcon->border = 0;
        }
        vindex = ptcon->p[ptcon->valence-1];
        plyscan[plyindex] = NULL;
        found = TRUE;
        break;
      }
    }
    if (ply->p[1] == ptindex){
      if (ply->p[0]==vindex){
        if (ply->p[2]!=ptcon->p[0]){
          ptcon->p[ptcon->valence++] = ply->p[2];
        }else{
          ptcon->border = 0;
        }
        vindex = ptcon->p[ptcon->valence-1];
        plyscan[plyindex] = NULL;
        found = TRUE;
        break;
      }
    }
    if (ply->p[2] == ptindex){
      if (ply->p[1] == vindex){
        if (ply->p[0]!=ptcon->p[0]){
          ptcon->p[ptcon->valence++] = ply->p[0];
        }else{
          ptcon->border = 0;
        }
        vindex = ptcon->p[ptcon->valence-1];
        plyscan[plyindex] = NULL;
        found = TRUE;
        break;
      }
    }
  }
  if (!found){
    //Must be a border vertex store the current count so we can
    //order the list later
```

```
                ptcon->border = count;
                //Reset search with next unused polygon
                for (plyindex = 1; plyindex < plycount; plyindex++){
                  //Find next polygon
                  if (plyscan[plyindex]{
                    if (plyscan[plyindex]->p[0] == ptindex){
                      ptcon->p[count++] = plyscan[0]->p[2];
                      ptcon->p[count] = plyscan[0]->p[1];
                    }
                    if (plyscan[plyindex]->p[1] == ptindex){
                      ptcon->p[count++] = plyscan[0]->p[0];
                      ptcon->p[count] = plyscan[0]->p[2];
                    }
                    if (plyscan[plyindex]->p[2] == ptindex){
                      ptcon->p[count++] = plyscan[0]->p[1];
                      ptcon->p[count] = plyscan[0]->p[0];
                    }
                    ptcon->valence += 2;
                    vindex = ptcon->p[count++];
                    plyscan[plyindex] = NULL;
                    break;
                  }
                }
              }
            }
          }else{
            //Point index not found must be a point with
            //no polygons so ignore it.
            ptcon->valence = 0;
          }
          if (ptcon->border && ptcon->border!=plycount){
            memcpy(p, ptcon->p, sizeof(USHORT)*ptcon->valence);
            memcpy(ptcon->p, &p[ptcon->border],
                    sizeof(USHORT)*(plycount - ptcon->border);
            memcpy(&ptcon->p[plycount - ptcon->border], p,
                    sizeof(USHORT) * ptcon->border);
          }
          ptcon++;
        }

        return TRUE;
      }
```

At this stage we have all the information we need to apply modified butterfly subdivision. The purpose of subdivision is to add polygons to the mesh, so we include a utility function for this purpose. This function is passed a reference to the new polygon and sets the vertex indices and texture coordinates. Texture coordinates are calculated as simply the mid-point of an edge. If the end-points of the edge have texture coordinates *tc*1 and *tc*2 then the mid-point for this edge will have texture coordinates:

$$u = (tc1 * u + tc2 * u)/2$$
$$v = (tc1 * v + tc2 * v)/2$$

These coordinates are calculated by the caller to the CreatePolygon function.

```cpp
BOOL CT3DObject::CreatePolygon(POLYGON &sdply, int srfID,
    int v1, int v2, int v3, TEXVEC &tv1, TEXVEC &tv2, TEXVEC &tv3){
    sdply.numverts = 3;
    sdply.p[0] = v1;
    sdply.p[1] = v2;
    sdply.p[2] = v3;
    sdply.srf = srfID;
    if (oi.srfs[srfID].tex){
        sdply.tc[0].u = tv1.u;
        sdply.tc[0].v = tv1.v;
        sdply.tc[1].u = tv2.u;
        sdply.tc[1].v = tv2.v;
        sdply.tc[2].u = tv3.u;
        sdply.tc[2].v = tv3.v;
    }else{
        memset(sdply.tc, 0, sizeof(TEXVEC)*3);
    }
    return TRUE;
}
```

The actual function call to subdivide a mesh iterates through all the polygons in the mesh and replaces a single polygon with four polygons. The first step in creating the new polygons is to add the three edges in the triangle to an edge array. This is achieved using the *AdgeEdge* function call, which has seven parameters.

```cpp
int CT3DObject::AddEdge(EDGE *edges, POINT3D *pts, POINTCON *con,
                int &pointcount, int &edgecount, int v1, int v2)
```

- **edges** – the current edge array;
- **pts** – the point list for the mesh;
- **con** – the connectivity array for the mesh;
- **pointcount** – the number vertices in the pts, point list;
- **edgecount** – the number of edges in the edges, edge list;
- **v1** – end-point index;
- **v2** – end-point index;
- return value – the index of the mid-point for this edge.

The AddEdge function first checks if the edge already exists. If it does, then it simply returns the index of the mid-point of the existing edge. If it does not exist, then a new edge is added to the edge array and the value edgecount is updated. The mid-point of the edge is calculated using the POINTCON array for the end-points. Vertices are passed using indices into the pts array and the con array. The calculation uses the valence of one end-point in the array to calculated a new vertex location pt1. Then the function looks at the other end-point and calculates a new vertex location pt2. If both end-points are extraordinary, then the average of the two points is used. When using the POINTCON for the current vertex, it is important to get the correct orientation, that is p[0] must be the opposite edge vertex. This is done by iterating through the vertex indices in the point array to find the opposite edge vertex index and then constructing a new POINTCON structure using this information. When a vertex is a border edge this simply means moving the end of the array to the beginning and placing the beginning of the array on the end of the new

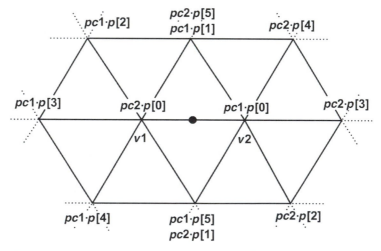

Figure 15.11 Identifying vertices as named in the AddEdge function.

list. An example may help. If the vertex indices for each end of an edge are (10, 23) and the connectivity array for the vertex with index 10 is (2, 34, 56, 23, 12, 14), then we need to adjust the connectivity array so that it reads (23, 12, 14, 2, 34, 56). Now the vertex with index 23, the opposite edge vertex, is first in the connectivity array. The same work must be done to the connectivity array for the vertex with index 23. This time the first member of the connectivity array must be the vertex with index 10. Figure 15.11 shows how the vertices relate to the code naming.

```cpp
//=================================================================
//AddEdge

//Takes an array of count edges and tests to see if vertex indices
//v1 and v2 have already been assigned an edge if so function returns
//the index of the edge. If not it creates a new edge, updates the
//count value, assigns the connectivity of end vertices, sets
//the valences and returns the index of this edge
//The connectivity array must have been pre calculated
//=================================================================

int CT3DObject::AddEdge(EDGE *edges, POINT3D *pts, POINTCON *con,
int &pointcount, int &edgecount, int v1, int v2)
{
    EDGE *edge = edges;

    for (int i=0; i<edgecount; i++){
        if (edge->a == v1 && edge->b == v2) return edge->v;
        if (edge->a == v2 && edge->b == v1) return edge->v;
        edge++;
    }

    //If we get here then the edge has not been found
    edge = &edges[edgecount];
    edge->a = v1;
    edge->b = v2;
    edge->v = pointcount;
    edgecount++;
    pointcount++;

    POINT3D *v = &pts[edge->v], pt1, pt2;
    double w=0.0125,weight,valence;
    int index,j;
    POINTCON pc1, pc2;
```

```cpp
            pc1.p[0] = -1;
            pc1.valence = con[v1].valence;

//Set pc1 so that the opposite vertex is v2
        for (i=0; i<con[v1].valence; i++){
            if (con[v1].p[i]==v2){
                index = 0;
                for (j=i; j<con[v1].valence; j++){
                    pc1.p[index++] = con[v1].p[j];
                }
                for (j=0; j<i; j++){
                    pc1.p[index++] = con[v1].p[j];
                }
            }
        }
        if (pc1.p[0]==-1) return -1; //Error

        pc2.p[0] = -1;
        pc2.valence = con[v2].valence;

//Set pc2 so that the opposite vertex is v1
        for (i=0; i<con[v2].valence; i++){
            if (con[v2].p[i]==v1){
                index = 0;
                for (j=i; j<con[v2].valence; j++){
                    pc2.p[index++] = con[v2].p[j];
                }
                for (j=0; j<i; j++){
                    pc2.p[index++] = con[v2].p[j];
                }
            }
        }
        if (pc2.p[0]==-1) return -1; //Error

        if (con[v1].border && con[v2].border){
            //Must be boundary edge
            //Based on 9/16 * v1 + 9/16 * v2 -
            //1/16 * ca[valence-1] - 1/16 * cb[0]
            v->x = 0.5625 * pts[v1].x +
                0.5625 * pts[v2].x -
                0.0625 * pts[pc1.p[pc1.valence-1]].x -
                0.0625 * pts[pc2.p[0]].x;
```

```
    v->y = 0.5625 * pts[v1].y +
           0.5625 * pts[v2].y -
           0.0625 * pts[pc1.p[pc1.valence-1]].y -
           0.0625 * pts[pc2.p[0]].y;
    v->z = 0.5625 * pts[v1].z +
           0.5625 * pts[v2].z -
           0.0625 * pts[pc1.p[pc1.valence-1]].z -
           0.0625 * pts[pc2.p[0]].z;
    return edge->v;
}

//Calculate the location of the new vertex based on
//modified Butterfly
switch(pc1.valence){
case 3:
    //v1=3/4,ca[0]=5/12, ca[1],ca[2]=-1/12
    pt1.x =  pts[v1].x * 0.75 +
             pts[pc1.p[0]].x * 0.4167 -
             pts[pc1.p[1]].x * 0.0833 -
             pts[pc1.p[2]].x * 0.0833;
    pt1.y =  pts[v1].y * 0.75 +
             pts[pc1.p[0]].y * 0.4167 -
             pts[pc1.p[1]].y * 0.0833 -
             pts[pc1.p[2]].y * 0.0833;
    pt1.z =  pts[v1].z * 0.75 +
             pts[pc1.p[0]].z * 0.4167 -
             pts[pc1.p[1]].z * 0.0833 -
             pts[pc1.p[2]].z * 0.0833;
    break;
case 4:
    //v1=3/4,ca[0]=3/8, ca[1]=0, ca[2],=-1/8,ca[3]=0
    pt1.x =  pts[v1].x * 0.75 +
             pts[pc1.p[0]].x * 0.375 -
             pts[pc1.p[2]].x * 0.125;
    pt1.y =  pts[v1].y * 0.75 +
             pts[pc1.p[0]].y * 0.375 -
             pts[pc1.p[2]].y * 0.125;
    pt1.z =  pts[v1].z * 0.75 +
             pts[pc1.p[0]].z * 0.375 -
             pts[pc1.p[2]].z * 0.125;
    break;
```

```cpp
case 6:
    //We can leave this to be calculated in the next switch
    //statement. It only applies to valence 6 for both vertices
    break;
case 5:
default:
    //v1=3/4,ca[n]=(1/4+cos(2pi*n/valence)+1/2(cos(4pi*n/↵
      valence))/valence
    valence = pc1.valence;

    pt1.x =  pts[v1].x * 0.75;
    pt1.y =  pts[v1].y * 0.75;
    pt1.z =  pts[v1].z * 0.75;

    for ( i=0; i<pc1.valence; i++){
        weight = (0.25 + cos((PI2 * (double)i)/valence) +
            0.5 * cos((PI2 * 2 * (double)i)/valence))/valence;
        pt1.x +=  pts[pc1.p[i]].x * weight;
        pt1.y +=  pts[pc1.p[i]].y * weight;
        pt1.z +=  pts[pc1.p[i]].z * weight;
    }

    break;
}

switch(pc2.valence){
case 3:
    //v2=3/4,cb[0]=5/12, cb[1],cb[2]=-1/12
    pt2.x =  pts[v2].x * 0.75 +
            pts[pc2.p[0]].x * 0.4167 -
            pts[pc2.p[1]].x * 0.0833 -
            pts[pc2.p[2]].x * 0.0833;
    pt2.y =  pts[v2].y * 0.75 +
            pts[pc2.p[0]].y * 0.4167 -
            pts[pc2.p[1]].y * 0.0833 -
            pts[pc2.p[2]].y * 0.0833;
    pt2.z =  pts[v2].z * 0.75 +
            pts[pc2.p[0]].z * 0.4167 -
            pts[pc2.p[1]].z * 0.0833 -
            pts[pc2.p[2]].z * 0.0833;
    if (pc1.valence==6){
        v->x = pt2.x; v->y = pt2.y; v->z = pt2.z;
```

```
    }else{
        v->x = (pt1.x + pt2.x)/2.0;
        v->y = (pt1.y + pt2.y)/2.0;
        v->z = (pt1.z + pt2.z)/2.0;
    }
    break;
case 4:
    //v2=3/4,cb[0]=3/8, cb[1]=0, cb[2],=-1/8,cb[3]=0
    pt2.x =  pts[v2].x * 0.75 +
            pts[pc2.p[0]].x * 0.375 -
            pts[pc2.p[2]].x * 0.125;
    pt2.y =  pts[v2].y * 0.75 +
            pts[pc2.p[0]].y * 0.375 -
            pts[pc2.p[2]].y * 0.125;
    pt2.z =  pts[v2].z * 0.75 +
            pts[pc2.p[0]].z * 0.375 -
            pts[pc2.p[2]].z * 0.125;
    if (pc1.valence==6){
        v->x = pt2.x; v->y = pt2.y; v->z = pt2.z;
    }else{
        v->x = (pt1.x + pt2.x)/2.0;
        v->y = (pt1.y + pt2.y)/2.0;
        v->z = (pt1.z + pt2.z)/2.0;
    }
    break;
case 6:
    //ca[0],cb[0] = 1/2-w, ca[1],cb[1] = 1/8+2w,
    //ca[2],ca[4],cb[2],cb4[]=-1/16-w
    //ca[3],cb[3] = w;
    if (pc1.valence==6){
        v->x = pts[v1].x * (0.5-w) +
                pts[v2].x * (0.5-w) +
                pts[pc1.p[1]].x * (0.125 + 2*w) +
                pts[pc1.p[5]].x * (0.125 + 2*w) +
                pts[pc1.p[2]].x * (-0.0625 - w) +
                pts[pc2.p[2]].x * (-0.0625 - w) +
                pts[pc1.p[4]].x * (-0.0625 - w) +
                pts[pc2.p[4]].x * (-0.0625 - w) +
                pts[pc1.p[3]].x * w +
                pts[pc2.p[3]].x * w;
        v->y = pts[v1].y * (0.5-w) +
                pts[v2].y * (0.5-w) +
```

```
                        pts[pc1.p[1]].y * (0.125 + 2*w) +
                        pts[pc1.p[5]].y * (0.125 + 2*w) +
                        pts[pc1.p[2]].y * (-0.0625 - w) +
                        pts[pc2.p[2]].y * (-0.0625 - w) +
                        pts[pc1.p[4]].y * (-0.0625 - w) +
                        pts[pc2.p[4]].y * (-0.0625 - w) +
                        pts[pc1.p[3]].y * w +
                        pts[pc2.p[3]].y * w;
            v->z = pts[pc1.p[0]].z * (0.5-w) +
                        pts[pc2.p[0]].z * (0.5-w) +
                        pts[pc1.p[1]].z * (0.125 + 2*w) +
                        pts[pc1.p[5]].z * (0.125 + 2*w) +
                        pts[pc1.p[2]].z * (-0.0625 - w) +
                        pts[pc2.p[2]].z * (-0.0625 - w) +
                        pts[pc1.p[4]].z * (-0.0625 - w) +
                        pts[pc2.p[4]].z * (-0.0625 - w) +
                        pts[pc1.p[3]].z * w +
                        pts[pc2.p[3]].z * w;
        }else{
            //Already calculated
            v->x=pt1.x; v->y=pt1.y; v->z=pt1.z;
        }
        break;
    case 5:
    default:
        //v2=3/4,cb[n]=(1/4+cos(2pi*n/valence)+1/2(cos(4pi*n/↵
          valence))/valence
        valence = pc2.valence;

        pt2.x = pts[v2].x * 0.75;
        pt2.y = pts[v2].y * 0.75;
        pt2.z = pts[v2].z * 0.75;

        for ( i=0; i<pc2.valence; i++){
            weight = (0.25 + cos((PI2 * (double)i)/valence) +
                0.5 * cos((PI2 * 2 * (double)i)/valence))/valence;
            pt2.x += pts[pc2.p[i]].x * weight;
            pt2.y += pts[pc2.p[i]].y * weight;
            pt2.z += pts[pc2.p[i]].z * weight;
        }

        if (pc1.valence==6){
```

```
        v->x=pt2.x; v->y=pt2.y; v->z=pt2.z;
    }else{
        v->x = (pt1.x + pt2.x)/2.0;
        v->y = (pt1.y + pt2.y)/2.0;
        v->z = (pt1.z + pt2.z)/2.0;

    }
    break;
    }

    return edge->v;//Zero start for the indices
}
```

This leaves just the main function call to the function *SubDivide*. The passed parameter indicates how many times to subdivide the mesh. The first step in the subdivision is restoring the original mesh. Then we create a connectivity array and iterate through the base polygons, adding the new polygons to the subdivided polygons' array. The subdivided mesh uses all new polygons, but it uses the original vertex list. The new polygons are formed from the existing and new vertices using the following stencil:

p[0], *v*1, *v*3
p[1], *v*2, *v*1
p[2], *v*3, *v*2
*v*1, *v*2, *v*3

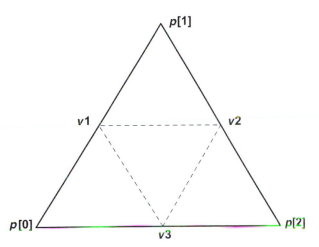

Figure 15.12 Indices of added polygons.

```
//===============================================================
//SubDivide

//Sub divides the mesh pointed to by the OBJECTINFO data structure
//The results of the subdivision are stored in the OBJECTINFO
//data structure.
//===============================================================

BOOL CT3DObject::SubDivide(int subDivIndex)
{
  if (subDivIndex<1) return FALSE;

  //The PATCHINFO structure stores the original mesh
  if (pi.numpoints==0) CreatePatchInfo();
  //Start by copying original mesh
  //We are using Butterfly subdivsion so the existing vertices
  //must be part of the cage information
  delete [] oi.pts;
  delete [] oi.plys;
  oi.pts = new POINT3D[pi.numpoints];
  oi.plys = new POLYGON[pi.numpatches];
  memcpy(oi.pts, pi.pts, sizeof(POINT3D) * pi.numpoints);
  memcpy(oi.plys, pi.pchs, sizeof(POLYGON) * pi.numpatches);
  oi.numpoints = pi.numpoints;
  oi.numpolygons = pi.numpatches;

  int numpolygons, numedges, numpoints, edgecount, pointcount;
  int i,k,v1,v2,v3;

  EDGE *edges;
  POLYGON *ply, *sdply, *plys;
  POINT3D *pts;
  POINTCON *con;

  for ( i=0; i<subDivIndex; i++){
    numpolygons = oi.numpolygons * 4; //Accurate
    numedges = (numpolygons * 3); // Worst case
    numpoints = oi.numpoints + numedges;
    plys = new POLYGON[numpolygons];
    pts = new POINT3D[numpoints];
    con = new POINTCON[oi.numpoints];
    edges = new EDGE[numedges];
```

```cpp
if (!edges|||!plys || !pts || !con) goto subdivabort;

//Create an array of vertex connectivity
CreateConnectivityArray(con);

edgecount = 0;
pointcount = oi.numpoints;
ply = oi.plys;
sdply = plys;
TEXVEC tv[3];
//Copy base points
memcpy(pts, oi.pts, sizeof(POINT3D)*oi.numpoints);

for(k=0;k<oi.numpolygons;k++){
  v1 = AddEdge(edges, pts, con, pointcount, edgecount,
        ply->p[0], ply->p[1]);
  v2 = AddEdge(edges, pts, con, pointcount, edgecount,
        ply->p[1], ply->p[2]);
  v3 = AddEdge(edges, pts, con, pointcount, edgecount,
        ply->p[2], ply->p[0]);

  //Create the polygons and interpolate the texture coordinates
  if (oi.srfs[ply->srf].tex){
    tv[0].u = (float)(ply->tc[0].u + ply->tc[1].u)/2.0f;
    tv[0].v = (float)(ply->tc[0].v + ply->tc[1].v)/2.0f;
    tv[1].u = (float)(ply->tc[1].u + ply->tc[2].u)/2.0f;
    tv[1].v = (float)(ply->tc[1].v + ply->tc[2].v)/2.0f;
    tv[2].u = (float)(ply->tc[0].u + ply->tc[2].u)/2.0f;
    tv[2].v = (float)(ply->tc[0].v + ply->tc[2].v)/2.0f;
  }

  if (!CreatePolygon(sdply++, ply->srf,
    ply->p[0], v1, v3, ply->tc[0], tv[0], tv[2])) goto↵
      subdivabort;
  if (!CreatePolygon(sdply++, ply->srf,
    ply->p[1], v2, v1, ply->tc[1], tv[1], tv[0])) goto↵
      subdivabort;
  if (!CreatePolygon(sdply++, ply->srf,
    ply->p[2], v3, v2, ply->tc[2], tv[2], tv[1])) goto↵
      subdivabort;
  if (!CreatePolygon(sdply++, ply->srf,
    v1, v2, v3, tv[0], tv[1], tv[2])) goto subdivabort;
```

```
        if (edgecount > numedges){
          //Not sure if we need this but I'll put it in for safety
          AfxMessageBox("Edge count exceeds memory limit");
          goto subdivabort;
        }
        ply++;
      }
      //Now we know the actual number of edges
      delete [] edges;
      delete [] oi.pts;
      delete [] oi.plys;
      delete [] con;
      oi.pts = new POINT3D[pointcount];
      memcpy(oi.pts, pts, sizeof(POINT3D) * pointcount);
      delete [] pts;
      pts = NULL;
      oi.numpoints = pointcount;
      oi.plys = plys;
      oi.numpolygons = numpolygons;
   }

   CalcNormals();

   return TRUE;

subdivabort:
   if (pts) delete [] pts;
   if (plys) delete [] plys;
   if (con) delete [] con;
   return FALSE;
}
```

Optimization

If you intend to use subdivision for character animation, then the vertex placement must be calculated for every change in the base mesh. Connectivity will not alter throughout the animation, however, so it will improve the performance to calculate the connectivity values only once. If the maximum subdivision is order three, then calculate and store three connectivity arrays. You could also store the number edges and points in the subdivision after the first call, thereby reducing the memory

allocations, which by default use the worst case scenario. If a mesh has 100 triangles, then the maximum number of edges is $100 \times 3 = 300$. This implies that every triangle is a separate item and no triangles share any edges. Clearly, in a character mesh this is not going to happen. If a mesh has no deformations then subdivision needs to be called only once, after which the subdivided mesh is used for all screen paints. Character animation, however, involves mesh deformation and needs to be called for each deformation of the mesh. Since this could be 50 times a second, any optimizations will pay dividends in performance. It is possible to subdivide a mesh an arbitrary number of times in a single pass with no iteration. One technique was presented at Siggraph 1998 by Jos Stam. The method uses the invariance of eigenvectors and eigenvalues. It is a fairly mathematical presentation, but you are advised to refer to Appendix C for a link to his paper.

Summary

Subdivision allows the modeller to use all the low polygon methods that they have used in the past with the benefit that the final rendered mesh can be as smooth as you choose. Subdivision addresses the increasing sophistication of computer hardware while not excluding users with less capable machines. It is fairly easy to implement and can greatly improve the appearance of low polygon meshes. As the gap between low- and high-end computer hardware grows wider, the requirement of scalable solutions becomes increasingly important.

16 Using multi-resolution meshes

In this chapter we will look at how to reduce polygons from your mesh. In essence this is the opposite of the previous chapter. Whereas in the previous chapter we were concerned with smoothing the display of a low polygon mesh by using progressive refinement of the mesh, in this chapter we will look at a technique for reducing the polygons in a mesh. The aim is to gradually reject polygons until a target polygon total is achieved. There are many options for polygon reduction and we will look briefly at these alternatives before examining one technique in detail. Michael Garland and Paul S. Heckbert first introduced the one method that I felt gave the best results for low polygon meshes. Their method is known as *Quadric Error Metrics* and is discussed in detail in this chapter.

Overview

Painting polygons is the most time-consuming aspect of generating real-time computer graphic displays. If instead of painting 10 000 polygons we can paint just 1000, then the display update time will improve dramatically. As a character heads off into the distance, the area of the screen display occupied by this character will be reduced. Suppose your key character uses 2000 polygons. At some stages in the game her on-screen height is 500 pixels. At another stage her height occupies just 50 pixels. If she looks good using 2000 polygons when 500 pixels high, then using 2000 polygons for the 50 pixels high version is unnecessarily complex. The purpose of this chapter is to show how to create several versions of the character that are suited for use at different distances from the camera.

Most modelling software will include tools for polygon reduction. One option would be to include the different resolution meshes in the application. While this approach would be suitable for CD-ROM distribution, it does not suit low bandwidth Internet applications. For the latter, we

Figure 16.1 A 2000-, 500- and 250-polygon character.

Figure 16.2 The same model viewed at different camera distances.

want as little data in the file as possible and to let the transformation and rendering engine look after the creation of the different resolution meshes. Another problem of storing the data within the file will be the use of a single mesh deformation engine. The approach we will adopt for the movement of characters is to have a key resolution that is deformed using some kind of bones system, as outlined earlier. Having deformed the mesh we then create a display resolution version of this mesh. If the character is close to the camera, then we may use subdivision to smooth the mesh. If the character is further away, then we can use polygon reduction.

The options for polygon reduction

When reducing the number of polygons in a mesh there are fundamentally three alternative routes.

Removing vertices

An algorithm is adopted to scan a mesh and determine the vertex which, if removed, would make the least difference to the mesh. This vertex is removed leaving a hole. The hole is re-triangulated and the iteration process continues until a target number of polygons is in the mesh or a limiting error is reached. Most algorithms that take this approach cannot work on arbitrary meshes, so this approach is not really suited to the multi-resolution meshes we intend to create.

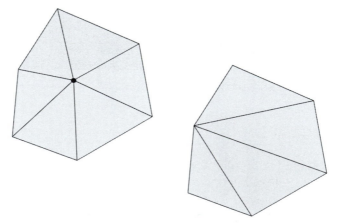

Figure 16.3 Removing a vertex and re-triangulating the hole.

Real-time 3D Character Animation with Visual C++

Cell analysis

The idea behind this algorithm, introduced by Rossignac and Borrel, is to encase the mesh inside a bounding box. This bounding box is divided into an even array of cells. The cells are scanned to see if any vertices from the original mesh are contained within the cell. In the resulting model, a single vertex will be used for each cell that contains vertices from the source model. Merging all the vertices that are found in a single cell creates the resulting mesh. This algorithm has the benefit of speed but the resulting models can be improved upon.

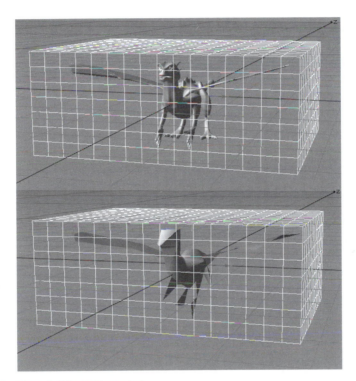

Figure 16.4 Using cell-based analysis.

Removing edges

The final option is to scan all the edges in the mesh using an algorithm to determine the edge that will be least missed. Having decided on the edge to remove, this is achieved by merging the end-points of this edge into a single vertex. It is this approach that is used in Quadric Error Metric polygon reduction.

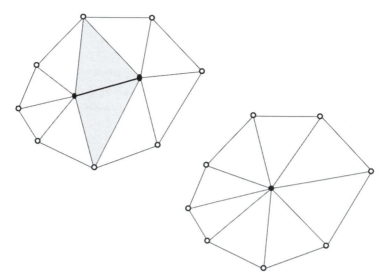

Figure 16.5 Removing an edge.

There is a limitation to the edge contraction-based technique where an unconnected mesh is involved. Because we only allow for edge contraction, the model can change dramatically in the volumes perceived. In a low polygon game, the perceived volumes are the most important aspect of the display. A useful way to avoid the problem of changing volume when reducing polygons is to allow for two vertices that are close together to be regarded in the same way as an edge. The human eye works in much the same way, with distant detail merging together. Determining the limiting distance for such vertex pairs has to be handled with care, but the resulting models hold their volume much more effectively.

Deciding who can stay and who must go

The algorithm we use must determine an error for the removal of an edge. If by removing the edge we retain a similar shape to the original, after this contraction then this edge can be safely removed. We do this by calculating a quadric matrix, **Q**, for each vertex. The error at a vertex is then given by $v^T \mathbf{Q} v$. When calculating the effect of merging two vertices, we create a new matrix by using the sum of the matrices for each vertex:

$$\mathbf{Q}' = \mathbf{Q}_1 + \mathbf{Q}_2$$

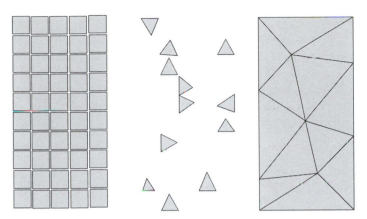

Figure 16.6 The benefits of allowing merging of close vertex pairs in addition to edge contraction.

The location of the merged vertex can be found using the inverse of this matrix if it is invertible or some point along the current edge if it is not. The effect of merging a vertex pair is found using this vertex location and the sum of the two vertex quadrics:

$$v^{T\prime} \mathbf{Q}' v'$$

In their paper, Garland and Heckbert summarized the algorithm as:

1 Compute the **Q** matrices for all the vertices in the mesh.
2 Select all valid pairs, edges and unconnected vertices that are within the distance parameter.
3 Compute the position of the vertex when a vertex pair is merged.
4 Compute the error for these new vertices using $v^T(\mathbf{Q}_1 + \mathbf{Q}_2)v$.
5 Place the pairs on a heap based on the error calculated in step 4.
6 Iteratively merge a pair and update the costs of any other vertices affected by this change.
7 Repeat until the desired polygon total is reached.

Deriving the quadric matrix

Each vertex in the mesh is one corner of a number of triangles. If we think of the triangles as planes, then the vertex represents the intersection of a group of planes. If these planes are almost in line with each other, then the effect of removing this vertex will be minimal. If the planes are at a sharp

Real-time 3D Character Animation with Visual C++

angle to each other, then the effect of removing the vertex will be dramatic. For any vertex we can define the error with respect to the current vertex as the sum of the distance to planes. To find a distance will require us to use a square root, which is a computationally expensive procedure. Since we are concerned with the error rather than the distance, we can just use the squared distance.

If we describe each of the n planes using p and a vertex as v, then the error becomes

$$\sum_{p=1}^{n} (p^T v)^2$$

A plane p is defined by the equation

$$ax + by + cy + d = 0$$

where

$$a^2 + b^2 + c^2 = 1$$

Deriving the values for a, b, c and d using the three vertices of a triangle requires some careful algebra. The exercise becomes one of solving four simultaneous equations in four unknowns. If we define the three vertices of the triangle as p, q and r, then the equations are:

$$ap_x + bp_y + cp_z + d = 0 \tag{1}$$
$$aq_x + bq_y + cq_z + d = 0 \tag{2}$$
$$ar_x + br_y + cr_z + d = 0 \tag{3}$$
$$a^2 + b^2 + c^2 = 1 \tag{4}$$

Let

$$k = r_x / q_x$$

Therefore, we can create E5 using E2 $-$ k(E3) (where E represents equation):

$$b(q_y - kr_y) + c(q_z - kr_z) + d + kd = 0 \tag{5}$$

Let

$$m = p_x / q_x$$

Therefore, we can create E6 using $E1 - m(E2)$:

$$b(p_y - mq_y) + c(p_z - mq_z) + d + md = 0 \tag{6}$$

Let

$$n = (p_y - mq_y)/(q_y - kr_y)$$

We can create E7 using $E6 - n(E5)$:

$$c(p_z - mq_z - n)(q_z - kr_z) + d(1 - m - n + kn) = 0 \tag{7}$$

Let

$$s = \frac{p_z - mq_z - n(q_z - kr_z)}{n + kn - 1 + m}$$

$$v = \frac{(m - 1)s - p_z + mq_z}{P_y - mq_y}$$

$$w = \frac{vp_y + p_z + s}{p_x}$$

With some careful manipulation, we get

$$c = \sqrt{(1/(1 + w^2 + v^2))}$$
$$d = cs$$
$$b = cv$$
$$a = -cw$$

A quadric matrix for a single plane is defined from these values using

$$\mathbf{K}_p = \begin{bmatrix} a^2 & ab & ac & ad \\ ab & b^2 & bc & bd \\ ac & bc & c^2 & cd \\ ad & bd & cd & d^2 \end{bmatrix}$$

Since this matrix is symmetrical about the leading diagonal (top left to bottom right), we do not need to store 16 values, we can make do with just 10:

$$
\mathbf{K}_p = \begin{bmatrix} q11 & q12 & q13 & q14 \\ q12 & q22 & q23 & q24 \\ q13 & q23 & q33 & q34 \\ q14 & q24 & q34 & q44 \end{bmatrix}
$$

The quadric matrix for the vertex is defined as the sum of each plane quadric.

Implementation

Now we will look at how this algorithm can be implemented. We start by creating a structure to store the information we need for a vertex pair. Since the rest of our code uses point indices into a point list to describe each vertex, we use two indices to indicate the number of each vertex in the vertex pair. The next member is a VECTOR storing the (x, y, z) location of the contraction target for this pair. Finally, we store the numerical value for the error for this vertex pair.

```
typedef struct stQUADRICPAIR{
    unsigned short v1, v2;    //point indices
    VECTOR v;                 //location for contraction target
    double error;             //Stores quadric error
}QUADRICPAIR;
```

The function call to reduce polygons takes a single parameter, which is the target total polygons. The purpose of the function is to take an arbitrary mesh containing more polygons than the target and reduce the polygon total to that passed as a parameter. If you examine the function, you will see that after checking whether the target polygon total is less than the current total and marking any morph targets as invalid, a copy of the original mesh is created using the function call *CreatePatchInfo*.

The function proceeds by creating quadric matrices for each vertex in the mesh. We do this using a *CQuadric* class. This class has member variables to represent the quadric matrix and constructors to create a quadric matrix from the plane variables *a*, *b*, *c* and *d*. Member functions are available to create the matrix from three points or three quadrics. A member function, *QEM*, returns the error for a vertex and a member function, *CreateValidPairsArray*, can create an array of quadric pairs that forms the basis of the algorithm.

The *ReducePolygons* function creates an array of quadric pairs using the *CreateValidPairsArray* function and then calculates the optimum location for the contraction target using *CalculateVDash*. At this stage, the list of QUADRICPAIRS is sorted into a new list based on the calculated error. Then the function enters a loop where an edge is removed at each iteration until the target polygon total is achieved. The removal of an edge may delete one or more polygons. The *RemoveEdge* function returns the number of polygons that have been removed from the mesh. When a vertex is removed, we set the valid flag for the quadric with the same index to false to indicate that it is no longer used in the target mesh. On completion of the algorithm, we must tidy up the data, because we have a vertex list that now contains gaps indicated by the invalid flag. The function call *StreamlineMesh* takes the quadric list and recreates a mesh based on the current state of the vertex list.

```
BOOL CToon3DObject::ReducePolygons(int polyTotal){
    if (polyTotal >= oi.numpoints) return FALSE;
    if (morph) usemorph = FALSE;

    //Save original mesh data so we can restore the original
    if (pi.numpoints==0) CreatePatchInfo();

    CQuadric *q = new CQuadric[oi.numpoints], k;
    if (!q) return FALSE;
    POLYGON *ply;
    int i, j, n, pTotal, qpTotal, count, vTotal;
    QUADRICPAIR *qp = NULL, *qparray;

    //Calculate the Quadric matrices for each vertex
    for (int ptindex=0; ptindex < oi.numpoints; ptindex++){
        ply = oi.plys;
        q[ptindex].SetVertex(oi.pts[ptindex]);
        for(i=0; i<oi.numpolygons; i++){
            if (ply->p[0] == ptindex || ply->p[1] == ptindex ||
                ply->p[2] == ptindex || ply->p[3] == ptindex){
                k.CreateFromPoints(oi.pts[ply->p[0]],
                                   oi.pts[ply->p[1]],
                                   oi.pts[ply->p[2]]);
                q[ptindex]+=k;
            }
            ply++;
        }
    }
```

```
    }

    //Create array of valid pairs
    qp = k.CreateValidPairsArray(oi, qpTotal);
    if (qpTotal<1) return FALSE;

    for (i=0; i<qpTotal; i++) k.CalculateVDash(qp[i], q);
    qparray = SortQuadricPairs(qp, qpTotal);
    delete [] qp;
    qp = qparray;

    pTotal = oi.numpolygons;
    vTotal = oi.numpoints;

    //Now remove the edges
    while(pTotal > polyTotal){
        n = RemoveEdge(q, qp, qpTotal);
        if (!n){
            AfxMessageBox("Unsuitable mesh for polygons↵
              reduction");
            RestoreMesh();
            return FALSE;
        }
        pTotal -= n;
        vTotal-;
    }
    StreamlineMesh(q);

    delete [] qparray;
    delete [] q;
    Transform();

    return TRUE;
}
```

Having got an overview of the method, we will look in more detail at the
CQuadric class. The class contains a constructor that can be used to
create a quadric from the plane coefficients.

```
CQuadric::CQuadric(double a, double b, double c, double d)
{
    q11 = a*a;
    q12 = a*b;
```

Real-time 3D Character Animation with Visual C++

```
q13 = a*c;
q14 = a*d;
q22 = b*b;
q23 = b*c;
q24 = b*d;
q33 = c*c;
q34 = c*d;
q44 = d*d;
v.x = 0.0; v.y = 0.0; v.z = 0.0;
valid = TRUE;
deleted = FALSE;
}
```

The function that is used in the *ReducePolygons* function to create plane quadrics is the member function *CreateFromPoints*. This function will create the quadric directly from any three points in the plane. The algebra was shown earlier in the chapter. By passing the three points in the triangular polygon we can construct a plane quadric. Summing these plane quadrics for the polygons meeting at a vertex gives the vertex quadric. Since we are interested in vertex quadrics, we must build these from plane quadrics. The speed of the *ReducePolygons* function could be improved by creating an array of plane quadrics so that the fundamental quadric is calculated only once.

```
BOOL CQuadric::CreateFromPoints(POINT3D &p1, POINT3D &p2, POINT3D⏎
  &p3)
{
    double a, b, c, d, k, m, n, s, v, w;

    k = p2.x/p3.x;
    m = p1.x/p2.x;
    n = (p1.y - m*p2.y)/(p2.y - k*p3.y);
    s = (p1.z - m*p2.z - n*(p2.z - k*p3.z))/(n + k*n - 1 + m);
    v = (s*(m - 1) - p1.z + m*p2.z)/(p1.y - m*p2.y);
    w = (v*p1.y + p1.z + s)/p1.x;
    c = sqrt(1.0/(1 + w*w + v*v));
    a = -c*w;
    b = c*v;
    d = c*s;

    q11 = a*a;
    q12 = a*b;
    q13 = a*c;
```

```
            q14 = a*d;
            q22 = b*b;
            q23 = b*c;
            q24 = b*d;
            q33 = c*c;
            q34 = c*d;
            q44 = d*d;
            valid = TRUE;
            v.x = 0.0; v.y = 0.0; v.z = 0.0;
            deleted = FALSE;

            return TRUE;
    }
```

To return the quadric error metric of a pair, we take the sum of the vertex quadrics and multiply by the contraction target and its transpose. This utility function assumes that the sum of the vertex quadrics is stored in the member variables. We pass the contraction target as a VECTOR reference.

```
    double CQuadric::QEM(VECTOR &v)
    {
        double vx, vy, vz;

        vx = q11*v.x + q12*v.y + q13*v.z + q14;
        vy = q12*v.x + q22*v.y + q23*v.z + q24;
        vz = q13*v.x + q23*v.y + q33*v.z + q34;

        return (vx*v.x + vy*v.y + vz*v.z + 1.0);
    }
```

When creating an array of valid pairs we first assign every edge. This is done by iterating through each polygon and adding each edge of a polygon to the valid pairs array. If the pair is already present in the array then the algorithm moves on without adding this pair. If the pair is not present then the current pair is added to the valid pairs array. After adding the pair a counter *qpTotal* is incremented. If this value exceeds the array size, which is stored in the variable *qpMax*, then the array is doubled in size and the original array copied to the new memory allocation. This dynamic allocation of memory can provide a useful technique for array expansion. Valid pairs include vertices whose distance apart is within a certain boundary. One of the parameters used for the function *CreateValidPairsArray* is *distance*.

Real-time 3D Character Animation with Visual C++

Table 16.1 Distances and squared distances

Distance	Distance squared
0.01	0.0001
0.1	0.01
1	1
10	100
100	10 000

The distance between two points in 3D space is easily calculated from an extension to Pythagoras' theorem.

```
double x, y, z;
x = (x1 - x2);
y = (y1 - y2);
z = (z1 - z2);
dist = sqrt(x * x + y * y + z * z);
```

Unfortunately, square roots are computationally expensive. But we are only interested in staying inside a parameter, so we can use the squared distance (see Table 16.1).

```
QUADRICPAIR *CQuadric::CreateValidPairsArray(OBJECTINFO &oi, ↵
  int &qpTotal, double distance)
{
    POLYGON *ply = oi.plys;
    int qpMax = oi.numpolygons*4, i, n, m, j;
    QUADRICPAIR *qp = new QUADRICPAIR[qpMax], *qptmp;
    BOOL found;
    double vsqdist, sqdist = distance * distance;

    qpTotal = 0;
    if (!qp) return NULL;

    for(i=0; i<oi.numpolygons; i++){
        found = FALSE;
        for(n=0; n<ply->numverts; n++){
            m = (n==(ply->numverts-1))?0:n+1
            for (j=0; j<qpTotal; j++){
```

```
            if (qp[j].v1==ply->p[n] && qp[j].v2==ply->p[m]){
                found=TRUE;
                break;
            }
            if (qp[j].v1==ply->p[m] && qp[j].v2==ply->p[n]){
                found=TRUE;
                break;
            }
        }
        if (!found){
            //Add edge
            qp[qpTotal].v1 = ply->p[n];
            qp[qpTotal].v2 = ply->p[m];
            qp[qpTotal].deleted = FALSE;
            qpTotal++;
            if (qpTotal>=qpMax){
                //Enlarge the array
                qptmp = new QUADRICPAIR[qpMax * 2];
                if (!qptmp) return FALSE;
                qpMax *= 2;
                memcpy(qptmp, qp, sizeof(QUADRICPAIR)*qpTotal);
                delete [] qp;
                qp = qptmp;
            }
        }
    }
    ply++;
}

if (sqdist>0.0){
    //Add any vertex pairs closer than distance
    for (i=0; i<oi.numpoints; i++){
        for (j=0; j<oi.numpoints; j++){
            vsqdist = (i.x - j.x)*(i.x - j.x) + (i.y - j.y)*
                      (i.y - j.y) + (i.z - j.z)*(i.z - j.z);
            if (vsqdist < sqdist){
                //Add this pair
                qp[qpTotal].v1 = i;
                qp[qpTotal].v2 = j;
                qpTotal++;
                if (qpTotal>=qpMax){
                    //Enlarge the array
                    qptmp = new QUADRICPAIR[qpMax * 2];
```

```
                    if (!qptmp) return FALSE;
                    qpMax *= 2;
                    memcpy(qptmp, qp,
                    sizeof(QUADRICPAIR)*qpTotal);
                    delete [] qp;
                    qp = qptmp;
                }
            }
        }
    }

    qutmp = new QUADRICPAIR[qpTotal];
    memcpy(qptmp, qp, sizeof(QUADRICPAIR)*qpTotal);
    delete [] qp;

    return qptmp;
}
```

When creating the contraction target we attempt to invert the matrix created from the sum of the end vertex quadrics. Matrices are not always invertible; it depends on the determinant of the matrix not being zero. If the current matrix is not invertible, then we use the vertex that gives the least error from the end-points and the mid-point as the contraction target.

```
BOOL CQuadric::CalculateVDash(QUADRICPAIR &qp, CQuadric *q)
{
    CQuadric vq, vqInv;
    VECTOR v;
    double err[3];

    vq = q[qp.v1] + q[qp.v2];
    if (vq.Invert()){
        qp.v.x = vq.q14;
        qp.v.y = vq.q24;
        qp.v.z = vq.q34;
        qp.error = vq.QEM(qp.v);
    }else{
        //vq is not invertable so select v dash as lowest error
        //from the mid point and endpoints
        v.x = (q[qp.v1].v.x + q[qp.v2].v.x)/2.0;
        v.y = (q[qp.v1].v.y + q[qp.v2].v.y)/2.0;
        v.z = (q[qp.v1].v.z + q[qp.v2].v.z)/2.0;
```

```
            err[0] = vq.QEM(q[qp.v1].v);
            err[1] = vq.QEM(q[qp.v2].v);
            err[2] = vq.QEM(v);
            if (err[0]<err[1] && err[0]<err[2]){
                qp.v.x = q[qp.v1].v.x;
                qp.v.y = q[qp.v1].v.y;
                qp.v.z = q[qp.v1].v.z;
                qp.error = err[0];
            }
            if (err[1]<err[0] && err[1]<err[2]){
                qp.v.x = q[qp.v2].v.x;
                qp.v.y = q[qp.v2].v.y;
                qp.v.z = q[qp.v2].v.z;
                qp.error = err[1];
            }
            if (err[2]<err[0] && err[2]<err[0]){
                qp.v.x = v.x;
                qp.v.y = v.y;
                qp.v.z = v.z;
                qp.error = err[2];
            }
        }

    return TRUE;
}
```

Using single mesh deformation

It is certainly possible to transform a single key mesh and then choose an appropriate rendering level using either subdivision to enhance the mesh or polygon reduction to decimate the mesh. Another strategy when using polygon reduction techniques is to pre-calculate several versions of your model and choose the appropriate model depending on the viewing angle. If you choose to adopt this strategy, which will involve less work at display time, then you will need some way of deforming a single mesh based on some kind of bones system. Identifying which vertices belong to which control sets can be hard under these circumstances. If your original mesh is split into point sets that are controlled by individual controls, then you need to track the control sets as the vertex contraction takes place. You will need some kind of strategy when contracting an edge that belongs to two control sets. Which control set should the contraction target belong to? One technique is to calculate the distance from the

vertex to the pivot point of its control and choose the vertex that is closest to its pivot.

Summary

Polygon reduction and its sister technique subdivision are very important in games intended for a PC platform. They offer the key to scalable displays on hardware that can be very different. While pre-calculated meshes of different polygon depths offer the tightest possible control, this method does not lend itself to the important area of Internet distribution. The dawn of 3D distribution via the Internet is always just around the next corner. But it has so much to offer that it seems certain to eventually dominate. Using the methods outlined in this chapter and the previous one, you will have a head start in awareness of the techniques you should use to enhance your games and demos.

17 The scene graph

A simple game may include an intro, a configuration screen, two or three game levels, a successful end, an unsuccessful end and a play again selection screen. Trying to manage all this in a single scene can be complex and wasteful in terms of memory resources. In this chapter we will look at how to break a project down into manageable sections so that we can deal with one thing at time. We will look at how to manage texture resources across scenes and how using shared libraries can prove useful.

What are we going to store in a scene?

In true OOP style, we are going to create a class called *CToon3DScene* that will contain all the data that will constitute a scene. A project may contain several scenes and data that are stored globally, so that all scenes can access these resources conveniently. The simplest project, however, will contain just a single scene and no global resources. For this reason, our scene class must provide a data structure capable of storing everything that is to be used in a simple animated demo. A list of resources a scene requires is as follows:

1 Meshes
2 Morph targets
3 Surface data
4 Images
5 Motion files
6 Text objects
7 Buttons
8 Cameras

9 Scripts
10 User control
11 Texture objects
12 Sounds
13 Collision boxes
14 Interactive behaviours

The design of the data needs to be as flexible as possible. Let's consider the main data members.

Meshes and morph targets

A mesh must know about its own topology. The simplest way to store a mesh is as a vertex list and a polygon list. The polygon list defines a polygon using indices into the point list, together with a surface ID, which is an index into the surface list. But a surface list could be global, scene level or mesh level. If the surface ID is a 32-bit integer, then we could use the top 2 bits to flag to which surface list the ID refers; a surface that uses a bitmap texture is quite demanding of resources so should be shared wherever possible. When dealing with character animation, complex and repeated animations can be handled easily with morph targets. In the accompanying software Toon3D Creator the morph targets are saved and loaded by the mesh object. In a complex and involved game, the central characters may require many morph targets for a face. Different targets may be required as the player moves through the game. The scene class needs the ability to use some targets and not others. A simple way to provide this facility is to check the animation that has been created and test for any targets that have zero level throughout the animations within a scene. If this is the case then these targets are unnecessary within that scene. But if the scene is then saved excluding these morph targets, it will be more complicated for a developer to change the animations to use them again. This leads to an interesting conclusion. The scene file that a developer needs to save is different from the scene file that an end-user needs to load. A developer needs the ability to change tack and revise the animation and interactivity, while the end-user just needs the minimum necessary to display the appropriate meshes, at the right time, with the correct deformation. Toon3D Creator uses project files and published files. In the next and final chapter we will look at how we can compress the final end-user files using simple compression techniques. For now, we will be more concerned with creating a structure to store everything and less concerned with keeping the data size small.

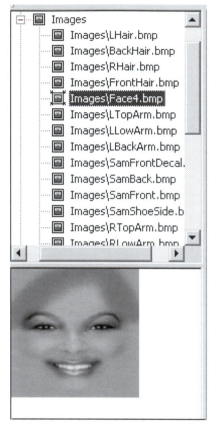

Figure 17.1 Image list.

Images

Bitmap images are memory hungry. It is essential that these resources be used economically. Just as surface ID can point to global, scene level and mesh level surfaces, we can have image lists that are global, scene level and mesh level. The images that are used for the central character are likely to be used across scenes and so would be a good choice for a global library of images, while the bitmaps used to texture a character that appears in a single scene are more suited to a scene level list. If your project has characters that may appear in a scene and yet could very well not appear, then some type of dynamic loading would be more suitable. The problem with dynamically loading a character mesh and textures is that the user is likely to experience a brief delay. For some games this can easily be hidden by a short tension-building animation. Dynamic loading has the distinct benefit that it is the best use of resources.

Motion files

Most animated characters have libraries of movements. For a biped character, all parts of the body are connected to the hips in most cases. The movement of these characters is created from a combination of the transformation, scaling and orientation of the hips and the orientation of all the other parts. In most cases the animation will be created using rotations only; no transformation or scaling is used other than for the hips. This means that a character with the same hierarchy could share the same animation for all parts other than the hips. This makes the creation of the animation quicker and the file sizes are going to be smaller as a result. In common with surface and image lists, we can define a motion

Real-time 3D Character Animation with Visual C++

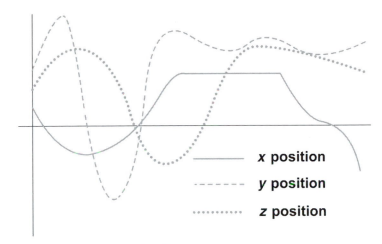

Figure 17.2 A three-channel motion file.

globally, at the scene level or at the mesh level. The mesh object knows about its animation so we will include a flag that informs the transformation engine that the motion is coming from a mesh, scene or global level motion file.

Text and buttons

No game or demo is going to be complete without at least some text and the odd button. Buttons are usually best defined at the global level, since they define a look and feel for a game that should remain consistent. Text, however, is a scene level object. The displayed string of characters, the font, colour, size and location will vary from scene to scene. Toon3D defines a *CGLText* class to handle text objects. Because text can move on the screen, the *CGLText* class uses a special format for key values. As well as frame value, *x* and *y* position, scale and the smoothing factors tension, bias and continuity, the actual string value to be displayed is part of the key value.

```
typedef struct stTEXTKEY{
    int frame;
    GLfloat x,y,scale;
    char str[80];
    float tn,ct,bs;
    BYTE linear;
}TEXTKEY;
```

To use fonts within OpenGL, they need to be converted into a series of OpenGL lists. OpenGL can use a series of commands in a single call by storing them inside a list. The principle behind using fonts is to create a list that describes to OpenGL how to draw each character within a font. Thankfully we can use the Windows-specific function *wglUseFontOut-lines*. Before we do this, we need to set the font we are intending to use as the active font for the OpenGL window. We can easily display a font selector using a font dialog box. The choice is stored as a LOGFONT structure. The code used in Toon3D to display the font dialog box is as follows:

```
void CGLTextDlg::OnTextSetfont()
{
    CFontDialog dlg;

    //Initialise the LOGFONT structure
    dlg.m_cf.lpLogFont = &m_logfont;
    //Tell the dialog box to use the LOGFONT member
    dlg.m_cf.Flags |= CF_INITTOLOGFONTSTRUCT|CF_EFFECTS;
    //Set the current colour
    dlg.m_cf.rgbColors = m_clr;
    //Display the dialog box
    if (dlg.DoModal()==IDCANCEL) return;

    //Store the new LOGFONT definition
    dlg.GetCurrentFont(&m_logfont);
    //Delete the old font
    if (m_font.m_hObject) m_font.DeleteObject();
    //Set the new one
    m_fontready = m_font.CreateFontIndirect(&m_logfont);
    //Update the colour value
    m_clr = dlg.GetColor();
    //Tell our dialog box to redraw itself
    Invalidate(FALSE);
}
```

Using the MFC class *CFontDialog* involves initializing the member variable m_cf, which is a CHOOSEFONT structure. When initializing this member variable, we set the CF_INITTOLOGFONTSTRUCT and CF_EFFECTS bits of the *Flag* member. CF_INITTOLOGFONTSTRUCT informs the dialog box that the font is specified by the pointer to a logical font, the *lpLogFont* member of the CHOOSEFONT structure. The CF_

Real-time 3D Character Animation with Visual C++

EFFECTS bit tells the dialog box that colour and other effects such as underline are to be used. We wish to specify colour so we use this bit.

Having got a user choice for the LOGFONT we need to ensure that this is the font used by the OpenGL window. First, we create a handle to a font using *CreateFontIndirect*. Then we select this into the device context for the OpenGL window. Now OpenGL knows which font to use when creating the font outlines. At this stage we are ready to create the display lists needed to display fonts. The parameters for *wglUseFontOutlines* are:

```
BOOL wglUseFontOutlines(
    HDC hdc,                    // device context of the outline font
    DWORD first,                // first glyph to be turned into a display
                                //list
    DWORD count,                // number of glyphs to be turned into
                                //display lists
    DWORD listBase,             // specifies the starting display list
    FLOAT deviation,            // specifies the maximum chordal deviation
    FLOAT extrusion,            // extrusion value in the negative z
                                //direction
    int format,                 // specifies line segments or polygons in
                                //display lists
    LPGLYPHMETRICSFLOAT lpgmf   // address of buffer to receive
                                //glyph metric data
);
```

Having done some Windows programming, you should by now be familiar with device contexts, so the *hdc* parameter should be clear. If we look at an ANSI table for character values (Table 17.1), you will see that the first displayable character is 32 (space) and that the standard set of characters goes up to 126 (~). To display a standard string, we therefore need to be able to display characters 32 through to 126. When creating the display lists, we therefore set *first* to 32 and *count* to 126 − 31 = 95. The parameter listbase refers to where in the display lists to store the result. If this is the first use of display lists then we could set this value to 0. If we have several fonts then each font needs 95 display lists. It is the responsibility of the scene to make sure that fonts being assigned in this way use display lists appropriately.

Table 17.1 ANSI character set

0	□	32		64	@	96	`	128	€	160		192	À	224	à	
1	□	33	!	65	A	97	a	129	□	161	¡	193	Á	224	á	
2	□	34	"	66	B	98	b	130	,	162	¢	194	Â	226	â	
3	□	35	#	67	C	99	c	131	ƒ	163	£	195	Ã	227	ã	
4	□	36	$	68	D	100	d	132	,,	164	¤	196	Ä	228	ä	
5	□	37	%	69	E	101	e	133	…	165	¥	197	Å	229	å	
6	□	38	&	70	F	102	f	134	†	166	¦	198	Æ	230	æ	
7	□	39	'	71	G	103	g	135	‡	167	§	199	Ç	231	ç	
8	□	40	(72	H	104	h	136	^	168	¨	200	È	232	è	
9	□	41)	73	I	105	i	137	‰	169	©	201	É	233	é	
10	□	42	*	74	J	106	j	138	Š	170	ª	202	Ê	234	ê	
11	□	43	+	75	K	107	k	139	‹	171	«	203	Ë	235	ë	
12	□	44	,	76	L	108	l	140	Œ	172	¬	204	Ì	236	ì	
13	□	45	-	77	M	109	m	141	□	173	-	205	Í	237	í	
14	□	46	.	78	N	110	n	142	Ž	174	®	206	Î	238	î	
15	□	47	/	79	O	111	o	143	□	175	¯	207	Ï	239	ï	
16	□	48	0	80	P	112	p	144	□	176	°	208	Ð	240	ö	
17	□	49	1	81	Q	113	q	145	'	177	±	209	Ñ	241	ñ	
18	□	50	2	82	R	114	r	146	'	178	²	210	Ò	242	ò	
19	□	51	3	83	S	115	s	147	"	179	³	211	Ó	243	ó	
20	□	52	4	84	T	116	t	148	"	180	´	210	Ô	244	ô	
21	□	53	5	85	U	117	u	149	•	181	µ	213	Õ	245	õ	
22	□	54	6	86	V	118	v	150	–	182	¶	214	Ö	246	ö	
23	□	55	7	87	W	119	w	151	—	183	·	215	×	247	÷	
24	□	56	8	88	X	120	x	152	~	184	¸	216	Ø	248	ø	
25	□	57	9	89	Y	121	y	153	™	185	¹	217	Ù	249	ù	
26	□	58	:	90	Z	122	z	154	š	186	º	218	Ú	250	ú	
27	□	59	;	91	[123	{	155	›	187	»	219	Û	251	û	
28	□	60	<	92	\	124			156	œ	188	¼	220	Ü	252	ü
29	□	61	=	93]	125	}	157	□	189	½	221	Ý	253	ý	
30	□	62	>	94	^	126	~	158	ž	190	¾	222	Þ	254	þ	
31	□	63	?	95	_	127	□	159	Ÿ	191	¿	223	ß	255	ÿ	

Since OpenGL draws polygons, all curves are approximations. The parameter *deviation* indicates how precise the linear approximation needs to be. Figure 17.3 shows how a small value for *deviation* can create a large number of line segments, while a large value would create a cruder version of a letter using fewer line segments. If you choose you can extrude the font to make it have depth using the *extrusion* parameter. The format parameter must be either WGL_FONT_POLYGONS or WGL_FONT_OUTLINES. If polygons are selected, then the font will be painted solid. If outlines are used then the outline of the font will be used.

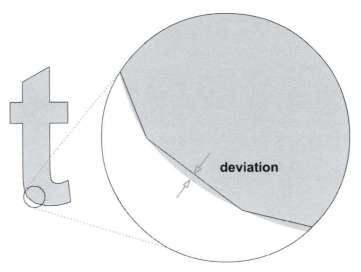

Figure 17.3 The effect of altering the deviation parameter in function call wglUseFontOutlines.

In this function call to create a GL font we pass the device context and the listbase value, and the function creates a set of display lists.

```
BOOL CGLText::CreateGLFont(HDC hdc, int listbase)
{
  HFONT hfont, sfont;
  Hfont = CreateFontIndirect(&m_logfont);

  if (!hfont){
    AfxMessageBox("Problem creating logical font");
    return FALSE;
  }

  sfont = (HFONT)SelectObject(hdc,hfont);
  m_listinit = wglUseFontOutlines(hdc, 32, 95, listbase, 0.0f, 0.1f,
      WGL_FONT_POLYGONS, NULL);
  if (!m_listinit){
    AfxMessageBox("Problem creating font display list");
  }
  m_listbase = listbase;
  SelectObject(hdc, sfont);
  return m_listinit;
}
```

Now to display a string we can use a simple function. First, we set the transformation matrix, disable lighting calculations, set the current colour and set the base number for list use. To actually display the characters we use the GL function *glCallLists*. This function takes three parameters: the number of lists that are to be drawn, a type value which we set as an unsigned byte and finally an array of numerical values that define the lists to use. A string is actually an array of unsigned bytes. A string that reads 'This is a string' is stored in memory as

```
T       h       i       s               i       s               a
084     104     105     115     032     105     115     032     097     032

s       t       r       i       n       g
115     116     114     105     110     103     000
```

Since for our list value 32 or space is actually the first list, we need to make sure that when the value 32 is encountered we use the first list we stored. This is achieved by setting the listbase to 32 less than the stored value. Now when displaying the string above, list 52 is used to display 'T' and list 0 displays a space.

```
void CGLText::DrawText(int x, int y, int scale, CString str)
{
    //Create a transformation matrix
    glLoadIdentity();
    glTranslatef(x, y, -5.0f);
    glScalef(scale, scale, scale);

    glDisable(GL_LIGHTING);

    glRGB(m_red,m_green,m_blue);

    // Display a string
    glListBase(m_listbase - 32); // Indicates the start of display
                                  // lists
    // Draw the characters in a string
    glCallLists(str.GetLength(), GL_UNSIGNED_BYTE, (LPCTSTR)str);

    glEnable(GL_LIGHTING);
}
```

An alternative approach to text involves using a bitmap-based font. You could create a bitmap which contains an array of an ANSI character set. If the font is elaborate then this is often a good way to proceed. Since most

Real-time 3D Character Animation with Visual C++

Constant height

Variable Width

Figure 17.4 Bitmap-based text resources.

fonts are not evenly spaced, you need a way of being able to access the correct character using this bitmap font. One way is to store each character with a dot drawn beneath the letter that defines the right extent of the character. If each line of the bitmap stores 32 characters and you want to display character 'T', which is ANSI value 84, then your code must consider the third line. The bitmap for this character is 20 characters across on this row. By scanning the alignment line until 20 dots have been read, the code now knows the top left of this character cell and the bottom right.

Another useful resource is buttons; your application will have its own technique for button use. Whatever method you choose it is important to be consistent. If you want to display a button simply by giving an ID value, yet the button has a rollover highlighting method and a down location, then each of these display differences can be easily handled using three different bitmaps. Displaying buttons is simply a question of displaying the correct bitmap.

Figure 17.5 Buttons defined using bitmaps.

Cameras

Cameras come in two basic forms, the camera that moves with the action and the camera that is fixed. One simple way to use the camera is to attach it to the user's character. Using this technique, the user always gets the same view of the character. Another method is to let the camera swing around as the player moves about the environment. While considerably more complex to implement, this has a much more filmic feel. If the game environment lends itself to a grid structure then the camera direction can be stored in a three-dimensional array. As the player moves from one block to the next, the transformation engine will probably use quaternion interpolation to swing the camera orientation around. The details of this are best stored in a scene level camera structure.

Scripts, user control and behaviours

Unless the scene is strictly linear, with no interaction, then a scene must store the details about how the interaction occurs. This may include scripts, how the user interacts with the scene resources. Often, a user will control a central character and the scene must know how this control is handled. Each character in an interactive scene will have a set of behaviours. A character may have an animation loop for walking, running, falling, jumping, etc. The behaviour policy will link the condition of the game and the user control to an appropriate behaviour for the character.

Texture objects

Real-time 3D character animation makes extensive use of textures to add detail to a scene that cannot be achieved via more complex geometrical models. Textures can be stored at the object level, the scene level or the global level. Characters that appear infrequently and use unique textures should use textures that are assigned at the object level, while the central character if she appears in several scenes would be a good candidate for a texture that is stored at the global level. Scene level texture storage applies to characters that appear only in a specific scene and make use of textures that appear only in that scene. Texture objects are stored in an array and are accessed when rendering via the OpenGL texture ID. Each polygon in a scene has a surface index into the surface list. The surface list contains a pointer to a texture. The texture contains the OpenGL

texture ID. By using a pointer to a texture within the surface structure, we ensure that a simple surface that defines only colour does not contain unnecessary details about a texture.

Collision boxes

When handling interaction, collisions are always an important considera-tion. A character may collide with the background elements of a scene and collision boxes can be used to handle this. The developer sets up a series of boxes that define the geometry of the background in the simplest way possible, then a collision check will detect if the central character has fallen off a wall, is trying to walk through a wall or is underwater. A character may intersect with another simple object such as a box; in code you may want to trigger a cut scene animation whenever this happens. Again, using a collision box list it is possible to route the code to the appropriate place. A collision box needs dimensions and it also needs to store the information about what to do in the event of a collision. You may simply want to reorient the central character so that they are not walking

Figure 17.6 Collision boxes defining background collisions.

through the wall, you may want the character's action to switch, perhaps this collision triggers another character's action or it may cause program navigation to switch.

The most complex collisions occur between two characters and you are advised to read Chapter 13, which covers collisions in detail.

Application-dependent resources

There are other resources a scene may need to handle which are application dependent. The use of physics in the real-time environment is becoming more common. If you are using physics in a scene then the most common use of physics is to have a value for gravity. The classic definition of the location of a projectile under gravity is

$$x = ut\cos(\theta) \qquad y = ut\sin(\theta) - \tfrac{1}{2}gt^2$$

where u is the launch speed in $m\,s^{-1}$ (metres per second), t is the time in seconds since the launch began and g is a value for gravity that is commonly set to $9.81\,m\,s^{-2}$. To use this simple physics device in your scene will involve defining a value for g in the scene and informing the transformation engine that physics is active. When your central character begins to fall, then gravity can kick in to take over the control. For the effect to look realistic with the value for gravity indicated, the character's scale must be in metres; that is, the height of a human biped must be around 1.8 m.

Physics can be as simple as this or complex enough to include flowing hair. If you want to include physical simulations in your code then most developers adopt some variant on a mass–spring network. The principle here is to regard each vertex as a point mass. That is a mass that has no

Figure 17.7 Projectile motion.

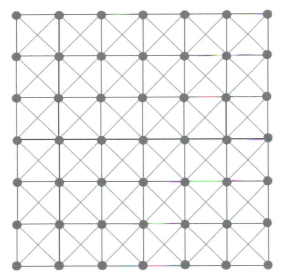

Figure 17.8 Mass–spring network.

real size. Then the edges in a mesh are defined as primary springs and with a quad mesh secondary springs are defined that join the diagonals of the mesh. The strength of the springs defines how the mesh will deform. In general, part of the mesh will be defined as non-deforming, while some of the mesh is given this physical behaviour.

Classical mechanics gives all the information we need to deal with a damped spring. The extension of a spring is defined by Hooke's law to be

$$F_s = -K(x - e)/e$$

where K is the spring constant defining the strength of the spring, x is the actual length of the spring and e is the equlibrium length of the spring. In our case, e is the length of the edge in the original model.

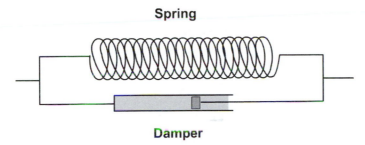

Figure 17.9 A damped spring.

The damping of a spring is defined using

$$F_d = L(v_1 - v_2)$$

where L is the damping constant and v_1 and v_2 are the velocities of the two point masses at each end of the spring.

Now at each time step the acceleration, velocity and position of each point mass are calculated according to the classical laws of dynamics. Each point mass is acted upon by a force which is a combination of the effects of external forces, usually just gravity for a real-time application, and internal forces due to the springs and dampers. The aim of a simulation is to solve the location for each point mass effected in this way. Since each point mass has an effect on the other masses, we need to use numerical methods to solve what is called a differential equation. The simplest method is called Euler's method, after the famous mathematician. Euler's method is quick but prone to error unless the time interval is very short. Creating robust physical simulations is beyond the scope of this book, but some of the references at the end should provide a useful starting point for those interested in extending their knowledge into this cutting edge area.

Physics simulations are computationally demanding but can often be effectively pre-calculated. This involves a slight delay on loading. The pre-calculation stores the final position of a mesh at each time step. Displaying the mesh is then just an exercise in displaying the correct mesh for the current time.

Using globally shared resources

As we have seen, some resources should be available globally throughout an application, while others can be set to object level. A central character that appears in the same costume throughout an application is ideally suited to be a global level resource. A single prop that only ever appears if the animation arrives in a particular scene under a certain combination of conditions is suited to be an object level resource. Choosing which resource is available globally, which at the scene level and which at the object level is something of an exercise in guesswork. The aim is to cut down on load times and minimize memory use from the main memory and from the graphics card. With today's (April 2000) graphics cards offering at least 32 MB of memory, such considerations are proving less necessary than when graphics cards had only 4 MB on offer. Nevertheless, careful use of such resources

speeds up the flow of a game or demo and so is well worth taking into consideration. A useful strategy is to adopt a statistical approach. If resources are used across more than 60 per cent of the game, then set them as globally available resources. These are kept across scene loads and are loaded just once as the program does the initial load and initialization. If resources are used across more than 60 per cent of a scene, then set them at scene level so they are loaded and initialized on scene load. If resources are used less than 60 per cent of the time within a scene, then load them dynamically. These are the hardest to achieve and the most demanding because the load and initialization have to be done seamlessly while the user is playing the game or demo. Since processor time is scarce at such times, you may decide that all resources are loaded at either initial load time or scene load time. But this approach will only suit the smaller demos; at some stage as a production becomes more sophisticated you will need to be dynamically switching texture resources. One approach to this problem is to keep overall scenes smaller, but this only means that the user experiences more delays as scenes are switched. In the end, it is a question of play testing across a range of machines and graphics cards to see which is the best approach to the availability of resources.

Cloning mesh data within a scene

One of the best ways to achieve economy in the use of hardware resources is to use clones. If you have six characters in the same uniform, then they could have exactly the same mesh data. If a mesh has 2000 vertices and 2000 triangles, then we can calculate the memory requirement for a single use of this mesh.

A single vertex that stores origin position, transformation position, original vertex normal and transformed vertex normal as 12-byte vectors will be 48 bytes. Therefore, a 2000-vertex character will use $2000 \times 48 = 96\,000$ bytes, nearly 94K. This may not seem a lot, but if the same character uses 12 128×128 bitmaps as textures, then this adds another 576K to the total. So a single character is using nearly 700K of memory before it starts moving. If we have six of these characters then we are using around 4 MB for the internal storage. If, however, we clone the characters, then we reference the original mesh data and textures. If the characters are moving in a regimented fashion in synchronization with each other, then we can use the same motion files and just apply a small offset to ensure that they are not all sharing the same screen space. If they need to move independently, then the storage system can use a

vertex structure that saves both the origin position and the transformed position separately.

```
typedef struct stT3DPOINT{
    float x, y, z;
    float nx, ny, nz;
}T3DPOINT;
```

Using this method we can clone the original mesh and geometry while tracking a uniquely transformed version of the mesh.

Cloning mesh data from scene to scene

It may well be that a character that is not available as a global resource is nevertheless used across several scenes. We may want to use a storage system that saves the character once and then references the character from the original storage. The advantage of such an approach is that if the character changes in one scene because it is decided that the costume or mesh should be altered, then the change is seen across all scenes. Cloning mesh data across scenes leads to a concern about what part of a character you intend to clone. Potentially a character contains

- Mesh data
- Surface data
- Hierarchy
- Motion data

It is conceivable that any combination of these data is cloned. Tracking this across a development environment becomes quite taxing. Things to consider are deletions and replacements. Let's consider an example. A character is used in scene 2 and then cloned in scenes 5 and 7. In scene 5 just the mesh data are cloned, while in scene 7 the motion is cloned to use on another character. A production decision is made to remove the character from scene 2. If the character is deleted, then the mesh data in scene 5 and the motion data in scene 7 will be lost. Since only part of the resource is used in each scene, we cannot simply switch the main storage from one scene to another. You will need to implement some kind of strategy to offer the developer some replacement options. The simplest option is to switch the character to a global resource, but then it is going to be using lots of resources unnecessarily. Another method would be to split the data between the two scenes and lose any information that is not

immediately required. A final method within the development environment is to have a global resources library that is available only at development time. Such resources are only added to the runtime if they are actually used in the execution of the program. If you are concerned at all with the development environment, then you will realize that giving the user the options to retrace their steps is often one of the hardest parts of providing development software.

Defining animation action libraries

If you followed the chapter on motion capture then you will realize just how much data can be involved in a mocap character. A standard hierarchy using nine channels for the top level bone and three for all the others leads to 59 motion channels, each using 4 bytes. That is a minimum of 236 bytes per time step. If the time step is based on film rates of 24 per second, then 2 minutes of animation stored in this way will use

59 (Channels) × 4 (bytes per channel) × 24 (keys per second) × 60 (seconds per minute) × 2 (minutes) = 679 680 bytes (664K)

Motion capture is very popular in real-time applications because the motion is very realistic and production costs tend to be lower, but internal memory storage is huge. For this reason, if an action such as a walk can be shared across several characters, then the resource implications are minimized. Motion is very distinctive, however, and the viewer is likely to see the similarities. One effective way to hide the similarities is to add a secondary motion on top of the motion capture motion, perhaps a more exaggerated swing to the hips or maybe a higher jump. Since this secondary animation is keyframed it will be much smaller in memory use. The chapter on motion capture gives advice on using secondary motion channels.

Cloning surface attributes

With a real-time game the biggest consumer of hardware resources is the display of bitmapped textures. If these scarce resources can be shared by cloning then this is highly desirable. By using UV texturing methods it is possible for the same rectangular bitmap to provide the texture for several surfaces. This technique provides the most economical use of texture memory. If all textures can be stored on the graphics card within the memory resident there the frame rates are going to be significantly higher than if main memory has to be used for such storage.

Switching scenes

Having set up the game or demo to use several scenes, we need to consider the steps necessary to switch a scene. First, we must delete any resources that are unique to the current scene. These include texture objects and fonts. Then we create any new textures. In the source code from Toon3D the user is offered three options for texture quality. At the highest level the full texture size is used. If frame rates are suffering the user can choose to show textures at half or quarter size. The bitmap that supplies the texture to OpenGL is resized before being passed. Another memory saving option is not to use MipMaps. You will know from the OpenGL chapters that MipMaps are multiple sizes of bitmap texture that can be created with better filtering at creation time and then used at runtime to avoid the sparkling inherent in using the nearest pixel method for filtering a scaled bitmap. For full details, refer to Chapter 4. OpenGL uses a texture ID to reference a texture. We need to ensure that our surfaces refer to the correct texture ID that is only determined at runtime. For this reason, we iterate through all the surfaces and set the appropriate texture ID by matching the texture name and the GL texture name. Scene switching is finalized by the creation of any GL fonts that may be used and the transformation of all objects in the scene by setting a starting frame. Remember that GL fonts use display lists which, once created, are the responsibility of the calling program to delete.

```
BOOL CToon3DDoc::SetScene(CToon3DScene *scn)
{
  //Return if the choosen scene is already selected as active
  if (scn==selScene) return FALSE;

  //Deselect any object, surface, image etc;
  SelectNone();

  //Clear existing GL textures
  if (selScene && selScene->texTotal){
    for (int i=0;i<selScene->texTotal;i++){
      glDeleteTextures(1,&selScene->gltextures[i].texID);
    }
  }
  //Clear existing fonts
  if (selScene) selScene->textList.ClearGLFonts();
  glClearColor(scn->bgCol[0], scn->bgCol[1], scn->bgCol[2], 1.0f);
```

```
//Update variables
selScene = scn;
camera = &scn->camera;

CDIB pic;
CLWObject *obj;
TEXTURE *tex;
int i, j, srcwidth, srcheight, destwidth, destheight;

if (selScene->texTotal){
  //Assign new textures. If texture quality is less than high
  //then the bitmaps are sized down before being passed to OpenGL
  for (i=0;i<selScene->texTotal;i++){
    if (selScene->gltextures[i].pic){
      srcwidth = selScene->gltextures[i].pic->GetWidth();
      srcheight = selScene->gltextures[i].pic->GetHeight();
      switch(selScene->m_texQuality){
        case TEX_HIGH:
          destwidth = srcwidth;
          destheight = srcheight;
          break;
        case TEX_MED:
          if (srcwidth > srcheight){
            destwidth = srcwidth/2;
            destheight = srcheight;
          }else{
            destwidth=srcwidth;
            destheight=srcheight/2;
          }
          break;
        case TEX_LOW:
          destwidth=srcwidth/2;
          destheight=srcheight/2;
          break;
        default:
          destwidth=srcwidth/2;
          destheight=srcheight/2;
          break;
      }
      pic.Create(destwidth, destheight,
            selScene->gltextures[i].pic->BitDepth());
      selScene->gltextures[i].pic->CopyBits(&pic, 0, 0,
            destwidth, destheight, 0,0,srcwidth,srcheight);
```

```
glGenTextures(1, &selScene->gltextures[i].texID);
glBindTexture (GL_TEXTURE_2D, selScene->gltextures[i].↵
  texID);
glPixelStorei (GL_UNPACK_ALIGNMENT, 1);
if (selScene->gltextures[i].wrapS){
  glTexParameteri (GL_TEXTURE_2D, GL_TEXTURE_WRAP_S,↵
    GL_REPEAT);
}else{
  glTexParameteri (GL_TEXTURE_2D, GL_TEXTURE_WRAP_S,↵
    GL_CLAMP);
}
if (selScene->gltextures[i].wrapT){
  glTexParameteri (GL_TEXTURE_2D, GL_TEXTURE_WRAP_T,↵
    GL_REPEAT);
}else{
  glTexParameteri (GL_TEXTURE_2D, GL_TEXTURE_WRAP_T,↵
    GL_CLAMP);
}
glTexParameteri (GL_TEXTURE_2D, GL_TEXTURE_MAG_FILTER,↵
  GL_NEAREST);
glTexParameteri (GL_TEXTURE_2D, GL_TEXTURE_MIN_FILTER,↵
  GL_NEAREST);
glTexEnvf (GL_TEXTURE_ENV, GL_TEXTURE_ENV_MODE,↵
  GL_MODULATE);
if (selScene->m_mipmaps){
  gluBuild2DMipmaps (GL_TEXTURE_2D, GL_RGB,
      pic.GetWidth(), pic.GetHeight(),
      GL_BGR_EXT, GL_UNSIGNED_BYTE, pic.GetBitsAddress());
}else{
  glTexImage2D(GL_TEXTURE_2D, 0, GL_RGB,
      pic.GetWidth(), pic.GetHeight(), 0,
      GL_BGR_EXT, GL_UNSIGNED_BYTE, pic.GetBitsAddress());
}
  }
}

//Now that textures have been created set the actual texture ID
//for all surfaces
obj = selScene->objList.next;
while (obj){
  for (j=0; j<obj->oi.numsurfaces; j++){
    tex = obj->oi.srfs[j].tex;
```

```
      if (tex){
        tex->texID=0;//Zero existing value
        for (i=0; i<selScene->texTotal; i++){
          if (strcmp(tex->name, selScene->gltextures[i].┘
            name)==0){
            tex->texID = selScene->gltextures[i].texID;
          }
        }
        ASSERT(tex->texID);//Was it found?
      }
    }
  }
  glFinish();
  if (m_glhdc) selScene->textList.CreateGLFonts(m_glhdc);

  int tmp = selScene->curframe;
  selScene->curframe=-1;
  SetFrame(tmp);
  UpdateAllViews(NULL, UPDATE_SCENE);
  return TRUE;
}
```

Because this section of code comes from the development environment for Toon3D, it includes the MFC call to UpdateAllViews. Refer to Appendix B for more information about MFC.

Summary

That concludes our consideration of using scenes within your game. You are probably left with more questions than answers. Should resources be global or scene level? Should the scene use physics simulations? What memory requirement for textures should be assumed? These questions have no definite answers. The answers will depend both on your game and the users. It is fair to expect hardware to improve at incredible rates, but does that mean you should necessarily exclude those users with older machines? At the beginning of a project you should set a minimum target for the destination hardware and keep within this definition. If the project is only going to take a week or so to create, a simple Web3D demo, then this is easier to achieve than if the project lifetime is 2 years.

18 Web3D, compression and streaming

The Internet is an exciting way to get your work seen by a large audience. If you intend to distribute your masterpiece on the Internet then you will find this chapter particularly useful. There are many options available when delivering 3D content across the web, but whatever option you choose compression is an very important issue. A 56k dial-up connection delivers around 4k per second; this is a huge restriction to developers who have to be cunning to work within the limitations created by this narrow bandwidth. In this chapter we will look first at how 3D data can be

Figure 18.1 Viewing 3D data in a browser window.

compressed. Then we will look at some alternative options to get some content on to the user's screen before they decide to leave your production for another site that delivers content quicker. Finally, we will look in detail at how Toon3D chooses to stream the content.

Options for 3D compression

Only save what you are going to use

An important first step in compressing 3D data is to analyse the game or demo and to remove any resources that are not used. This may seem a strange conclusion, but in an interactive environment it can sometimes be difficult to predict what a user may see in their journey through the cyber land you have created. Often, culling data resources is best handled by the developer, but sometimes software can usefully highlight seemingly unused resources. As we discovered in the previous chapter, the developer often needs considerably more resources than the end-user. We have looked at how project files will contain resources that are not actually used within the project and are simply stored as a convenience for further development. If a project uses extensive scripting and interactivity, then some resources that appear unused at first glance are used via interactive code and must be present within a compressed project to allow for their display. If this display is only occasional, then you may decide to split the compression between resources that are essential and resources that are optional. Whichever approach is taken, it is essential that only the resources necessary for the user are saved to any file that is intended for Internet distribution.

Lossy or not lossy

A real-time game or demo is already only an approximation to the real world. It is not essential to copy most of the project data to a byte level accuracy; what is important is you retain the look and feel of the original when the data are restored. In the arena of bitmap compression of photographic pictures, the compression technology used by Jpeg files provides a good example of lossy compression. When the picture is restored you do not get a byte level copy of the original; nevertheless, the representation gives a good impression of the original even though every byte in the compressed picture may differ from the original. Using a lossy compression gives the developer a great deal of freedom when

Real-time 3D Character Animation with Visual C++

Compressed

Original

Figure 18.2 Close-up of Jpeg file and source.

considering compression strategies. The table-based methods used by LZW (Zip and gif) compression do not lend themselves to 3D, since it would be useful if we could display content as it streams rather than wait for the entire file to download before decompression takes place. We will concentrate on looking at ways that we can compress and decompress as each bit of information is set and received.

Compressing a mesh

To define a mesh we need a point list, a polygon list and a surface list. We do not need to pass normal information since the program that we are going to use to display the content can easily generate this. We will look at techniques to compress each list in turn.

The vertex list contains an array of vector values, each vertex having an *x*, *y* and *z* value. If we define a vertex using *double* values then each vertex will take 24 bytes. If we use *float* values then each vertex will use 12 bytes. A considerable improvement, but can we do better? Since real-time applications are relatively low polygon, we could choose to store a

mesh using even fewer bytes. Suppose we scan a mesh and do some analysis. When scanning the mesh we look for two things: the bounding volume and the shortest edge. As an example, suppose that after such a scan we find that the bounding volume is (0.835, 1.824, 0.234) >> (−0.835, 0.000, −0.35) and the shortest edge is 0.002. If we use a 2-byte integer value we can store 65 536 different values. Will this number of values give sufficient accuracy to display the mesh without destroying the overall look? The answer in most cases is yes. Given that the maximum dimension of the bounding box is less than 2, if we represent 2 using 65 536 then we can represent 1 using 32 768. The maximum accuracy we can therefore achieve is 1/32 768, approximately 0.00003. If we think of a value of 1 as being 1 metre in world space, then we can resolve the accuracy to 3/100 mm. For a real-time game that is more than enough accuracy. Generally, you will find that a 2-byte integer will give enough accuracy to display objects in the 3D environment. To use this method effectively you will need a scaling factor that compares the stored integer values with actual values in world coordinate space. In this example, every value must be divided by 32 768 to give a close approximation to the original vertex values. Therefore, the compression strategy would be to precede each point list with a scaling value stored as a 4-byte floating-point value. Since we save 2 bytes every vertex, this means that with a point list containing just three values we have already experienced some compression and as the point list increases in number the compression gets nearer to 50 per cent over floats and 25 per cent over doubles. With a real world example of around 5000 vertices per scene across six scenes, Table 18.1 gives an approximation to the bytes needed to store the point list.

Table 18.1 Point list compression using doubles, floats and shorts

Doubles	703K
Floats	351K
Two-byte integers	176K

The next list to consider is the polygon list. We allow three- and four-sided polygons. A polygon contains either three or four indices into the point list that must be byte accurate or the mesh will be deformed, plus a polygon needs to know what surface it is using to define its appearance. If we were content that the vertex list would not exceed 255, then we could use 1 byte to define the vertex index. This is not likely and future proofing

tends to lead us to think that even a 2-byte integer value for the point index is likely to be exceeded relatively quickly. A polygon list also needs to store any texture coordinates that are used. The technique used is to use the first byte in a polygon as a flag, with the following bit pattern:

Bit 7	Not used
6	Texture coordinates stored as short integer
5	Texture coordinates stored
4 and 3	Number of bytes used to store surface index
2 and 1	Number of bytes used to store point index
0	Quad if set

Bits 1 and 2 store the number of bytes used to store the point index. This allows between 1 and 4 bytes for a point index. Using this technique the current requirement of around 5000–10 000 vertices per scene is accommodated using 2 bytes but future proofed to allow for over 16 million vertices!

A similar technique is used when dealing with the surface index for a polygon. Some scenes are going to have less than 256 surfaces. By reading bits 3 and 4 of the flag, we know whether to read 1, 2, 3 or 4 bytes when reading the surface index.

Another aspect of the polygon list is the texture coordinates used by a polygon. Texture coordinates are only used when a texture is present, so we use bit 5 of the flag to indicate this. If we are storing texture coordinates then we can use the method indicated for the point list for storing a floating-point value. Texture coordinates are numbers between 0 and 1. By storing these as a 2-byte integer value, we save half the file size we would use if floats were adopted. Again, because we are dealing with relatively crude levels of detail, this loss of precision should not create any major problems. For completeness we use a bit in our flag to indicate whether texture coordinates are stored as short integers or floats.

Finally, we have the surface list. Here we have some potential for compression. There are many reasons why object level surface lists are to be recommended, but file size is not one of them. In a character with many segments there could easily be many repetitions of the same surface. When compressing surfaces it is best to create a scene level surface list by iterating through all the objects in a scene and checking the surface list against a global level list that is created on the fly. When creating a global surface list we must ensure that the polygon surface indices refer to the global list of surfaces, not the object level. By adding a member to the object level surface structure that gives a global index for the surface, this can be updated as the surfaces are checked. You should

find that this technique makes the surface lists much smaller than object level surface lists. The minimum surface detail that needs to be stored in the surface list is the surface colour as 3-byte size integer values. Transparency level is stored as a byte-sized integer, allowing for 256 levels of transparency. Specularity is handled in the same way as transparency, taking the floating-point value, multiplying it by 255 and storing the result as a single byte integer. The texture ID for a surface is stored as an index into the OpenGL texture objects; once the actual texture IDs are generated, this value can be replaced with the OpenGL value. A surface also contains a flag giving information about whether the surface is luminous, smoothed or double sided.

```
for (i=0; i<obj->m_numsurfaces; i++){
  if (srf->tex){
    for(j=0; j<textotal; j++){
      //Save the texture index
      if (strcmp(gltex[j].name, srf->tex->name)==0) texID=j+1;
    }
  }else{
    texID = 0;
  }
  //Surface details without the name
  ar.Write(&srf->r, sizeof(BYTE));
  ar.Write(&srf->g, sizeof(BYTE));
  ar.Write(&srf->b, sizeof(BYTE));
  byt = (BYTE)(srf->transparency * 255.0f);
  ar.Write(&byt, sizeof(BYTE));
  byt = (BYTE)(srf->specular * 255.0f);
  ar.Write(&byt, sizeof(BYTE));
  ar.Write(&texID, sizeof(GLuint));
  ar.Write(&srf->flag, sizeof(USHORT));
  srf++;
}
```

Compressing motion files

The key to compressing a motion file is storing the channel value as a 2-byte integer value rather than an 8- or 4-byte floating-point value. To do this, we need to iterate through a channel temporarily storing the minimum and maximum values. Since key values can be both positive and negative, we will be use signed integers as the storage medium. For

a 2-byte integer, this gives a range of ±32 767. The aim is to create a scale value for a channel; using this scale value we will adjust each key value so that instead of using floating-point values we can use integers. The scale factor is found using the absolute maximum of the two values we have temporarily stored. For example, if the minimum value for a channel is −123.8 and the maximum value is 32.98, then the absolute maximum is 123.6. We need to scale 123.6 up to 32 767. This is done by taking

$$32\,767/123.6 \ = \ 265.105$$

If the maximum and minimum were 124 932 and −234 578 respectively, then the absolute maximum is 234 578 and the scale factor would be

$$32\,767/234\,578 \ = \ 0.14$$

We save the channel scales as floats at the start of the file. Although saving channel scale values takes 36 bytes, each key value uses 18 bytes rather than 36. A motion file with just three keyframes is already smaller than one stored as straight floats.

When restoring the values we divide each integer value by the scale value for the channel to get the correct world size for that channel as a floating-point value.

Since the motion channels are stored as TCB curves, we need to save the tension, continuity and bias. For most applications, restricting these values to between −127 and +128 will give sufficient accuracy. This is easily achieved by multiplying the values which range between +1 and −1 by 128.

```
if (obj->keytotal < 128){
  byt = (BYTE)obj->keytotal;
  ar.Write(&byt, sizeof(BYTE));
}else{
  sht = ((obj->keytotal & 0xFF)<<8) | 0x80 | (obj->keytotal>>8);
  ar.Write(&byt, sizeof(USHORT));
}
SetChannelScales(scales);
key = obj->keys;
for (i=0;i<obj->keytotal;i++){
  //Write minimum keyframe data
  //int frame mapped to USHORT, top level bit sets linear key
  //double x, y, z mapped to short
  //double h, p, b mapped to short
```

```
//double sx, sy, sz mapped to short
//double tn, bs, ct mapped to byte
sht = key->frame;
if (key->linear) sht |= 0x8000;
ar.Write(&sht, sizeof(USHORT));
WriteShortVector(ar, key->x, scale[0], key->y, scale[1],
                     key->z, scale[2]);
WriteShortVector(ar, key->h, scale[3], key->p, scale[4],
                     key->b, scale[5]);
WriteShortVector(ar, key->sx, scale[6], key->sy, scale[7],
                     key->sz, scale[8]);
byt = (char)(key->tn * 128.0);
ar.Write(&byt, sizeof(char));
byt = (char)(key->bs * 128.0);
ar.Write(&byt, sizeof(char));
byt = (char)(key->ct * 128.0);
ar.Write(&byt, sizeof(char));
key++;
}
```

Strategies for delivering content quicker

If you have experienced the Internet via a dial-up modem, then you will know it can be very frustrating.

For many users this is the way they will see your content. You owe it to them to deliver this content as quickly as possible. We can approach this in one of three ways.

Using loading scenes

The simplest technique is to use loading screens. By keeping loading screens small, the browser will at least be able to display some content. If the loading screen includes game play instructions, then this can keep the user occupied while the actual content downloads. A useful method is to load the main character while the user is reading game instructions. When the main character is loaded you can switch to a scene where the main character can be displayed, often including some animation. This could be used to provide some background to the game while the first environment loads. As the navigation through the 3D environment evolves, you may need to return to the main character scene or the pre-loader if your code detects that resources are not yet available. It is a very

good idea in the design of a game that is intended for Internet distribution to provide cut scenes that use very little additional resources over and above your central character. If you use the strategy of loading this character early, then you can rely on it being there to at least play some trailer-style animation, a few splash titles and the like while your central character struts their stuff.

Displaying lower resolutions before full load

Gif files can be stored where a download adds progressive detail to an image. The user sees a crude image first and as the file continues to load detail is added. This strategy can be used with 3D imagery. If you store a scene so that the first load is bounding boxes and a camera, then you could start to display an indication of the scene with very few bytes of data. The next element in the file could be motion files. Then your bounding boxes can start to move. The human eye can detect form from movement. Take a look at some of the motion capture scenes in Chapter 12; some of these are displayed using just null objects yet the character still shines through. As the scene download continues, the next section will bring in mesh detail, so that your character will have form. Then the background meshes will arrive and finally textures and lights. Although this approach will not work for every game, it does mean the player is viewing animation almost instantly.

Figure 18.3 Progressive refinement.

Using standard libraries

If you are developing a website that features the same characters in several different settings, then you may benefit from the use of standard libraries. Because website data can be cached on the local hard drive, you can load a character once and then know that future loads are likely to place from the cached version of the file. Separately loading background and sound resources means that your character can be involved in many locations without the requirement to download the same data several times. A similar technique can be adopted for any regularly used resources such as fonts, buttons and sounds. If such resources are embedded into each file that uses them and the typical visitor to the site visits three areas, then single file loads will force the user to download the same data three times.

Providing the low bandwidth user with a web experience that is entertaining and holds their attention places heavy demands on the developer. It is well worth adopting some of the methods indicated, otherwise your visitor will click the back button and all the work you have done will never be seen.

Toon3D compression

Toon3D can make use of loading screens and if the user switches to a scene that is not currently loaded then the developer has the option to choose which pre-loading scene to display. Toon3D plays within the browser via an ActiveX control, which takes its data from a single file. This file has a header that informs the ActiveX about the remaining data.

```
T3DX
Number of scenes
[Number of scenes (only read if previous byte has bit 7 set)]
Version
Use scene 1 as load scene
Byte length of scenes (4 bytes * number of scenes)
```

Using this header, the control soon knows how to display the data. If the first 4 bytes are not the ASCII characters 'T3DX', then this is not a compressed Toon3D file suitable for Internet distribution. Byte 5 stores the number of scenes. If bit 7 of this byte is set, then the total number of scenes is calculated using the next byte as the low order byte and the current byte with the bit 7 set to zero as the high order byte. The next byte

gives the version number, so that the code can react to the remaining data. Following version number is a byte-sized flag that currently is only used to indicate whether to use scene 1 as a loading scene. If this is the case, then the control will display the frames in scene 1 proportional to the load of the next scene. If the scene has 100 frames and the next scene is 50 per cent loaded then the control will display frame 50 of this scene. The next bytes are an array of 4-byte integers storing the length of each scene. The ActiveX control can check the size of the data file that is loaded against this array. If the code requires a load of scene 4 and current loading is perhaps only half way through scene 2, then Toon3D calculates the bytes needed to load scene 4. If a load scene is used, then this will display its current frame based on the length of the load scene and the number of bytes remaining to be loaded against the total bytes to load when the load scene was initialized.

Since Toon3D is an ActiveX control intended for use on a web page development environment, Toon3D Creator allows the user to easily create an html page that will embed the control and the data file that is being created. The next section of the function that creates a compressed file creates this html file using the MFC implementation of a text file. MFC has several file types; a standard text file is created and written to using CStdioFile.

```
void CToon3DDoc::OnFilePublish()
{
  CMainFrame *pFrm = (CMainFrame*)AfxGetApp()->m_pMainWnd;
  CStatusBar *pStatus = &pFrm->m_wndStatusBar;
  CString      str = GetPathName(), msg;
  str = str.Left(str.GetLength()-3) + "t3x";
  CString filename = str;
  CFile      file(str, CFile::modeCreate|CFile::modeWrite);
  CArchive   ar(&file, CArchive::store);
  CToon3DScene *scn = sceneList.next;

  char buf[]={'T', '3', 'D', 'X'};
  ar.Write(buf, 4);
  int i, pos;
  USHORT sht;
  BYTE byt, byt2;

  //Count how many scenes there are in the project
  while(scn){ i++, scn = scn->next; }
  //Store number of scenes as one byte integer if total less than 128
```

```
//and two byte integer if total exceeds 128
if (i<128){
  byt = (BYTE)i;
  ar.Write(&byt, sizeof(BYTE));
}else{
  if (i>32767){
    AfxMessageBox("Scene limit exceeded please use less
                   than 32000 scenes");
    return;
  }
  byt2 = i & 0xFF;
  sht = 0x80 | (i>>8);
  ar.Write(&sht, sizeof(USHORT));
}
BYTE ver = VERSION, useloadscene = (BYTE)m_loading;
ar.Write(&ver, sizeof(BYTE));
ar.Write(&useloadscene, sizeof(BYTE));
ar.Write(&i, sizeof(int)*i);//Will be used to store scene Total

scn = sceneList.next;
i = 0;

while(scn){
  ar.Flush();
  scn->Publish(ar, pStatus);
  ar.Flush();
  pos=file.GetPosition();
  file.Seek(10 + sizeof(int)*i, CFile::begin);
  ar.Flush();
  file.Write(&pos, sizeof(int));
  file.Seek(pos, CFile::begin);
  i++;
  scn=scn->next;
}
file.Close();

if (m_html){
  //Now write an html file
  CString name;
  str=GetPathName();
  pos=str.Find('.');
  if (pos==-1){
    name=str;
```

```
}else{
  name=str.Left(pos);
  str=name+".html";
}
pos=name.ReverseFind('\\');
if (pos!=-1) name=name.Right(name.GetLength()-pos-1);
CStdioFile htmlFile(str, CFile::modeCreate|CFile::modeWrite);
htmlFile.WriteString("<html>\n<head>\n");
htmlFile.WriteString("<meta http-equiv=\"Content-Type\"
                      content=\"text/html; charset=iso-↵
                      8859-1\">\n");
htmlFile.WriteString("<meta name=\"Author\" content=\"Nik
                      Lever\">\n");
htmlFile.WriteString("<meta name=\"keywords\" content=\↵
  "toon3d,
    games, animation, multimedia, Catalyst Pictures\">\n");
htmlFile.WriteString("<meta name=\"description\" content=\↵
  "Toon3D is a 3D game creator. It is designed to enable \n");
htmlFile.WriteString("            animators to create 3D games
            suitable for fast Internet downloads.\">\n");
str.Format("<title>%s</title>\n", name);
htmlFile.WriteString(str);
htmlFile.WriteString("</head>\n");
htmlFile.WriteString("<body bgcolor=\"#000000\" text=\↵
  "#FFFFFF\">\n");
str.Format("<p><object id=\"%s\"\n", name);
htmlFile.WriteString(str);
htmlFile.WriteString(" classid=\"clsid:B65948FE-FB4B-11D3-↵
  ABB2-0020186539CF\"\n");
htmlFile.WriteString(" codebase=\"http://toon3d.com/files/↵
  toon3d.cab#version=1, 0, 1, 6\"\n");
str.Format(" align=\"baseline\" border=\"0\" width=\"%i\"↵
  height=\"%i\">\n", m_width, m_height);
htmlFile.WriteString(str);
str.Format(" <param name=\"ToonFile\" value=\"%s.t3x\">\n", ↵
  name);
htmlFile.WriteString(str);
htmlFile.WriteString(" Toon3D is an ActiveX control suitable ↵
  for Windows95/98/2000 and NT platforms.\n");
htmlFile.WriteString(" It works best with graphics cards that ↵
  support OpenGL acceleration.\n");
```

```
    htmlFile.WriteString(" If you see this text then the control has ↵
      not installed. This could be\n");
    htmlFile.WriteString(" because you are not using Internet ↵
      Explorer or because you have high\n");
    htmlFile.WriteString(" security settings that exclude ActiveX ↵
      controls. If this is set correctly\n");
    htmlFile.WriteString(" and you still experience problems then ↵
      check that the files OpenGL32.dll\n");
    htmlFile.WriteString(" , Glu32.dll, and MFC42.dll are in your ↵
      Windows\\System folder.\n");
    htmlFile.WriteString(" </object>\n</p>\n</body>\n</html>");
    htmlFile.Close();
  }
  CPublishDlg dlg;
  dlg.m_filename=filename;
  dlg.m_html=m_html;
  dlg.m_width=m_width;
  dlg.m_height=m_height;
  dlg.DoModal();
  pStatus->SetPaneText(2, "Current movie published");

}
```

Showing content in the browser

ActiveX controls provide a useful way of extending the functionality of the browser. Using Visual C++, an ActiveX control is easily created by starting a project using the appropriate settings. An MFC ActiveX control extends the *COleControl* class to add specialist functionality. One feature of ActiveX controls is that they can be provided with data from a URL. The source code for Toon3D includes all the source for the ActiveX control that can be embedded into an html page. There are many useful books and Internet-based resources to help extend your knowledge regarding ActiveX controls. In this section we will look at how ActiveX controls can load data over an Internet connection.

The Toon3D ActiveX control uses an MFC class called *CCachedData-PathProperty*. This class does most of the work for you. A member variable of the Toon3D ActiveX control *m_ToonFile* is a *CCachedData-PathProperty* class. This class can access the control that is using it by referencing the member function *GetControl*. In this short code snippet, we access the control in order to call functions that indicate to the control the state of the loading process.

Figure 18.4 Using a loading screen.

A load is initialized when the bscfFlag has the BSCF_FIRST-DATANOTIFICATION bit set. If this is true then the control is informed by calling the control's member function *ToonFileAvailable*. Intermediate calls use *ToonFileLoading* and the final call *ToonFileLoaded*.

```
void CToonFileProperty::OnDataAvailable(DWORD dwSize, DWORD ↵
  bscfFlag)
{
  CToon3DAXCtrl *t3d=(CToon3DAXCtrl*)GetControl();
  CCachedDataPathProperty::OnDataAvailable(dwSize, bscfFlag);

  if ((bscfFlag & BSCF_FIRSTDATANOTIFICATION) != 0){
    t3d->ToonFileAvailable();
  }
  if ((bscfFlag & BSCF_INTERMEDIATEDATANOTIFICATION) != 0){
    t3d->ToonFileLoading();
  }
  if ((bscfFlag & BSCF_LASTDATANOTIFICATION) != 0){
    t3d->ToonFileLoaded();
  }
}
```

When a new *ToonFile* is available we must clear any existing data. The control stores all the data inside a single variable, '*m_toon3d*'. This is a *CToon3Ddoc* class, which has a *Clear* function that takes care of deleting any existing data.

```
void CToon3DAXCtrl::ToonFileAvailable()
{
  toon3d.Clear();
}
```

Most of the work of a data file load takes place within the function call *ToonFileLoading*. The purpose of this call is to inform the control of the current load status, so the user can be kept informed of the progress. If a control has just cleared the document file, then the 'm_init' member variable will return FALSE. The first section of this function tests for this. If the document is not initialized then we send the current *ToonFile* back to the start and attempt to initialize the document using this file. Initialization will be successful if the entire file header is successfully parsed, that is from 'T3DX' up to all the scene section lengths. If this is the case, then the control will know how to handle the remaining data and can be regarded as initialized. One feature of the Initialize call is the setting of the scene that is currently loading. This information is stored in the member variable *m_sceneLoading*.

The next section of the function is a loop that checks the current data file position against the bytes required for the loading scene. If we have sufficient bytes to initialize a scene then the current file position is set to the start of the current scene and the scene is initialized. If the control wants to display this scene then it is set as the current movie scene; if not, then loading continues and the display scene remains set to the previously displayed scene. If scene initialization was successful then the member variable *m_sceneLoading* is incremented. If this exceeds the total number of scenes in the file then we can set the fully loaded member variable m_loaded to TRUE.

If the control cannot display the required scene then we update the load screen using either scene 1 if this is a load screen or the internal load screen. Toon3D has its own loader that is used if scene 1 is not set as the load screen.

```
void CToon3DAXCtrl::ToonFileLoading()
{
  //Set the progress bar
  CToon3DScene *scn;
```

```
int pos = m_ToonFile.GetPosition();
TRACE("CToon3DAXCtrl::ToonFileLoading %i\n",pos);

//Attempt to initialise the document
if (!toon3d.m_init){
  CArchive ar(&m_ToonFile.m_Cache, CArchive::load);
  m_ToonFile.m_Cache.SeekToBegin();
  if (!toon3d.Initialise(ar)){
  m_ToonFile.m_Cache.SeekToEnd();
  return;
  }
  m_ToonFile.m_Cache.SeekToEnd();
}

//Process the loading file
while (pos >= toon3d.m_sceneSize[toon3d.m_sceneLoading]){
  scn = toon3d.sceneList.Index2Scene(toon3d.m_sceneLoading);
  if (scn){
    CArchive ar(&m_ToonFile.m_Cache, CArchive::load);
    if (toon3d.m_sceneLoading){
      m_ToonFile.m_Cache.Seek(
          toon3d.m_sceneSize[toon3d.m_sceneLoading-1],↵
            CFile::begin);
    }else{
      m_ToonFile.m_Cache.Seek(
          10 + toon3d.m_sceneTotal * sizeof(int), CFile::begin);
    }
    if (scn->Load(ar,toon3d.m_ver)){
      TRACE("CToon3DAXCtrl::ToonFileLoading Scene %i loaded\n",
          toon3d.m_sceneLoading);
      //Flush the Archive and the file to ensure that position is
      //correctly set
      m_ToonFile.m_Cache.SeekToEnd();
      if (!playing && toon3d.m_sceneLoading >=↵
        toon3d.m_sceneIndex){
        TRACE("CToon3DAXCtrl::ToonFileLoading Playing↵
          initialised\n");
        scn=toon3d.sceneList.Index2Scene(toon3d.m_sceneIndex);
        toon3d.SetMovieScene(scn);
        if (toon3d.m_useloadscene && toon3d.m_sceneIndex==0){
          playing=FALSE;
          toon3d.m_sceneIndex=1;
```

```
        }else{
          playing=TRUE;
        }
        InvalidateControl();
      }
    }
  }
  toon3d.m_sceneLoading++;
  if (toon3d.m_sceneLoading == toon3d.m_sceneTotal){
    toon3d.loaded=TRUE;
    break;
  }
}
//Update display as loading proceeds
if (!playing && toon3d.init){
  if (toon3d.m_useloadscene){
    if (toon3d.m_sceneLoading){
      //Must have loaded scene 1
      double loadpos = (double)(pos-toon3d.m_loadStart) /
          (double)(toon3d.m_sceneSize[toon3d.m_sceneIndex] -
              toon3d.m_loadStart);
      int frame = (int)(loadpos *↵
        (double)(toon3d.sceneList.m_sceneEnd -
              toon3d.sceneList.m_sceneStart) +
              toon3d.sceneList.m_sceneStart);
      TRACE("CToon3DAXCtrl::ToonFileLoading m_sceneIndex %i,↵
        loadpos
              %4.2f, frame %i (%i,%i)\n",
              toon3d.m_sceneIndex,loadpos,frame,
              toon3d.sceneList.m_sceneStart,
              toon3d.sceneList.m_sceneEnd);
      toon3d.SetFrame(frame);
      InvalidateControl();
    }
  }else{
    //Use internal load screen
    double newX = ((double)pos /
        (double)toon3d.m_sceneSize[toon3d.m_sceneLoading])
            * load_len + load_min;
    bar_pts[1*3] = newX;
    bar_pts[2*3] = newX;
    InvalidateControl();
  }
}
}
```

Real-time 3D Character Animation with Visual C++

Toon3D embeds both content and interactive scripting into a single document. This is one approach that can work effectively. Another approach is to use compression for the content while using XML (extended mark-up language) for the scripting. One benefit of using XML is that the scripting is a text file that can be easily edited. XML provides all the necessary tools to take the Internet to a higher level of interactivity and if Web3D is an area of interest then it is well worth getting your head into an XML primer to get up to speed on this technology.

Summary

At the time of writing, May 2001, Web3D promises to be the next big thing on the Internet. Hopefully, armed with your new knowledge you can contribute to supplying users with exciting new fast-moving images. The keys to successful Internet distribution are good development tools and bandwidth-friendly compression.

So that completes your initial journey through the wonderful world of real-time character animation programming. I hope it has whetted your appetite to learn more. I have tried to present the material in the most approachable way possible. Unfortunately, there is a great deal to learn to get even an overview of the subject. You should find the source code supplied a useful place to learn more and the info section will provide links to more information.

Appendix A:
Using Toon3D Creator

Overview

Toon3D is an interactive 3D development tool that enables you to create games, interactive demos and animations for distribution on the web. It can import 3D models and animation, letting you give models behaviours so they can react to collisions and script commands. Toon3D also has keyframing capabilities so you can develop all your animation within the program, and it also supports multiple lights, 2D text, sound and camera moves.

Figure A.1 The Toon3D Creator application.

The most impressive thing about Toon3D is that it makes it possible to produce 3D interactive content for the Internet at extremely low file sizes. An example of this can be found on the demos page at toon3d.com, where a 1-minute demonstration video showing how to replace a printer cartridge has a file size of only 29K.

At present, Toon3D only supports Newtek Lightwave models and scenes. If you develop your 3D models and animation in another package, then you will need to export them in Lightwave format if available. Multiple file type support is planned for future releases of Toon3D.

The basic philosophy behind how you would develop an interactive movie in Toon3D is as follows:

- Develop all your models in Lightwave (or use existing ones).
- You could also create all your animation in Lightwave as well.
- Import all the models/animation into Toon3D.
- If you imported just models then you would set up parent hierarchy and create your keyframe animation in Toon3D:
 - If, for example, you were developing a game where you controlled a walking character who could also fly, you would create an animation loop for its walk (let's say frames 1–16) and a loop for its flying (frames 17–29). You would build up a 'library' of animations in this way, which could then be called on by the user or events that happen in the movie.
- You can also develop keyframe morphing in Toon3D.
- To develop realistic 3D characters you can use the Bendy Points plug-in, which allows you to deform a seamless single mesh object with control objects.
- You can introduce collision boxes which mark out collisions in your 3D environment.
- Once your animations are complete you would convert your main character object into a Toon. You could then assign them Toon Actions, which relate to the animation segments you had developed. These Actions can then have sounds attached to them.
- You could then set your Toon to be under user control so the user can move, rotate and change their Action with keyboard and mouse clicks.
- Set up collisions so the Toon object would react when they collided with other objects in your world.
- Write scripts so interactive gameplay could be developed.
- Set up lights, camera and text to enhance your 3D movie.
- Publish it to a web page so it can be viewed on the Internet.

This is just a basic framework of how you might develop an interactive 3D movie or game.

As well as Toon3D's power as a game development tool, it can also be used to produce free-running 3D animations. The synchronized sound facility in Toon3D means that you can effectively produce self-contained videos that play back in time with their embedded sound. This can be achieved at a fraction of the size of digital video at the comparative resolution.

Layout and view

The Toon3D working environment is split into three main windows, **Control**, **Scripts** and **Stage**.

Control Window

The Control Window contains all the Objects, Toons, Text, Collision Boxes, Sounds, Lights, Camera and User Views in the current project. The view works in the same way as the Windows Explorer with expandable and collapsable lists of controls. In the objects lists, child objects appear under their respective parents and in the Toons list, each Toons action appears under the respective Toon.

Left clicking on a control makes it the active selection, and all changes such as scale, position and rotation made in the Stage Window will relate only to the selected control.

Right clicking on an active control will reveal an options menu that lists all the possible actions and properties

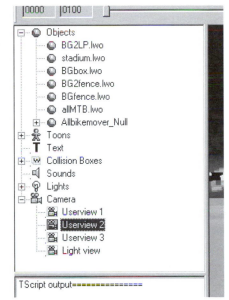

Figure A.2 The Control Window.

that can be set to that particular control. All these options can also be found under the main menu headings for the particular item (i.e. Object, Toon, etc.).

Script Window

The Script Window is used as a debugging tool where you can send data to it during testing of your project. This is done using Toon3D's own scripts

Figure A.3 The Script Window.

library TScripts. Variables and Toon property values, as well as plain text, can be sent to the Script Window using the Put method, enabling debugging of your projects.

Stage Window

The Stage Window shows a real-time solid OpenGL perspective view of the current project. Up to three user views can be set to make it easier to work with models and animation, and the view will switch from solid to wireframe mode when manipulating pivot points.

Left and right clicking and dragging in the stage window will affect the currently selected item according to whether scale, rotation or move are selected on the toolbar.

Figure A.4 The Stage Window.

Real-time 3D Character Animation with Visual C++

You can view the Stage Window full screen:

To view full screen

1 **View. . .Full Screen.**

2 **To return to normal viewing press Esc.**

Toon3D allows you to test your movies as you develop:

To test Toon3D movie

1 **Click on the Test Toonfile button on the Toolbar.**

OR

1 **View . . . Test ToonFile.**

2 **To stop testing click the Stop button.**

Toolbar

Toon3D has all the tools for viewing your project and manipulating items on the main toolbar. The toolbar is split into the **File Tools**, **Player Controls**, **Timeline** and **Modify Controls**.

Figure A.5 The toolbar.

File Tools

The first three tools represent the standard windows functions of **New**, **Open** and **Save** respectively.

The fourth icon is to **Publish** your movie to a web page. See 'Preferences' for more details.

Figure A.6 The file bar.

Player Controls

◄| Go to First Frame

◄◄ Go to Previous Keyframe of selected object

◄ Go to Previous Frame

■ Stop

► Go to Next Frame

►► Go to Next Keyframe of selected object

▷ Play

►| Go to Last Frame

↰ Loop (toggle)

Timeline

The two values to the left of the timeline represent the global movie **Start** and **End frames**. To set these go to File. . .Preferences.

Figure A.7 The timeline.

Dragging the pointer along the timeline will go forwards and backwards, the **current frame** being displayed immediately to the right of the bar.

You can also jump to a specific frame by pressing the **f key**, then entering the frame number.

The two numbers to the right of the current frame display the Frame Range Start and End frames. The timeline pointer extends to between these two values, which default to the global scene length when the program is first started. These frame range values are set to Toon Action Start and End frames when the Toon is highlighted in the Control Window, or can be set manually.

Setting the frame range

1 **View. . .Set frame range**

2 **Enter Start and End frames.**

Now, how do you modify Objects, Toons, Lights, Text and Camera and Userviews?

Modify Controls

The modify controls allow you to move, rotate, scale and size items in the Stage Window:

1 **Select the item you wish to modify in the Control Window.**

2 **Click on a modify icon:**

Move – deselect **X**, **Y** or **Z** to limit axis movement

Rotate – deselect **H**, **P** or **B** to limit rotational axes

Scale – deselect **X**, **Y** or **Z** to limit axis scaling

Size – modifies the size of the object in all axes

3 **Click and drag the mouse in the Stage Window:**

Left Mouse Button	Left and Right	**X** axis or **H**eading
	Up and Down	**Z** axis or **P**itch (**Y** axis for Text)
Right Mouse Button	Up and Down	**Y** axis or **B**ank (Size for Text)

You can also enter numerical values by pressing the **n key** when the Stage Window has focus. This will bring up a dialog box where you can enter individual values, depending on which modify icon is active.

Positioning and rotating objects accurately often involves regularly changing your viewing angle. Find out how you can set up your user views here.

Working on Toon Actions

You can work on a Toon Action in isolation:

1 Select the Toon Action to modify in the Control Window.

2 ⚄ **Click on the Action modify icon**

Only the Toon is displayed in the Stage Window and all changes made will affect the Toon Action.

Preferences

To set Toon3D Preferences

1 File. . .Preferences.

Publish Settings:

JPEG Quality – sets the quality of any JPEG surface textures used in your project in the final movie. Setting the quality to a high level will result in better reproduction of the image texture but at the expense of smoother playback, and vice versa.

Create HTML doc – will generate an HTML file into which your movie will be embedded when you publish your project. The HTML document will include the codebase data needed so the ActiveX Toon3D plug-in required to play back Toon3D files will be downloaded to the user's browser if it's not already installed.

Other preferences you can set include:

- **Set Background Colour** -- sets the colour displayed behind all the objects in your project.
- **Disable Textures** – disables all image textures applied to objects in your project. This is effective in both creation mode and in the final published movie.
- **Autokey Create** – determines whether to create a key automatically at the current frame when you modify an item in the Stage Window. With Autokey Create turned off you must apply Create Keyframe to set a key at a particular frame.
- **Scene Start and End** – sets the global scene start and end frames of your project.

- **Fps** – the playback rate in frames per second of the movie. Toon3D will attempt to play back the movie at this rate, but this is largely dependent on the amount of polygons in your movie and the speed of the user's computer and graphics hardware.
- **Sync Sound** – setting this will force the movie to play back at the frame specified in the Fps box. This is used so you can produce standalone animations that have no interactive elements to them. Setting Sync Sound will play the first sound file in the sounds list at the beginning of the movie and will maintain a playback rate so the animation can be synchronized accurately with the accompanying sound.

Grid size

1 **World. . .Grid Size.**

2 **Grid Size – the X and Z size of each square on the grid.**

3 **Grid Number – the number of squares in the grid.**

Setting the Grid Size affects the rate at which items move in the Stage Window with the mouse. Increasing the grid size increases the distance the item moves per mouse move, and vice versa.

Importing objects and animation into Toon3D

Importing Lightwave objects

File. . .Import Lightwave Object

At present, you can only import standard Lightwave objects (.lwo) into Toon3D. Geometry and surface colour and image texture information for the object are maintained. Procedural textures applied in Lightwave are not supported, however.

 Note: three-sided polygons will be smoothed in Toon3D, and four-sided polygons not smoothed. With polygons that are more than four-sided, Toon3D will only use the first four vertices to create the polygon. So, keep your models' polygons to four or less sides, and if you want your objects to be smoothed triple them to three-sided polygons before importing to Toon3D.

Importing Lightwave scenes

File. . .Import Lightwave Scene

When you import a Lightwave scene (.lwo) into Toon3D, all the objects and parenting information, and keyframe animation are imported. If Bendy Points has been applied in the scene, this is also imported and applied to all relevant objects.

Object properties

Setting object properties

1 **Select the object in the Control Window.**

2 **Right click and select Properties.**

3 **Select Use Textures to make image surface textures visible.**

4 **Select Hide to hide an object in the Stage Window. This is set automatically when the object is assigned as a control to a Bendy Point object.**

5 **Choose a 'Parent' for the object.**

Pivot points

To position the pivot point of an object

1 **Select the object in the Control Window.**

2 ⛶ **Click on the Pivot Point icon on the Toolbar**

The Stage Window changes to wireframe mode and the pivot point of the selected object is centred in the view. It is generally good practice to set up user views from the side and top to make it easier to accurately position the pivot point.

3 **Selecting the Move icon enables you to move the pivot point by dragging in the stage window with the left mouse button for X and Z, and the right mouse button for moving in the Y.**

Limiting the axis by unchecking them on the toolbar will help control the positioning of the pivot point. Selecting the rotation icon will rotate your view only.

Parenting

To assign an object's parent

1 Select the object in the Control Window.

2 Right click and select Properties.

3 Select the parent object from the Parent dropdown list.

Child objects will appear hierarchically under the Parent objects in the Control Window.

Morphing

Toon3D allows you to morph between multiple objects that comprise the same array and number of points. To do this you must assign a Morph Controller to the object.

To create a Morph Controller

1 Select the object you wish to morph from in the Control Window.

2 Right click and select Create Morph Controller.

A morph controller can be thought of as a point displacement plug-in which uses the selected object as the base control object. An object can have only one morph controller. To be able to morph between other objects we need to **Add Morph Objects**:

3 Select the Morph Controller and right click and select Add Morph Object.

This brings up an Import Lightwave object dialog box where you can select objects to act as morph targets. Each object must comprise the same number of points or Toon3D will generate a warning.

To morph between objects

1 Select a morph object in the Control Window.

2 Click and drag to the right in the Stage Window and the morph amount increases, the value being displayed in the status bar at the bottom of the window.

Keyframes are created in the morph controller, not the morph object or the base object. You can set the morph levels of multiple morph objects on a keyframe.

Bendy Points

Bendy Points is a point manipulation tool that allows you to generate single mesh objects that can be manipulated by a set of control objects, thus enabling you to create realistic character animation. There is a Lightwave plug-in for Bendy Points which you can download. Tutorials and documentation come with the Bendy Points plug-in, which is worth checking out before you use it extensively in Toon3D.

Bendy Points can either be applied in Lightwave and then imported as part of the Lightwave scene file, or applied directly in Toon3D, the latter method being a much simpler process. If you import a scene with Bendy Points applied, then the affected objects are automatically assigned correctly as either a control object or the target object – no user intervention is required.

To set up Bendy Points in Toon3D

1 **Set up the parenting for the control objects.**

2 **Select the target object which comprises the full mesh of control objects.**

3 **Right click and select Make Bendy.**

4 **Select the base object. This is the parent of all the control objects.**

The target object is then assigned and all child objects below are set as control objects. Only the target object comprising a single mesh will now be visible, all the control objects become invisible.

Animation

Toon3D has all the tools you need to animate your objects. It uses the standard method of creating keyframe splines for each object, with control over the spline curves using Tension, Bias and Continuity at the keyframe.

Before delving into how to create keyframe animation, it is worth getting familiar with all the tools on the Toolbar and Modify Controls.

Keyframing

The first thing to decide before doing any keyframe animation is whether to turn on Autokey Create or not. If Autokey Create is turned on then every change performed to an object on a frame will be updated automatically and the frame set as a keyframe. With it turned off, you must create a keyframe manually.

Turning Autokey Create on

1 Select File. . .Preferences.

2 Click on Autokey Create.

Even with Autokey Create on, you can still opt to Create Keyframe, giving you the flexibility of assigning keyframe characteristics, and creating the key on other frames.

Creating keyframes

1 Set the current frame to the frame you wish to create a keyframe on (this is essential if Autokey Create is on, not so if it's off).

2 Select a control – i.e. an object, Toon, text object, light or camera.

3 Move, rotate, scale or size to desired position.

If Autokey Create is on, then you've created a keyframe at the current frame for the selected control. If Autokey Create is off, or you wish to adjust keyframe characteristics or create the keyframe on another frame, go to step 4.

4 Select Create Keyframe from the item's menu (right click on the control, or press Enter when the Stage Window has focus).

5 Select a frame for the key – the default is the current frame.

6 Selecting linear will create a straight line characteristic at the keyframe, i.e. the animation will go through the keyframe with linear motion – no acceleration or deceleration at the keyframe.

7 Dragging the Tension, Continuity and Bias sliders will affect the keyframe characteristic:

Tension – speed at which an item approaches and travels through a keyframe. High values slow it up to create an ease-in, and low values a speed-up or ease-out.

Continuity – determines the shape of the transition at a keyframe. High values give a wider transition and low values a sharper transition (sudden change in motion).

Bias – makes the spline path lean to one side of the keyframe. Used to give the feeling of anticipation at a keyframe.

8 **Create key for all descendants will generate a keyframe in all the child objects of the selected item.**

That's it for creating keyframe animation!

Deleting keyframes

1 **Move the current frame to the keyframe you wish to delete.**

2 **Select the item you wish to delete the keyframe for.**

3 **Right click on the item and select delete keyframe (or press delete when the Stage Window has focus).**

If you use the delete key for deleting keyframes, ensure the Stage Window has the focus by clicking in the window first.

Creating Toons

A Toon is basically an object controller that we can assign behaviours to and can be under user control. This means that the object can react to collisions and script commands, by triggering different animation sequences and manipulation of the object's properties such as position, etc.

You can have multiple Toons in a project but only one can have user control at any one time. This is selectable in script at runtime.

Creating a Toon

1 **Select the Toon icon in the Control Window and right click and select Create Toon.**

2 **Select the object you wish to control as a Toon from the drop-down list.**

If an object was a base level parent, or a Bendy Point target object, then it would normally be the one assigned as a Toon. All child and control objects would be assigned to the Toon.

To develop interactivity for a Toon you must assign it behaviours.

Collision boxes

Collision boxes are bounding rectangles that are used to trigger behaviours in Toon when they intersect other collision boxes. They have no orientation, only position and size.

There are two types of collision boxes in Toon3D, **Toon collision boxes** and **World collision boxes**.

Toon collision boxes

When you create a Toon, a collision box that is the same size and position as the bounding rectangle of the Toon base object is created by default. A Toon's collision box is always relative to the Toon's position and scale (i.e. it always moves and scales with the Toon).

The relative position and scale are set by selecting the collision box and scaling and positioning in the Stage Window as you would an object or any other control.

To reset the collision box to the default values, right click it and select Reset.

World collision boxes

1 **Select Collision box in the Control Window and right click and select Create Collision box.**

Positioning and scaling a world collision box follows the same process as for objects. The usual use of a world collision box is to set a collision area around a static object.

Deleting collision boxes

1 **Select Collision box in the Control Window and right click and select Delete Collision box.**

Real-time 3D Character Animation with Visual C++

To help you see where all the collision boxes you have in your movie are:

View. . .All collision boxes.

Actions

Actions are basically animation sequences of the Toon object combined with a sound. By assigning segments of a Toon object's keyframe animation to an Action, you can build up a library of such Actions which can then be called upon by collision detection and scripts.

Figure A.8 Actions dialog.

Adding Actions

1 **Right click on the Toon object and select Edit Behaviours.**

2 **The Actions tab is the first one displayed in the dialog box.**

3 **Click Insert to create a new Action.**

4 **Give the Action a Name, Start Frame and End Frame in the boxes.**

The Start and End frames relate to the Toon objects' keyframe animation. For example, if you had created a Toon object who had a walk animation that ran from frames 1 to 24, then these would be the start and end frames for the action you would probably call Walk.

5 Choose whether you want the Action to loop or not, and enter the first frame of the loop in the Loop frame box.

If Loop action is selected the animation will play from the Start to the End frame, then return to the Loop frame and continually loop between the Loop and End frame. It will continue to loop unless stopped by script or another behaviour.

6 Select a sound to play from the dropdown list if required.

The selected sound will play every time the Action is called, and will loop with the Action if Loop action is selected.

7 Select Enable keyboard control to allow the Action to be controlled by the user.

If you enable keyboard control, you must set the user control in the Control tab.

8 Enter position and rotation vectors in the boxes provided if required.

The values entered in these boxes will move or rotate the Toon by the specified amount on each new frame in the movie when it is performing this Action.

9 Click Apply to enable the Action.

You can delete an Action using the delete button, and move between multiple actions using the Prev and Next buttons.

You can have multiple Actions that use the same frame segments. For example, you might want to use the same walk cycle for an object but change the sound file if it was walking on grass or snow.

User control

Toons in your project can be under user control via the keyboard. You can control a Toon's movement and rotation, as well as which Action to perform upon a designated key press.

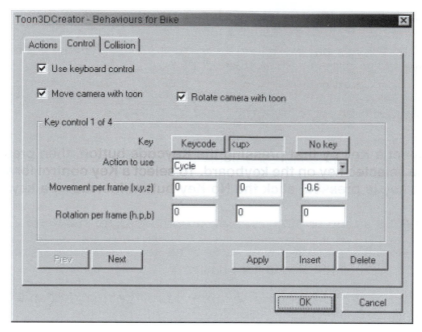

Figure A.9 Control dialog.

The basic theory behind controlling Toons with the keyboard is assigning Actions to be called upon certain keys being pressed. As well as Actions being called, you can also modify a Toon's position and rotation upon key presses.

You can set up control for a Toon then disable it by unchecking the Use keyboard control. You can then switch user control on or off for a Toon using scripts at runtime.

Controlling a Toon

1 Right click on the Toon object and select Edit Behaviours.

2 Select the Control tab and select Use keyboard control.

3 If you want the camera to follow the Toon's movement then select Move with Toon.

4 If you want the camera to follow the Toon's rotation then select Rotate with Toon.

Steps 3 and 4 effectively parent the camera to the Toon. The position and orientation of the camera is defined by its position and orientation at

frame 0. All other keyframes in the camera are ignored when it is under Toon control.

The Camera's parenting can be switched by scripts at runtime. By default, the last Toon in your Toon list that has **user** and **camera** control is assigned initial control of the camera in your movie.

5 Click Insert to create a new Key control.

6 Select a Key by first pressing the Keycode button, then pressing the selected key on the keyboard. To select a Key control for when No key is pressed, click the No Key button instead of a key.

It's a good idea to give a Toon a **No Key** pressed control, which can be thought of as a default action which occurs when no key is currently pressed.

7 Select an Action to call when the key is pressed from the drop-down list of Actions available to the Toon.

If you choose **No Action change** then the Action of the Toon will remain in its current state and will not change. This is useful when multiple keys are pressed.

8 Next you can set how much to move and rotate the Toon when the key is pressed. The values you enter in the boxes relate to movement in the X, Y, Z axes and H, P, B rotation, and are based on metres/degrees per frame.

If no movement is required then leave all values at 0. The Actions and movement/rotation applied will occur only while the key is pressed. Thus, to maintain the key control you must hold the key down.

If multiple keys are pressed then the movement and rotation of the Actions called by the key presses are combined. This means if you were to control a Toon's movement using the arrow keys you could perform movement in more than one axis by holding down two or even three keys. If you do this then the Toon will perform the first Action in the Action's list.

9 To create the Key control click Apply.

You can delete a key control using the **delete** button, and move between multiple actions using the **Prev** and **Next** buttons.

Collisions

In order for the Toon to react to the 3D environment around it, detection of collisions can be set up. Collisions can occur between another Toon, a static collision box, a specified value in the *Y*-axis or an invisible bounding box. The collision is determined by the bounding boxes of the Toon intersecting the bounding box of the collision item or values. The result of a collision is to change the Action of the Toon.

Figure A.10 Collisions dialog.

There are two states for detecting collisions, **Global collisions** and **Action collisions**. A Global collision can occur when the Toon is in any Action state, i.e. at all times. An Action collision is only detected when the Toon is performing a specified action. The process for adding both types of collisions is the same.

Adding collision detection

1 **Right click on the Toon object and select Edit Behaviours.**

2 **Select the Collisions tab.**

3 a. If you want the collision to be detected at all times leave the Global Collision Box checked.

OR

3 b. If you want the collision to be detected only when a specific Action is being performed, uncheck the Global Collision box and then choose an Action from the dropdown list.

4 Click Insert to add the collision and give it a name in the box provided.

5 Choose the type of collision to detect:

Y equals zero – detects whether the Toon's *Y* position value is equal to or less than zero.
Minimum position – minimum *X, Y, Z* values that the Toon can reach.
Maximum position – maximum *X, Y, Z* values that the Toon can reach.
Toon – detects a collision with another Toon.
Collision Box – detects a collision with a static collision box.

6 Set the Glance angle.

The **Glance angle** can help prevent the scenario when you are travelling almost parallel to a collision box and you keep generating an unwanted collision. Setting a low Glance angle (typically 5–10°) will cause the Toon to travel parallel to the collision box without generating the collision, unless an Action is specified in the Less than glance angle box. Setting the Glance angle to 0 will always generate a collision, setting it to 90 will never generate a collision.

The **Glance angle** feature in Toon3D only works with objects travelling in the −*Z* direction. If you wish to use the glance angle feature, orientate your environment so the Toon using the glance angle collision moves mainly in the −*Z* direction.

7 Select an Action to perform upon detection of the collision when Less than the glance angle from the dropdown list, if required.

If you select an Action for a Less than glance angle collision then the Toon will perform this Action and not be redirected to travel parallel with the collision box.

8 Select an Action to perform upon detection of the collision when Greater than the glance angle from the dropdown list.

This is the Action to perform when a normal collision occurs with the collision box.

9 Click Apply.

You can delete a Collision using the **delete** button, and move between multiple collisions using the **Prev** and **Next** buttons.

Text

Toon3D has the facility to create text objects in your project. You can simply create a static text object or you can write values to the text object using scripting. The text object can also be keyframed in its position, size, text and colour.

Adding a text object

1 Right click on Text in the Control Window and select Add text object.

2 Name the text object by left clicking it in the Control Window.

If you want to write information to the text object it is important that you name it, as the name is how scripts identify and pass data to the object.

A text object only appears as a 2D object so can only be positioned and sized in the *X-* and *Y-*axes:

3 To position the text left click and drag it to the desired location.

4 To size the text right click and drag horizontally to desired size.

5 To reset the position and scale (0,0 and 100 per cent) right click the text object and select reset.

Text Properties

1 Right click on Text object and select Properties.

2 In the dialog box you can type in the actual text required, select a font and a colour for the text.

The font you select will need to be installed on the user's machine in order for it to be displayed correctly. It is thus a good idea to select common fonts such as Arial, Courier or Times New Roman, etc.

You can add keyframes to a text object as you would a normal object. You can also change the text and colour of the text object on a keyframe. This will cause it to change text or colour when that keyframe is reached – it won't 'tween' these properties from the previous keyframe.

Sound

You can import sound into Toon3D in the Windows Wave format .wav. In order for the sound files to publish they must be PCM with a sampling rate of 44.1 kHz and 16-bit resolution. You can import sounds with other sampling frequencies and they will play inside Toon3D Creator, but won't play in your published movie.

If you import stereo sound both channels are stored separately, so the file size of the sound file is doubled. Unless it's necessary for the movie, it's better to import sound in mono format to reduce the final movie size.

Sounds can be linked to Toons via Toon actions and can also be controlled by scripts.

Adding sound

1 **Select Sounds in the Control Window and right click and select Add Sound.**

2 **To play a sound right click on it and select Play, and similarly to stop it select Stop.**

3 **If you want a sound to loop continuously select Loop from the right click options.**

When you set a sound to loop it will always loop when attached to a Toon Action or played from scripts. If the Toon Action is set to loop then the sound will be played on the first frame of the loop. If the sound is set to loop then this will cause it to be interrupted when the Action loops.

A Toon can play only one sound at a time. If you have different sounds on Toon Actions then a change of Action will cause the outgoing Action sound to stop and the incoming Action sound to play.

4 You can rename a sound by left clicking on the name then entering the new name.

5 You can replace sounds by right clicking and selecting Replace.

If you rename or replace a sound file, all instances where it is attached to a Toon Action are updated automatically. However, if you rename a sound, or replace it with a sound of a different name, you will have to update any script references to the sound.

Lights

You can set up multiple lights in a Toon3D movie. The three types of light you can add are **Distant**, **Spot** and **Point** lights. You can also set a global **Ambient** light level in the movie.

Lights can be parented and have keyframes in your lights position and rotation, and you can also keyframe the diffuse level of a light to fade between different colours.

Adding lights

1 Select Lights in the Control Window and right click and select Add Light.

2 You can rename a Light by left clicking on the name then entering the new name.

Setting the Ambient light level

1 Right click the light and select Properties.

2 Click on the Ambient button and choose a colour.

The Ambient level is global to the whole scene and represents the light level where no light is being cast from the main movie lights. The default colour that is set is usually fine for most scenarios.

Selecting a Light type and its Properties

1 Right click the light and select Properties.

2 Select either Distant, Point or Spot.

Distant – a distant light simply radiates light in a specific direction, like the sun. The position of a distant light doesn't alter its effect, only its orientation is taken into account.

Point – a point light radiates light in all directions from its source, like a light bulb.

Spot – a spot light radiates light in a specific direction from its source. You can also set the 'spread' or cone angle of a spotlight.

3 **To set the cone angle of a spotlight, type a value in degrees in the box.**

4 **To set the Diffuse colour, click on the Diffuse button and choose a colour.**

The diffuse colour is the colour the light will cast in scene. This can be set on keyframes so the colour can be ramped between different colours in the movie.

5 **If you wish the light to be parented, select a Parent from the list.**

Lights' positions and rotations can also be keyframed following the same process as for keyframing objects.

Camera

Toon3D supports a single camera view which can be parented to a user controlled Toon, or can be keyframed. In development mode you can also assign three independent user views and a light view to aid you when modifying items in the Stage Window.

User Views

1 **Select a User View or Light View under Camera in the Control Window.**

The Stage Window automatically switches to the selected view which you can then set using the move and rotate tools.

If you select Light View then select Light in the Control Window any changes made in the Stage Window will affect the light's position and orientation, and create a keyframe if required.

Reset User Views

1 View. . .Set default user views.

This resets the user views **1**, **2** and **3** to their default settings, which are **Face**, **Front** and **Top** respectively.

Camera View

1 Select the Camera in the Control Window.

The Stage Window switches to Camera View. The position and orientation of the camera can be keyframed as you would an object.

The Camera can also be parented to a Toon that is under user control. This is explained in 'User controls'.

Parenting the camera to a Toon will force the movie to ignore any keyframes you put in the Camera. The parenting of the Camera can be turned off or switched to other Toons using script. The position and orientation of the Camera with respect to the Toon at frame 0 will dictate the view the camera will show the user throughout the movie.

TScripts overview

Toon3D has its own built-in scripting language called TScript, which allows you to use variables, read and write properties of items in your movie, detect key presses, navigation, subroutines, conditional statements and loops, plus lots more.

TScripts use a familiar syntax to many other programming languages such as VB, C++ and Director Lingo, so will be quick and easy to learn for people with some previous programming experience. There is also a debugging facility during development in the Script Window.

TScripts are based at scene level and can appear in three places in the movie, **StartMovie**, **NewFrame** and in a **Subroutine**.

Edit Scripts

1 World. . .Edit Scripts.

2 Click the Add Sub button.

3 Overwrite the name of the Sub and name it as follows.

StartMovie – the script between the **On StartMovie** and **End StartMovie** tags will only be run when the movie first loads into the browser. You would usually use the On StartMovie script to initialize variables and arrays, and start any background music.

NewFrame – the script between the **On NewFrame** and **End NewFrame** tags will be run on every frame in the movie. The NewFrame script is the main movie script where you would develop all the main scripting in your project.

You can also break up your scripts and make code reusable in multiple areas by creating subroutines. The TScript dialog box also has the facility to check the syntax of your script code.

Compiling scripts

In the TScript dialog box, click the Compile Button.

This will check through the current script and if any faults are found then a compilation error will be generated and the offending code will be highlighted. Scripts are automatically compiled when you click OK, but it is often useful to compile them as you write.

Syntax and operators

TScripts uses a familiar syntax to many other programming languages such as VB, C++ and Director Lingo.

Referencing variables, controls and strings

Controls within your movie, such as objects, Toons, Text objects and Lights, etc., are referenced by their name, as are variables. Strings have to be placed in quotation marks (""), otherwise they will be read as variables.

Examples
 Set count = 0 "sets variable count equal to zero"
 Set Text1 = "This is the text that will be displayed in the Text object Text1"

Case sensitivity

The names of controls (objects, Toons, Lights, etc.), subroutines and variable names *are* case sensitive.

Command names and property arguments and parameters are *not* case sensitive.

Colour, scale and size ranges

Colour levels for Red, Green and Blue in Lights and the Background colour are measured as floating-point numbers from **0** (**minimum saturation**) to **1** (**maximum saturation**).

Similarly, scale and size values are measured as floating-point numbers from **0** (**no size**) to **1** (**100 per cent or default size**). A number higher than 1 increases the scale and size from its default value (e.g. 2 is equivalent to twice the size).

Comments

To place comments in your code for reference use '.

Operators

Numerical operators

+ Add
− Subtract
/ Divide
* Multiply
= Equals
<> Not equal to
> Greater than
< Less than
>= Greater than or equals
<= Less than or equals

String operators

"" String
+ Concatenate

Logical operators

and Logical AND
or Logical OR

Grouping

The use of brackets () to group arithmetic and logical expressions is of great importance.

Arithmetic expressions are calculated left to right, but it is generally safer always to use brackets to group operations.

The rule for logical expressions is that expressions either side of the **or** and **and** operators should always be grouped by brackets.

Examples

Set x = 6 + 2 * 3 'will yield x = 24
Set x = (6 + 2) * 3 'will yield x = 24
Set x = 6 + (2 * 3) 'will yield x = 12

If (x = 3 AND y = 2) 'would generate an error
If ((x = 3) AND (y = 2)) 'correct syntax

Properties

Most of the controls in Toon3D have properties that can be read and set using scripts.

Reading property values

The syntax for reading a property is:

Get property (controlname, *propertyname*)

The control name is the name of an object, Toon, Text object or Light. There are also pre-defined control names, which are:

- **camera** – main movie camera
- **ambient** – ambient light colour
- **scene** – see Table A.1 for scene properties

Table A.1

propertyname	Value	Applies to
x	x position (m)	object, toon, text, camera, light
y	y position (m)	object, toon, text, camera, light
z	z position (m)	object, toon, camera, light
h	Heading (degrees)	object, toon, camera, light
p	Pitch (degrees)	object, toon, camera, light
b	Bank (degrees)	object, toon, camera, light
scalex	x scale (0–1 (1 = 100%))	object, toon
scaley	y scale (0–1 (1 = 100%))	object, toon
scalez	z scale (0–1 (1 = 100%))	object, toon
size	Size (0–1 (1 = 100%))	object, toon, text
drawwire	Draw the object in wireframe (true or false). Default is false.	object
frame	Current frame at Toon level	toon
action	Current Toon action name	toon
usekeys	Whether the Toon is under user control (true or false)	toon
visible	Visibility (true or false)	toon, object, text
parent	Parent of object or light	object, light
red	Red colour value of light (0–1)	light, ambient
green	Green colour value of light (0–1)	light, ambient
blue	Blue colour value of light (0–1) Green colour value of light (0–1)	light, ambient
tooncam	The user controlled toon with camera control (toonname). Set to none for no camera control with toon.	camera

Setting property values

All the property names in the list in Table A.1 can also be set using the Set Property command with the following syntax:

Set property (controlname, *propertyname*) = value

Example
When the *x* position of the Toon Ball1 reaches the value 250m, Ball1 is made invisible and the Action of Ball2 is set to Bounce.

```
On NewFrame
    If (Get Property (Ball1, x)) >= 250
        Set Property (Ball1, visible) = False
        Set Property (Ball2, action) = Bounce
    EndIf
End NewFrame
```

Real-time 3D Character Animation with Visual C++

Scene properties

The Toon3D movie has properties at global scene level which can be read and set. These properties relate to frame navigation and the background colour.

To set and get global scene properties the following syntax is used:

Set property (scene, *propertyname*) = propertyvalue
Get property (scene, *propertyname*)

Table A.2

propertyname	propertyvalue
startframe	Start frame of current play segment
endframe	End frame of current play segment
currentframe	Current frame of current play segment
bgRed	Red value of background colour (0–1)
bgGreen	Green value of background colour (0–1)
bgBlue	Blue value of background colour (0–1)

Example
When the current frame of the movie reaches frame 50 it will go to play the frames from 100 to 200 starting at 150, and set the background colour to black.

```
On NewFrame
    If (Get Property (scene, currentframe)) = 50
        Set Property (scene, startframe) = 100
        Set Property (scene, endframe) = 200
        Set Property (scene, currentframe) = 150
        Set Property (scene, bgRed) = 0
        Set Property (scene, bgGreen) = 0
        Set Property (scene, bgBlue) = 0
    EndIf
End NewFrame
```

Variables and arrays

TScripts support the use of variables and arrays for storing and retrieving numerical and string data.

Variables do not have to be declared and can store strings and both integers, longs and floating-point numbers. They act as global variables so all other scripts in your project can access them.

Arrays must be declared, usually in the StartMovie script, and can only be used for storing numerical data.

Setting variables

The syntax for setting a variable's value is:

Set *variablename* = value

The *variablename* can be a combination of numbers and characters, but must *not* start with a number and you can't use any TScript command names (key, set, call, etc.).

The variable value can be an integer, floating-point number, string, or numerical or string expression.

Reading variable values

To read a variable's value you simply reference it by the variablename.

Example

The integer variable score is incremented by 10 then concatenated to some text and written to the text object ScoreText.

```
On NewFrame
    Set score = score + 10
    Set ScoreText = "Your current score is" + score
End NewFrame
```

Arrays

Toon3D supports the single dimension arrays for storing indexed values. Arrays can only be used for storing numeric data and must be declared before they can be set or read.

Declaring arrays

The syntax for declaring an array is:

Array *arrayname* (*indextotal*)

The *arrayname* can be a combination of numbers and characters, but must *not* start with a number and you can't use any TScript command names (key, set, call, etc.).

The *indextotal* is the maximum integer number of indexed values in the array, up to a maximum of 255. The index values start at 0, so to declare an array with 10 indices you would enter an *indextotal* of 9.

Arrays can be declared anywhere within your script, the most common place being in the StartMovie script.

Using arrays

The syntax for setting an array is:

Set *arrayname* (*index*) = value

The *index* can be an integer or variable integer, and the value must be numerical data.

To read an array's value you reference it by the arrayname and index.

Example

An array of eight game scores **score(n)** is declared then initialized in the StartMovie script. Then, in the NewFrame script, all the game scores are accumulated in the variable **total** when the movie reaches frame 100.

```
On StartMovie
    Array score(7)
    Set num = 0
    Do
        Set score(num) = 0
        Set num = num + 1
    Loop (num <= 7)
End StartMovie
On NewFrame
    If (Get Property (scene, currentframe)) = 100
        Set num = 0
        Set total = 0
        Do
            Set total = total + score(num)
            Set num = num + 1
        Loop (num <= 7)
    Endif
End NewFrame
```

Loops and conditional statements

TScripts supports the Do...Loop command, and the If...Else...EndIf condition.

Do...Loop() command

The syntax for the Do...Loop command is:

Do
 '*script commands*
 break
Loop (*condition*)

The script commands inside the loop will be processed each time through the loop while the *condition* in the **Loop** brackets equate to **TRUE**. Once the *condition* equates to **FALSE**, the loop terminates. The condition *must* be in brackets.

You can also terminate a loop by inserting the **break** statement.

Example
Each index of the array **score** is incremented by 10 until either all eight in the array are incremented, or one the array values exceeds 100.

```
On NewFrame
    Set num = 0
    Do
        Set score(num) = score(num) + 10
        If (score(num) > 100)
            break
        EndIf
        Set num = num+1
    Loop (num <= 7)
End NewFrame
```

If...Else...EndIf command

The syntax for the If...Else...EndIf command is:

If (*condition*)
 '*script commands to run if condition is TRUE*
Else
 '*script commands to run if condition is FALSE*
EndIf

If the *condition* in the brackets equates to **TRUE**, the script commands immediately after the **If** statement will run. If **FALSE**, the script commands immediately after the **Else** statement will run. The **Else** statement is optional.

Multiple **If** statements can be nested to create an ElseIf condition.

The condition *must* be in brackets.

Example

This scripts tests the Action and X position of a Toon called **player** with respect to a Toon called **ball**, and either kicks or throws the Toon ball accordingly.

```
On NewFrame
    Set playerAction = Get Property (player, action)
    Set xdistance = Get Property (player, x) – Get Property (ball, x)
    If ((playerAction = kick) and (xdistance < 1))
        Set Property (ball, action) = kick
    Else
        If ((playerAction = throw) and (xdistance < 1.5))
            Set Property (ball, action) = throw
        EndIf
    EndIf
End NewFrame
```

Detecting key presses

TScripts supports detection of key presses and left and right mouse button clicks, using the **Key** command:

```
Key (keycode) <key>
    'script commands to run upon keypress
EndKey
```

The *keypress* argument is the keycode of the key, or mouse button, being detected. The <key> is the actual key or mouse button pressed and *must* be entered in the script by using the **Keycode Button** as follows:

1 **Position the cursor in the script position where you want the Key command.**

2 **Press the Keycode Button.**

3 **Hit the key or mouse button you wish to detect.**

The Key command and all its parameters are inserted into your script. Once entered, the Keycode becomes inactive and typing in the script window returns to normal.

All the script commands inside the Key(). . .EndKey statement are run upon the designated keypress.

Example

Each time the **b** key is pressed the sound **bassnote** is played.

```
On NewFrame
    Key (66) <B>
        playsound bassnote
    EndKey
End NewFrame
```

Playing sounds

You can play sounds contained within your Toon3D project directly from TScripts:

playsound *soundname*

The *soundname* is the name given to the sound file in your project and must be referenced exactly as it appears in the Control Window (case sensitive).

The sound will be looped indefinitely until it is stopped, if it has its properties set to loop.

To stop a sound:

stopsound *soundname*

To stop all sounds:

stopallsounds

Example

Each time the **m** key is pressed the sound **music** is played, and when the **n** key is pressed the **music** is stopped.

```
On NewFrame
    Key (m)
        playsound music
    EndKey
    Key (n)
        stopsound music
    EndKey
End NewFrame
```

Generating a random number

You can generate a random number using TScripts:

Random (*maxvalue*)

The *maxvalue* is an integer value of the range of numbers the Random command will generate. The generated number will be an integer between *zero* and the *maxvalue* − 1.

Example
The *X* position of the Toon **Cheese** is set to a random value between 0 and 99.

```
On NewFrame
    Set Property (Cheese, x) = Random (100)
End NewFrame
```

Subroutines

You can create individual subroutine scripts in TScripts, making your scripts reusable and more manageable.

Adding a subroutine

1 Click on the Add Sub button in the TScript dialog box.

A subroutine is created and given an indexed name SubN. To rename the subroutine simply overwrite its default name.
 Script that is written between the On SubName and End tags will be run every time the subroutine is called. A subroutine can be called as many times as you like from the StartMovie script, another subroutine and anywhere in the NewFrame script.

Calling a subroutine

Call *SubName*

Debugging using the Script Window

You can debug your TScripts by writing information to the script window from within your scripts:

Put *argument*

The *argument* can either be a string value ("") or the name of a variable. You *cannot* **Put** arithmetic operations or script expressions to the Script Window – you must write them into a temporary variable and then **Put** the variable.

Each **Put** statement is written to a new line in the Script Window.

Example

The text "The Cheese *X* position is" is first written to the script window, followed by the actual *X* position of the Toon called **Cheese**, stored in the variable **xpos**.

```
On NewFrame
    Set xpos = Get Property (Cheese, x)
    Put "The Cheese X position is"
    Put xpos
End NewFrame
```

If the Toon Cheese was at *X* value 125 then the output of the script window would be:

```
The Cheese X position is
125
```

Publishing

When you've developed your Toon3D movie you can publish directly to a web page. Before you publish there are a couple of preferences you can set.

To set Publish preferences

1 File. . .Preferences.

Publish Settings:

JPEG Quality – sets the quality of any JPEG surface textures used in your project in the final movie. Setting the quality to a high level will result in better reproduction of the image texture but at the expense of smoother playback, and vice versa.

Create HTML doc – will generate an HTML file into which your movie will be embedded when you publish your project. The HTML document will include the codebase data needed so the ActiveX Toon3D plug-in required to play back Toon3D files will be downloaded to the user's browser if it's not already installed.

To publish your movie

1 File. . .Publish.

This will generate an HTML page (.html) and a Toon3D file (.t3x) in the folder where your project is saved, and both with the same name as the published project.

The HTML page uses the Object tag to include the Toon3D file in the page. If the user doesn't have the Toon3D plug-in installed, it will download automatically when they load a Toon3D web page. The download process is automated and is only 130 kB, so is relatively quick to install.

The Toon3D player is set to a default size of width = 550, height = 400. If you wish to modify the size or alignment of the Toon3D movie, then edit the HTML file directly. To make the Toon3D movie size with the browser window, then use width and height percentages (width = 100 per cent, height = 100 per cent for full size).

At present, only Microsoft Internet Explorer running under a 32-bit Windows operating system supports Toon3D.

Troubleshooting

System requirements for Toon3D

- PC running a 32-bit Windows operating system (currently Windows 95, 98, 2000 and NT).
- OpenGL supported graphics card (requires the file Opengl32.dll to be installed in the Windows system directory).
- Microsoft Internet Explorer for viewing.

If you experience problems with the displaying of Toon3D, then the most likely source of the problem will lie with your graphics card and OpenGL drivers. If you go to the OpenGL website at www.opengl.org, you'll find utilities which can test and update your OpenGL installation.

If you have any specific problems running Toon3D you can contact our support by email at support@toon3d.com

Appendix B:
MFC Document/View architecture – a short introduction

Most of the source code in this book uses Microsoft Foundation Classes (MFC). If you have never done any MFC programming then you may find the approach strange. The purpose of this short appendix is to get you started with MFC programming. If you intend to use MFC in your own programs then I recommend getting a good MFC book (check Appendix C for some suggestions); this is just a quick introduction.

Creating a Dialog-based application

When you start up Visual C++ and choose to create a new workspace, you can select 'MFC AppWizard (exe)' to create an MFC application. Having chosen your project's name and selected OK, you are faced with the first of several boxes in the application wizard.

An MFC application can be Single document, Multiple document or Dialog based. The simplest case is the Dialog-based option.

Any MFC application is derived from the MFC class *CWinApp*. All MFC classes use a prefix C to denote a class. A *CWinApp* class looks after the basics of an application set-up. *CWinApp* is in turn derived from *CWinThread*. All MFC applications can be made multi-threaded quite easily by creating a new *CWinThread* object. In a simple Dialog-based application the main window is created from a Dialog resource, which can be visually created using the Visual C++ resource editor. The main window is shown to the user via the *InitInstance* function, which is automatically created in the derived application class by the application wizard.

Figure B.1 Creating a new workspace with Visual C++.

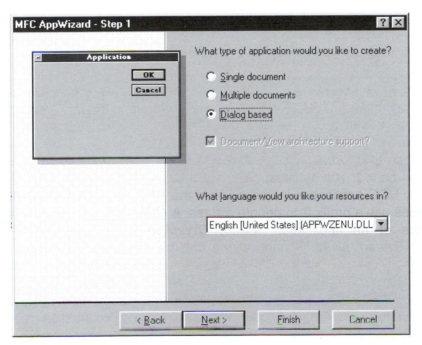

Figure B.2 Selecting the MFC application type.

```
BOOL CMFCDialogApp::InitInstance()
{
    //Only use AfxEnableControlContainer if you intend to use ActiveX
    //controls in the dialog
    AfxEnableControlContainer();

#ifdef _AFXDLL
    Enable3dControls();    // Call this when using MFC in a shared DLL
#else
    Enable3dControlsStatic();   // Call this when linking to MFC
                                // statically
#endif
    CMFCDialogDlg dlg;
    m_pMainWnd = &dlg;
    int nResponse = dlg.DoModal();
    if (nResponse == IDOK)
    {
        // TODO: Place code here to handle when the dialog is
        // dismissed with OK
    }
    else if (nResponse == IDCANCEL)
    {
        // TODO: Place code here to handle when the dialog is
        // dismissed with Cancel
    }
    // Since the dialog has been closed, return FALSE so that we
    // exit the application, rather than start the application's
    // message pump.
    return FALSE;
}
```

Figure B.3 A simple Dialog-based application.

Notice that the main window is the Dialog class *CMFCDialogDlg*, which is derived from *CDialog*. A dialog box is shown using the member function *DoModal*. When a dialog box is closed, DoModal returns the ID of the control that closed it. The default implementation uses the buttons OK and Cancel, which return IDOK and IDCANCEL.

Dialog boxes are easily handled by adding event handlers using class wizard.

The dialog in Figure B.3 contains five added controls. You can access the IDs of the controls by right clicking on the control and selecting 'Properties' from the pop-up menu. Working from left to right, the ID of the controls are IDC_NUM1, IDC_STATIC, IDC_NUM2, IDC_STATIC and IDC_NUM3. Notice here that more than one control has the ID, IDC_STATIC. To connect a variable to a control you can use Class Wizard.

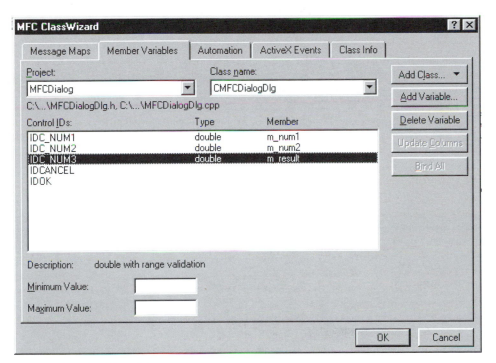

Figure B.4 *Using Class Wizard to connect a variable to a control.*

Select the Member Variables tab and highlight the control ID that you wish to be attached to a variable. Click the 'Add Variable' button.

Set the variable name and type and press OK in the new dialog box.

Now select the message map tab to connect a function to an event. In this case we will react to any change to the IDC_NUM1 control by selecting this from the Object IDs. In the Messages list you will see an EN_CHANGE message. Select this and click 'Add Function'.

In the new dialog box, give the function a name or select the default name. Now whenever a change to the text in the control with the ID IDC_

Real-time 3D Character Animation with Visual C++

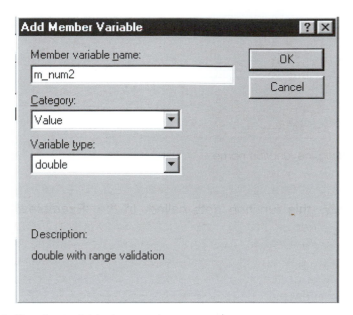

Figure B.5 *Setting the variable type and name.*

Figure B.6 *Connecting a function to an event.*

Figure B.7 Setting the function name.

NUM1 occurs, this function gets called. In the 'Examples/AppendixB/ MFCDialog' folder on the CD you will find this project. This project has functions for both IDC_NUM1 and IDC_NUM2. For each of these we will look at how to get at the control data. If you have created member variables for the controls then you can load the control data into these member variables using the function *UpdateData(TRUE)*. By passing TRUE to this function you are transferring the control data to your variables. In this simple example, we get the two numerical values, add them together and store the result in the member variable *m_result*. In the project *m_result* maps to the control IDC_NUM3, which we use to display the result. To transfer the value in the variable *m_result* into the control IDC_NUM3, we can use *UpdateData(FALSE)*. By passing FALSE to this function the tied variable value is transferred into the control.

```
void CMFCDialogDlg::OnChangeNum1()
{
    //Get values of m_num1 and m_num2 from the controls
    UpdateData(TRUE);
    m_result = m_num1 + m_num2;
    //Put the sum, m_result, into the control IDC_NUM3
    UpdateData(FALSE);
}
```

If we had not used tied member variables we could still get the data out of the control. All controls are derived from the class *CWnd*. This class has a member function *GetWindowText*. The Dialog class *CDialog* has a member function *GetDlgItem*. Passing the ID of the control to *GetDlgItem* returns a pointer to a *CWnd*. We can use this pointer and the function *GetWindowText* to retrieve the text in the control. We convert the text into a number, repeat for the second number and then sum the result. We convert the sum into a string using another MFC class, *CString*. This class

has a member function *Format* that works like *sprintf*. We can then transfer this string value into the control IDC_NUM3 using the *CWnd* member function *SetWindowText*.

```
void CMFCDialogDlg::OnChangeNum2()
{
    double a, b;
    CString str;

    GetDlgItem(IDC_NUM1)->GetWindowText(str);
    a = atof((LPCTSTR)str);
    GetDlgItem(IDC_NUM2)->GetWindowText(str);
    b = atof((LPCTSTR)str);
    str.Format("%f", a + b);
    GetDlgItem(IDC_NUM3)->SetWindowText(str);
}
```

If you want to populate the dialog before displaying it then tied member variables are the best way. You can create a dialog, then set the values of the member variables before calling *DoModal*. The *DoModal* function that displays the dialog looks after transferring the data from the variable into the control.

Creating an SDI application

If your application is a little more complex, then a good choice is an SDI application. For this type start a new MFC AppWizard (exe) workspace. In the first AppWizard panel choose the Single document for the application type.

A default single document application contains the following:

CMFCSingleDocApp derived from CWinApp
CMFCSingleDocDoc derived from CDocument
CMFCSingleDocView derived from CView
CMainFrame derived from CframeWnd

This type of approach is called the document view architecture. The idea is that you store all your data in the document and you decide how this is displayed using the view. The benefit of this is that you can display the same data in several ways. Toon3D uses four views of the same data. The view in the top left is a tree view of the document, allowing the user

to select different parts of the document. Middle left is an image view, to display bitmaps. Bottom left is a debug view for scripts. The biggest view is the OpenGL window on the right. Each of these views is handled by a completely different view class. This architecture structures the source code in a logical and easy to use way.

The default implementation has just one view. The sample project 'Examples\AppendixB\MFCSingleDoc' is a very simple SDI application. The document stores a rectangle and the view draws it. If you click on the view and drag you can draw a new rectangle. The file menu allows you to save the square or load another square. So how is this all achieved?

First, we add a *CRect* member variable to the document. A *CRect* is an MFC class that stores a rectangle structure. We can use this class to store the position on the view of the top left corner of a rectangle and the bottom left. The default values for the rectangle are initialized in the function *OnNewDocument()*, which is created for you by Visual C++ for all *CDocument* derived classes. A *CRect* class has a member function *SetRect*, which can set the *left*, *top*, *right* and *bottom* member variables.

Figure B.8 Toon3D is an SDI application.

```
BOOL CMFCSingleDocDoc::OnNewDocument()
{
    if (!CDocument::OnNewDocument())
        return FALSE;
    rect.SetRect(100, 100, 300, 300);

    return TRUE;
}
```

We draw the rectangle with the view shown in Figure B.9.

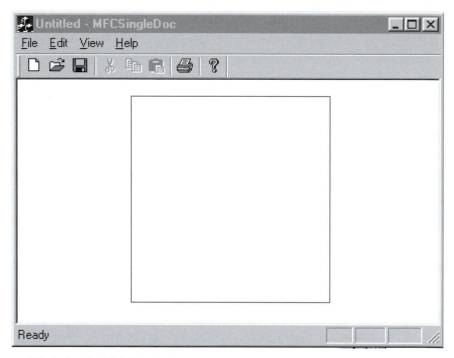

Figure B.9 A simple MFC Single document application.

The view class has a function already created by Visual C++ that allows you to implement any drawing necessary. The *OnDraw* function is passed a point to a device context class *CDC*. You can use this function to do any drawing of the document you require. First, get hold of a pointer to your document. The default AppWizard implementation includes a member function to access the document, *GetDocument()*. With the device context and the document pointer you can use a simple GDI (Graphics Device Interface) function to draw a rectangle.

```
void CMFCSingleDocView::OnDraw(CDC* dc)
{
    CMFCSingleDocDoc* doc = GetDocument();
    ASSERT_VALID(doc);

    dc->FrameRect(&doc->rect, &CBrush(RGB(255, 0, 0)));
}
```

To reshape the rectangle we can use Class Wizard to add an event handler. We select CMFCSingleDoc as the class we are dealing with in the Message Maps tab. Then select WM_LBUTTONDOWN from the message ID list. Select 'Add Function' and a message handling function is created. You can add code to this function to handle your specific needs.

```
void CMFCSingleDocView::OnLButtonDown(UINT nFlags, CPoint point)
{
    GetDocument()->rect.left = point.x;
    GetDocument()->rect.top = point.y;

    CView::OnLButtonDown(nFlags, point);
}
```

We use the same technique to implement a mouse button release function.

```
void CMFCSingleDocView::OnLButtonUp(UINT nFlags, CPoint point)
{
    GetDocument()->rect.right = point.x;
    GetDocument()->rect.bottom = point.y;

    CView::OnLButtonUp(nFlags, point);
}
```

As the mouse moves, we redraw the view if the left mouse button is held down, VK_LBUTTON.

```
void CMFCSingleDocView::OnMouseMove(UINT nFlags, CPoint point)
{
    if (VK_LBUTTON & nFlags){
        GetDocument()->rect.right = point.x;
        GetDocument()->rect.bottom = point.y;
        Invalidate();
    }
    CView::OnMouseMove(nFlags, point);
}
```

Figure B.10 Saving the document.

The default implementation of a document includes a Serialize function. This is called whenever the user chooses *Save* or *Open* from the default menu. The function is passed a *CArchive* reference that takes care of much of the complexity of saving and loading documents. Most MFC classes have the operators << and >> overridden so that to save a class you simply need to use << to save and >> to load. When using a *CArchive* class the function *IsStoring* evaluates to TRUE if the user has chosen to *Save* and FALSE if the user has chosen to *Load*.

```
void CMFCSingleDocDoc::Serialize(CArchive& ar)
{
    if (ar.IsStoring())
    {
        ar<<rect;
    }
    else
    {
        ar>>rect;
    }
}
```

Finally, we will add a new menu item using the resource editor in Visual C++. This new item has a unique ID.

If we again use Class Wizard we can add a message map handler to the CMainframe class to handle the new menu item. The CMainframe class accesses the document using *GetActiveDocument*. This function

Figure B.11 Adding a new menu item.

returns a pointer to the document which must be cast to the specific document type for your application. To make sure this is possible, remember to add the header file for your document to the start of the 'mainfrm.cpp' file. This simple function gets the centre of the current frame window and re-centres the document's rectangle to this centre. Having done this, it uses the *CDocument* function *UpdateAllViews* to tell the view to redraw itself.

```
void CMainFrame::OnEditCentre()
{
    CRect rect;

    GetClientRect(&rect);

    CPoint cen;

    cen.x = rect.Width()/2;
    cen.y = rect.Height()/2;
    CMFCSingleDocDoc *doc =
        (CMFCSingleDocDoc*)GetActiveDocument();

    CSize size;

    size.cx = doc->rect.Width()/2;
    size.cy = doc->rect.Height()/2;

    doc->rect.SetRect(cen.x - size.cx, cen.y - size.cy,
    cen.x + size.cx, cen.y + size.cy);

    doc->UpdateAllViews(NULL);
}
```

Real-time 3D Character Animation with Visual C++

Figure B.12 An MFC Multiple document application.

Creating an MDI application

An MDI application has one additional file in the default implementation, a class that is derived from *CMDIWnd* called *CChildframe*. When you select New from the menu a new document and view are created, allowing the user to work on multiple documents at the same time. MDI applications are basically the same to work with except that where you would use the *CMainframe* class in an SDI application you use the *CChildframe* in an MDI application. The sample Examples\AppendixB\MFCMultiDoc project gets you started with MDI applications.

So that concludes the whirlwind guide to MFC. Hopefully, this gives a brief overview and will help when you work your way through the source code for Toon3D. If you intend to work with MFC to any extent, then please try one of the books mentioned in Appendix C.

Appendix C:
Further information

General

Book corrections and source code updates: toon3d.com/rt3d

Gamasutra programming index:
www.gamasutra.com/features/index_programming.htm

Game Developer Magazine – For the best source of up-to-the-minute details about the games industry, check out
www.gdmag.com

Clapham, C. (1990). *The Oxford Dictionary of Mathematics*. Oxford University Press. ISBN 0–19–866156–8.

Eberly, D. H. (2001). *3D Game Engine Design*. Morgan Kaufmann. ISBN 1–55860–593–2. This book is not for the faint hearted; the mathematical level is very high, but the material contained is worth the effort.

Farin, G. (1996). *Curves and Surfaces for CAGD*. Academic Press. ISBN 0–12–249054–1.

Flowers, B. H. (1995). *An Introduction to Numerical Methods in C++*. Clarendon Press. ISBN 0–19–853863–4.

Muller, C. (1997). *Mathematics in Video Games*.
www.gamasutra.com/features/programming/061997/video_games.htm

Piegl, L. and Tiller, W. (1997). *The Nurbs Book*. Springer-Verlag. ISBN 3–540–61545–8.

Chapter 1

Baker, M. (1999). *3D World Simulation*.
www.martinb.com/threed/index.htm

Bobick, N. (1998). *Interpolating the Orientation of an Object*.
www.gamasutra.com/features/programming/19980703/quaternions_
02.htm

Watt, A. and Watt, M. (1992). *Advanced Animation and Rendering Techniques*. Pearson Education. ISBN 0–201–54412–1.

Chapters 3 and 4

The main OpenGL website at
www.opengl.org

Marques, A. OpenGL tutorial. http://arturnarques.com/tutorials/opengl/
lesson2/opengl_lesson2.htm

Woo, Neider and Davis (1997). *OpenGL Programming Guide*. Addison Wesley. ISBN 0–201–46138–2.

Chapter 9

Lander, J. (1999). *Oh My God I Inverted Kine: Inverse Kinematics for Real-Time Games*.
www.darwin3d.com

Baker, M. (1998). *Kinematics*.
www.martinb.com/threed/animation/kinematics/index.htm

Chapter 10

Ernie Wright's website: http://members.home.net/erniew/

Newtek's site:
www.newtek.com

A good source of Lightwave information is:
www.flay.com

Chapter 12

Dyer, S. (1995). *Motion Capture White Paper.*
reality.sgi.com/jam_sb/mocap/MoCapWP_v2.0.html

Sample BVH files are available at Biovisions website:
www.biovision.com

Chapter 13

Bobic, N. (2000). *Advanced Collision Detection Techiques.*
www.gamasutra.com/features/20000330/bobic_01.htm

Lander, J. (2000). *Crashing into the New Year.*
www.gamasutra.com/features/20000210/lander_ptv.htm

Chapter 15

Sharp, B. (2000). Implementing subdivision surface theory. *Game Developer Magazine*, February.

Jos Stam has several interesting papers, some involving subdivision surfaces: http://reality.sgi.com/jstam_sea

Chapter 16

Garland, M. and Heckbert, P. S. (1997). *Surface Simplification Using Quadric Error Metrics.*
www.graphics.cs.uluc.edu/~garland/research/thesis.htm

Lee, A. (2000). *3D Mesh Simplification.*
www.gamasutra.com/features/20000908/lee_02.htm

Chapter 17

Howlett, P. (1997). *Cloth Simulation Using Mass–Spring Networks.* University of Manchester Department of Computer Science, October.

Real-time 3D Character Animation with Visual C++

Chapter 18

The Web3D Consortium:
www.web3d.org

Appendix A

Toon3D website:
www.toon3d.com

Appendix B

Wilkins, Garg and Meyyammai (2000). *MFC Development Using Microsoft Visual C++ 6.0*. Microsoft Press. mspress.microsoft.com

Links to MFC websites:
http://www.brunel.ac.uk/~empgamh/cpp_win.htm

Index

Real-time 3D Character Animation with Visual C++

Real-time 3D Character Animation with Visual C++

Real-time 3D Character Animation with Visual C++

Real-time 3D Character Animation with Visual C++

FOCAL PRESS VISUAL EFFECTS AND ANIMATION SERIES

The Animator's Guide to 2D Computer Animation

Hedley Griffin

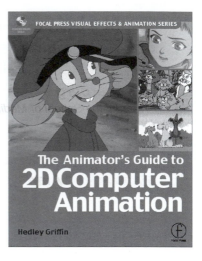

- A practical step-by-step manual written from the animator's point of view
- Foreword by Tony White, international animation director and author
- Will save you hours of frustration with complicated computer manuals!
- International coverage of all leading software: including Animo and Toonz
- Free CD-ROM with animation clips and demo PC software
- Highly illustrated, practical and easy to follow

"I thoroughly recommend that all those who aspire to making better and more efficiently produced animated movies should get this book as their starting place for their journey, or as renewed inspiration for those already journeying."
Tony White

"This book is an essential read for any person wishing to enter into media studies"
Bob Godfrey

December 2000 • 192pp • 246 x 189mm • 160 illustrations • Paperback
ISBN: 0 240 51579 X

To order your copy call +44 (0)1865 888180 (UK) or +1 800 366 2665 (USA)
or visit the Focal Press website – www.focalpress.com

A Guide to Computer Animation
for tv, games, multimedia and web

Marcia Kuperberg
Deputy Head of the School of Media Arts & Technology,
West Herts College, UK

*With contributions from **Martin Bowman**,*
Rob Manton** and **Alan Peacock

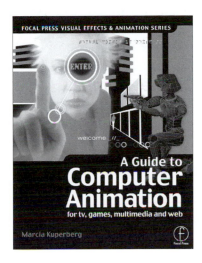

- Clear overall coverage of the principles and techniques of digital animation to put you ahead of the rest with step-by-step illustrations

- Get the best from your software and hardware ⁻ understand the constraints and demands when creating for different media

- Expert advice and huge range of resources to help you make the most of animation opportunities in TV, video, online, multimedia and games

Any questions you have about animation in this new digital age are answered in this new comprehensive text for all budding digital animators and media production students. Whether you want to move into creating moving digital imagery for TV, video, or new media you need to understand the production processes as well as the constraints of each and how they fit together.

March 2002 • 272pp • 246 x 189mm • 326 colour photos • 40 line illustrations • Book with Website
ISBN: 0 240 51671 0

To order your copy call +44 (0)1865 888180 (UK) or +1 800 366 2665 (USA)
or visit the Focal Press website – www.focalpress.com

Producing Animation

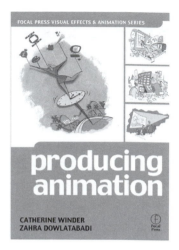

Catherine Winder and Zahra Dowlatabadi

- Complete guide to identifying, pitching, selling, developing and producing an animated show

- Includes a detailed description and flow charts of the production process for traditional (2D) and 3D CGI

"This is a bridge book between the fiscal and creative forces of animation… It ought to be required reading in animation schools for students and teachers, to show how much there is to learn and is needed to do to bring out the best in animation." **TAISzine**

"While there's a useful library of books covering the tools, techniques and aesthetics of animation, until now there's been scant coverage of the highly refined skill sets needed to produce animation… " **Kit Laybourne, Head of Animation at Oxygen Media and author of *The Animation Book***

"Producing an animated film is a mind boggling confluence of art, business, frustration, and elation. This book is a veritable treasure of information and inspiration on one of the toughest, most rewarding jobs in the film industry." **Don Hahn, Producer (Beauty and the Beast, The Lion King, Atlantis: The Lost Empire)**

"*Producing Animation* is an indispensable book for anyone working or thinking of working in animation. Covering features, direct-to-video and television - so few [producers] have experience in all mediums, it provides comprehensive information on the nuts and bolts of the business." **Bonnie Arnold, Producer (Tarzan, Toy Story)**

June 2001 • 324pp • 234 x 180 mm • 60 line illustrations • Paperback
ISBN: 0 240 80412 0

To order your copy call +44 (0)1865 888180 (UK) or +1 800 366 2665 (USA)
or visit the Focal Press website – www.focalpress.com

 Focal Press

www.focalpress.com

Join Focal Press on-line

As a member you will enjoy the following benefits:

- an email bulletin with **information on new books**
- a regular **Focal Press Newsletter**:
 - featuring a selection of new titles
 - keeps you informed of **special offers, discounts and freebies**
 - alerts you to **Focal Press news and events** such as author signings and seminars
- complete access to **free content** and reference material on the focalpress site, such as the focalXtra articles and commentary from our authors
- a **Sneak Preview** of selected titles (sample chapters) *before* they publish
- a chance to have your say on our **discussion boards** and **review books** for other Focal readers

Focal Club Members are invited to give us feedback on our products and services.
Email: worldmarketing@focalpress.com – we want to hear your views!

Membership is **FREE**. To join, visit our website and register. If you require any further information regarding the on-line club please contact:

> Emma Hales, Marketing Manager
> Email: emma.hales@repp.co.uk
> Tel: +44 (0) 1865 314556
> Fax: +44 (0)1865 314572
> Address: Focal Press, Linacre House,
> Jordan Hill, Oxford, UK, OX2 8DP

Catalogue

For information on all Focal Press titles, our full catalogue is available online at www.focalpress.com and all titles can be purchased here via secure online ordering, or contact us for a free printed version:

USA
Email: christine.degon@bhusa.com
Tel: +1 781 904 2607

Europe and rest of world
Email: jo.coleman@repp.co.uk
Tel: +44 (0)1865 314220

Potential authors

If you have an idea for a book, please get in touch:

USA
editors@focalpress.com

Europe and rest of world
focal.press@repp.co.uk

Real-time 3D Character Animation with Visual C++ – CD Contents

At the root of the CD you will find two folders. To make the most of the CD please follow the advice below.

Examples

All test programs referred to in the text and source code are in this folder. Within this folder is a sub-folder for each chapter in the book that includes samples. All C++ examples include a Visual C++ 6 workspace. If you intend to play with the source then transfer it to your computer and remove the read-only attribute from the files by selecting the files in 'Explorer', right clicking, choose 'Properties' and click the tab 'Attributes/Read-only'. Do this for the source files and the files in the 'res' folder. You do not need to copy across the 'Release' folder as it will be created when you compile; if you do copy it you will need to remove the read-only attribute from the 'exe' file, otherwise Visual C++ will not be able to recreate this file. Read-only attributes are inevitable for files that originate from a CD.

Toon3D

Toon3D is a game creator application that can take Lightwave content and allows you to package it for the Web along with interactivity. The full source for Toon3D is available in the 'Toon3D1_7_SourceCode' sub-folder. The executable 'Toon3Dcreator' is included in this folder along with sample content in the 'Content' sub-folder. In the 'Content' sub-folder you will see project files '*.t3d' that can be opened in Toon3D Creator 1.7 and web-based runtime versions that can be viewed in a browser by running the '*.html' file. This will install an '*.ocx' the first time it is run so you must use Internet Explorer to view the content in a browser. Toon3D Creator is fully functional, however, for licensing reasons the 'Publish' option is disabled. Full details are given in Appendix A.

Minimum specification for CD: P400 64 Mb 3D accelerated graphics card.